# ARTIST'S
# COLOR
# MANUAL

# ARTIST'S COLOR MANUAL

## THE COMPLETE GUIDE TO WORKING WITH COLOR

### SIMON JENNINGS

First Published in the United States in 2003 by Chronicle Books LLC

Library of Congress Cataloging-in-Publication Data available.

ISBN: 0-8118-4143-X

Cover design by Julie Vermeer.

Distributed in Canada by
Raincoast Books
9050 Shaughnessy Street
Vancouver, British Columbia V6P 6E5

10 9 8 7 6 5 4 3 2 1

Chronicle Books LLC
85 Second Street
San Francisco, California 94105

www.chroniclebooks.com

This book was conceived, edited, and designed at Hill Top Studio, East Sussex, UK

Research and Text,
Design and Art Direction
Simon Jennings

Text Editor
Geraldine Christy

Technical Consultant
Emma Pearce
Winsor & Newton

Art Educational Consultant
Carolynn Cooke
Impington Village College
Cambridge, UK

Consultant Editor
Sally Bulgin
Publisher, The Artist and
Leisure Painter Magazines

Studio Photography
Ben Jennings

Design and page make-up assistant
Amanda Allchin

Color charts and research
Chris Perry, Rose Jennings

Index
Mary Morton

Manufactured in Thailand

# Artist's Color Manual
# Contents

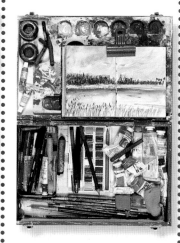

**The Artist's Color Manual**
Sketchbooks 12¼ x 8¼in (31 x 21cm)
**Simon Jennings**
Examples of original manuscript, research notes
and color experimentation for the
*Artist's Color Manual,* 2001–03

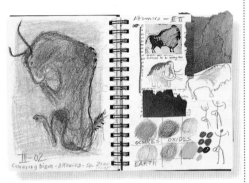

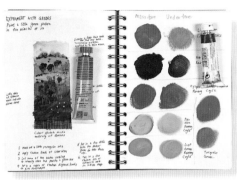

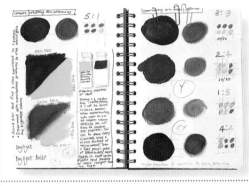

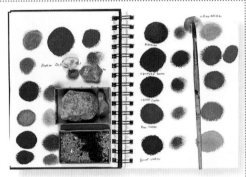

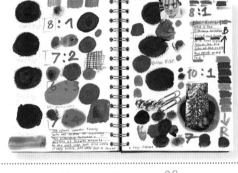

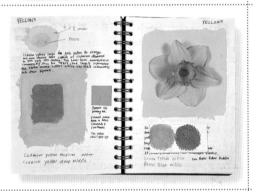

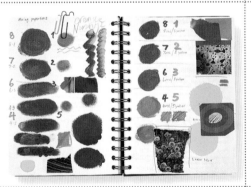

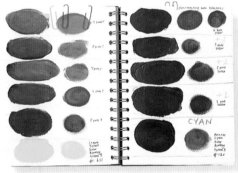

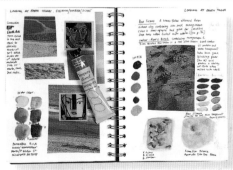

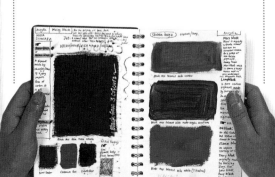

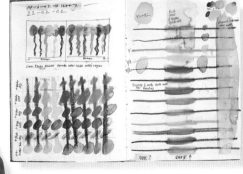

*"Color possesses me.
I don't have to pursue it.
It will possess me always,
I know it.
Color and I are one,
I am a painter."*

PAUL KLEE (1879–1940)

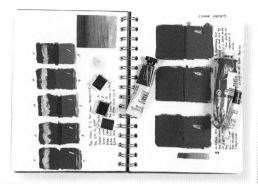

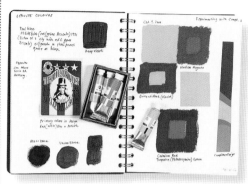

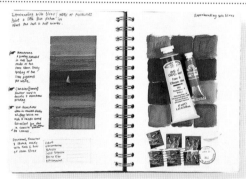

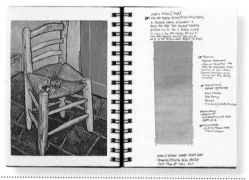

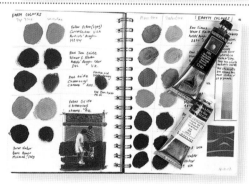

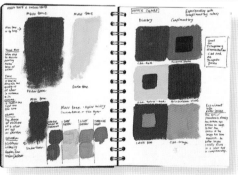

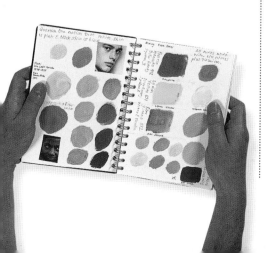

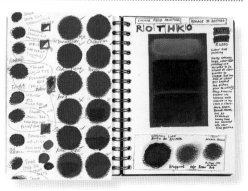

# COLOR

is essentially such a visual subject that perhaps it is rather strange that so many millions of words have been written about it. But that is no bad thing – and to add to them here are a few more, along with some stunning pictures as well. Many thanks to all who have contributed to the *Artist's Color Manual*, especially the eleven participating manufacturers who supplied invaluable technical information and scores of colors with which to experiment. I am also deeply grateful to the galleries that pointed me toward artists whose work demonstrates a unique relationship with color, and finally to the individuals themselves who opened up their studios and provided me with firsthand information and access to their fabulous imagery. Their inspiration and enthusiasm demonstrated to me that "hands-on, eyes-open" is the one and only way when it comes to understanding

# COLOR .

simon jennings, hill top studio (mmiii)

A book such as this is made possible by the goodwill and cooperation of many people and represents the work of many hands and minds. I am indebted to the following for their generous contributions, enthusiasm and support.

## Main contributing artists
in alphabetical order:

Ray Balkwill, page 98

Joan Elliott Bates, page 102

Nick Bowering, page 104

Jessie Carr, page 136

Judith Chestnutt, page 140

Lucy Dunsterville, page 136

Sue Fitzgerald, page 118

Peter Graham, page 28

Desmond Haughton, page 110

Daphne Jo Lowrie, page 128

Chris Perry, page 148

John Reay, page 132

Tim Riddihough, page 106

George Rowlett, page 114

George Underwood, page 113

Marina Yedigaroff, page 124

## Additional contributing artists
in alphabetical order:

Helen Banzhaf, page 148

Carolynn Cooke, page 152

Helen Dougall, page 148

Jackie Simmonds, page 39

Douglas Wilson, page 39

## Art materials suppliers
The following manufacturers generously donated materials and equipment for review and sampling, and for use in color charts and photography throughout this book.
In alphabetical order:

Daler-Rowney

Golden

Liquitex

Lukas

Maimeri

Old Holland

Royal Talens

Schmincke

Sennelier

Tri-Art

Winsor & Newton

(See pages 180–81 for contact details)

I am particularly grateful to the following individuals and companies for their support in organizing and obtaining materials and images for use in the *Artist's Color Manual*:

Andrew Long, Winsor & Newton
George Frangeskou, Liquitex UK
Neil Hamer, Daler-Rowney
Arjan Knegt, Royal Talens
Ben Woolfitt, Tri-Art
Guenda Burgheim, Maimeri
Ute Hallerbach, Lukas
Christine Wiegold, Schmincke
Andrew Street, Schmincke UK
Paul Schulz, Golden

Jason Mackie, Global Arts
Unit 8, Leeds Place, Tollington Park
London N4 3QW, UK
Telephone: (+44) 020 7281 2457
Email: mail@gas.demon.co.uk
For facilitating the cooperation of:
Old Holland in the Netherlands, Sennelier in France and Golden in the USA.

James Stock, Great Art
(Gerstaecker UK Ltd)
Normandy House, 1 Nether Street
Alton, Hants, GU34 1EA, UK
Telephone: (+44) 0845 601 5772
Email: welcome@gerstaecker.co.uk
www.greatart.co.uk

For technical and editorial support, advice and encouragement, my particular thanks to:

Emma Pearce
of Winsor & Newton, for reading the manuscript, corroborating the Color Index International listings and writing the Pigment History and Pigment standards information at the beginning of the book.
(Emma Pearce's quotation p.12, is reproduced by kind permission of David Pyle.)

Sarah Miller
UK Education Manager at Winsor & Newton, for cheerfully answering questions and promptly dealing with my technical and general enquiries.

Carolynn Cooke
of Impington Village College, Cambridge, UK, for supporting the project, reading the manuscript and commenting on art-educational and curriculum issues.

Sally Bulgin
Publisher of *The Artist & Leisure Painter Magazines,* for enthusiastically supporting the project and ratifying the content.

Dr Francis Duck
of The Royal United Hospital, Bath, UK, for reading and corroborating the technical and scientific content of the physics of color and the colors of the spectrum information.

Geraldine Christy
for editing my manuscript and research notes, and contributing to the writing, and looking after the details of text, type and language and preparing the text for press.

Chris Perry
for enthusiasm and general all-round support and particularly for diligent work in the preparation of color samples and pigment declarations for the color index.

Additional contributions
Additional research, writing and editing contributions: Emma Pearce (Pigments general), Brenda Howley (Choosing media), Rose Jennings (Blue and general research), Sally-Anne Schilling (Blue), Kate Gwynn (Red), Susanne Haynes (Yellow), Chris Perry (general research), and Ashley Howard (additional editing).

Color samples and swatches
All the color samples and swatches were created specifically for this book by Simon Jennings, Rose Jennings and Chris Perry, with the exception of the diagonal color chart samples used in Chapter 2, "Color by Color." These samples, on pages 48, 49, 50, 54, 55, 60, 62, 66, 67, 68, 72, 84 and 85, were kindly supplied by Schmincke and show colors from their Mussini resin-oil range. The color swatches on page 98, "Watercolor:straight and mixed," are by Ray Balkwill.

Special photography
All special photography, studio set-ups and rostrum photography by Ben Jennings. Thank you.

Page make-up
Thanks to Amanda Allchin.

American text translation
Thanks to Theresa Bebbington.

The following Galleries assisted in contacting artists for participation in this project, and I am grateful for their help:

Len Hodds (Gallery Manager) and Robin Prewer of
The Buckenham Gallery
81 High Street
Southwold, Suffolk, UK
Telephone: (+44) 01502 725 418
Email:
len@buckenham–galleries.co.uk
www.buckenham–galleries.co.uk

Michael Richardson
(Michael Richardson Contemporary Art)
Art Space Gallery
84 St Peter's Street
London N1 8JS, UK
Telephone: (+44) 020 7359 7002
Email: artspacegallery@msn.com
www.artspacegallery.co.uk

Bourne Gallery
33 Lesbourne Road
Reigate, Surrey, UK
Telephone: (+44) 01737 241 614
Email:bournegallery@aol.com
www.bournegallery.com

The Alresford Gallery
36 West Street
Alresford, Nr. Winchester
Hampshire S024 9AU, UK
Telephone: (+44) 01962 735286

**Picture credits/Image sources**

All images are identified in the following listing by chapter and page number (p.), followed, in italics, by either description or abbreviated title, or column (col.) position, from left to right.

Chapter 1

p.12 *Abbé Breuil, Young Bison*/Avalon Press, 1948; *Portrait of a Woman*/British Museum; *Michelangelo, Madonna, Child and St John with Angels*/National Gallery, London. p.13 *pigment samples*/Sennelier; *Mauve*, Simon Garfield (book jacket)/Faber & Faber, design by Pentagram (portrait of William Henry Perkin courtesy of the National Portrait Gallery, London). p.15 *Science of Art images*/Winsor & Newton. p.16 *watercolor pans*/Sennelier. pp.16–17 *main image*/Great Art (Gerstaecker). p.17 *pigments, left*/Sennelier; *pigments, right*/ Winsor & Newton. p.19 *pigment jars*/Sennelier. pp.20–21 *dot screen*/Simon Jennings archive. p.22 *Masterpiece*, Roy Lichtenstein/©DACS. p.23 *Le Chahut*, Georges Seurat/Kröller-Müller; *Sigmar Polke, Girlfriends*/Tate Modern. p.24 *Newton and the Prism, after George Romney*/from *Life of George Romney*, William Hayley,1809; *Dark Side of the Moon Album Cover*/George Hardie, Storm Thorgeson; *John Everett Millais, The Blind Girl*/Birmingham Museums & Art Galleries. pp.24–25 *Patrick Gries, The Hand of Nature*/Fondation Cartier pour l'art contemporain, Paris. p.26 *diagrammatic color*/Daler-Rowney; *sketchbooks*/Simon Jennings. p.27 *Orange jug*/Simon Jennings. pp.28–29 *all paintings*/PeterGraham. p.31 *col.3*/Schmincke. p.32 *cols 3–4*/Sennelier. p.38 *Sudden Storm over Thames, Rotherhithe Pier*/George Rowlett; *Red Tulips*/Marina Yedigaroff (photograph Richard Heeps); *Morning Mist*/Ray Balkwill; *Shoreline*/Judith Chestnutt. p.39 *Carnevale di Venezia*/Jackie Simmonds; *Lemon*/Douglas Wilson; *Check Headband*/Tim Riddihough, *cols 3–4, centre photos*/Sennelier. p.40 *col.3*/Winsor & Newton; *col.4, top*/Winsor & Newton, *col.4, bot.*/Daler-Rowney; *col.5, mid. and bot.*/Winsor & Newton. p.41 *col.1, top*/Winsor & Newton; *col.2, palettes*/from *Art Class*/HarperCollins; *col.4, top*/Winsor & Newton, *col. 4, bot.*/Schmincke. p.42 *col.4, color sketches*/Simon Jennings. p.43 *Hymn, photograph*/*Science, On the Way to Work*, Hirst & Burn/Faber & Faber; *Young Scientist Toy*/Joustra/Humbrol Ltd. p.44 *color sketch*/Simon Jennings.

Chapter 2

p.51 *col. 1, Benedetto di Bindo*, c.1400, *Madonna of Humility* (diptych detail)/Philadelphia Museum of Art; *col. 4, Iznik tile*/from Turkish Ceramics, Tashin Öz; *col.4, Dutch tile*/*Traditional Dutch Tile Designs*,The Pepin Press, Amsterdam, from the collections of the Royal Tichelaar Makkum. p.52 *cols.2–3, pigments*/Sennelier, *col.4, pigment*/Sennelier. p.53 *col.1, pigment*/Sennelier; *col.3, tube*/Schmincke; *col.4, IKB*/Simon Jennings, *col.4, Franz Marc, Blue Horse 1* (detail)/Stadtische Galerie im Lenbachhau, Munich. p.57 *col.1, fire bucket*/Phil Hind; *col.2, Giotto, Kiss of Judas* (detail)/Scala, Scrovegni Chapel, Padua. p.58 *col.2, preparing madder*/Winsor & Newton; *col.3, dried madder*/Winsor & Newton; *col.4, crimson and carmine*/Winsor & Newton. p.59 *col.1, factory*/Lukas. p.60 *col.1, factory*/Maimeri, Giovanni Manzoni; *col.2, Antonio Mensaque, Oranges*/National Trust. p.61 *col.2, color swatches*/Great Art (Gerstaecker). p.63.*col.2, bot.*/Winsor & Newton. p.65 *col 1, yellow pigments*/Maimeri, Giovanni Manzoni; *col.2, Lemons*/Simon Jennings; *col.3, bot.*/Simon Jennings Archive. p.66 *col.4, top*/Simon Jennings Archive; *col.4, bot. pigments*/Maimeri, Giovanni Manzoni. p.67 *col.4, Earth*/Simon Jennings Archive. *p.68 col.3, Scheele engraving*/Chromatography, 1869. p.69 *col 4, bot. color swatch*/Great Art (Gerstaecker). p.70 *col.2 and col.4, top*/Maimeri, Giovanni Manzoni; *col.3, bot.*/Great Art (Gerstaecker). p.71 *Green sketch*/Simon Jennings, *Vincent van Gogh,Night café*/Yale University Art Gallery. p.72 *col.3, bot.*/Maimeri, Giovanni Manzoni. p.77 *col.2, top*/*Observer*, Simon Jennings Archive, *col.3, Vines*/How To Books, Simon Jennings Archive. p79 *Kasimir Malevich, Black Suprematist Square*/Tretyakov, Moscow; *Rembrandt, Self-portrait*/National Gallery London; *After Ad Reinhardt* (facsimile)/Simon Jennings. p.81 *col.4, pigments*/Royal Talens. p.83 *Our Lady of Czestochowa*/Polish National Tourist Board. p.85 *Homage to Gray* (facsimile)/Simon Jennings. p.86 col.1, *White lead stacking*/G. Dodd, British Manufacturers 1844; *col.1 bot.*/Winsor & Newton; *col.3*/Winsor & Newton; *col 4*/Daler-Rowney. p.87 *col.2, Resists*/Simon Jennings. p.88 *Antique Bronze*/Simon Jennings Archive. p.89 *Framed Madonna* (facsimile)/Simon Jennings Archive. p.90 *col.1, Flesh experiments*/Simon Jennings. p.92 *Vincent van Gogh, Italian Girl*/Musée d'Orsay, Paris.

Chapter 3

p.96 *col.3, from top*/Ray Balkwill, Joan Elliott Bates, Nick Bowering; *col.4, from top*/Tim Riddihough, Desmond Haughton, George Underwood. p.97 *col.1, from top*/George Rowlett, Sue Fitzgerald, Marina Yedigaroff. *col.2 from top*/Daphne Jo Lowrie, John Reay, Jessie Carr and Lucy Dunsterville; *col.3, from the top*/Judith Chestnutt, Simon Jennings, Simon Jennings; *col.4, from top*/Chris Perry, Simon Jennings, Simon Jennings. p.98 *col.1, artist at work*/Ray Balkwill, *cols. 3–4, color charts*/Ray Balkwill. p.99 *paintings*/Ray Balkwill. p.100 *studio details*/Ray Balkwill, *col.4, painting detail*/Ray Balkwill. p.101 *painting*/Ray Balkwill. p.102 *Sir William Coldstream*/Simon Jennings Archive. p.103 *painting and detail*/Joan Elliott Bates. p.104 *col.4, Linear detail*/Nick Bowering. p.105 *all images*/Nick Bowering. p.106 *Red man standing*/TimRiddihough. p.107 *Check Headband*/Tim Riddihough. p.108 *col.1, bot.*/Tim Riddihough. p.109 *all images*/Tim Riddihough. p.111 *main image and detail*/Desmond Haughton. p.112 *Michelangelo, Madonna, Child and St John with Angels*/National Gallery, London. p.113 *all images*/George Underwood. p.115 S*unlit Walmer Beach, Deal Pier, Bathers and Crab Boat*/George Rowlett; *col 4, Sudden Storm over Thames, Rotherhithe Pier*/George Rowlett. pp.116–117 *Sudden storm over Thames, Rotherhithe Pier* (detail)/George Rowlett. pp.118–119 *Cardinal Grapes and Silken Shawl* (and detail)/Sue Fitzgerald. pp.120–121 *Two Dragons*/Sue Fitzgerald. p.122 *col.1, detail*/Sue Fitzgerald. p.123 *col.2, bot. painting* (detail)/Sue Fitzgerald, *col.3 painting* (detail)/Sue Fitzgerald. p.125 *Chrysanthemums*/Marina Yedigaroff (photo Richard Heeps). p.127 *Red Tulips*/Marina Yedigaroff (photo Richard Heeps). p.129 *Siblings*/Daphne Jo Lowrie. p.130 *all images*/Daphne Jo Lowrie. p.131 *cols 2–3, paintings* (and details)/Daphne Jo Lowrie. p.133 *Lowestoft Beach*/John Reay (photo Dean Annison). p.134 *col.1*/John Reay. p.135 *main image*/John Reay (photo Dean Annison). p.131 *preparatory sketch*/Jessie Carr and Lucy Dunsterville. p.140 col.1, *Color sample*/Judith Chestnutt. p.141 *Shoreline*/Judith Chestnutt. p.142 *col.4, top and middle*/Judith Chestnutt. p.143 *col.1, Color samples*/Judith Chestnutt, cols. 3–4, *Wastepaper collages*/Simon Jennings. pp.144–145 *all images*/Simon Jennings. pp.146–147 *main image and details*/Simon Jennings. p.148 *col.1 and cols.3–4, Vessels*/Helen Banzhaf; *foot of page, Set Aside*/Helen Dougall. p.149, *all images* Chris Perry. p.150, *all images* Heinz Edelman/TVC, King Features. p.151 *Building Fascias*/Simon Jennings. p.152 *col.2, centre images*/Carolynn Cooke. pp.152–153 *all other images*/Simon Jennings.

**WHAT** IS **COLOR?**

CHAPTER 1

*"Today's artists work with colors produced by an industry which has spent two centuries getting better and better and better, while most people in this world have to work with things that have got worse and worse."*

EMMA PEARCE
(IN "WHAT EVERY ARTIST NEEDS TO KNOW ABOUT PAINT & COLORS" BY DAVID PYLE)

**Young Bison**
(Altamira, N. Spain)
From a watercolor by the Abbé Breuil
*Prehistoric Painting/Brodric/Avalon Press 1948*

Today's artists are lucky in being constantly provided with pigments that are more permanent and offer an ever-widening choice of handling properties. In less than 200 years the finest quality ranges have improved from around 30 percent permanent to 99–100 percent, as well as providing two or three times the number of colors.

Although many early pigments are now replaced by more reliable ones, many are not. Incurable romantics may find it pleasing that the first pigments remain some of the finest available to the artist.

### The first colors
More than 15,000 years ago cavemen began to use color to decorate cave walls. These were earth pigments, yellow earth (ochre), red earth (ochre) and white chalk. In addition they used carbon black (Lamp Black) by collecting the soot from burning animal fats. These colors were all that were needed to produce the sensitive and exquisite drawings and stencils that we are still able to see today.

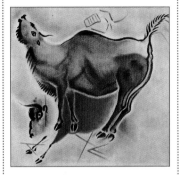

### The Egyptians
There is evidence that by 4000BC the Egyptians were manufacturing colors. The earth colors were cleaned by washing, which increased their strength and purity, and new pigments were being derived from minerals. Perhaps the most famous is Egyptian Blue, first produced around 3000BC. This was a blue glass made from sand and copper, which was then ground into a powder. It was replaced in the sixteenth century by Smalt, itself finally superseded by Cobalt Blue in the early nineteenth century.

The Egyptians also utilized malachite, azurite and cinnabar by crushing and washing each mineral. Cinnabar was prized as the first known bright red.

Vegetable dyes were also developed by the Egyptians, who found a way of "fixing" the dye onto a transparent white powder to produce a pigment. This process is called lake making, and it is still used today to produce rare colors.

Excavated at Hawara in 1888
**Portrait of a Woman, AD100–120**
Encaustic on limewood
*British Museum, London*

### The Chinese
Although the discoveries and knowledge of the Chinese civilization ran parallel with other ancient societies, the Chinese were well in advance of the rest of the world with many inventions, including paper. Pigments were no exception and Vermilion was developed in China around 2,000 years before it was used by the Romans. Vermilion was made by heating mercury and sulfur, producing an extremely opaque, strong red pigment that had almost entirely replaced Cinnabar by the eighteenth century. By the end of the twentieth century, Vermilion itself was replaced by a range of cadmium colors, which provide greater permanence.

### The Greeks
The Greeks also added to the artist's palette, notably by manufacturing white lead, the first completely opaque white (known today as Flake White or Cremnitz White). The manufacturing process took several months and involved stacking lead strips in a confined space with vinegar and animal dung. This method (with a few refinements) was used until the 1960s and produced arguably the finest pigment of all for the artist's palette. The physical structure and reaction with oil give a superbly flexible and permanent paint film. The Greeks also made red lead, which was used for priming metal until the 1990s, when lead pigments were banned for use by the general public.

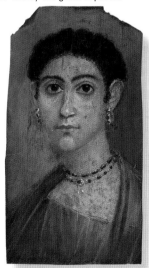

### The Romans
For the most part the Romans inherited the palette of the Egyptians and Greeks. Pompeii is one of the main historical sources, dating to AD79, and Vermilion has been identified on many Pompeiian wall paintings. One of the most important colors was Tyrian Purple, which was also one of the most costly. The color is prepared from a small color-producing cyst within a whelk. Huge quantities of whelks were required – P. Friedlander, in 1908, collected just ⅟₂₀oz (1.4g) of pure dye from 12,000 molluscs. Huge piles of discarded shells can still be seen at the sites of ancient dye works in the Mediterranean. Its high price ensured that Tyrian Purple was reserved as a dye for the togas of Roman dignitaries, and it became a symbol of power and status.

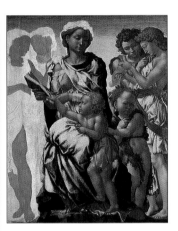

### The Renaissance
**Little changed in the first millennium AD with regard to colors, and it was the rebirth of artistry that fueled new pigment development from the fourteenth century. The Italians further developed the range of earth pigments by roasting siennas and umbers to make the deep rich red of Burnt Sienna and the rich brown of Burnt Umber. Earth colors featured heavily in their painting technique, Terre Verte (Green Earth) being the principal underpainting color for flesh.**

Michelangelo Buonarroti (1475–1564)
**Madonna, Child and St. John with Angels, *c*. 1506**
Oil on wood panel (detail)
*National Gallery, London*

### Renaissance developments

The Italians improved the lake-making processes of the Egyptians and developed Naples Yellow, another opaque lead-based pigment. However, it was the development and use of genuine Ultramarine that perhaps personifies the paintings of the Renaissance.

Lapis lazuli was first used as a pigment by simply grinding it, but even the best stone can have up to 90 percent impurities and it was the discovery of how to extract the blue that enlightened the Renaissance palette. The bright, deep blue produced had excellent lightfastness and was the most expensive pigment known to man. This high value was the reasoning behind gracing the Madonna in blue.

### The beginning of modern pigments

**By the eighteenth century, the world was not only enjoying greater trade between the continents, and, therefore, more industry than previous centuries, but it was also beginning to see the benefits of modern scientific chemistry. In 1704 a German color maker named Diesbach was manufacturing red lake pigments, which required the use of potash as an alkali. He ran out of his supply and used some that was contaminated with animal oil. Instead of making red he made purple and then blue – the first chemically synthesized color, Prussian Blue, had been produced! Prussian Blue remains a popular color to this day and is also known for its novel ability to fade in daylight, yet recover its strength in darkness!**

### Early nineteenth century

The Industrial Revolution at the beginning of the nineteenth century produced both new processing possibilities and new opportunities for trade in every quarter of life, including artists' pigments. Scientists were driven by the demand for new, more permanent, colors and were able to utilize new minerals and chemistry to invent many of the colors that we think of today as "traditional."

### Cobalt pigments

Cobalt Blue was discovered in 1802 by Thénard. It was a wonderful transparent, granulating mid-blue of great permanence. It is used widely in ceramics and loved by artists for its moderate tinting strength, as well as for its fast-drying and watercolor characteristics.

Cobalt Green, although first made in 1780, did not enter common usage until after Cobalt Violet first appeared in 1860, with Cobalt Yellow (Aureolin) becoming available in 1862. The color Cerulean Blue is also a type of cobalt and was available as early as 1805.

By combining cobalt oxide with aluminum, phosphorus, tin, zinc or a number of other metals, a variety of colors is produced. The cobalt pigments have always been expensive and the search continued for a less expensive dark blue pigment for the artist's palette. In the 1820s a national prize of 6,000 francs was offered in France to anyone who discovered a method of artificially making Ultramarine at a cost of less than 300 francs per kilogram. Both the French and Germans competed, but it was J.-B. Guimet who succeeded in 1828. Known as French Ultramarine ever since, the pigment is chemically identical to genuine Ultramarine, but physically finer and is without the impurities of the lapis rock.

### Chrome pigments

The isolation of new elements in the late eighteenth century also played a part in providing new colors. In 1820 deposits of chrome in the USA facilitated the easy manufacture of Chrome Yellow, a highly opaque, low-cost color available in a variety of hues. Although chrome colors had a tendency to darken, they remained popular until the 1990s, because of their good covering power and economical price. Chemically, the colors are lead chromes, and, as such, they fell foul of the legislation against lead pigments at that time.

### Zinc pigments

Similarly, the isolation of zinc in 1721 eventually led to the use of zinc oxide by the late eighteenth century. This was used as an artists' white in preference to lead white, because it was less hazardous and more permanent, particularly in watercolor. However, it lacked opacity until 1834, when Winsor & Newton developed a method of heating the oxide to increase its opacity. This new type of zinc oxide was called Chinese White.

### Cadmium pigments

In 1817 the metal cadmium was discovered by Strohmeyer, but it was not until 1846 that cadmium yellows were introduced to the artist's palette. Immediately popular for their great permanence, range of hues, moderate tinting strength and high opacity, Cadmium Yellow remains the mainstay for artists in this area of the spectrum. Cadmium Red was not available until after 1910.

### Genuine Emerald

Genuine Emerald Green was first documented in 1822 and was highly toxic. Consisting of copper aceto-arsenite, it provided a bright clean emerald color until the 1960s. It is most famous, however, for its potentially fatal effects. It is thought that Napoleon died as a result of arsenic poisoning from the wallpaper in his prison home on St Helena. Emerald Green was a very popular wallpaper color, but, unfortunately, in damp conditions arsenical fumes were released.

### The first modern organic pigments

**In 1856 William Henry Perkin was a student at the Royal College of Chemistry. In his improvised laboratory at Greenford, Middlesex, he was attempting to synthesize quinine when he unexpectedly produced a purplish dye from oxidizing impure aniline with potassium bichromate. Mauvine, the first organic color (based on carbon chemistry) was born. This led to the distillation of coal tar, which produced a huge range of new pigments over the decades to come. Mauvine as a dye was an instant success and became the most fashionable dress color for Victorian ladies.**

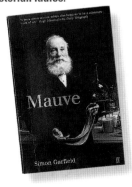

**Impressionism and portable colors**
The explosion of new pigments during the nineteenth century, the invention of the metal tube and the arrival of the railways all combined to facilitate the rise of the Impressionist movement. Bright new colors in portable, stable tubes and a method of easy traveling led to a period of painting that has become one of the most recognized in the history of art.

## Alizarin Crimson
Alizarin Crimson is arguably the most important organic pigment of the nineteenth century. It was introduced in Germany in 1868, providing a blue-shade crimson of strong tinting strength and high transparency. At that time, and until the 1960s, it was the most permanent crimson available. However, in pale washes it is susceptible to fading and modern quinacridones are more lightfast.

## Synthetic iron oxides
The nineteenth century also saw the development of the Mars colors. These "earth" colors are produced in a wide range of browns, reds, yellows and black, according to the levels of moisture and heat used. Originally, they tended to be opaque, and they are much stronger than the natural earths. They have become important to artists of today, because the deposits of good natural earths have become depleted.

**The twentieth century**
**Pigment development continued apace into the new century.**

### "Hansa" yellows
During the first decade of the twentieth century, the Hoechst company brought out the first of the "Hansa®" yellows. Here was a synthetic organic pigment of good permanence, clear bright hue and high transparency. The color is known as Lemon Yellow, but the Hansa group quickly led to darker yellows, and this pigment type is still important. The chemistry of this and other synthetic organic pigments is immensely complex. In a few words, Hansa is made by coupling diazotized amines containing nitroso and/or halide groups with acetoacetanilide or one of its derivatives! No longer can they be called a basic name relating to their origin, such as cadmium or cobalt. Instead, we see trade names, such as "Winsor" Yellow, or sometimes shortened names, such as Azo Yellow Medium. Reds were similarly developed, and, from the 1920s onward, these new pigments were offered as artists' materials.

### Titanium White
The most important pigment of the century in terms of volume was Titanium White. Although the element had been identified in 1795, it was not until 1920 that an economical method of purifying the metal oxide was established. A nonhazardous, and the strongest, most opaque white available, Titanium quickly became the most popular white for artists.

### Monastral Blue
In 1935 Monastral Blue was introduced by ICI. Known also as Phthalocyanine Blue, this offered a deep transparent blue of enormous tinting strength, yet moderate cost. Prized for its mixing abilities, it has also become the basis of many student-range blues, because it can be reduced considerably and still offer a strong color.

### Quinacridones
A very important group of pigments originated in the 1950s. The first quinacridones were introduced to the artist's palette as Permanent Rose and Permanent Magenta. Until then the pink and mauve color area had suffered from poor lightfastness; now crystal-clear hues were available without fading. Over the next 50 years many more colors became available, ranging from deep crimson to gold. This is achieved by juggling the chemicals involved. It is a quinacridone that is used as Permanent Alizarin Crimson.

### Artists' pigments today
**An average palette today of only 12 colors contains a selection of pigments from every historical era, as well as every pigment type. Broadly defined, there are three pigment types.**

### Earth colors
Ochres, siennas, umbers and Mars colors.
### Traditional colors
Cobalts, cadmiums, titanium and ultramarines for example.
### Modern colors
Phthalocyanines, quinacridones, perylenes and pyrroles for example.

Chemically, pigments are categorized by whether or not they contain carbon. This results in a more technical, but more accurate, definition of possible types.

### Inorganic pigments
Earth, mineral (for example, cinnabar), synthetic (for example, cobalt).
### Natural organic pigments
Rose Madder is an example in this category.
### Synthetic organic pigments
The quinacridone colors fall into this category.

### Can it get any better?
By the 1990s more pigment types of synthetic organic origin were appearing. Perylenes, pyrroles and new arylides (for example, Hansa yellows) have come into use. In some cases new hues are available, further extending the possibilities in watercolor or filling a perfect gap in portraiture, or providing even greater transparency for mixing or glazing. In other cases some good lightfast pigments were replaced by pigments that were even more lightfast. So, we replace colors that last for a few hundred years with colors that last many hundreds and hundreds of years! Today's artists are certainly fortunate to be living and painting in the twenty-first century.

### Thanks to the automobile!
The car has to permanently endure the elements, whether rain, hail or sunshine, and pigments used for automobiles must withstand snowbound or desert conditions. Artists have everything to be thankful for that such lightfast pigments had to be developed. Without the car we would not have the reds, yellows and purples that we enjoy today.

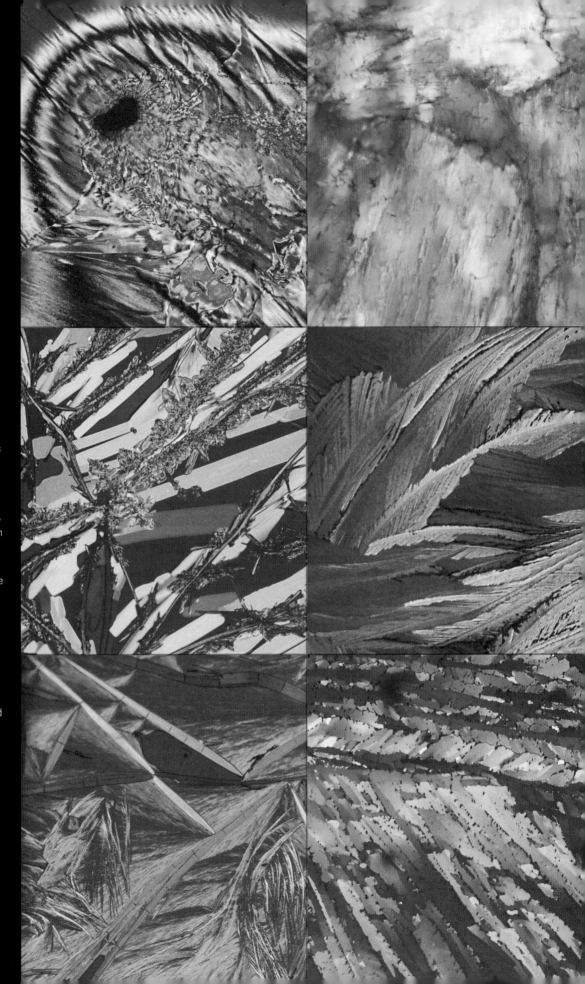

**Winsor Green, magnified x 240**

Winsor Green, which is found in most Winsor & Newton color ranges, is made from a single pigment. Despite the higher cost, single pigments give cleaner, brighter mixtures, better handling, and greater brilliance when they are diluted.

Microscopic photography by Florida State University

**Lapis lazuli, magnified x 150**

Lapis lazuli, the semiprecious stone from the hills of Afghanistan, is the secret of the blue used by the old masters. Modern pigments used for Ultramarine Blue are chemically indistinguishable from lapis lazuli, resulting in a beautiful blue with the characteristics of lapis lazuli at an affordable price.

Microscopic photography by
The Natural History Museum, London

**Cochineal beetle shell, magnified x 150**

The rich pigment of Carmine is created from the cochineal beetle, yielding a unique crimson that is beautiful, but not lightfast. In 1996 Winsor & Newton scientists finally succeeded in formulating Permanent Carmine, a new pigment that enables artists to enjoy this unique color with superior permanence.

Microscopic photography by Florida State University

**Madder root, magnified x 240**

The unique pigment of Genuine Rose Madder is impossible to match precisely in hue, strength and texture with modern pigments. Winsor & Newton's formula for Genuine Rose Madder pigment, developed by George Field in 1806, still yields the most permanent Genuine Rose Madder color available today.

Microscopic photography by Florida State University

**Indian Yellow, magnified x 240**

Used in India from the fifteenth century, this warm transparent yellow of great depth and beauty was said to be made from the urine of cows fed solely on a diet of mango leaves. Production of the color halted in the 1920s due to concern over the religious status of the cows and the rise of improved, more easily manufactured colors.

Microscopic photography by Florida State University

**Alizarin Crimson, magnified x 150**

Alizarin Crimson has been one of the most popular colors through the ages. However, it can fade in thin layers or washes. In recent years Winsor & Newton, in the pursuit of improved lightfastness, developed and introduced Permanent Alizarin Crimson into its ranges wherever possible.

Microscopic photography by Florida State University

There are a number of universal systems and standards that help artists to identify and build knowledge in key areas of concern. Most importantly, artists are interested in the specific characteristics of pigments, so that they can use them to achieve their own creative ends.

**Colors are not the same**
Just as loaves of white bread from different bakers will differ, so will artists' colors from different manufacturers. The formulation or recipe of the color in conjunction with the manufacturing method and choice of raw materials produce variations between colors with the same name from different suppliers.

Next, they need information regarding the permanence of pigments. The characteristics of a color – such as granulation, staining, bleeding, transparency or opacity, color bias, drying rate, etc. – are to be found in both reference books and manufacturers' color charts. Permanence ratings are also provided by manufacturers.

There are no set standards for pigment characteristics. After all, it is the diversity and individuality of each material that painters want to exploit. Generally, good-quality products are offered by the whole art materials industry, and for most artists the literature and information supplied is sufficient for their needs. However, you may want to know more about the media you are using, and to do this, pigments need to be clearly identified.

**The Color Index International**
Since the development of modern organic pigments, pigment names are no longer sufficient to identify the actual pigment being used. For instance, there are dozens of naphthol reds with varying characteristics and different levels of lightfastness. The Color Index International identifies each pigment (see pages 18–19), ensuring artists know what they are using. Most artists' materials manufacturers publish the pigment content of their colors.

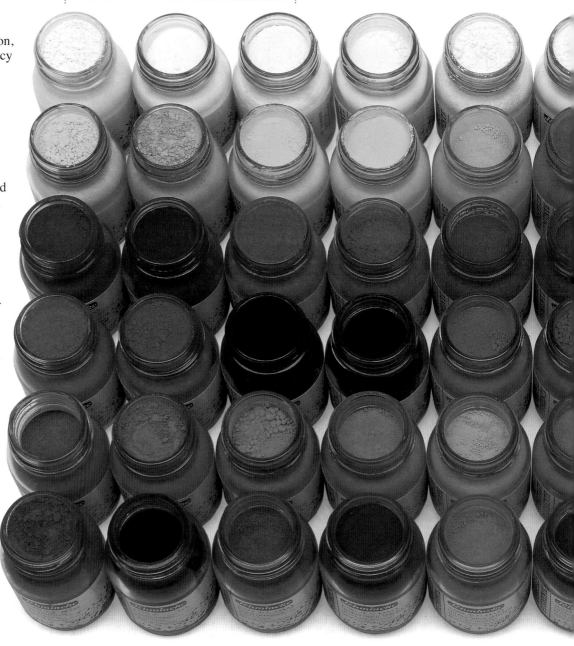

### ASTM

The ASTM abbreviation stands for the American Society for Testing and Materials. (The UK equivalent is the British Standards Institute.) The ASTM has set standards for the performance of art materials and this includes lightfastness. It is the lightfastness ratings with which artists are most familiar. Pigments are tested in reduction with white in both artificially accelerated conditions and desert sunshine. Ratings I and II are recommended as "Permanent for artists' use." Art materials manufacturers rate their colors in a similar way, and, where no ASTM rating is given, this usually means that the pigment is new and has not yet been tested by ASTM. In these cases the manufacturer's rating will be available.

### Do not take color for granted!

With just one color there are many factors that affect what you see on the paper or canvas; these include thickness of color, medium used, surface used, strength of pigment, use in mixtures, juxtaposition, transparency, color bias and more. This variation is multiplied by the number of colors available. In a well-spaced artists' range, there may be as many as 80 single pigment colors. Combine this with individual artists and an infinite array of results is an understatement!

Painting is a joy and there are certainly more colors available than any one artist can use in a lifetime. Of course, it is important to remember that each artist is aiming for self-expression, and this means that what is right for one painter is not suitable for another. Some may never need opaque colors; some will never use more than six hues, for example. The important point is that the widest variety of characteristics is available to all artists.

☞**See also**

The Color Index International is the standard compiled and published by the American Association of Textile Chemists and Colorists and The Society of Dyers and Colourists. The Color Index classifies pigments by their chemical composition. This is an excellent identification method for lightfastness, because the Index separates variations of pigment types, such as Naphthol, so that you can see if the permanent versions are being used. However, the physical characteristics, as well as the chemical ones, affect the actual color of the pigment. For example, all Cadmium Reds are PR108, yet hues exist from scarlet to maroon. Most art materials makers print the abbreviations and often the chemical description on the tube label and in their literature.

☛ See opposite page for explanation of tables and pigment identification systems.

## PY: PIGMENT YELLOW

| CI Name | Color/Pigment Name | Chemical Description |
|---|---|---|
| NY24 | Gamboge (Natural Yellow) | Garcinia gum resin |
| PY1 | Hansa: Arylamide | Arylide |
| PY3 | Hansa: Arylamide | Arylide |
| PY4 | Hansa: Arylamide | Arylide |
| PY5 | Hansa: Arylamide | Arylide |
| PY10 | Hansa: Arylamide | Arylide |
| PY12 | Diarylide Yellow | Diarylide yellow |
| PY13 | Diarylide Yellow | Diarylide yellow |
| PY14 | Diarylide Yellow | Diarylide yellow |
| PY16 | Diarylide Yellow | Diarylide yellow |
| PY17 | Diarylide Yellow | Diarylide yellow |
| PY30 | Benzimidazolone Yellow | Benzimidazolone |
| PY32 | Strontium Yellow | Barium chromate |
| PY34 | Chrome Yellow | Lead chromate |
| PY35 | Cadmium Yellow | Cadmium zinc sulfide |
| PY37 | Cadmium Yellow | Cadmium sulfide |
| PY40 | Aureolin | Potassium cobaltinitrite |
| PY41 | Naples Yellow | Lead antimoniate |
| PY42 | Yellow Oxide | Synthetic yellow iron oxide |
| PY43 | Yellow Ochre | Natural yellow iron oxide |
| PY53 | Nickel Titanate Yellow | Nickel titanium oxide |
| PY65 | Hansa: Arylamide | Arylide |
| PY73 | Hansa: Arylamide | Arylide |
| PY74 | Hansa: Arylamide | Arylide |
| PY83 | Diarylide Yellow | Diarylide yellow |
| PY97 | Hansa Yellow | Diarylide yellow |
| PY98 | Hansa Yellow | Diarylide yellow |
| PY100 | Tartrazine Yellow | Tartrazine lake |
| PY108 | Indian: Gamboge Modern | Anthrapyrimidine |
| PY109 | Isoindolinone Yellow | Isoindolinone |
| PY110 | Isoindolinone Yellow | Tetrachloroisoindolinone |
| PY112 | Flavanthrone Yellow | Naphthol |
| PY119 | Mars Yellow | Zinc iron oxide |
| PY120 | Benzimidazolone Yellow | Benzimidazolone |
| PY128 | Azo Condensation Yellow | Azo condensation |
| PY129 | Green Gold | Azomethine copper complex |
| PY137 | Isoindolinone Yellow | Isoindoline |
| PY138 | Isoindolinone Yellow | Isoindoline |
| PY139 | Isoindolinone Yellow | Isoindoline |
| PY150 | Nickel Azo Yellow | Nickel azomethine |
| PY151 | Benzimidazolone Yellow | Benzimidazolone |
| PY153 | Nickel Dioxine Yellow | Nickel dioxine |
| PY154 | Benzimidazolone Yellow | Benzimidazolone |
| PY155 | Benzimidazolone Yellow | Benzimidazolone |
| PY156 | Benzimidazolone Yellow | Benzimidazolone |
| PY175 | Benzimidazolone Yellow | Benzimidazolone |
| PY184 | Bismuth Vanadium | Bismuth vanadate |

## PO: PIGMENT ORANGE

| CI Name | Color/Pigment Name | Chemical Description |
|---|---|---|
| PO13 | Pyrazolone Orange | Pyrazolone |
| PO20 | Cadmium Orange | Cadmium selenosulfide |
| PO34 | Pyrazolone Orange | Pyrazolone |
| PO36 | Benzimidazolone Orange | Benzimidazolone |
| PO43 | Perinone Orange | Perinone orange |
| PO48 | Quinacridone Gold | Quinacridone gold |
| PO49 | Quinacridone Gold | Quinacridone deep gold |
| PO62 | Benzimidazolone Orange | Benzimidazolone |
| PO65 | Golden Barok Red | Methine nickel complex |
| PO67 | Coral Orange | Pyrazoloquinazolone |
| PO69 | Isoindoline Orange | Isoindoline |
| PO71 | Translucent Orange | Diketo-pyrrolo pyrrole orange |
| PO73 | Pyrrole Orange | Diketo-pyrrolo pyrrole orange |

## PR: PIGMENT RED

| CI Name | Color/Pigment Name | Chemical Description |
|---|---|---|
| NR4 | Carmine | Cochineal lake |
| NR9 | Rose Madder | Lake of natural madder |
| PR3 | Toluidine Red | Toluidine |
| PR4 | Chlorinated Para Red | Chlorinated para red |
| PR5 | Naphthol Red | Naphthol |
| PR8 | Naphthol Red | Naphthol |
| PR9 | Naphthol Red | Naphthol |
| PR12 | Naphthol Red | Naphthol |
| PR23 | Naphthol Red | Naphthol |
| PR48 | Scarlet Lake | Beta oxynaphtholic acid |
| PR48:3 | Geranium | Strontium salt |
| PR49 | Lithol Red | Lithol |
| PR81 | Basic Dye Toner (Red) | Rhodamine |
| PR83 | Alizarin Crimson | Dihydroxyanthraquinone lake |
| PR88 | Thioindigo Violet | Thioindigo |
| PR101 | Venetian/Indian/English/Light Red | Calcined synthetic red iron oxide |
| PR102 | Red/Burnt Ochre/Mars | Calcined natural red iron oxide |
| PR104 | Molybdate Orange | Lead molibdate |
| PR106 | Vermilion (genuine) | Mercuric sulfide |
| PR108 | Cadmium Red | Cadmium selenosulfide |
| PR112 | Naphthol Red | Naphthol AS-D red |
| PR122 | Quinacridone Red/Magenta | Quinacridone |
| PR146 | Naphthol Red | Naphthol |
| PR149 | Perylene Red | Perylene |
| PR166 | Azo Condensation Red | Azo condensation red |
| PR168 | Dibromanthone | Anthraquinone scarlet |
| PR170 | Naphthol Red | Naphthol AS carbamide |
| PR171 | Benzimidazolone Maroon | Benzimidazolone |
| PR173 | Basic Dye Toner (Red) | Rhodamine/Aluminum lake |
| PR175 | Deep Scarlet | Benzimidazolone |
| PR176 | Benzimidazolone Red | Benzimidazolone |
| PR177 | Permanent Alizarin Crimson | Anthraquinonoid red |
| PR178 | Perylene Red | Perylene |
| PR179 | Perylene Maroon | Perylene |
| PR188 | Scarlet/Naphthol | Naphthol/Arylamide |
| PR190 | Perylene Red | Perylene |
| PR202 | Quinacridone Crimson | Quinacridone |
| PR206 | Quinacridone Burnt Orange | Quinacridone burnt orange |
| PR207 | Quinacridone Red | Quinacridone |
| PR209 | Quinacridone Red | Quinacridone |
| PR214 | Deep Red | Disazo condensation red |
| PR224 | Perylene Red | Perylene |
| PR251 | Permanent Red | Pyrazoloquinazolone scarlet |
| PR254 | Pyrrole Red | Diketo-pyrrolo pyrrole red |
| PR255 | Pyrrole Scarlet | Diketo-pyrrolo pyrrole scarlet |
| PR260 | Vermilion Extra | Isoindoline scarlet |
| PR264 | Pyrrole Red | Diketo-pyrrolo pyrrole red |
| PR270 | Pyrrole Red | Diketo-pyrrolo pyrrole red |

**Identification system** Pigments are identified in two ways:

**1. CI Name** – Color Index Generic Name

Pigments are placed within their part of the spectrum and then given a number. For example: Cadmium Red is Pigment Red 108, abbreviated to PR108; PG is Pigment Green; PB is Pigment Blue, and so forth. PBr is Pigment Brown and PBk is Pigment Black.

**2. CI Number** – Color Index Number

Pigments can also be identified by their number. For example: Cadmium Red is 77202.

*Of the two methods, the Color Index Generic Name is the most common and is used in these tables.*

## PV: PIGMENT VIOLET

| CI Name | Color/Pigment Name | Chemical Description |
|---|---|---|
| PV1 | Basic Dye Toner (Violet) | Rhodamine violet |
| PV2 | Basic Dye Toner (Violet) | PTMA toner |
| PV3 | Basic Dye Toner (Violet) | PTMA toner |
| PV4 | PTMA Violet | PTMA toner |
| PV14 | Cobalt Violet | Cobalt phosphate |
| PV15 | Ultramarine Violet | Sodium aluminum sulfosilicate |
| PV16 | Manganese Violet | Manganese ammonium pyrophosphate |
| PV19 | Quinacridone | Quinacridone |
| PV23 | Dioxazine Violet/Purple | Dioxazine violet |
| PV31 | Isoviolanthrone Violet | Isoviolanthrone |
| PV42 | Quinacridone | Quinacridone |
| PV49 | Cobalt Violet | Cobalt aluminum phosphate |

## PB: PIGMENT BLUE

| CI Name | Color/Pigment Name | Chemical Description |
|---|---|---|
| PB15 | Phthalo Blue | Copper phthalocyanine |
| PB15:1 | Phthalo Blue | Alpha copper phthalocyanine |
| PB15:3 | Phthalo Blue | Beta copper phthalocyanine |
| PB15:4 | Phthalo Blue | Beta copper phthalocyanine |
| PB15:6 | Phthalo/Blue | Epsilon copper phthalocyanine |
| PB16 | Phthalo Blue/Turquoise Green | Metal-free phthalocyanine |
| PB27 | Prussian Blue | Hydrous ferriammonium ferrocyanide |
| PB28 | Cobalt Blue | Cobalt aluminum oxide |
| PB29 | Ultramarine Blue | Sodium aluminum sulfosilicate |
| PB33 | Manganese Blue | Barium manganate |
| PB35 | Cerulean Blue | Cobalt tin oxide |
| PB36 | Cobalt Turquoise | Cobalt chromium oxide |
| PB60 | Indanthrene Blue | Indanthrone |
| PB72 | Cobalt Deep | Cobalt zinc aluminate |
| PB73 | Cobalt Deep | Cobalt silicate |
| PB74 | Cobalt Deep | Cobalt zinc silicate |

## PG: PIGMENT GREEN

| CI Name | Color/Pigment Name | Chemical Description |
|---|---|---|
| PG7 | Phthalo Green | Chlorinated copper phthalocyanine |
| PG8 | Naphthol Green | Nitroso iron complex |
| PG10 | Green Gold/Nickel Azo Yellow | Azomethine nickel complex |
| PG12 | Naphthol Green | Ferrous nitroso-beta naphthol lake |
| PG17 | Chromium Oxide Green | Anhydrous chromium sesquioxide |
| PG18 | Viridian | Hydrous chromium sesquioxide |
| PG19 | Cobalt Green | Cobalt zinc oxide |
| PG23 | Terre Verte | Green earth |
| PG24 | Ultramarine Green | Polysulfide of sodium alumino-silicate |
| PG26 | Cobalt Green Deep | Cobalt chrome oxide |
| PG36 | Phthalo Green | Brominated copper phthalocyanine |
| PG50 | Cobalt/Teal/Light/Oxide Green | Cobalt titanium oxide |

## PBr: PIGMENT BROWN

| CI Name | Color/Pigment Name | Chemical Description |
|---|---|---|
| NBr8 | Vandyke Brown | Bituminous earth |
| PBr6 | Mars Brown | Calcinated synthetic iron oxide |
| PBr7 | Raw & Burnt Sienna/Umber | Natural iron oxide |
| PBr23 | Azo Condensation Brown | Azo condensation brown |
| PBr24 | Naples Yellow Deep | Chrome titanium oxide |
| PBr25 | Benzimidazolone Brown | Benzimidazolone brown |
| PBr33 | Mineral Brown | Zinc iron chromite |

## PBk: PIGMENT BLACK

| CI Name | Color/Pigment Name | Chemical Description |
|---|---|---|
| NBk6 | Bitumen | Gilsonite |
| PBk1 | Aniline/Jet Black | Aniline black |
| PBk6 | Lamp/Blue Black | Carbon black |
| PBk7 | Lamp Black | Carbon black |
| PBk8 | Vine Black | Wood charcoal |
| PBk9 | Ivory Black | Bone black |
| PBk10 | Graphite | Powdered graphite |
| PBk11 | Mars Black | Ferrite black iron oxide |
| PBk19 | Davy's Gray | Powdered slate/Hydrated aluminum silicate |
| PBk28 | Mineral Black | Copper chromate |
| PBk31 | Perylene | Perylene |

## PW: PIGMENT WHITE

| CI Name | Color/Pigment Name | Chemical Description |
|---|---|---|
| PW1 | Flake White | Basic lead carbonate |
| PW4 | Zinc White | Zinc oxide |
| PW5 | Lithophone | Coprecipitated zinc sulfide/Barium sulfate |
| PW6 | Titanium White | Titanium dioxide |
| PW18 | Whiting | Calcium carbonate |
| PW19 | China Clay | Hydrated aluminum silicate |
| PW20 | Mica | Aluminum potassium silicate |
| PW21 | Blanc Fixe | Barium sulfate |
| PW22 | Barium Sulfate | Natural barium sulfate |
| PW24 | Aluminum Hydrate | Aluminum hydrate |
| PW25 | Gypsum | Calcium sulfate |
| PW26 | Talc | Magnesium aluminum silicate |
| PW27 | Silica | Silica |

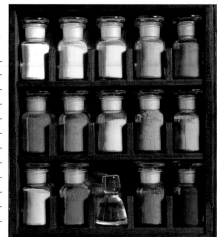

**See also**

The subject of color is so vast and the ranges of pigments and materials available to the artist so wide, variable and subtle, it is inevitable that the best means of finding out how particular colors really look and handle is by actually using them. In this book there is a great deal of information about color and its value to the artist. Hundreds of colors are mentioned and shown in the various media in numerous combinations, mixtures and applications. To a certain extent, Doerner's comment holds true and most artists will admit that the only effective way to knowledge and confidence is to experiment with the actual colors and different media yourself.

### Four colors make all colors

It is hoped that this book can provide a springboard into the world of color for the artist. Unfortunately, there is one obvious drawback to it. This is that when it comes to the subtlety of reproducing color, all of the colors shown in this book are printed, not painted. They are not the actual colors but are reproduced by the four-color printing process, using only four ink colors.

Modern printing technology and the skills of graphic reproduction have brought us very close to the reality of seeing real, pure pigment color on the printed page. Although color printing has been around for a long time, 50 years or so ago, or even 25 years ago, it would not have been easily possible to mass produce a color-printed book to this standard, and the expense of doing so would have been immense. Color printing is among those technologies that, in the right hands, improves in quality year by year.

**Process colors**
Artists' paint colors that resemble the process ink colors used by printers are available. Some manufacturers, particularly in acrylic ranges, offer colors that are specifically identified as process colors, and these, too, are very versatile for mixing and for color experimentation.

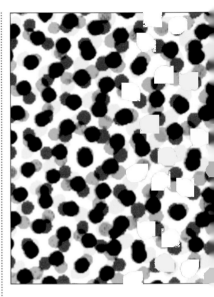

**Four-color enlargement**
White is crucial to the four-color printing process. Without a white background, the full-color illusion does not work properly.

**Billboard detail, actual size**
The four-color dots that create a full-color image can be clearly seen on outdoor advertisements that are designed to be viewed from a distance.

PROCESS CYAN
120

PROCESS MAGENTA
412

PROCESS YELLOW
675

PROCESS BLACK
040

### CMYK ("smike")

Every color you see in this book is printed by using the four-color process. Every hue, tint and shade is made up of a combination of only four colors. These are: cyan – a bright, greenish blue; magenta – a bluish-shade red; yellow – a middle yellow, neither reddish nor greenish; and black. White is provided by the white of the paper on which these four colors are printed.

In printing terms these colors are known as the process colors and are designated as CMYK – C for cyan, M for magenta, Y for yellow and K for black. The last letter K is used for black, because, if the initial B were used, this might lead to B being misinterpreted as meaning blue. The acronym for the four process colors is "smike." This was previously only a term that was heard within the confines of the printing industry, but, with the advent of computers, scanners, desktop publishing and digital photography, it is becoming more familiar to the general public.

**Color control**
At the foot of every page proofed, a control strip is printed. This enables the printer to judge the weight, density and accuracy of the four colors used to create a full-color image.

**CMYK**
Cyan, magenta, yellow and black are the four process colors from which all mass-produced, full-color images are derived.

**PROCESS CYAN**

| BLEU CYAN | 10% | 30% |
|---|---|---|
| NORMAL BLAU | | |
| AZUL CYAN | 50% | 70% |
| CYAAN BLAUW | | |

C/100%

**PROCESS MAGENTA**

| MAGENTA | 10% | 30% |
|---|---|---|
| NORMAL MAGENTA | | |
| MAGENTA | 50% | 70% |
| MAGENTA | | |

M/100%

**PROCESS YELLOW**

| JAUNE | 10% | 30% |
|---|---|---|
| NORMAL GELB | | |
| AMARILLO | 50% | 70% |
| GEEL | | |

Y/100%

**PROCESS BLACK**

| NOIR | 10% | 30% |
|---|---|---|
| NORMAL SCHWARZ | | |
| NEGRO | 50% | 70% |
| NERO | | |

k/100%

B C+M+Y C+Y C C+M M M+Y Y 25% 75% B 50% Super Balance Kreuzmiren C 50% Super M 50% Super 50%

Druckkontrollstreifen © 1981 system Brunner CH-6600 L

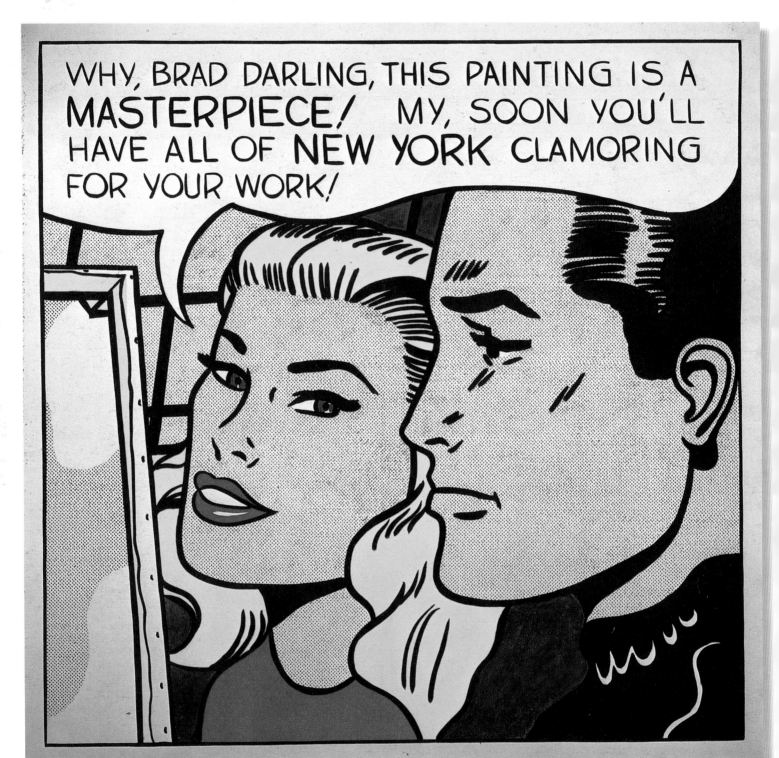

Roy Lichtenstein (1923–97)
**Masterpiece, 1962**
Oil on canvas
54 x 54in (137.2 x 137.2cm)
*Hirsch Collection, Los Angeles*
© DACS

Lichtenstein exploited the dot screen seen in crude comic-strip printing, using what was cheap and popular as the inspiration for his imagery. He did not, in fact, use the process colors to achieve his color effect, but a kind of purplish blue, a lemon yellow, a green that was between the red and blue in value, a medium-standard red, and black and white.

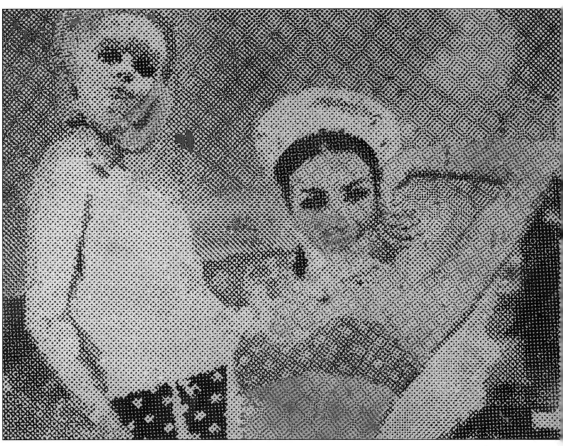

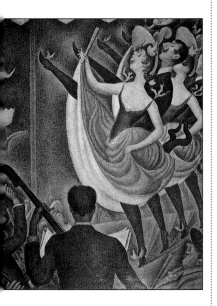

Georges-Pierre Seurat (1859–91)
**Le Chahut, 1889–90**
Oil on canvas
66½ x 54¾in (169cm x 139cm)
*Kröller-Müller State Museum,
Otterlo, Netherlands*

Seurat juxtaposed dots and dashes
of color to produce brilliant,
luminous effects in his paintings.
The detail below is actual size.

### Dot screens

The infinite range of printed colors is formed out of dots of
only the four process colors. These dots conform to a regular
pattern or screen for each of the four colors, although they are
printed in various combinations and proportions to achieve a
multicolored effect. Along with the white of the paper, these
minute dots form the printed image. This process is known
as optical mixing, because it is the eye of the viewer that
translates the dots into recognizable pictures or shapes with
continuous tone and color.

As well as being a technical process, optical mixing is a
device that has been employed by artists in their quest for
color originality. In the late nineteenth century, Georges
Seurat (1859–91) and Camille Pissarro (1831–1903) were
two painters who experimented with dots of color effectively,
a technique that became known as pointillism. This approach
to color mixing in painting was happening at the same time as,
but independently of, late-nineteenth-century developments in
printing. Later, in the twentieth century, such artists as Sigmar
Polke (b. 1941) and Roy Lichenstein (1923–97) exploited
optical color mixing and dot screen effects in their work,
consciously celebrating the effects to be derived from four-
color printing methods.

Sigmar Polke (b. 1941)
**Girlfriends, 1965–66**
Oil on canvas
59 x 75in (150 x 190cm)
*Froehlich Collection, Stuttgart*

Polke based his paintings on
magazine photographs. By
emphasizing the printed dot
patterns, he could transport a low-
quality, mass-culture snapshot to
the high-culture realm of painting.

**☞See also**

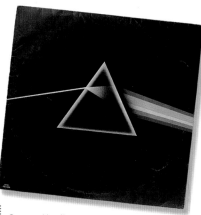

**Sir Isaac Newton (1642–1727)**
English mathematician, physicist, astronomer and philosopher, Newton was known for his law of gravitation and his work on the physics of color. In this engraving after a painting by George Romney, Newton demonstrates the formation of the spectrum through a prism.

After George Romney
**Newton and the Prism**
From *The Life of George Romney* by William Hayley, 1809

**The prism and the spectrum**
Newton discovered that sunlight (white light) is separated into colored components when passed through a prism. He observed a sequence of colors ranging from violet through indigo, blue, green, yellow and orange to red. This range of colors is the visible spectrum.

White light can also be separated into colors when it is reflected from very thin films and layers. Many transparent natural objects form colors in this way. Soap bubbles, sea spume, oil on water, and some birds' plumage are prime examples of colors produced by interference through thin layers.

A similar phenomenon of segmented colored light known as "Newton's Rings" can also be seen in light reflected through a curved glass lens laid on a mirror.

**☞ See also**

In physics color is defined as an attribute of an object or entity that results from the light that is reflected, transmitted or emitted by that object or entity. This light is transmitted in different wavelengths, which are perceived by the viewer as different colors – thus, for example, butter is yellow, the sky is blue, a rose is red.

**The spectrum**
The simplest demonstration of color physics is to transmit a beam of white light (sunlight) through a prism and see how the white light is refracted and separated into different wavelengths. The wavelengths are transmitted through the other side of the prism as a spectrum or band of colors, from red, the longest wavelength, to violet, the shortest. Seven colors are usually distinguished in a spectrum, and these are red, orange, yellow, green, blue, indigo and violet.

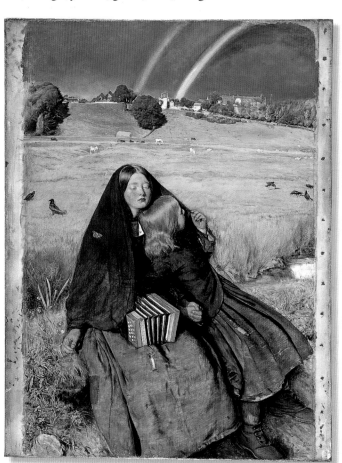

John Everett Millais (1829–96)
**The Blind Girl, 1856**
Oil on canvas (whole image, unframed)
32½ x 24½in (82.6 x 62.3cm)
*Birmingham Museums and Art Gallery*

George Hardie
**The Dark Side of the Moon, 1973**
Album cover 12 x 12in (30 x 30cm)

On this well-known Pink Floyd album cover, the artist employs a graphic illustration of the prism and the spectrum as a powerful visual metaphor for expectation, anticipation and uncertainty.

**Colors of the rainbow**
A rainbow is a prime example of sunlight passing through millions of prisms – raindrops – to create a spectrum. In this sentimental painting, the sighted girl is awestruck by the rainbow, but, sadly, her companion can never experience its beauty.

### Iridescence

The photograph of the insect displays a spectrum of colors that shimmer and change due to interference and the scattering of light as the position of the observer changes. This phenomenon is known as iridescence.

### Additive color mixing

The term additive color mixing refers to the mixing of light. When you mix colored light, it behaves very differently from when you mix paints. Colored light is essential for film, theater, television and video, and photography to a certain extent, so a knowlege of additive color mixing is important for those working in these media.

The additive primary colors are red, green and blue, and they are often referred to as RGB. When white light is projected through filters of these colors and two of the beams are mixed, they produce the secondary colors yellow, cyan and magenta. When you combine the three primaries, RGB, the result is white light.

### Subtractive color mixing

The term subtractive color mixing refers to the mixing of pigments, and this is where some knowledge of the color wheel helps (see page 26). Pigments approximate the appearance of reflected and projected light, but when mixed together, they produce very different results from those achieved by mixing colored light. Subtractive color mixing is the concern of the painter, and in subtractive mixing the primaries are red, yellow and blue. When two of these primaries are mixed, they produce the secondary colors orange, green and violet. When the three primaries are combined, the result is black.

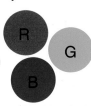

**Additive primary colors**
The additive primary colors are red, green and blue, and these are often referred to as RGB.

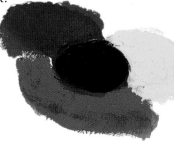

**Subtractive color**
Red, yellow and blue make black.

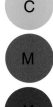

**Additive secondary colors**
When white light is projected through filters of these colors and two of the beams are mixed, they produce the secondary colors yellow, cyan and magenta.

**Mix red, green and blue**
When you combine the three primaries, RGB, the result is white light.

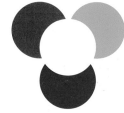

Patrick Gries
**The Hand of Nature**
Photograph
*Fondation Cartier pour l'art contemporain, Paris*
*Nature démiurge, insectes*
*Collection Anne et Jacques Kerchache, Paris*

**Spectrum colors**
The seven distinguishable colors of the spectrum are all available in the various artists' media. These colors are red, orange, yellow, green, blue, indigo and violet.

The spectrum is the foundation for understanding the physics of color. From this, a useful system for classifying pigment color for artists, known as the color wheel, has been developed.

This circular diagram helps to explain subtractive color mixing and provides a theoretical basis for using colors. The color wheel acts as common reference for the terminology and language of color for artists, and it demonstrates how colors relate and interact with one another. An understanding of the color wheel helps with color mixing and color identification.

## Diagrammatic color

The color wheel, also known as the color circle, may be described as the spectrum turned into a circle, reflecting the natural order of colors. The primary colors are red, blue and yellow, and they are unmixable. Secondary colors are mixtures of any two primaries. Complementary colors – for example, yellow and violet, or red and green – are colors that are directly opposite one another on the diagrammatic color wheel.

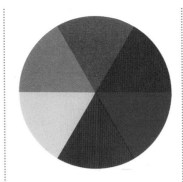

### Six-color division
A basic six-color division of the wheel shows the primaries (red, yellow and blue) and the secondaries (orange, green and violet).

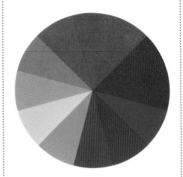

### Twelve-color division
By increasing the number of divisions, the intermediate colors linking the basic primary and secondary colors become apparent. These colors are often described as having a bias – bluish reds or reddish yellows, for example.

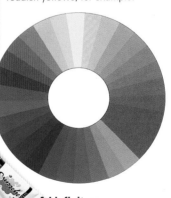

### Ad infinitum
It is theoretically possible to continue subdividing the color wheel until the appearance of a continuous merge is achieved.

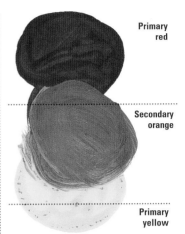

Primary red

Secondary orange

Primary yellow

## Primary colors
Primary colors are those that cannot be mixed from others. These are red, yellow and blue. Because pigment colors are not as pure as those of the spectrum, when all three are mixed together, they produce "black" or gray-brown. Varying proportions of the primaries mixed together will produce all other colors, and different sets of primaries will produce different mixes.

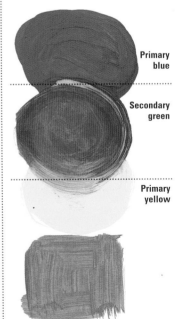

Primary blue

Secondary green

Primary yellow

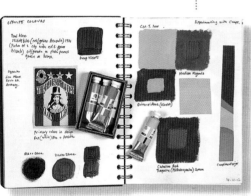

## Color experimentation
Many manufacturers recommend primary colors within their ranges that are suitable for clean mixing. Follow the concept of the color wheel to experiment with colors and mixing combinations.

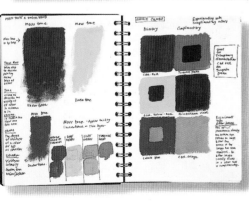

**Cadmium Red is a yellowish red.**

**Alizarin Crimson is a bluish red.**

### Top tone and undertone

The particular hue or top tone of a primary color may have an undertone that veers toward one of the other primaries – for instance, a red may be a yellowish red, such as Cadmium Red, or a bluish red, such as Alizarin Crimson – and this will affect the resulting mixes.

### Basic primaries

Three primaries that can produce a practical range of mixed colors are those used in photography and printing – magenta, yellow and cyan. These colors, or close approximations to them, are available in many ranges of artists' colors.

**Naturally occurring color inspiration**

### Secondary colors

A color produced by mixing two primaries is termed a secondary color. Red and yellow produce orange as a secondary color; yellow and blue create green; and blue and red make violet. The secondary colors are situated between the primary colors on the color wheel.

When mixing secondary colors, cleaner and brighter hues may be obtained by mixing primaries that have related undertones and veer toward each other. A yellowish red mixed with a reddish yellow, for instance, will result in a clean, bright orange.

### Tertiary colors

A further set of colors, termed tertiaries, are produced by mixing a primary with one of its secondaries; for instance, blue mixed with violet makes blue-violet and red mixed with orange creates red-orange. An infinite number of colors can be mixed by combining tertiaries with secondaries, and so on with neighboring pairs, enlarging the color wheel into a gradated progression of colors.

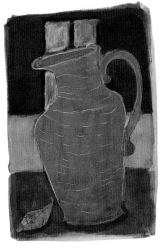

**Orange jug with complementary accent**

### Complementary colors

Colors that are immediately opposite each other on the color wheel are termed complementary. A primary color is complemented by the secondary color mixed from the other pair of primaries. So green is the complement of red, violet of yellow and orange of blue. This process continues around the color wheel, with red-orange the complementary of green-blue, and so on.

### Using complementary colors

Artists can use complementary colors paired together effectively, because visually one enhances the other when they are juxtaposed. For instance, an orange placed next to a blue will make it look much brighter, and vice versa. Conversely, adding a small amount of the complementary to a color can help to gray it slightly, toning down its brightness.

### Darks or "palette mud"

When two complementaries are mixed, they produce a gray or brown, because the resulting color contains all three primaries. These mixes may be planned, but it is all too easy to make mixes that lack subtlety. Artists term these "mud."

### Harmonious colors

Colors from the same section of the color wheel share common color roots and are termed harmonious. They involve the use of only two primaries and the colors in-between. When combinations of harmonious colors are used together, they create no visual discord.

### Warm and cool colors

An important aspect of a color for use is its temperature. Colors are considered to be warm or cool. Generally, warm colors are those that are in the red/orange/yellow sector of the color wheel, while cool ones are in the green/blue/violet sector. The undertone of a color can make it appear warm or cool when compared to other colors of the same hue. Warm colors appear to advance toward the viewer, while cool colors recede toward the background. Assessing the temperature of a color can help the artist create space and depth in a painting.

### Tints and shades

Adding white to a color lightens it and creates a tint. Similarly, a color darkened with black is called a shade. Tints and shades may be further classified by their tone – that is, how dark or light they are compared with other colors. Tone can be altered by adding varying amounts of gray, not necessarily mixed from black and white, but also from combinations of colors that contain the three primaries.

☛**See also**
CI International 18–19
Optical illusions 20–21
Color by color 48–93
Color index 156–179

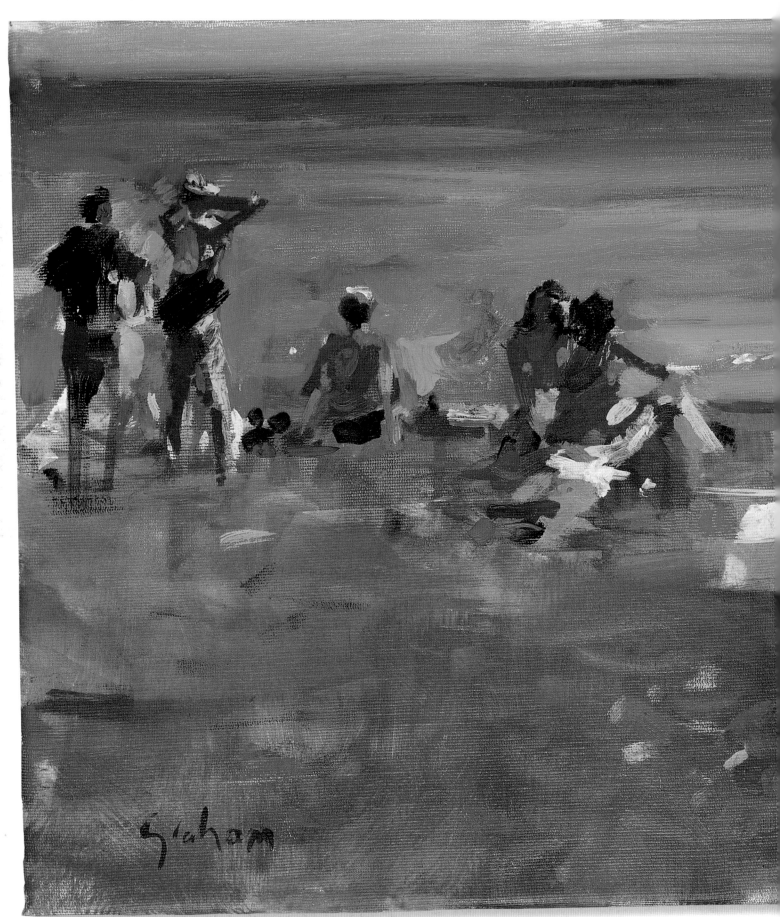

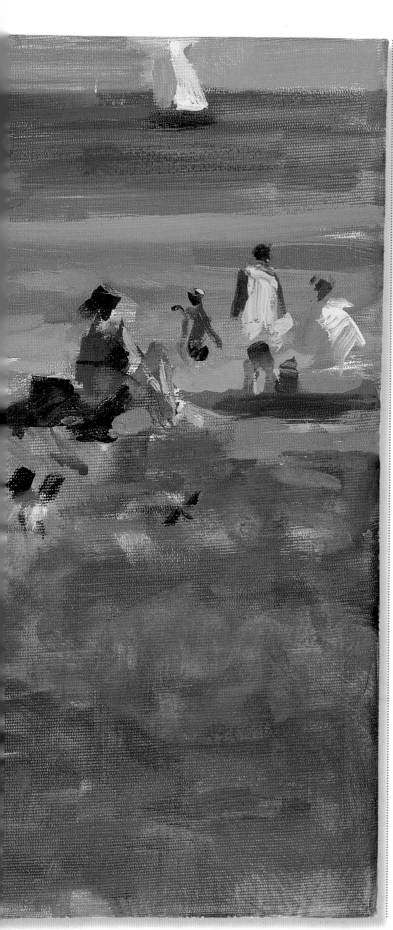

### Theory into practice

Peter Graham is an artist who uses a radiant palette, and he is anything but faint-hearted when it comes to color use and interpretation. Employing a bold and robust brushwork technique, he achieves an unexpected visual harmony with the use of seemingly opposite colors. His vibrant oil and watercolor paintings show hot red, pink and orange hues forming exotic relationships with blues, turquoise, violet and accents of yellow.

*"Through color I strive to bring the canvas to life. Looking into the evening sun presented me with a chance to evoke the sounds and flavors of the scene, and interpret what I saw into how I felt."*

Peter Graham
**Southern Sun**
Oil on canvas
12 x 16in (30.5 x 40.5 cm)

**Manhattan** (detail)

Peter Graham
**Manhattan**
Watercolor
17 x 24in (43.4 x 61cm)

**Manhattan** (full image)

*"The layers of watercolor tell my story of New York. Here, color conveys my experience of a great city that's full of sensation and power – a city glowing with confidence."*

This section is included to give those who may be uncertain about what to buy an idea of the media available. Nearly all the major manufacturers provide informative leaflets and brochures on their products and publish comprehensive catalogs.

Many independent suppliers, too, have detailed catalogs of materials that are available by mail order. Most towns have an art supplies store, ranging from a corner display in the stationery department of a bookstore to large retail outlets dedicated solely to art materials. Here, you can look at the stock and pick up useful product information, so a visit to one of these is well worth it in order to make an informative choice.

A huge amount of different media is available to artists who wish to express themselves in color. Oil paint is probably the accepted traditional medium, while the most popular option favored by amateur artists, and widely respected by professionals, too, is watercolor.

In comparison to these two traditional media, acrylics are a relatively modern invention and provide a medium that combines the versatility of both watercolors and oil paints. More specialized media are also available, and these include egg tempera and gouache, or body colors, which have their own unique characteristics.

Some coloring materials cross the divide between drawing and painting – pastels, water-soluble colored pencils and oilbars are among the numerous products in this category that you can use for creative expression. A number of manufacturers and suppliers also list products with applications in craft and hobby areas for painting on textiles, ceramics and glass.

Art materials can be expensive, particularly if you consider products labeled "artists' quality," which indicates that they contain the finest pigments. This is not to say that students'-quality and less-expensive products are not good, for there are continuing significant advances in pigment manufacture. In some cases the less-expensive brands from the major manufacturers may have particular desired characteristics.

In the upper price ranges, you will find more choice of colors and stronger pigments, but when it comes to making a personal selection, particularly if you have not picked up a paintbrush for a number of years and you are in the experimental stage, it may be worth considering buying a starter set or a limited selection of mixable primaries in your chosen medium before making a greater investment.

In addition to cost, other important considerations when choosing your media are space and facilities for cleaning up. Do you have a studio or dedicated working area? Is there a sink and water supply close? Are you affected by chemicals and solvents? The style of your work may affect your first choice of medium, too. Will you need volume and texture? Is your approach precise and graphic? Think about the support or surface on which you will be applying your chosen color. Will it be board, canvas, paper, textile or some other material? These factors all have price and practicality considerations.

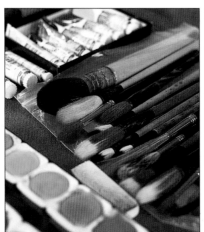

## Oil colors

### Traditional Oils
When they were first developed during the fifteenth century, oils were described as "a most beautiful invention."

Many leisure painters think they are too difficult, or too smelly, to tackle at home – and even if they did want to try using them, they do not know where to begin or what exactly they need to get started.

Oil colors have a mild odor, but it is not strong or unpleasant. The powerful smell associated with them is produced by the turpentine or mineral spirits used to thin color and to clean brushes. However, you can reduce the smell considerably by keeping a lid on your jars and using low-odor thinners.

### Drying times
Oils take longer to dry than watercolors or acrylics, because they dry by absorbing oxygen from the air instead of by the more speedy evaporation of water. But it is still possible to complete a painting in one session or, as it is sometimes known, "alla prima." The Impressionists worked in this way, capturing the transient mood of a subject and completing a finished painting in a matter of hours. Different colors dry at different rates, so drying agents are usually added to the slower drying colors, such as Alizarin Crimson and Ivory Black, to help equalize them.

### Correcting mistakes
An advantage of this slow-drying medium is that you can simply wipe mistakes away or paint over them.

### Quality and price
Artists'-quality oil colors are the most expensive, and they are usually priced in series, according to the cost of the pigment. Students'-quality oil colors are more affordable and, with the increasingly sophisticated synthetic pigments that are now available, they are even better value for the newcomer to painting.

Most colors are made by dispersing pigment in linseed oil, which is generally considered to be the best oil for a flexible paint film. However, linseed oil has a natural tendency to yellow, so it is often replaced with sunflower oil or another similar oil in the manufacturing process for making whites.

### A basic starter palette
Six to eight colors are all you need to begin with – three primaries, an additional green, an earth color and white. A good starter palette might be Cobalt Blue, Alizarin Crimson, Cadmium Yellow (Hue), Yellow Ochre, Raw Umber, Viridian (Hue), Cadmium Red (Hue) and Titanium White. This is the type of selection you often find in small sets, or you can buy them individually.

As you progress, you will want to broaden your palette of colors, and there is no shortage of good ready-mixed tube color from which to select.

## White

White is probably the most important color on an oil painter's palette. Titanium White is the whitest and the most opaque, with the best covering power, and it is the best to use for highlighting. It is also a useful white for mixing paler tints. Although the most versatile all-purpose white, because of its strength, the beginner may find it overpowering for mixing precise tints.

Zinc White is a less powerful, semi-opaque white, so it is good for tinting and translucent glazing. (See White, pages 86–87, 179.)

## Solvents and diluents

Turpentine is the most commonly used diluent for thinning oil color and cleaning up, but low-odor thinners are more pleasant to use, because they give off less harmful fumes and irritate the skin less. They are also less flammable, so safer – and they keep better.

Household turpentine is not recommended for art use. It contains impurities that can leave a sticky residue, cause yellowing and stop the color from drying.

## Oils and mediums

The more oil or painting medium you add to color, the "fatter" it becomes (see Mediums, page 36). "Fat" paint is more prone to movement as it dries, so it prevents cracking. It is usual to thin early layers of paint with diluent and increase the medium as you go.

In the early stages of drying, oil color increases in weight and it expands. As it continues to dry, it loses weight and starts to shrink and harden. So, if you apply less flexible "lean" paint over more oil-rich, flexible paint, there will be more movement in the lower layers than the top ones. This may result in wrinkling and cracking.

## Water-Mixable Oils

There is a saying that "oil and water will not mix," but the introduction of water-mixable oils has proved that it can be done. If you hate the smell of turpentine, mineral spirits or even low-odor thinners, but you want to paint in oils, these could be the materials for you.

The linseed and safflower oils used to make water-mixable oils are modified so that they mix with water instead of repelling it. For the best results, it is recommended to use compatible water-mixable mediums to improve paint flow, to build heavy impasto and to alter drying times. During drying, the water evaporates quickly, but the oil component takes the usual 2 to 12 days to become touch dry.

## Alkyd Oils

Alkyd oils are a fast-drying alternative to conventional oils. They are ideal for single-session "alla prima" painting, as an underpainting medium for oil painting, for quick design work and for decorative painting on a range of surfaces, from glass to ceramics.

They are made from pigment mixed with oil and a synthetic resin, originally developed for use in industrial coatings and house paints, which accelerates drying and creates a durable water-resistant finish. In use they are very similar to traditional oils. Thin them with a diluent, such as turpentine or low-odor thinners, and enrich them with linseed oil or Liquin.

## Resin Oil Colors

Natural resins, extracted from living and fossilized trees, have been used by artists for almost 2,000 years. Byzantine painters added natural resins to enhance color brilliance and the impression of depth – and, in the early days of oil painting, artists are known to have added resins, such as mastic and copal.

The practice died out when it was found that resin colors did not take kindly to transportation in leather or hide pouches, which was the traditional packaging for oil color before the invention of the metal tube.

In 1881 a collection of old masters' formulations was acquired from a Professor Cesare Mussini, who lent his name to today's Mussini resin oils.

The paints are made from artists'-quality pigments, mixed with artists' oils and natural dammar resins that allow light to penetrate further into the paint layers. It is this enhanced reflectivity that makes colors look more brilliant. The addition of resin also promotes more even drying times, giving a more stable paint film.

Resin oils come in over 100 ready-mixed tube colors. You will not find them in every art store, but they are available from larger specialty art stores and mail-order suppliers.

## Oilbars

Drawing and painting come together in one fluid movement with oilbars, also known as oil-painting sticks. Not to be confused with oil pastels, oilbars are made from artists'-quality pigments mixed with drying oils and waxes.

Oilbar enthusiasts love their immediacy and the direct link they forge between artist and canvas, without the intervention of a brush.

Colors can be blended and spread directly on the surface with a knife or brush and traditional diluents, or you can buy special colorless bars, designed to blend colors and increase their transparency. Dipping the tip of the stick in turpentine will improve the flow of color. Applied in thick layers, then modeled with a knife or brush, creates heavy impasto effects. You can use oilbars on their own, or as a painterly drawing tool in combination with traditional tube oil colors.

### Oils

Oils are the traditional artist's medium. Renowned in modern times for their opacity and robustness, they can equally be used thinly to create delicate glazes, depth and luminosity.

All artists have an urge to communicate their own unique view of the world, and one of the beauties of watercolor is its immediacy. It invites a direct and spontaneous response to a subject – whether you are painting a landscape, a portrait, a figure study, still life or an expressive abstract.

No other medium has the capacity to capture a subject with such speed and economy of brushstroke. By far the most popular painting medium, watercolor is also probably the most challenging for the artist. Used well, it can make a clear statement in pure color.

The clarity and freshness of a good watercolor painting depends on skilled glazing with dilute washes of richly pigmented paint. For the best results, lightly mix the color in a clean palette with clear water and apply with single, confident strokes.

## Availability, price and quality

In recent years advances in pigment technology have extended the choice of colors available, improved tinting strength and enhanced permanence.

Watercolor can be bought in tubes and moist cakes, also known as pans. As with oils and acrylics, major manufacturers produce both artists'- and students'-quality colors.

Professionals and serious amateurs working indoors usually choose tube color, squeezing out small blobs of paint, then picking up the color they need with a brush. Beginners and artists working outdoors often find dipping into pans easier and more immediate.

## Buying watercolors

You can buy both tubes and pans as individual colors or in sets. Starter sets and field boxes offer a limited selection of colors, which you can mix to create all the colors you will need. The larger the set you choose, the bigger selection of ready-mixed color you will have to work with – but that is not always an advantage.

## A basic starter palette

Traditional pigments still form the basis of many colors, but newer pigments, such as quinacridones, have opened the way to brilliant new transparent colors.

Newcomers tend to use too many colors and the finished work lacks harmony across the whole surface. If you opt to buy colors separately, a basic palette might include Alizarin Crimson, Yellow Ochre, Cadmium Yellow Pale, Cadmium Red, Hooker's Green and French Ultramarine. Useful additional colors would be Cerulean Blue, Raw Umber and Burnt Sienna. (See also page 41.)

## Black and white

Watercolor sets usually contain Chinese White and Ivory Black. Nothing causes more heated debate among watercolor painters than the rights and wrongs of using black and white. Most watercolor artists consider tube black to be too flat and lifeless, preferring to mix their own darks. For paler tints, the traditional technique is to add more water, but Chinese White is useful for highlighting and adding opaque body to pastel tints. For even more covering power try Titanium White, which is useful for highlighting in cases where the white of the paper has been lost.

Bright white highlights can add sparkle to a watercolor painting. The traditional method of portraying white is to leave the area unpainted and rely on the reflected white of the paper, but this is not always as easy as it sounds, especially for less experienced painters.

Art masking fluid can be applied to keep white areas white as the painting progresses. Once it is dry, it creates a waterproof rubbery film that can be painted over with complete confidence. When the paint is dry

remove the masking fluid by simply rubbing it away to reveal the white of the paper beneath.

## Watercolor boxes and mixing palettes

Until a few years ago, watercolor boxes were either made of wood or tin, and you can still buy these today. More recently, tubes and pans have been packaged in lighter-weight plastic boxes. These, in turn, have seen some innovative changes with additional features such as extra slide-out palettes added.

You can buy cylindrical field sets now that flip open to reveal mixing areas. The wells within a watercolor box set probably offer enough mixing area for small outdoor sketches, but they have to be cleaned regularly as you paint or the colors will lose their clarity and become muddy and confused.

More serious watercolorists tend to choose large flat-sectioned plastic palettes or muffin-tin style mixing wells. Choice of mixing surface is largely a matter of personal preference, but because of the transparency of watercolor, it must always be white.

## Transparency and opacity

The formulations used by leading makers vary according to the nature and behavior of the individual pigment, which is suspended in a solution of gum arabic dissolved in water. The mix is then passed repeatedly through a triple roll mill to grind it to super micron fineness and release the full intensity of the color.

By their nature, pigments vary in their transparency and opacity. Highly transparent colors allow the reflective white of the paper to shine through, imparting an airy luminosity that captures light, space and atmosphere. As you would expect, more opaque colors have more covering power. Check artists'-quality color charts for details of transparency and opacity.

## Staining and granulation

Artists'-quality color charts will also give you information on properties such as staining and granulation. Powerful colors, such as Prussian Blue and Alizarin Crimson tend to penetrate the fibers of the paper, leaving traces of color behind when you try to lift them off – whether to correct a mistake or when creating a special effect.

Some pigments, particularly the traditional earth colors, have a natural tendency to separate out when you mix them with water. As the wash dries, particles of pigment float to the surface and tiny granules may sink and settle into the hollows of the paper surface, causing an effect known as granulation. This is a useful phenomenon when you want to add character and texture, but where a smoother, more uniform wash is required, choose a color that will not granulate as it dries.

Acrylic resin was first developed in the early nineteenth century for industrial use. Its potential for development into artists' colors was quickly noted by art materials companies, and the first acrylics were available by 1947. Today, they are used around the world by leisure painters and professionals, working in both watercolor and oil painting styles.

When acrylic colors were first developed, many purists discounted them as "plastic paints," because they lacked the subtlety of color and tone associated with oils. They have improved considerably since then, and their position as the second most popular painting medium speaks for itself. Acrylics are particularly popular among illustrators, floral artists and silk painters, who move from fabric to paper as a painting surface (see Color on cloth, page 148).

### Versatility
You can use acrylic colors in a variety of techniques for fine-art painting, murals, mixed media, airbrushing, screen printing and decorative crafts. No other painting medium matches acrylic color for versatility.

Thinned with plenty of clean water, acrylics create transparent washes of color. Used straight from the tube, they retain the mark of the brush to add character to artwork – and you can create highly textured impasto surfaces by applying the paint with a knife.

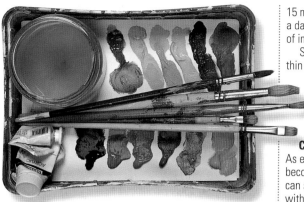

### Quality and price
The major manufacturers produce a choice of students' and artists' qualities, sold in standard size tubes and larger containers for high-volume users. As with other painting media, the quality of the pigment used in artists'-quality brands is reflected in the price, but it is worth noting that with advances in color technology, some of the student-quality brands now on the market perform exceptionally well and offer high lcvcls of permanence.

### An acrylic starter palette
Being a heavy-bodied medium, a basic acrylic starter palette can follow closely that recommended for oil paints and might include Cadmium Red, French Ultramarine, Cadmium Yellow, Burnt Umber, Raw Umber, Yellow Ochre and Titanium White – but you will probably want to add a few more useful colors, such as Permanent Rose, Phthalo Blue, Cerulean Blue and Cobalt Blue.

### Diluents and mediums
Because acrylics are water based, you do not need to use solvents during the painting process. You can add a variety of mediums to alter the consistency, texture, handling properties and drying times (see Mediums, page 36).

Acrylic whites do not yellow with age and the painting surface does not become brittle over time, so paintings on canvas can be safely rolled and stored without danger of cracking.

### Drying times
Acrylic colors dry more quickly than oils through uniform evaporation of the water in the binder. As the color dries, the acrylic resin around each tiny particle of pigment fuses to create a flexible water-resistant film with a matte-satin finish.

The rapid drying time of acrylic colors enables the artist to apply layers of color in quick succession and finish a painting in a fraction of the time it would take in oils.

The down side is that because acrylic color dries so quickly, the paint cannot be manipulated for long periods on the surface. Also, it soon tends to dry out on the palette. To overcome this problem, you can use special palettes that keep the color moist for weeks.

It is also important to wash the color out of brushes thoroughly – once the paint has dried into the head, it sets like concrete.

While acrylic paint is still wet it looks slightly milky, but that disappears as it dries and the color deepens. Undiluted acrylic paint applied thinly takes about

15 minutes to dry, but allow a day or more for thick layers of impasto.

Some oil painters use thin layers of acrylic color as a quick-drying underpainting to speed up the painting process.

### Correcting mistakes
As each glaze dries it becomes insoluble, so you can safely paint over it without fear of lifting the layer beneath and losing the clarity of the color. The water resistance of acrylics makes them an ideal choice for outdoor work.

Good-quality acrylics have great covering power, and it is easy to paint over mistakes, so they are a boon for beginners.

### Liquid acrylics
Liquid acrylics can be used like watercolors, applied with a traditional brush or an airbrush. They are sold in small bottles and, like their thicker, creamy counterparts, are also available in tubs. With liquid acrylics, you can create transparent layers of brilliant permanent color that can be repeatedly glazed over without disturbing the color beneath.

**Acrylics**
Acrylics have become a popular medium since their invention in the 1960s. They can be diluted for use like watercolor or with added mediums for impasto effects similar to oil paints.

## Gouache

Before the advent of computer-generated design, gouache was the most popular painting medium in professional design studios, where it was widely used to create crisp visuals and illustrations in solid color that reproduced well in print.

Gouache is, in fact, a refinement of the more familiar poster paints, but the quality and permanence of pigments used in good makes are far superior.

Also known as body color, gouache is a water-based paint with chalk or *blanc fixe* added to create opaque color with good covering power, which can be further enhanced with the addition of Permanent White. It dries to a matte, chalky finish and can be used on its own or with transparent watercolor.

Considering its versatility, gouache is an underrated medium. Use it in dilute washes to achieve attractive misty effects. Thicker gouache creates a more rugged finish, ideal for bold, energetic paintings. A starter palette might include Cadmium Yellow, Cadmium Red, French Ultramarine, Viridian, Raw Umber and Yellow Ochre – plus the essential Permanent White.

## Egg tempera

Egg tempera is one of the oldest painting media, used by the ancient Egyptians and later by the legendary master artists of the Renaissance before it was overtaken by oil color in popularity.

Egg tempera is not a mainstream painting medium. In fact, it is probably the least used of all the wet color media on the market, but it offers an exciting challenge to the more experienced artist who is prepared to experiment.

As its name suggests, this paint is made by dispersing pigment in egg yolk to create a long-lasting, highly adhesive painting medium. Some dedicated tempera artists make their own paint, but it is a difficult process that takes time and experience to perfect. Newcomers to egg tempera are more likely to buy color already mixed in tubes, which often contain a little added linseed oil to make the paint easier to work and increase its flexibility.

The painting techniques associated with egg tempera have much in common with watercolor, but glazing with transparent washes of tempera gives a denser, more painterly quality to a painting.

Egg tempera paintings are characterized by their pure, translucent color, and their luminosity and sheen. As a fine-art medium, tempera is particularly suited to painters who like to preplan, make detailed preliminary drawings and paint with precision.

Qualities essential for successful tempera painting are patience and sureness of touch. The medium works best when thin veils of color, diluted with clean water, are carefully applied in one-stroke washes. The brightness and translucence of a tempera painting rely on gradual and controlled buildup of these layers of diluted color.

While it is still wet, premixed egg tempera is very easy to lift and rework. It takes about a week or two to "cure," then it is fixed in place for good. To maintain the purity of the color, each layer must be left to dry completely before adding the next.

Egg tempera is best suited to smooth, rigid board or canvas panels, often primed with layers of white gesso to increase the surface reflection and intensify the luminosity of the color. Paper is not recommended unless it is soaked in gesso, stretched and backed with cardboard or metal. Hardboard is a good support for tempera painting, but it must first be sealed back, front and sides with rabbit-skin size.

**Gouache and Egg tempera**
Gouache, or body color, is an opaque watercolor paint favored by illustrators for artwork for reproduction. High pigment quality ensures brilliant colors that dry to a slightly chalky appearance.

Egg tempera consists of pigment bound with egg yolk and vegetable oils. Applied in thin layers, its pure color has a luminous sheen.

## Pastels

Pastels, sold in sticks or larger chunks, and also in pencil form, are probably the most popular of the so-called dry painting media. Unlike wet color, where the pigment bonds with the painting surface, pastel marks are held by the "tooth" or interweave of the paper fibers.

### Pastel sticks

Pastel sticks are made from a mix of unground pigment, chalk, china clay and small amounts of binder and preservative. The mixed "dough" is passed through an extruder to produce long strips of color, which are cut to size and dried.

### Choosing

Soft pastels have a deep velvety texture, best suited for broad sweeps of rich color and painterly effects. Hard pastels, pastel pencils and conté sticks contain more binder and give a harder, more defined mark; they are ideal for drawing and illustration work.

Chalk-based pastels of all kinds can generally be used together for a variety of effects – but they are not compatible with oil pastels (see opposite).

### Hard pastels and pastel pencils

Hard pastels, usually square in shape, come in fewer colors, and because they are more robust, they tend to be sold unwrapped. In use, they do not release their color as immediately as soft pastels, so you need to exert firmer pressure. The same goes for pastel pencils, which are cleaner to hold and easier to carry for sketching outdoors.

### Buying pastels

Artists'-quality pastels are sold in sets and as individual sticks of color. A starter set will probably contain about a dozen colors, and you can add to these as you discover which colors you find most useful. In addition to basic assorted sets, there are also boxes of colors specially selected for use in landscape and portraiture.

### Color choice

The major manufacturers of soft pastel offer a vast choice of up to 200 colors, subdivided into tints, ranging from the palest to the deepest shade based on the same pigment. Better-quality soft pastel sticks come handwrapped in paper to protect them from crumbling and contamination.

### A basic palette

You can start with as few as six colors in cool and warm tints of red, yellow and blue, which can be used to mix a wider range of colors on the paper surface. If you are not confident of your mixing skills, it is wise to choose a larger starter set.

### Papers for pastels

Pastels need a paper with enough "tooth" to catch the fragile color and hold it. Watercolor papers work well, but most pastel artists prefer to use tinted paper, which gives greater harmony and depth. You can choose from a range of subtle tones, according to your subject and key color theme. Darker colors add dramatic effect.

Ingres, named after the master pastellist who devised its characteristic chain-and-laid surface, is the most popular pastel paper. It comes in a wide range of tints in single sheets and books, or bonded to board for a more rigid working surface.

### Fixing pastel work

It is worth noting that work in soft pastel must be fixed to prevent it smudging. Aerosols give a fine, even spray, but they should be used outside if possible, or at least in a well-ventilated room. Bottled fixative delivered through a diffuser may be less harmful, but more tricky to apply evenly.

### Oil Pastels

Oil pastels are one of the least understood of painting mediums, yet they are also one of the cheapest and most convenient.

Not to be confused with soft and hard pastels, oil pastel sticks are made from pigment bound in oil, and sometimes animal fat. Applied directly onto paper, they make marks similar to wax crayon. Brush over with turpentine and the result is brilliant fluid color. Oil pastels are sold in sets, which are inexpensive and handy to carry for on-the-spot sketching and color notes.

### Colored Pencils

Colored pencils are an essential part of just about everyone's childhood, so they are not always granted the recognition they deserve as a more serious art medium.

### Choice

Recent years have seen a rapid expansion of different types of pencils for both drawing and fine art, with significant improvements in permanence at the top end of the market.

Alongside traditional graphite pencils, there are now water-soluble versions that are ideal for preparatory tonal sketches or for pieces of artwork in their own right. They are graded from hard to soft, giving powerful blacks to gentler tones of gray.

Colored pencils, with a waxy color core, come in a huge range of colors. Major manufacturers offer up to 120 colors, which may be bought individually and in a wide choice of sets in tins and boxes.

### Color mixing

Color mixing in pencil can be achieved with a variety of mark-making techniques, but you still need a wider range of colors than you do with wet media. Early attempts at colored pencil drawing usually have a childlike quality, but, with some experience, you can achieve a high-quality fine-art finish.

### Watercolor and aquarelle pencils

Watercolor and aquarelle pencils are increasingly popular, especially for outdoor sketching. You can use them dry like conventional colored pencils, or add water to the color on the paper for an instant wash of color.

### Pastel pencils

Pastel pencils create a harder mark than soft pastels, but they do not make the same clouds of dust, so are cleaner to use, and they are easier to carry. Charcoal pencils have similar advantages over sticks or pieces.

### Other media

In addition to the drawing and painting media covered here, you will find a host of other options in any good art store. For decorative art, there are specialty colors for painting on glass and ceramics, as well as silk paints and fabric colors.

You can draw and paint using wax crayons, felt-tip pens, watercolor sticks, and chalks. By their nature, artists love to experiment, and it is not unknown for the Royal Watercolor Society to hang a work painted in mud! The only limitation to creativity is lack of imagination — but, before you get carried away, make sure your chosen color medium is lightfast, so that your work will not fade when it sees the light of day.

**Dry color media**
Among the dry media (right) are traditional soft pastels with a chalky, friable texture (top), and pastel pencils, which are normally harder in texture and easier to control (center). There are many varieties of colored pencil, including the water-soluble types (below).

☛**See also**

In art materials' terminology, the word "medium" can sometimes be confusing. The type of paint you choose – for example, oil, acrylic or watercolor – is known as a medium (plural "media"). If you use two or more materials in a painting, it is termed a "mixed-media painting." However, the term "medium" (plural "mediums") is also used to refer to the various liquids, gels and pastes that may be added to paint when you use it. These mediums can be added to color to alter paint's handling properties or surface appearance.

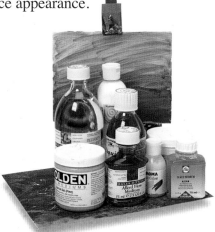

Mediums can be used to change the paint's characteristics of flow, transparency and drying rate. They include a wide variety of additives such as gloss mediums, matte mediums and various oils and drying agents. Pastes and gels can be added to build textures that the paint alone, if used undiluted from the tube, cannot provide, and certain other mediums may be used to create special effects.

The addition of mediums can also affect the color of the paint. Exactly how the addition of a medium will finally alter paint and color depends to a certain extent on the quality of the paint and the type and amount of medium added to it. Experimentation and trial and error are the best methods of learning and mastering the use of mediums.

The list on this page and opposite outlines the commonly available painting mediums and gives a brief description of what they can do to bring an extra dimension to the color and texture of your painting.

## Oil painting mediums

### The "fat over lean" rule
Thinners are used for the initial coats of paint and for washes. If you are intending to apply several layers of paint, however, you will need to add oil to the paint to prevent the possibility of the surface cracking at a later stage when dry. This "fat over lean" rule involves adding progressively more oil or medium ("fat") as you paint further layers.

### Turpentine
As water is to watercolor, so turpentine is to oil painting. It is the classic, traditional solvent-thinner used in oil painting. Used as a solvent, it thins paint to provide tints and washes of color. It is fairly slow in evaporation and, when mixed with colors, tends to create a matte finish. There are various types of turpentine available: you may come across "rectified turpentine essence" or "distilled turpentine," for example. Products such as these enjoy the same features as turpentine, but have been further processed and distilled to improve strength and purity.

### Mineral spirits
Artists'-quality mineral spirits, a purified form, provides an alternative diluent to turpentine and, while it has a characteristic smell, its odor is less pronounced. A completely odorless formulation is also available that evaporates more slowly. Mineral spirits dissolve the paint a little less than turpentine, however, and, like turpentine, it should only be used for the first layers of painting. Oily thinners, which are a mixture of solvent and linseed oil, are used to reduce the consistency of oil paint in later layers without affecting its richness; however, they may yellow.

### Low-odor thinners
Because turpentine has a strong odor and is flammable, in many studio situations, it has been superseded by less hazardous, commercially formulated low-odor or odorless products that perform a similar function. Another liquid thinner that avoids the smell of turpentine is oil of spike lavender, but this dries more slowly than turpentine or mineral spirits.

### Alkyd mediums
These mediums are based on alkyd resin. Depending on their formulation, they can be used not only to thin oil paint, increasing its flow and transparency, but can considerably accelerate its drying time. They provide durable glazing and can be thinned with mineral spirits. To avoid the risk of cracking, care should be taken not to use alkyd mediums over slow drying underlayers. Alkyd mediums are available in the form of liquid or gel.

### Artists' painting mediums
A huge range of proprietary liquid thinners and gels have been developed to minimize yellowing of colors and to dry to a durable, flexible film. Generally, these products improve transparency and the flow of paint, so they are particularly useful for fine detail work. They also tend to enhance the gloss effect and some are formulated for glazing. However, specific products are also available that ensure a matte surface when dry.

### Linseed oil
The traditional oil used as an additive for later layers of paint is linseed, available in many different forms. It may be described as "purified," "cold-pressed," "bleached," "boiled," "thickened," "refined," "stand" or "drying" linseed oil. Each has its own characteristics and you should read the manufacturers' labels to check which type is suitable for your purpose. Generally, linseed oil increases the flow, transparency and gloss of the paint. The various types tend to have different drying rates, but most increase it. One disadvantage of linseed is that it tends to yellow the colors. Linseed oil can be thinned with mineral spirits or turpentine.

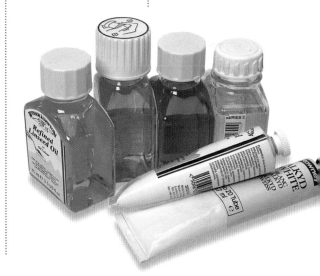

### Poppy oil

Variously described as "purified" or "bleached," this oil extracted from poppy seeds has less tendency to turn colors yellow and is more suitable for use with light colors and white than linseed. It also enhances the gloss effect, but the surface when dry is slightly less durable. Poppy oil generally takes longer to dry than linseed oil, but a "drying" version is also available. Thin with mineral spirits or turpentine.

### Walnut oil

Walnut oil, extracted from walnut kernels, is similar in use to linseed oil, but it does not store as well. It enhances color brightness and dries well.

### Safflower/sunflower oil

These oils have properties that are similar to those of poppy seed oil, and they are used by some makers. Because they do not have a yellowing effect, they are especially useful for light colors and white. They tend to soften the paint and increase fluidity.

### Drying mediums

These proprietary liquids and gels may be added to speed the slow drying times associated with oil painting. Sometimes, however, you may want to increase the drying time and retarding mediums are available for that purpose.

### Impasto mediums

Special gels and pastes provide the means of adding bulk and texture without using greatly increased amounts of oil paint. They are ideal for impasto work and for more expressive painting, where you want to retain the brush and knife marks on the surface.

## Acrylic painting mediums

### Gloss mediums

Liquid gloss mediums impart a gloss finish to acrylic paint, forming a flexible film in the painting when dry. They maintain the color, sometimes making it look brighter, and they also improve the flow and fluidity of the paint, so that it is easier to work with, as well as more translucent. Gel gloss mediums thicken the paint slightly so that brush marks are retained, while dense or heavy gel mediums are available for even thicker paint and particularly for painting with a knife.

### Matte mediums

These mediums decrease the gloss effect of acrylic paint and produce a matte finish. They can also be mixed with gloss mediums to control the degree of shine required. In liquid form they improve the flow of color, while gel formulations are more useful for thick painting.

### Retarding mediums

Since acrylic paint dries relatively quickly, you may find it helpful to use an additive that changes the drying rate. Translucent gels are available that do not affect the consistency of the paint, but they may slightly increase brightness of color. These mediums are useful if you wish to work "wet-in-wet," and they also slow down the rate of drying on the palette. They should generally be used sparingly. Larger amounts may increase the transparency of the color.

### Flow improvers

Various commercially formulated products are designed to increase the flow of acrylic paint, so that large flat areas can be applied evenly and still retain richness of color. The addition of a flow enhancer is particularly useful for painting where hard edges are required.

### Texture gels and pastes

There are many texture gels and pastes on the market that will make it easier for you to achieve textured, impasto and molding effects with acrylics. These are available in a variety of thicknesses, such as light, medium and hard, or fine, medium and coarse, so choose depending on exactly what is required for your painting. The thicker formulations are more suited to knife painting. Some pastes contain texture materials, such as sand, pumice, marble dust or flint, and you will need to experiment to discover any small changes in color when they are used.

### Special-effects mediums

For more unusual color changes, you could try some of the additives that alter the effect of the color in a specific way. Pearlescent or iridescent mediums produce a shimmering metallic or pearlized surface, particularly when used with transparent colors. Interference mediums are available in colors, and using one of these with your chosen color will result in a surface that appears to change according to the direction of light and the angle from which the painting is viewed.

## Watercolor painting mediums

### Gum arabic

Gum arabic is the traditional binder for watercolor paint, and it can also be used as a medium. It is available as a pale solution in water. When added to color, it increases its gloss and transparency. Gum arabic may also be used with gouache paint to make it more flexible and less prone to cracking when dry.

### Ox gall

This is another traditional additive for watercolor. Only a few drops are needed to improve the wetting and increase the flow of color. Ox gall also helps the adhesion of the paint on the ground and helps to prevent change in color. It is available in synthetic form.

### Watercolor medium

These specially formulated mediums consist of formulations of gum arabic and glycerine in water. This combination helps to enhance the brightness of the color and increases the transparency of the paint. Glycerine extends the drying time a little and improves the solubility of the paint.

### Gouache medium

Special mediums for gouache or designers' colors help adhesion of the paint and prevent it from peeling when dry. By thinning the paint, they reduce its coverage, and it also dries with a slightly glossy sheen.

### Impasto gel

Impasto techniques are not usually associated with watercolor, but the addition of this gel enables washes to stay put and not flow into each other. They give watercolor the effect of impasto.

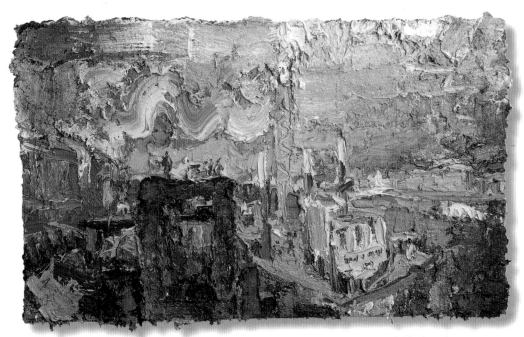

Oils, robustly applied for bold color and texture

(Left, clockwise from the top)

George Rowlett
**Sudden Storm Over Thames, Rotherhithe Pier, 1996**
Oil on board
24 x 40in (61 x 101.5cm)

Ray Balkwill
**Morning Mist**
Watercolor
5 x 7in (12.5 x 17.5cm)

Judith Chestnutt
**Shoreline, 2001**
Paper pulp
12 x 12in (30 x 30cm)

Marina Yedigaroff
**Red Tulips**
Oil on board
20 x 30in (51 x 91.5cm)

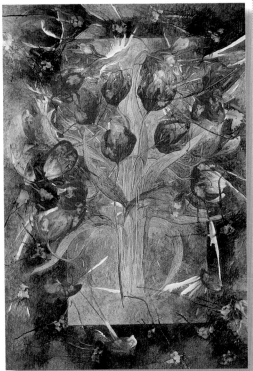

Oils for glazing and delicate transparency

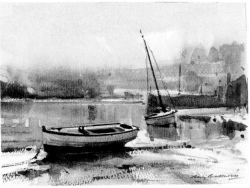

Watercolor, a classic medium for a classic subject

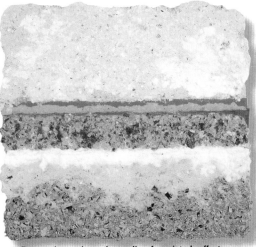

Paper pulp, an alternative medium for painterly effects

(Right, clockwise from the top)

Jackie Simmonds
**Carnevale di Venezia** (detail)
Pastel on paper
17 x 18in (43 x 46cm)

Douglas Wilson
**Lemon** (detail)
Acrylic on board
8 x 6in (20.3 x 15.3cm)

Tim Riddihough
**Check Headband**
Reed pen and ink,
and mixed media on tinted paper
19¾ x 13½in (50 x 35cm)

**Pastels,
a versatile dry medium for painting**

**Pure acrylic,
water-soluble opacity for depth of color**

## The visual qualities of materials

There are many aspects to consider when choosing media and many of the practical options are discussed on the previous pages. Oil paint is the traditional choice for professional artists, and the most popular choice among amateur painters tends to be watercolors. The versatility and high quality of today's acrylic colors are increasingly recognized, and there is a wealth of dry color and stick media available, too. Various types of pastels, colored pencils and oilbars provide fabulous color and handling abilities, and expressive possibilities in their own right, as well as contributing to the success of many mixed-media works. In Chapter Three, "Creative directions," you can learn firsthand how the works shown on this page were created, plus many more, and this information on the creative process, combined with the practical, may help you make a more informed and personal choice when it comes to media.

**Mixed media, pen and ink combined with pastel**

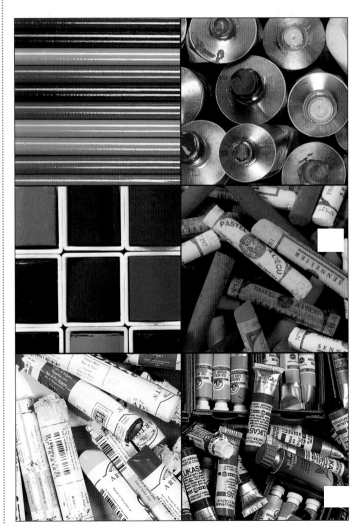

When it comes to your choice of palette, size matters. Bigger is better, because it gives a greater mixing area, which helps keep colors clean and pure. It is possible to work with a small palette, but you have to be an assiduous housekeeper. Once you are carried away with your painting, it is a chore to have to keep a tiny mixing area clean.

The traditional wooden kidney-shaped palette with a thumbhole has become an emblem of fine art, but it is only one of many options you can choose.

Before you rush out and buy an expensive mahogany palette, it is worth considering the variety of shapes, sizes and types of palette now available, and what is best suited to your media.

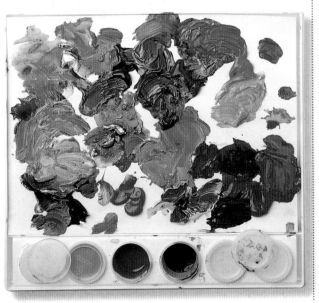

### Palettes for oils

Wooden thumbhole palettes are available in oblong and traditional kidney shapes. They are designed for oil painters who like to hold their palette as they stand at the easel. A well-designed thumbhole is contoured to relieve stress on the hand during long periods of painting. Try one before you buy it.

**Traditional palettes**
Mahogany looks sumptuous, and it is ideal if you are painting on a dark, preferably reddish brown, background. When painting on white and more neutral grounds, a paler shade of wood is preferable, so that you can gauge tonal relationships as you mix color on the palette.

Before using a new wooden palette, prime it with linseed oil to seal the surface and prevent the oil color seeping into the grain and drying out. Cover both sides, and leave the palette for a few days to allow the oil to penetrate the grain of the wood and harden.

Once you have prepared your palette, blobs of unused oil color need not be wasted. Simply break the surface film with a painting knife when you come back to it and use as normal.

**Tear-off paper palettes**
For a convenient disposable alternative, try tear-off paper palettes. You may waste some unused paint, but you will save yourself the task of cleaning up.

### Palettes for acrylics

Wooden palettes are not very suitable for water-based colors, and this includes acrylics. A nonporous material, such as metal, white plastic or melamine, is a more practical option.

One of the benefits of acrylic color is its speed of drying, but this is also one of its disadvantages when it comes to color on the palette. Like mustard on the plate, you can waste as much as you actually use.

**Stay-Wet Palette**
The Stay-Wet Palette is designed to keep color workable for longer. The color is held on a semipermeable membrane that draws water up from a reservoir sheet below. The paint will stay moist for days, as long as you keep adding water to the reservoir and keep the lid on between painting sessions. You can store it in the refrigerator.

### Palettes for watercolor

Fluid color calls for a palette with mixing wells. Metal and plastic paintboxes have mixing areas incorporated in the lid, and some have additional fold-out and slider palettes. They are useful for quick color sketches outdoors, but the mixing area is limited. Unless you keep cleaning them, you will end up with muddy color mixes.

**Plastic palettes**
Plastic palettes are sold in the traditional kidney shape with thumbhole and as oblong, square and round table palettes, with deep and shallow mixing wells. Artists working with broad sweeps of color need large deep wells, so they can mix enough paint to complete a wash. Muffin-tin style palettes provide plenty of separate deep mixing areas to help keep color mixes clean and contained. A big table palette with shallower mixing areas in a range of sizes is also useful.

**White porcelain**
As an alternative to white plastic, you could go for a versatile china palette, made from hard white porcelain, which resists staining and can also be used with solvents for oil painting.

**Home-made palettes**
Many artists working in a studio devise their own tabletop palettes from a sheet of nonporous material, such as white laminate or a sheet of glass. Others use a glass-topped table with a neutral backing below or a piece of hardboard sealed with white or a neutral-colored paint. You can mix water-based colors on an old white plate and in cups, cans and jars, which can be sealed with plastic wrap and stored. Whatever type of palette you use, the same rule applies – keep it clean and it will last for years.

**Palette management**
It pays to get into the habit of laying your colors out in a systematic order. You will soon get to know where each color is and find yourself picking them up automatically. A systematic layout allows you to concentrate fully on mixing and painting.

There are no hard and fast rules for the order in which you place colors on a palette, but many painters follow one of the following well-known layouts.

**Warm to cool**
Keep the warm colors and cool colors separate, with the white and the earth colors in between.

**Light to dark**
Precisely as it says, a counter-clockwise layout, ranging from white through to the darkest hue selected.

**Spectrum order**
A classic layout, which follows the colors of the visible spectrum as seen on the color wheel – from red through to violet, with the earths and darks separated by white.

**☛See also**

**Choosing colors**
As well as meaning a transportable surface, usually oblong or oval, on which a painter arranges and mixes color, "palette" also refers to the selection of colors the artist has chosen to work with or has selected to use in a particular picture. You will come across such descriptions as "limited," "restricted," "hot" or "cool" palettes, and these terms refer to the color range being used by the artist.

When buying colors for the first time, or if returning to painting after a number of years, it may be difficult to decide which colors to buy. Most manufacturers publish helpful leaflets on color choice for the beginner, with recommendations on the most useful reds, yellows and blues to choose from their ranges – the primary colors that give the widest and cleanest variety of mixing combinations.

Some manufacturers prefer buyers to make the decision on individual color purchases themselves, saying they believe color choice is a personal matter. However, all the major manufacturers offer sets of colors, and these can represent good value for the beginner who is uncertain of which direction to go in.

This is especially the case with watercolors. You can buy empty watercolor boxes and fill them with pans and tubes yourself, but more often than not people will start with a box selection that the manufacturer has put together. These boxes cover a wide range of painting situations and are a good initial investment; in addition to the colors, they provide a mixing area and, of course, a

means of storage. By the time the colors are finished, you may be more certain of your own creative direction and you can replace them with colors of your own choice.

Sets vary in size. The more colors they contain and the quality of the paint – whether artists' or the less-expensive student ranges – dictate the price, as does the box design, such as the number of mixing wells, brush storage areas, integral palettes and so on.

Similarly, starter sets are available in other media, particularly oils and acrylics. Some manufacturers even go as far as to market sets with color selections that are identified as appropriate for specific subjects – portraits or landscapes, for example.

From these fairly limited starter selection boxes, the choice proceeds upward to lavish, wooden presentation cases and chests, which, in addition to colors, contain brushes and mostly everything else you may need. These selections can be expensive and even look a little intimidating, but they are usually wonderful productions, and the boxes alone will probably increase in value as the years go by.

**Starting points**
There are many practical considerations to take into account when shopping for individual colors, such as budget, subject and media, and there is a temptation to buy more colors than you need at first. It is better to begin with a restricted range, adding to these gradually as you gain more experience.

A typical, small prepackaged box of starter watercolors contains about 12 colors: for example, Cadmium Yellow and Red, Alizarin Crimson, Burnt Umber, Raw Sienna, Yellow Ochre, Light Red, French Ultramarine, Prussian Blue and Ivory Black. (See also page 32.)

Palette choice is a subjective and individual area, too, but the colors listed above are a good general choice from which it is possible to mix many hues. You could extend your range further with the addition of a green hue – Viridian, for example. A lighter blue and a greenish blue are useful – perhaps Cerulean and Phthalo Blue – and you will have to include a white. Titanium White is usually the popular choice for the opaque media, and Chinese White for watercolors.

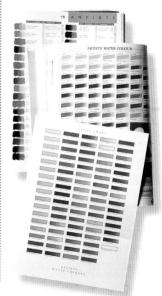

Color is a language and it has a vocabulary of its own. Just as spoken or written words have shades of meaning, so, too, do individual colors. Pink may convey soft, feminine; blue, brittle, cool; red, hot, dangerous; yellow, optimistic, sunny. An artist can record a scene much as a camera does, but you also have complete freedom of choice to call upon any color to communicate atmosphere or to emphasize a feeling or state of mind. You have full control over the palette to manipulate mood in your art.

### Color as function
The camera body is black plastic, which is cheap, seviceable, functional and honest. Green and gold are used for circuits and contacts; red, yellow, orange, gray and blue for the wiring loom. The person who assembles the camera knows what goes where every time, as does the engineer who services or repairs the camera. Both recognize the function of each colored wire.

### Manipulating mood and atmosphere
A simple palette of colors was used to make both these color sketches. Naples Yellow, Cobalt Blue, Raw Umber, Permanent Green and Titanium White, and a touch of Cadmium Red, form the basis of two very different atmospheres.

The subject matter greatly influences the different moods, too — moods that are again reinforced by the proportions of the colors and the way they are mixed and blended.

In the top study, simple uncomplicated color application conveys brightness and warmth. The bottom sketch is more somber in tone and darkened with mixes and washes of Raw Umber.

### Practical color
As well as being an emotional communicator, color is important for practical purposes. It is used to tell people what to do and what not to do: red, stop; green, go; yellow, caution; red, again, danger; and so on. Color can tell you what does what, and what goes where: green wire to earth, red wire to live. Color is widely used as a code to impart and order information and to give instructions.

### Change of use
Surplus telephone cable has been used to create this woven wire basket.

Anon., South Africa
**Woven Basket**
Plastic-coated wire
6in (15.2cm) diameter

### Color as communicator
Color has the power to instill images; it is a great communicator. When we look at a map, we can interpret the printed colors to imagine the busy highway and quiet minor road. We build a picture in our mind's eye of roads, lakes and mountains and visualize what to expect on our journey.

**Polychrome sculpture**

Much sculpture from the ancient world, particularly from the civilizations of Greece and Rome, was originally very colorful. Vestiges of pigment have been found on many examples that indicate sculpted figures may have been given blue hair and beards, and blue eyes, in addition to colored flesh and clothing.

The idea of sculpture remaining in the uncolored state of its natural material seems to have taken hold during the Renaissance period of the fourteenth to sixteenth centuries; artists were influenced by surviving sculptures and monuments from the classical period of Greece and Rome, most of which then survived only in their natural state, time having stripped them of their pigments.

British artist Damien Hirst was attracted by the color and form of an educational toy (shown right) and reinterpreted it on a large scale in painted bronze. His sculpture, entitled *Hymn*, stands some 20ft (6.10m) tall and weighs several tons in contrast to the few ounces and 10½in (26cm) height of the original toy. On its unveiling in April, 2000, Richard Cork, art critic of *The Times* in London, described Hirst's interpretation as the best sculpture of the twenty-first century. It cannot be denied that it is ambitious in size and color.

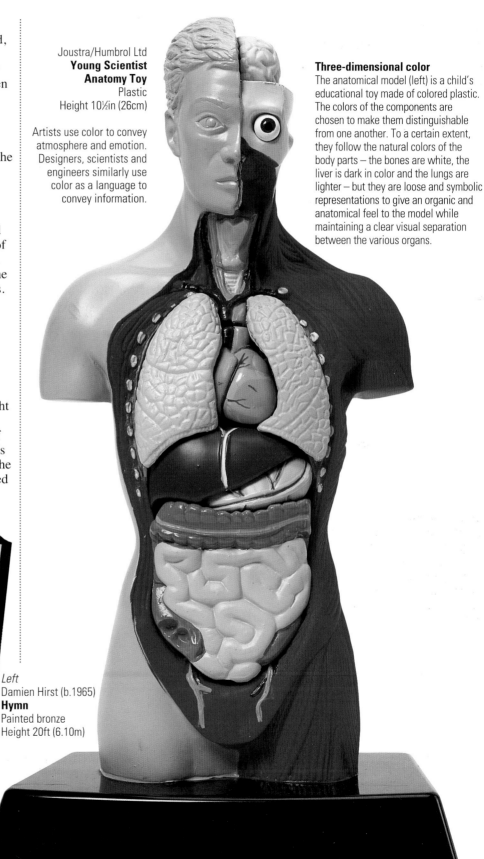

Joustra/Humbrol Ltd
**Young Scientist Anatomy Toy**
Plastic
Height 10½in (26cm)

Artists use color to convey atmosphere and emotion. Designers, scientists and engineers similarly use color as a language to convey information.

**Three-dimensional color**
The anatomical model (left) is a child's educational toy made of colored plastic. The colors of the components are chosen to make them distinguishable from one another. To a certain extent, they follow the natural colors of the body parts – the bones are white, the liver is dark in color and the lungs are lighter – but they are loose and symbolic representations to give an organic and anatomical feel to the model while maintaining a clear visual separation between the various organs.

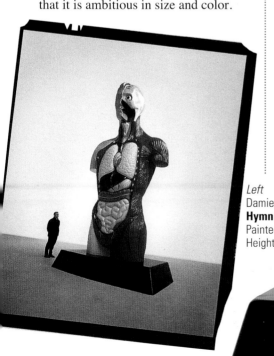

*Left*
Damien Hirst (b.1965)
**Hymn**
Painted bronze
Height 20ft (6.10m)

In this 10-minute sketch, the colors in nature are described as orange and yellow fruits on a white plate, on a black table. The setting is a neutral-beige room, and the back of a red chair breaks the line of the table.

These basic colors and simple shapes are influenced by the lighting conditions and the chosen media, as well as the artist's mood and technique. Chance and accident play a large part, too, in this quick study. Acrylics, gouache and ink are freely applied over a simple outline sketch, then vigorously worked and intermixed to build up a rapid interpretation of the natural colors of a classic still-life subject.

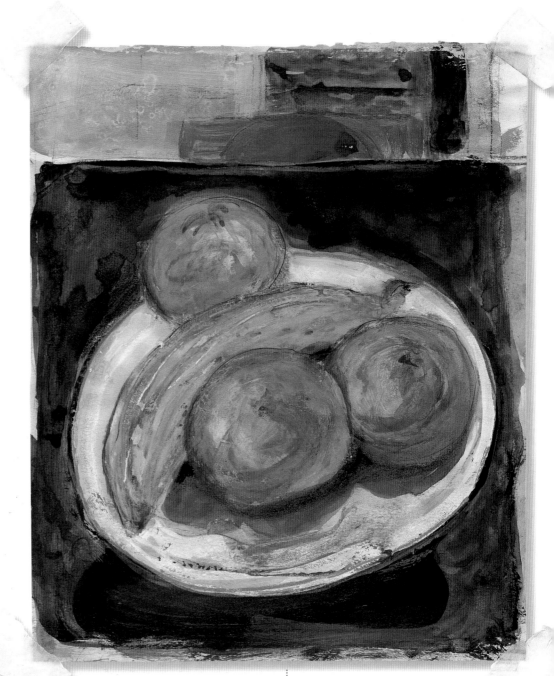

**Plate of Fruit**
Mixed media on paper
10 x 8in (25.5 x 20cm)

Robust solid colors and thinner washes show a versatile approach to mixing acrylic and gouache. Thinned with water and speedily applied, accidental blots occur and the pure colors spatter one another. Outlines made with water-soluble crayon and ink bleed and merge, tinting adjacent areas.

### Mixing media
Do not be afraid to mix media. Lay down colors using colored pencils, pastels, acrylics and gouache for lively color experimentation.

### Experimenting with color
Experiment with how you look at colors in nature; the colors are rarely like you think they are. Use any materials that are available, and ignore correct usage – lay gouache over acrylic, mix it with ink, and scribble over it with colored pencils and pastels.

Rub, scratch and scrub into the surface, using a simple limited palette of two or three colors to avoid the results looking too muddy. Use thick and thin paint, draw lines and apply washes.

Forget about making an accurate drawing or a photographic likeness of the objects – just apply the paint as fast as you can. All you are trying to do is capture a vibrant impression of the simple still life in front of you, so concentrate on the colors. See what turns out. If you like what you have done, keep it. If not, discard it and try again.

### Neutral-beige
White provides a neutral color to indicate the back wall. Scrubbed with watery red and a touch of black, it creates a warm interior.

### Red against black
The back of the chair behind the edge of the table is a basic red. Behind that, a dark patch of a thin wash of black indicates a doorway.

### Black
Black is used for the solid tabletop and shadows, with a touch of white and copious amounts of water. The green tint is created by the colored pencil outline used for the drawing.

### Orange
Cadmium Yellow Deep combined with pure red and a medium yellow makes a vibrant mix. White provides highlights and surface reflection.

### White
Here, a detail of the plate shows white used at its purest. Other colors break into its purity, giving a sense of light and shadow.

### Yellow
Cadmium Yellow Light forms the skin of the fruit, which is freckled with typical ripe markings indicated by random black and a touch of red.

### Playing with color
An orange is orange and a banana is yellow – but in art you can paint an orange or a banana any color you want. There are no rules about having to stick to nature's colors. So try painting the orange blue and the banana red.

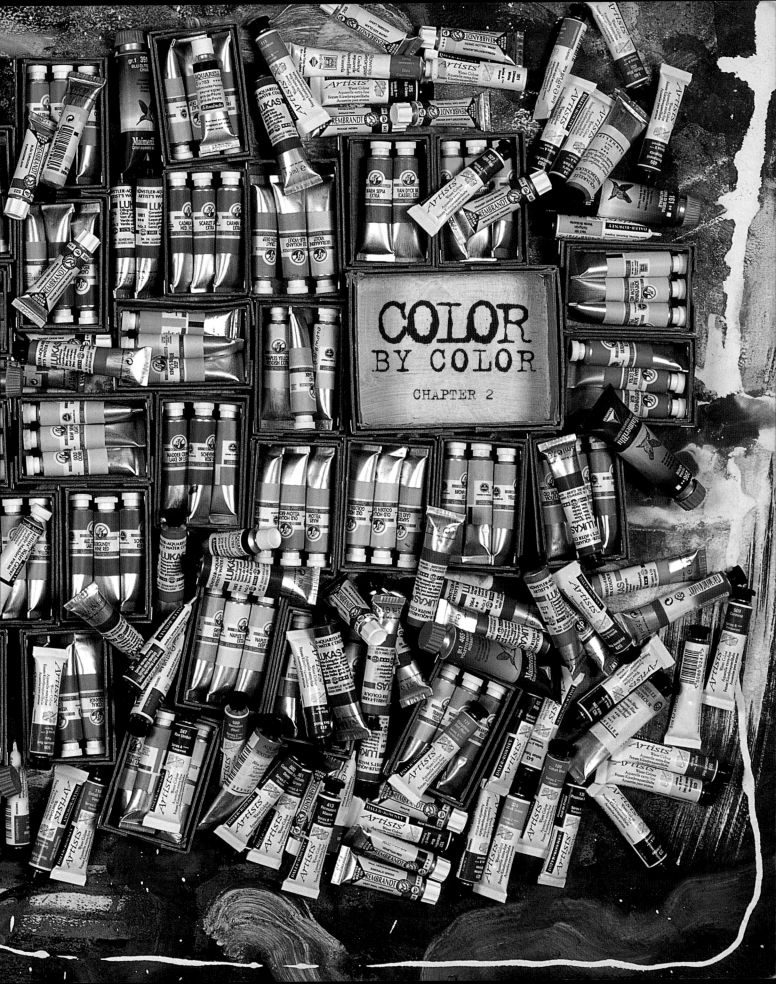

COLOR
BY COLOR

CHAPTER 2

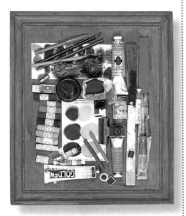

**Blue** ⇐ **50** ⇐ **51** ⇐ **52** ⇐ **53** ⇐     ⇐ **Blue** ⇐ **Turquoise** ⇐ **54** ⇐     ⇐ **Blue** ⇐ **Violet** ⇐ **55** ⇐     ⇐ **Red** ⇐ **56** ⇐ **57** ⇐ **58** ⇐ **59** ⇐

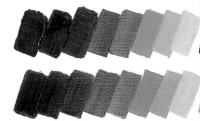

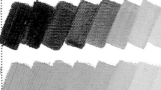

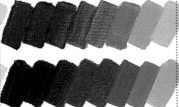

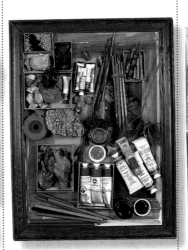

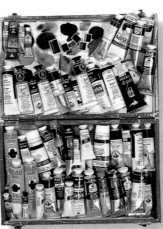

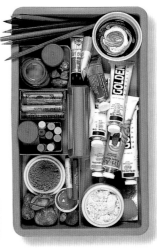

**Brown/Red Earth** ⇐ **72** ⇐ **73** ⇐     ⇐ **Brown/Red Earth** ⇐ **74** ⇐ **75** ⇐     ⇐ **Black** ⇐ **76** ⇐ **77** ⇐ **78** ⇐ **79** ⇐     ⇐ **Gray** ⇐ **84** ⇐ **85** ⇐

Darks 80, 81, 82, 83

On the following pages we explore many of the most popular "core" colors that are currently available to artists. We learn about the history, composition and attributes of these colors, and how they have been developed and refined into the artists' pigments we are familiar with today.

**Red Orange 60 61**

**Yellow 62 63 64 65 66**
Yellow Ochre 66

**67 Green 68 69 70 71**
Green Earth 67

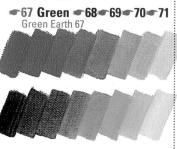

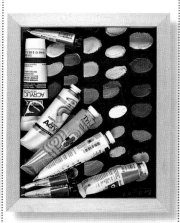

**NB**
Metallic colors,
Iridescent colors,
Fluorescent colors,
Interference colors, and
Mica formulations.
Due to the limitations of the four-color printing process, it is not possible to reproduce these special-effect colors with any degree of accuracy. See page 88 for further details and refer to manufacturers' color charts.

**White 86 87**

**Metallic 88 89**
and special-effect colors

**Flesh 90 91 92 93**
and reddish yellow tints

*"In music a light blue is like a flute, a darker blue a 'cello; a still darker a thunderous double bass; and the darkest blue of all – an organ."*

WASSILY KANDINSKY (1866–1944)

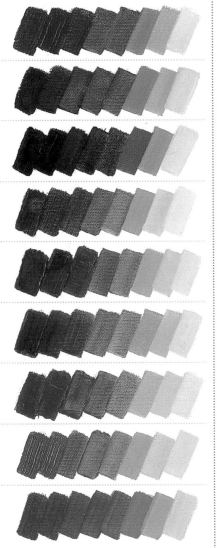

### What is blue?
"Of the color between green and violet in the spectrum, colored like the sky or deep sea (also of things much paler, darker, etc., as smoke, distant hills, moonlight, a bruise; and qualified by or qualifying other colors...)"

OXFORD ENGLISH DICTIONARY

Blue is overwhelmingly present in our lives, because it is the color of the sky, providing an ever-changing backdrop that is echoed and reflected in the sea, rivers and lakes. In relation to the spectrum and the color wheel, the term "blue" applies to all those colors that are between violet and turquoise. Blue retains its distinct character more clearly than the two other primary colors, red and yellow, when white or black is added.

From space our planet looks blue. Described by Kandinsky as the "typical heavenly color," blue carries a sense of the spiritual. It suggests calmness and serenity in its lighter tones and mystery as it approaches black. In some situations it may convey sadness and melancholy, hence to have "the blues." Used in mid-bright clarity it is an ethereal, expansive color, while deeper, richer blues have velvety depths that evoke opulence and mystique.

### Early blues
Though blue was known and used by the ancient civilizations, it was considered a lesser color. The Greeks had no separate word for blue, instead classifying individual blue colors with such terms as *kuanos*, from which we derive the word "cyan." Blue as an overall term was categorized as a black or dark.

### Frit
The ancient Egyptians used several shades of blue, among them a color that was synthesized from copper silicates and calcium oxide. These ingredients were fired with sand to produce a ceramic glaze and a glasslike substance known as "frit."

When ground this produced a soft blue pigment powder, a color later referred to by the Romans as Egyptian Blue or Alexandrian Blue.

### Azurite
Another color found in Egyptian wall paintings was derived from azurite, a copper carbonate mineral related to malachite. This gave a deep blue that veered toward green. Azurite was also used by the Greeks, who obtained its source mineral from Armenia, referring to it as "Armenian stone." It was still in use in the fifteenth century by Renaissance artists, who tended to use azurite as an underpainting for the more costly Ultramarine. The color was also known as *azzurro della magna* or sometimes as Mountain Blue.

### Woad
Woad had been used in northern Europe since the time of the ancient Britons, who dyed their faces blue in an effort to strike fear into the invading army of Julius Caesar in 55BC. It was obtained from the leaves of the *Isatis tinctoria* shrub and was a color similar to indigo. Artist monks used woad for blue to illuminate the *Book of Kells* in the eighth century.

### The growth of blue
Respect for blue increased with the discovery of the extraction of Ultramarine from lapis lazuli during the Middle Ages. It was not until the sixteenth century, however, that blue was properly recognized as an essential basic color.

### Naming blues
Many old names have been superseded, but you may see historical references to the following:

Alexandrian Blue
Antwerp Blue
Berlin Blue
Blue Ashes
Blue Bice
Blue Verditer
Bremen Blue
Delft Blue
Egyptian Blue
Indian Blue
Leyden Blue
Mountain Blue
Paris Blue
Pozzuoli Blue
Sky Blue
Smalt
Smalt Blue
Thénard's Blue
Vestorian Blue

## Oriental blues

While the Greeks and, particularly, the Romans had brought colors and dyes from the East, the Middle Ages saw flourishing trade routes reestablished. Two colors were especially important – Ultramarine and Indigo.

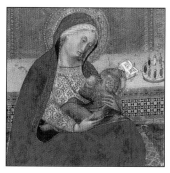

### Ultramarine

The name Ultramarine – meaning "from beyond the sea" – gives some indication of the color's exotic standing. This pigment, rich royal-to-purple blue in color and more expensive than gold, was obtained from a semiprecious gemstone called lapis lazuli ("blue stone"). Still rare, lapis lazuli is chiefly found in Afghanistan.

The cost of Ultramarine was reflected in its use, and master painters of the Renaissance were instructed to use the color to denote their patron's status and wealth. These artists were even contractually required not to economize on Ultramarine by substituting a cheaper blue, such as azurite. Artists tended to use the color symbolically for the most important areas in a painting, such as the Virgin Mary's robe. With the advent of oil paint, Ultramarine appeared less saturated unless lead white was added, and the color lost favor a little.

The stone's main coloring component is the mineral lazurite, but other components cause the pigment to take on a grayish tinge if it is ground, so another method is required to extract the brilliant blue. The process involves mixing the stone into a kind of dough that is washed to leave a sediment. Further washes give varying intensities.

### Indigo

Indigo, as its name implies, was imported from India. Fermented from the leaves of the *Indigofera tinctorum* plant, it produced a deep purple-blue dye that was 30 times stronger than woad.

For painters it was available in the form of a lake pigment produced by dyeing. Indigo was sometimes used by Renaissance artists as an underpainting to azurite to give depth and to warm its effect.

### Indigo dye

In the nineteenth century, under the Raj, the British turned Indigo production in India into a major industry. As a textile dye, the color was used all over the world for uniforms. Although all blues are fugitive, Indigo is particularly prone to fading. It is still used on a large commercial scale for work clothes, such as overalls, but the color has been synthesized since the early twentieth century. Perhaps its most popular and obvious use is for the coloring of denim blue jeans.

### Blue Bice

Light blue could be obtained from combining copper carbonates with the precious metal found in silver mines in India. Used in the seventeenth century, these colors were descriptively referred to as "ashes."

### Smalt

Smalt was one of the first useful blues that had cobalt as an ingredient. A deep blue color, Smalt was used widely from the sixteenth to the eighteenth century and superseded azurite. It was ground from a glass frit produced from cobalt oxide and J. M. W. Turner (1775–1850) is said to have used great quantities of "smalts of various intensities."

**Iznik tiles**
During the sixteenth century, the potters of Iznik in Turkey created beautiful glazed tiles based on geometric and floral motifs. Cobalt blue was used first as a single color, but later colors such as turquoise, copper greens and a manganese red-purple were incorporated.

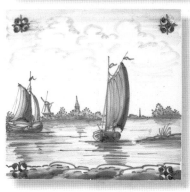

**Leyden Blue**
A type of cobalt blue called Leyden Blue was used as the glaze for the Dutch seventeenth-century earthenware that became known as Delftware. In their turn the Dutch were imitating the Ming Blue (also cobalt oxide) and white porcelain from China.

**How to make an excellent Ultramarine Blue**

"Take lapis lazuli and grind it fine on a porphyry stone. Then make a mass or paste of the following ingredients: for a pound of lapis, 6 ounces of Greek pitch, two of mastic, one of spike or linseed oil, and half an ounce of turpentine; bring it all to boil in a pot until almost melted, then filter and gather the product in cold water. Stir and mix it well with the powdered lapis lazuli and let sit for a week or so. The longer it rests, the better and finer the blue will be. Next, knead the paste with the hands, sprinkling it with warm water; the blue will come out with the water. The first, second and third rinsing should be done separately. When you see the blue fall to the bottom of the container, throw out the water and keep the blue."

LIBRI COLORUM
(THE BOOK OF COLORS)
COMPILED BY JEAN LEBEGUE
(FIFTEENTH CENTURY)

## The quest for blue

Chemical experiments and advances in industrial technology in the nineteenth century saw the discovery of new ways of synthesizing blues that were the forerunners of colors used by artists today.

### Prussian Blue

The first color to be made artificially was produced by accident. In 1704 a paint maker called Diesbach, working in the Prussian city of Berlin, added some impure potash containing animal oil into a cochineal lake he was making. The result was a chemical mixture of ferric ferrocyanide, and its color was a deep, slightly greenish blue.

A powerful, staining color, Prussian Blue was fairly inexpensive to produce for use in dyeing textiles and as artists' color. Other chemists in Europe were soon making their own versions. Prussian Blue is also known as Berlin Blue or Paris Blue. Antwerp Blue is a lighter version.

### Cobalt Blue

The first synthesized Cobalt Blue was created in 1802 by a French scientist called Thénard; thus the color was also known as Thénard's Blue. Its chemical composition was cobalt aluminate, and it took over from Smalt. Cobalt Blue is a clean-looking blue that is neither warm nor cool and is available in shades from light to deep. Cobalt is also used to describe other colors derived from the metal, including violet and green.

### Cerulean Blue

Named from *caeruleus* (Latin for "blue"), this color was discovered in 1802 by Höpfner, a German scientist, who produced it through heating cobalt and tin oxides. In 1870 it became an artists' color when the English paint maker George Rowney marketed it as Coeruleum. It is a bright, greenish blue, particularly suited to painting watercolor skies.

### French Ultramarine

Since Ultramarine was sourced from the rare lapis lazuli, it was prohibitively expensive. In 1824 the French Société d'Encouragement pour l'Industrie Nationale offered a prize of 6,000 francs to any chemist who could discover how to manufacture an artificial Ultramarine. Four years later the French color maker J.-B. Guimet came up with a winning recipe that included aluminosilicate, sodium carbonate, silica and sulfur. Heating and washing processes resulted in an ultramarine color that could be changed slightly by simply adapting the ingredient amounts. The color became known as French Ultramarine, reflecting its provenance. Its cheapness ensured that it became a core color for all artists.

## Modern blues

Many of the core modern blues that artists use have familar names, such as Prussian Blue, Cobalt Blue, French Ultramarine and Cerulean Blue. In addition there are several new blues such as Phthalo, Monastral and Indanthrene Blue. Manufacturers have developed their own colors and variations of them. With no historical tradition to these colors, they sometimes bear the maker's name or a descriptive name. Check the manufacturers' charts for accurate chemical descriptions.

**Pigment use**
The blue pigments most frequently seen and widely used by modern manufacturers are PB15 Copper phthalocyanine, PB73 Cobalt silicate and PB27 Ferric ferrocyanide. PB15 is an ingredient in Indigo, Manganese Blue (Hue), Neutral Tint, Payne's Gray and Mauve, as well as the colors named Phthalo. PB73 is used as a single pigment in Cobalt Blue Deep.

### Blue pigments

| | |
|---|---|
| PB15 | Copper phthalocyanine |
| PB27 | Ferric ferrocyanide |
| PB28 | Cobalt aluminum oxide |
| PB29 | Complex sodium aluminum silicate |
| PB35 | Cobalt tin oxide |
| PB36 | Cobalt chromium oxide |
| PB60 | Indanthrone |
| PB73 | Cobalt silicate |

## Chemical blues

The twentieth century saw new synthetic chemical pigments and dyes that mimicked natural colors. These colors have considerably expanded the choice available to artists.

### Phthalo Blue

This powerful color is made from copper phthalocyanine, first synthesized in the early 1930s. As a deep, intense blue (it is sometimes named Intense Blue), it has replaced Prussian Blue to a great extent. Phthalocyanine provides a variety of blue shades that are mostly slightly greenish, but sometimes have a reddish tinge – for instance, Winsor Blue (Green Shade) and Winsor Blue (Red Shade). Other blues with phthalocyanine as their base are Hortensia Blue, Monastral Blue, Monestial Blue, Old Holland Blue, Rembrandt Blue and Thalo Blue.

### Manganese Blue

This color, developed in the early twentieth century, was made from barium manganate. Described as having "an ice-blue undertone," it was a bright greenish blue, similar to Cerulean, but weaker in tinting power. Unfortunately, the pigment is now unavailable.

### Indanthrene Blue

This violet blue, similar to Indigo, was developed in 1901. Some manufacturers market this color instead of Prussian Blue, and it creates good dark colors when mixed with umbers. It is more lightfast than the phthalocyanine blues, especially when used in tints. It is also called Indanthrone Blue.

## Core blues

The most common blues are Phthalocyanine, Cyan or Primary, Cerulean, Ultramarine and Cobalt. The pigment contents are usually the same, but hues vary from one maker to another, depending on the formulation and the medium.

**Phthalocyanine Blue**

**Cyan and Primary Blue**

**Cerulean Blue**

**Basic blues**
Many manufacturers offer basic mixing blues – ones that are recommended as good mixers for creating secondary colors. Among these you will often see Cyan Blue and/or Primary Blue. Cyan is traditionally a highly saturated green-blue that is the complementary of magenta. Cyan Blue and magenta, along with yellow, form a set of primary colors that are well known within the printing industry (see page 21). The word "cyan" is from the Greek *kuanos*, meaning "dark blue."

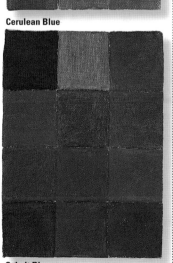

**Cobalt Blue**

**Ultramarine Blue**

## Blue obsessions

One of the most well-known examples of a blue obsession is probably Picasso's blue period (1901–04). Many other artists and movements in art have also become known for their association with blue.

### Homage to blue

French artist Yves Klein (1928–62) produced vivid single-hue paintings in the 1950s. In his desire to celebrate the full intensity of pigment, he developed a new Ultramarine, patenting it as International Klein Blue (IKB). Suspending pure pigment in clear resin allowed the particles of color to be displayed with startling vibrancy. IKB became Klein's trademark color.

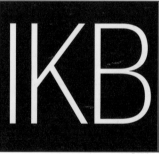

**International Klein Blue**

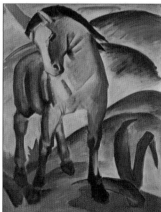

**Franz Marc, Blue Horse 1, 1911** (detail)

### The Blue Rider

Known in German as *der Blaue Reiter*, this group of Expressionist artists were associated with an art almanac founded by Kandinsky and Franz Marc (1880–1916). The name was chosen because Kandinsky and Marc both liked the color blue and were interested in painting horses and their riders.

*Frequently, "turquoise" is used as an adjective to describe blue or green, depending on its particular bias.*

The color turquoise replicates the hue of the same-named semiprecious stone. Europeans gave the mineral its name in the thirteenth century, because they imported turquoise through Turkey, although its source was probably Persia. Turquoise was also found in the American continent, where the Navajo, Zuni and Hopi Indians crafted artifacts and jewelry, working turquoise with silver.

### Turquoise pigments

Natural turquoise varies in color from a bright greenish blue to a pale bluish green. Its components are hydrated aluminum and copper phosphate. A pale turquoise green ceramic glaze can be produced from roasting aluminum, chromium and cobalt oxides.

There is no single synthetic organic turquoise. Artists can simply mix turquoise from blue and green pigments, thereby controlling the precise color of the turquoise required. There are also many prepared artists' colors that now bear the name turquoise. Manufacturers create turquoise by combining blue (PB) and green (PG) pigment ingredients. These are mainly based on phthalocyanines; these synthesized substances produce a range of blues that can veer toward red at one end, but generally tend to be greenish. Single pigment cobalt turquoises are also available. They produce clear, bright colors in watercolor, and both bright and duller colors in oils and acrylics that are said to more closely resemble the opaque, matte appearance of the natural stone.

### Blue or green

In ancient Mexico the Aztecs used turquoise mosaics to decorate sculptures and precious objects, combining the stone with jade. This juxtaposition of the two minerals perhaps led naturally to the use of one word to mean both blue and green. From the artist's point of view, this is apt, because turquoise sits between these two colors in the spectrum, although it is not named as a separate hue.

### Prepared turquoise colors

Manufacturers offer several colors named turquoise, but you can mix these hues.

*(From left to right, top to bottom)*
Phthalo Turquoise Light, Phthalo Turquoise, Turquoise Blue, Turquoise Deep, Turquoise Blue Deep, Phthalo Turquoise, Cobalt Teal, Cobalt Turquoise, Cobalt Green Turquoise, Cobalt Blue Turquoise Light, Cobalt Turquoise (Hue).

### Experiment with turquoise

It is easy to mix numerous varieties of turquoise using chosen blue and green pigments, which allows precise control of the required bias of the color.

### ☛See also

Blue 50–53

Green 68–71

Color index/Turquoise 168–169

Color index/Violet 165–166

Violet is a secondary color and is the complementary of yellow. The term violet is derived from the Old French "violete" or "violette," a plant or flower of the genus *Viola*, whose flower is of this color. Violet lies at one end of the visible spectrum, next to blue. Together with mauve and purple, violet describes colors ranging from reddish blues to bluish reds and also violet-tinged reddish browns (Mars violets).

*"I have finally discovered the color of the atmosphere. It is violet."*
Claude Monet (1840–1926)

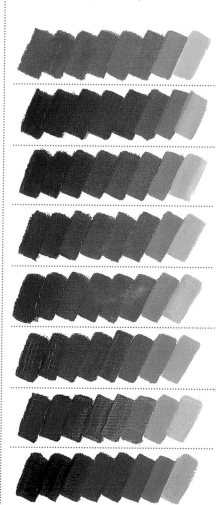

### Prepared violet colors

There are numerous manufactured violet hues available.
*(From left to right, top to bottom)*
Brilliant Violet, Light Violet, Quinacridone Violet, Deep Violet, Ultramarine Violet, Light Blue Violet, Medium Violet, Violet, Dioxazine Violet, Violet Bluish, Caput Mortuum, Permanent Violet Dark.

### Violet pigments

A number of violets exist as pure synthetic pigments. For example, PV15 (Ultramarine Violet), PV19 (Quinacridone) and PV23 (Dioxazine Violet) are frequently seen in product declarations on paint tubes. However, many manufactured colors that bear the name violet, including similar hues, such as the mauves, magentas and purples, are often combinations of red and blue pigments, sometimes with added white (see Light Blue Violet, above left). Many of the prepared violet hues can be obtained by mixing.

### Caput Mortuum

This is a subdued violet-brown color seen in artists' oil colors and sometimes in watercolors. Its strange name, "death's head," which originated in the eighteenth century, is said to be derived from the color of skulls piled in the catacombs in Rome. However, none of the constituents of the pigment are obtained from bone, and a more feasible explanation is that the color was obtained from iron salts that were baked down to their "dying" embers. Caput Mortuum or Mars Violet has a subtle violet character that some artists find useful in their repertoire of earth colors. It makes good flesh tones when mixed with white. Mars Violet is an artificial pigment (red iron oxide PR101). It is a color that can be easily mixed on the palette.

**Caput Mortuum is a maroon Mars violet.**

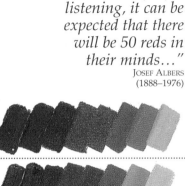

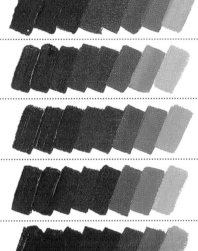

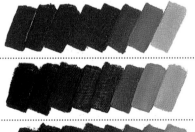

*"If one says 'Red' (the name of a color) and there are 50 people listening, it can be expected that there will be 50 reds in their minds…"*

JOSEF ALBERS
(1888–1976)

## What is red?

"Of or approaching the color seen at the least-refracted end of spectrum, of shades varying from crimson to bright brown and orange, esp. those seen in blood, rubies, glowing coals, human lips, and fox's hair…"

OXFORD ENGLISH DICTIONARY

Red is the most dynamic and vibrant color in the artist's palette. In its purest, saturated form it is the hottest of the warm colors. It is a color that needs to be used judiciously, since overuse may reduce its vibrancy. Set against its complementary, green, even a small amount will sing and sparkle. It is one of the oldest color names – the first color word we speak of after black and white.

Red is a color with countless symbolic and contradictory associations in different cultures. It can signify danger, or life; good luck, as well as evil. In India red is the sacred color of Lakshmi, the goddess of wealth and beauty, and in China a ruby represents longevity. The red planet Mars is named after the Roman god of war. Early physicians wore red robes to signify their healing profession, and doors were painted with a red cross to signify the presence of the bubonic plague.

### The first red palettes

Red was a difficult color to make successfully and early pigments were often fugitive, turned black when mixed with others and were sometimes extremely toxic. Early red pigments were mostly made from earth colors, berries, roots, insects and resins, and many of the red paints were originally obtained from dyes.

The Egyptians found a way of fixing dyes onto a transparent white powder (probably gypsum or even chalk); paint pigments made by this process are termed "lakes." Much later, Renaissance artists also used red lake pigments from resinous sources, such as brazil wood, and the Indian lac and kermes insects.

### Red lead

Once a highly prized color, first manufactured by the Greeks, this pigment is not used by artists today, because it is composed of lead monoxide and lead peroxide and, therefore, highly toxic. It is also known as Minium or Saturn Red. It was used for many years to protect steel from rusting.

### Earth reds

Red iron-oxide pigments produce many reddish hues with similar properties, but slightly different variations, such as Mars Red and Venetian Red with light, warm tones and Indian Red, Mars Violet and Caput Mortuum, which are darker, cooler versions. Earth reds are permanent, lightfast colors with good covering power. Other color names within this category are known as English Red, Pompeiian Red, Persian Red, Sinopia and Terra Rosa (see Brown and Red Earth, pages 72–75). These colors can be either natural or synthetic.

### Realgar

Realgar was made from red arsenic sulfide. It was a natural pigment found in volcanic areas and hot springs, and was used in ancient Mesopotamia. The word realgar stems from "rahj al-ghar" (Arabic for "powder of the mine"). Now an obsolete pigment, its use continued until the nineteenth century, when it was no longer used because of its extreme toxicity.

### Cardinal Red

In the Middle Ages, bright colors were rare – they were tedious and difficult to produce. Hence, red (along with purple) became the exclusive preserve for kings, judges, the nobility, and the pope and his cardinals. In 1464 Pope Paul II introduced "Cardinals' Purple," which was not purple, but a red dye made from the kermes insect.

## Redrot

### Red-letter day

The early Christian church used red for directions in prayer books to guide the conduct of church services and to show feast days on the ecclesiastical calendar, and so a red-letter day became a lucky day.

### Scarlet women

Red is associated with lust, and a woman suspected of committing adultery in Puritan times was branded with a scarlet letter. Even before Christianity linked red with the devil, the color had negative connotations. An ancient Egyptian incantation, praying for salvation from evil, was "Oh, Isis deliver me from the hands of all bad, evil, red things."

## Using red to attract attention

Red attracts the attention of the viewer, because the color appears to advance, making red objects seem closer than they actually are. This visual phenomenon occurs because red has the longest wavelength of all visible light. Artists can use this property of red to their advantage for added dimension. Making some colors warmer will make them stand out from a picture's surface, while cooler colors will appear to recede.

## Cinnabar

Cinnabar, the precursor to Vermilion, was made from a dense hard rock. According to Theophrastus (c. 300BC) in *The History of Stones*, cinnabar ore was dislodged from inaccessible cliffs by shooting arrows to loosen it. The chief mining area for cinnabar was Almadén in Spain. The Romans made paint from cinnabar and it was their only source of a bright orange-red color. It was not as bright as Vermilion, although both are forms of mercuric sulfide.

### "Judas hair"

A term used to denote bright-colored hair in paintings, particularly red hair. The expression originated, because artists traditionally gave Judas distinctive red hair in paintings.
Giotto di Bondone (1267–1337)
**The Kiss of Judas, c. 1305–06**
(detail)

## Dragon's Blood

Also called Indian cinnabar by the Greeks, Pliny maintained that the color came from a mixture of an elephant's and a dragon's blood, following a fierce battle between the two beasts. In fact, it is a red-brown resin produced by the sap of an Asian shrub known as *Calamus draco*. The leaves have prickly stalks that grow to resemble long tails and the bark is covered with spines.

## Vermilion

The Greeks made an artificial form of cinnabar, called Vermilion, which was an orange-red pigment. The recipe was not known in the West until the twelfth century, and it took another 300 years for the pigment to be in common use. Again, it was the best bright red available. The color was often used in manuscript painting where it was glazed with either egg yolk or "glair" (egg white). Similarly, in painting Vermilion was often glazed with madder or cochineal lakes in order to increase the purity of the color.

Vermilion is made by heating mercury and sulfur together in a flask. The combined substances vaporize and recondense at the top of the flask in the form of a black mixture. A red color develops as the mixture is cleaned. The longer it is ground, the brighter the color becomes. Cennini claimed that "if you ground it every day for 20 years, the color would still become finer and more handsome." Vermilion continued to be used until the mid-to late twentieth century.

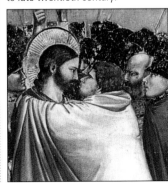

## Naming reds

A wide variety of reds is available in any of the media. Many of the colors are also known under secondary names – Alizarin Crimson is also referred to as Rose Madder or Permanent Madder, for instance. Some manufacturers attach their own names to colors they have developed, such as Winsor Red. There are individual inconsistencies that only become apparent to the artist after time and familiarity with a medium or particular paint manufacturer. Generally speaking, oil colors tend to have old names, while new media such as gouache or acrylic are often given more descriptive color names. Flame Red, for example, is a gouache name that is very close in terms of handling and range of color mixing abilities to the oil paint called Cadmium Red. Often, an old name may be attached to a paint color, but it is now made synthetically and the problems of permanence or toxicity that were associated with it in the past are no longer relevant. Here are some of the names you may find to describe various hues of red pigments:

**Alizarin Crimson**
**Bright Red**
**Brilliant Red**
**Burgundy**
**Cadmium Red**
**Carmine**
**Chinese Vermilion**
**Crimson**
**Florentine Red**
**French Vermilion**
**Genuine Red**
**Geranium**
**Helios Red**
**Intense Red**
**Magenta**
**Munich Lake**
**Nacarat Carmine**
**Naphthol Red**
**Pyrrole Red**
**Rose**
**Rowney Red**
**Ruby**
**Scarlet**
**Transparent Red**
**Vermilion**
**Winsor Red**

**Alizarin Crimson**
In general Alizarin Crimson mixes well with blues to obtain violet. Purples and violets mixed with Cadmium Red tend to be brownish in color.

**Cadmium Red**
Cadmium Red, however, is good for mixing with yellows to produce a clean bright orange.

**Complementary color**
As the complementary of green, red is a useful color for toning down bright saturated greens. Eventually, the two mixed together, with the addition of white, will create either a greenish gray or a warm pinkish gray.

## Reds in the artist's palette

As one of the primary colors, red is one of the most important elements in the artist's paintbox. Different artists choose different colors for their palette according to individual preferences, but a minimum palette will invariably include Alizarin Crimson, a coolish blue-red, and Cadmium Red, a warm orange-red. Alizarin Crimson is a transparent color and good for glazing, especially in oils and acrylics – for adding a blush to a cheek, for example – while Cadmium Red is opaque and has an excellent and greater covering power. From these two reds, it is possible to mix a wide spectrum of colors.

**Preparing natural madder**
Alun Foster, chief chemist at Winsor & Newton

**Synthetic madders range in hue from light, pinkish rose to deep reddish browns.**

**Madder plant**
*Rubia tinctorum*

**Red legs**
Natural madder produced the deepest and most permanent reds until the invention of Alizarin Crimson in the 1860s. The French government attempted to protect its traditional madder-growing industry by making it the compulsory red dye for army-uniform trousers.

## Madders

Madder Lake and Rose Madder are now produced synthetically, but the color was originally made from the root of the madder plant *Rubia tinctorum*. Native to Greece, it was introduced into France and Italy in the twelfth century. George Field, a great colorman of the nineteenth century, who supplied John Constable (1776–1837) and William Holman Hunt (1827–1910), invented a press in order to extract the dye from the madder root.

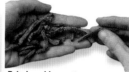

**Dried madder root**

**Genuine madders**
Winsor & Newton are the only remaining large commercial company to produce a natural madder in artists' colors, one that has a pinkish rose hue. The pigment declaration NR9 shows the product contains genuine madder. However, many modern colors (see left) bear the name madder, and these vary in hue from a medium rose color to a darkish violet-brown and contain various synthetic organic pigment combinations.

**Alizarin Crimson**
Alizarin Crimson is a synthetic substitute for madder and was first introduced by two German chemists, Graebe and Liebermann, in 1868. It was the first natural dye to be manufactured artificially. By 1920, it had replaced most of the old lakes and madders, which were often weak colors that discolored rapidly and were not lightfast. Alizarin Crimson is a color with a strong staining power – a little goes a long way. It is also transparent and is, therefore, used a lot with glazes.

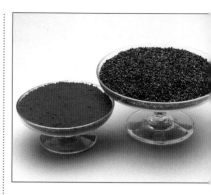

## Crimson and Carmine

The original paint colors known as crimson or carmine were precursors of Alizarin Crimson. The names come from the kermes insect, from which this color dye was first extracted. The sixteenth century saw the introduction of the same color derived from the cochineal beetle *Dactylopius coccus*. This tiny Mexican *Coccus cacti*–eating insect produces a transparent and highly fugitive color when ground and precipitated on clay. There are approximately 70,000 insects per pound of cochineal. The color was held in high regard by the Aztecs, and it was brought to Europe shortly after the discovery of Central and South America. Today, it is more commonly used as a food coloring, because as a paint it proved to be extremely fugitive. Paints using the word carmine or crimson are now synthetically produced.

## Scarlet Lake

Scarlet Lake is made from various pigments, but it was originally a mixture of Vermilion and Cochineal Lake. The color is also known as Scarlet Vermilion.

## Chrome Red

Orange-red was derived from chromium, discovered in the early nineteenth century. Although brilliant in hue, the color is toxic and unstable and is no longer used. It is also called Chinese Red.

## Aniline reds

A number of aniline pigments were developed in the 1850s and 1860s (see page 81). Among these were a cherry red that was named fuchsin and a violet-red that was named Magenta after the battle of 1859.

## Cadmium colors

In 1817 the heavy metal cadmium was discovered by the German scientist Friedrich Strohmeyer. By the mid-nineteenth century, various cadmium colors were being developed. Brilliant in hue, they were opaque and also reliable to use. These colors all veer toward the hotter part of the spectrum through the red/orange/yellow range.

### Cadmium Red

Cadmium Red was not introduced until the early 1900s, since when it has become a core red. Developed from Cadmium Yellow, Cadmium Red is made from cadmium sulfide and cadmium selenide. Top-quality ranges are composed of pure cadmium, while cheaper makes are a cadmium-barium mixture, which has less tinting strength and may produce a less vibrant color.

Cadmium Red is one of the most important colors in the artist's palette and is the best substitute for Vermilion. It is a very bright, hot red. Paint manufacturers will often have a variety of Cadmium Reds in their chart designated as light, medium and dark.

In a limited palette, Cadmium Red is often balanced by the inclusion of Alizarin Crimson, which acts as a cooler red. It makes an opaque permanent color, but there are some concerns with toxicity, particularly if undiluted pigment is used instead of ready-made paint.

## New reds

The twentieth century has seen the advent of new chemical pigments that have considerably augmented the artist's choice of reds. Many of these provide reliable versions of natural colors that are unstable.

**Sample selection of cadmiums**

**Sample selection of quinacridones**

**Sample selection of magentas**

### Quinacridones

The first quinacridone colors were brought onto the market in the 1950s. These are a wide and vibrant range of reds that range through oranges, pinks and purples. They have gradually replaced most of the lake colors and provide new colors, particularly increasing the choice of bright magentas. They are lightfast and resistant and, even in their oil versions, have a luminous quality. In acrylic and watercolor, they provide transparent luminosity and clean mixes. A particularly deep dark or colored black may be obtained from mixing Quinacridone Crimson with Phthalo Green.

### Perylene Red

Developed in the 1980s, these are strong deep brown-red and maroon pigments. In mixes they produce warm darks.

### Pyrrole Red

As their name implies, this is a group of bright, fiery orange-red colors. They were first introduced in the 1990s, and they are lightfast, have reasonable opacity and produce clean mixes that may give them an advantage over cadmium colors.

### Naphthol Red

Naphthol reds are a large group of organic pigments, first introduced in the 1920s. They range from yellow-shade reds right through to deep crimsons, and they belong to one of the most complex chemical families. The main factor that is of concern to artists is the variable lightfastness of the category, with some Naphthols being unsuitable for artists' colors. The more commonly used high-lightfast pigments are PR112, PR170 and PR188, which appear as Naphthol Red Light, Naphthol Red Medium and Scarlet Lake.

## Inspired by red

### The Fauves

The Fauves (French for "wild beasts") were the first artists to break away from using descriptive color and to use it as an emotive vehicle. Prime among them was Henri Matisse (1869–1954), one of the great colorists of the twentieth century. His influence can be seen in the early works of André Derain (1880–1954), who chose a bright, emotional palette before reverting to more subtle, traditional colors.

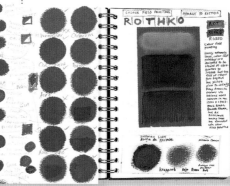

### Color field painting

The American painters of the 1950s and 1960s developed a style of abstract painting that became known as Abstract Expressionism. The work of the artist Mark Rothko (1903–70) emerged from this movement. Rothko's work was reliant on the pure sensation of color. He painted huge canvases, overlaying large areas of color, so that the field of color seemed to go beyond the picture plane to allow the viewer to become totally absorbed by the emotional impact of color.

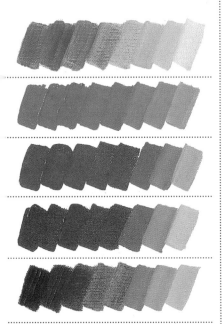

Antonio Mensaque
**Oranges, 1863**
Anglesey Abbey, Cambridgeshire
Collection of The National Trust

The color orange is named after the Sanskrit word "narangah" for the fruit. Orange conjures up warmth and vibrancy, and the color appears in the hot part of the spectrum between red and yellow. In pigment form orange may often have a slight bias toward either red or yellow. Although it may be mixed from these two primaries, the clearest and brightest oranges are single-pigment hues.

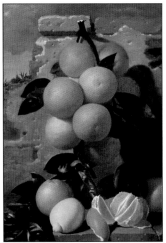

Orange has traditionally been sourced from earth colors ranging from golds to browns. The toxic Realgar, derived from volcanic minerals, which was used from ancient times and through the Renaissance period right up until the nineteenth century, could be classified as a red-orange. New mid-oranges were developed from chromium and cadmium in the early nineteenth century, and recent improvements in synthetic color manufacture have ensured reliable, lightfast versions of these.

### Chrome Orange
This bright reddish orange was developed from chromium in 1809. It was produced by the reaction of lead nitrate with potassium chromate and sodium hydroxide, and the resulting mixture was filtered and dried to produce the pigment.

Different proportions of ingredients gave deeper shades. The chrome colors were not lightfast and most were later replaced by cadmiums. Chrome Orange was also known by several other names, including Persian Red and Derby Red.

### Cadmium Orange
There is a huge number of cadmium colors that range from pale yellow to deep red. Cadmium was first discovered as a byproduct of zinc production in the early part of the nineteenth century, but cadmium colors were not widely used until much later, when cadmium was more generally available. Cadmium Orange is a bright warm color that is composed of cadmium sulfide and cadmium selenide. It is a reliable, permanent color and has good covering power. Some makers add Cadmium Red to Cadmium Orange to increase its reddish tone and the range of colors available.

**Some modern oranges**
Advances in chemical synthesis in the twentieth century have given the artist new orange pigments that are bright, clear and lightfast. Among these are the perinone, benzimidazolone and pyrrole oranges.

### Perinone Orange
An intense orange with a red bias, this color was first used as a dye in the 1920s. Eventually produced as a lake pigment, it is available in light or dark shades. In watercolor it may appear to be a granular and semiopaque pigment. It is lightfast and is sometimes combined with aluminum flakes to produce a copper-looking metallic paint.

### Benzimidazolone Orange
This mid-orange has a slight yellow bias. It is a reliable, staining color, and today it is often used instead of Cadmium Orange. These "azo" colors are often given manufacturers' names; an example is Winsor Orange. They may not be as strong as cadmium colors when mixed, but they have good lightfast properties.

### Pyrrole Orange
The pyrrole pigments were discovered in the early 1980s and create colors in the orange to red sector. Pyrrole Orange is a bright mid-orange that is transparent and lightfast. This is another color that may be used as a substitute for Cadmium Orange, and it produces a broad range of colors when mixed.

## Experimenting with orange

Orange exists as a single pigment (see page 18), but it is one of the easiest and most satisfying secondary colors to mix from reds and yellows.

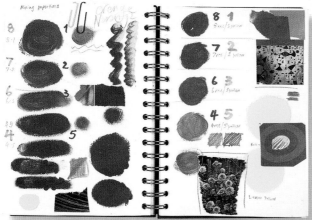

*"Warm red, intensified by a suitable yellow, is orange."*
Wassily Kandinsky (1866–1944)

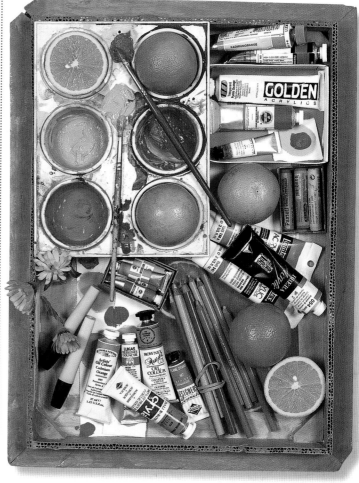

## Prepared orange hues

Manufacturers offer several prepared orange hues. Many are single pigment oranges and will carry the declaration PO, followed by the appropriate reference number. Others are mixed pigments containing red PR and yellow PY ingredients.

*(From top to bottom, left to right)*

| |
|---|
| Cadmium Yellow Orange (Old Holland) |
| Scheveningen Orange (Old Holland) |
| Perinone Orange (Winsor & Newton) |
| Chrome Orange Hue (Rowney) |
| Brilliant Orange (Liquitex) |
| Cadmium Orange Azo (Talens) |
| Transparent Pyrrole Orange (Golden) |
| Cadmium Orange (Lukas) |
| Indo Orange Red (Liquitex) |
| Cadmium Orange (Tri-Art) |
| Cadmium Orange (Rowney) |
| Cadmium Orange (Tri-Art) |
| Cadmium Orange (Maimeri) |

## Naming orange

Orange used as a name to describe a color was unknown until the importation of the fruit into Europe in the Middle Ages. Even in the fifteenth century, Cennini describes Realgar, which is an obvious orange hue, as a yellow.

### Burnt Orange

There are various hues carrying the descriptive name orange that veer toward transparent reddish browns. Among them are Chinese Orange and Quinacridone Burnt Orange.

> *"There are painters who transform the sun into a yellow spot, but there are others who, thanks to their art and their intelligence, transform a yellow spot into the sun."*
>
> PABLO PICASSO (1881–1973)

**What is yellow?**
"Of the color between green and orange in the spectrum, colored like buttercup or primrose or lemon or sulfur or gold…"
OXFORD ENGLISH DICTIONARY

Yellow is a versatile primary color and an indispensable mixing ingredient in the artist's palette. The yellow family ranges in hue from acid cool green-yellows to clean crisp lemons, and it includes pure unbiased primary yellows, rich warm cadmiums and chromes, and neutral creamy, fleshy Naples and earthy ochres.

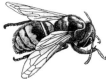

Yellow is perhaps the most schizophrenic of colors in terms of the associations it holds and the uses to which it is put. Yellow may suggest sunshine and cheerfulness, or sickness and cowardice. While yellow primroses and daffodils herald the spring, yellow and black stripes signal the warning of a wasp's sting or the danger of heavy machinery. Yellow has highly emotive connections. Yellow ribbons tied on trees signify hope and optimism for returning loved ones.

**Origins of yellow**
Yellows are derived from the earth, from arsenic, plants and even cow's urine. The word "yellow" comes from the Old English "geolu"; and similar names for yellow are found in Old Saxon and Old High German ("gelo"), and in Old Norse ("gulr"). The Latin for yellow is *helvus* and a similar word Helios is the name of the Greek sun god, a name that has been appropriated to identify certain modern brands of yellow.

**Prehistoric yellow**
Yellow was one of the four colors used by the cave painters of the Stone Age; yellow and red earth, white chalk, and black carbon have been dubbed the "prehistoric primaries." The iron content in the earth gives the yellow and red hues a full, soft quality, evident in the cave paintings of Lascaux and Altamira. Yellow earths and ochres are still used to this day.

**Massicot**
A lead-monoxide earthy yellow pigment, massicot was a byproduct of the production of red lead, made by the Greeks.

**Yellow Ochre**
Yellow ochres, or earths, have continued to be used throughout history and provide strong, economical, opaque color. Yellow Ochre consists of a mixture of clay, siliceous matter and hydrated iron oxide (limonite). It is known by many names, including Earth Yellow, Mars Yellow and Mineral Yellow (see page 66).

**Orpiment**
The Egyptians developed a brighter, more acidic yellow mineral pigment, a sulfide of arsenic, known as orpiment. It came from Smyrna and has been identified in Egyptian, Persian, Syrian and Chinese painting. It is mentioned in the writings of Pliny and, later, by Cennini. This highly poisonous and unpleasant-smelling color was also used in medieval and Renaissance manuscript illumination, from Europe and Ireland to Persia and Byzantium. Much later it was made chemically and known as King's Yellow. Other names for it are Arsenic Yellow and Chinese Yellow.

**Naming yellows**
These are some of the names for yellows that you may see:

| | |
|---|---|
| Aureolin | Indian Yellow |
| Azo Yellow | Lead-Tin Yellow |
| Barium Yellow | Lemon Yellow |
| Brilliant Yellow | Massicot |
| Cadmium Lemon | Naples Yellow |
| Cadmium Yellow | Orpiment |
| Chrome Yellow | Paris Yellow |
| Cobalt Yellow | Vanadium Yellow |
| Gamboge | Winsor Yellow |
| Golden Ochre | Yellow Ochre |
| Hansa Yellow | Zinc Yellow |

**Plant yellows**
Turmeric and saffron have been used as colors. Saffron is a bright yellow color obtained from *Crocus sativus*, but it is said to fade badly in daylight.

**☞ See also**

CI International 18-19
Orange 60–61
Yellow Ochre 66
Brown and Red Earth 72–75
Color index/Yellows 157–159
Color index/Yellow Ochres 172

**The gold-leaf maker**
"...hammers gold thin for painters, illuminators and other artists; gold is ground and rubbed into writing material; it is also woven and sewn into textiles..."
STANDEBÜCH (THE BOOK OF TRADES), NUREMBERG, 1568

## Gold

Heraldic convention ignores yellow as a color, but uses it to represent gold. Real gold leaf was reserved for the most prestigious and sacred works of art. Fifteenth- and sixteenth-century writings refer to the use of powdered gold as a watercolor for illuminating manuscripts. The grinding of gold as a pigment is a difficult process because of the softness of the metal, but there is mention of ground gold being suspended in honey as a binder.

**Gamboge**
This yellow pigment from Cambodia was first imported into Europe in the seventeenth century. Derived from the resin of the *Garcinia hanburyi* tree, it incorporates its own binder. It is moderately lightfast, so is only suitable for watercolor.

**Helios**
The Greek sun god Helios is often represented as a charioteer driving the sun across the sky. The names Helios and Helio have been adopted as appropriate brand names for certain bright yellow pigments.

**Indian Yellow**
Along with Mummy Brown (see page 75), the process of obtaining Indian Yellow may be considered rather offensive. It is reputed to have involved precipitating the urine of cows that had been force-fed with mango leaves. Its manufacture, from just one village, was banned in the 1920s by the Indian government in an effort to protect the cows from such an unhealthy diet. This bright, golden color is now replicated chemically, although it may lack the precise character of the original! Indian Yellow was most successful for watercolor, and had substantial lightfast properties. It is the bright yellow used in jewel-like Indian miniatures.

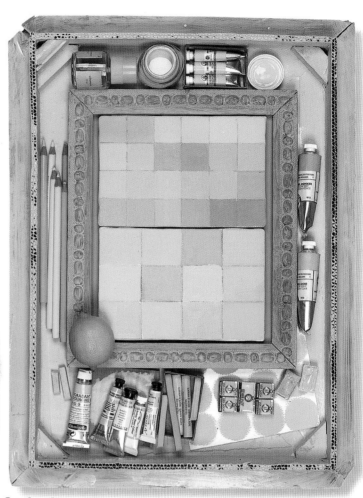

**On the character of yellow colors according to Cennini**

"**A color known as giallorino is yellow,** and it is a manufactured one. It is very solid, and heavy as stone, and hard to break up. This color is used in fresco and lasts forever...it is a very handsome yellow color; for with this color with other mixtures...attractive foliage and grass colors are made."

"**A color known as orpiment is yellow.** This color is an artificial one. It is made by alchemy and is really poisonous. And in color it is a handsome yellow more closely resembling gold than any other color. It is very good for painting on shields and lances. A mixture of this color with Bagdad indigo gives a green color for grasses and foliage.... Beware of soiling your mouth with it, lest you suffer personal injury."

"**A color known as realgar is yellow.** This color is really poisonous. We do not use it, except sometimes on panel. There is no keeping company with it. When you want to work it up, adopt those measures which I have taught you for the other colors. It wants to be ground a great deal with clear water. And look out for yourself."

CENNINO CENNINI, THE CRAFTSMAN'S HANDBOOK (FIFTEENTH CENTURY)

## Yellow "pinks"

Up until the late seventeenth and early eighteenth centuries the word "pink" was often used to describe yellow hues. Many of these yellows were derived from plants and berries and other natural sources, such as seashells. A "pink" was produced by dyeing a white substance, such as chalk, and was, in effect, a chemically simplified version of a lake.

Among the "pink" names you may see to describe colors with a decidedly brownish-yellow hue are Brown Pink (top), Italian Pink (middle) and Stil de Grain (bottom).

## Modern yellows

The advances in chemistry during the eighteenth and nineteenth centuries brought a wide range of new yellows. Particularly important were the yellow pigments derived from chromium and cadmium.

Artists today call on core yellows that include many cadmium colors, as well as colors with traditional and historical pedigrees. With the exception of natural Yellow Ochre, nearly all of these latter colors are made of synthetic ingredients, which ensures their permanence.

### Chrome Yellow

The metal chromium was discovered in 1797 by N. L. Vauquelin, a French chemist. Its constituents were of various colors, so he named it "chrome" (from Greek for "color"). Vauquelin developed Chrome Yellow by mixing lead acetate or lead nitrate with potassium chromate to produce lead chromate. The manufacture of this color began in the early 1800s and was in full flow by 1820. Similar in hue to orpiment, it soon replaced its poisonous predecessor, but it had disadvantages, too. It had a tendency to discolor on exposure to light and became darker as it aged. Chrome Yellow was also known as Paris Yellow or Leipzig Yellow. The color has now largely been replaced by the more reliable cadmiums.

### Chrome Lemon

By altering the amount of lead chromate in the pigment, a range of different colors could be made from chromium, from a pale primrose to a deep orange-scarlet color. By about 1830, three further pigments were developed from chromium. These were barium chromate, strontium chromate and zinc yellow, and all were sold as Lemon Yellow. All three colors were semitransparent, but the most permanent was strontium, which was a cool, light yellow. Again, however, even strontium tended to turn greenish in oils.

### Warm yellows
*(Right, from top to bottom)* Naples Yellow, Naples Yellow Deep, Naples Yellow Reddish. Some manufacturers offer pinkish combination pigments that fall into the yellow name category, but look more pink than yellow. Examples of these colors are Jaune Brillant and the Naples Yellow Reddish hues (see Flesh colors, page 90).

### Naples Yellow

A favorite color among painters, Naples Yellow, sometimes known as Antimony Yellow, was used in European painting as early as the fourteenth century. It is believed that its original source was the volcanic earth of Mount Vesuvius near Naples, but, by the seventeenth century, the color was made from lead antimoniate. Today, Naples Yellow is made with various pigments. The color is widely available in oil in light, medium and deep tones and in warm pinkish yellow hues, too. It is also produced as watercolor and acrylic. Artists generally find it lightfast, with excellent handling qualities.

### Cadmium Yellow

In the late 1840s, cadmium yellows were introduced. Produced from cadmium sulfide, the pigment was expensive. Cadmium colors still offer an important element in the artist's palette. As well as providing a range of hues, they have good durability and heat resistance, although humid atmospheres may affect their lightfast properties. Manufacturers usually provide Cadmium Yellow in three tones – light, medium and deep – ranging from pale primrose, to golden, to orange. There are also different tones of Cadmium Lemon.

### Aureolin

A cobalt yellow became available in the 1860s when William Winsor introduced Aureolin. The color was developed from a cobalt salt precipitated in acid solution with a solution of potassium nitrite. An expensive pigment, it has good lightfast properties, but it can decompose when subjected to heat or a change in acidity. The color is most suitable as a watercolor.

### Hansa yellows

The Hansa yellows were developed by the German chemical company Hoechst at the beginning of the twentieth century. They are derived from "azo" dyes, after which the colors are sometimes named. You may also see them with trade or brand names, such as Winsor Yellow. The colors range from cool lemon yellows to warm golden yellows. Significantly for such bright colors, they do not darken when used fully saturated.

## Pigment formulations

Most yellows are made from a single pigment formulation and employ chemicals such as cadmium zinc sulfide, arylamide, nickel titanate, potassium cobaltrinitrate and natural iron oxides. A few members of the yellow family are combination pigments, which can be approximated in mixes. Cadmium Yellow Deep is a good example where the yellow element has been warmed up with orange to give deeper hues. Naples Yellows have been softened and neutralized with additional white and ochres, and they are closely related to earth and oxide colors in hue.

### Lemon Yellow

Lemon Yellow may now be made from one of the arylamide synthetic organic pigments or nickel titanate. The color is a cool, clear acidic yellow that is considered useful for mixing powerful greens and oranges. It is transparent, with a somewhat weak tinting power.

*"...it would be easy to define by association the physical effects of color, not only upon the eye but the other senses. One might say that bright yellow looks sour, because it recalls the taste of a lemon."*
Wassily Kandinsky
(1866–1944)

### Indian Yellow, Gamboge and Golden Yellows

Nearly all of the older pigment yellows are now synthesized from combinations of red and yellow pigments. Indian Yellow is formulated from diarylide yellow pigment PY83 and synthetic iron oxide PR101. Many of the closer hues, often named Golden Yellows in catalogs, share similar ingredients. The exception is Gamboge Genuine, which is still available made from naturally occurring gum resin NY24.

### Van Gogh and yellow

Vincent van Gogh (1853–90) often used yellow in his vibrant paintings. Setting up his studio in Arles, the south of France, in the Yellow House, he painted his surroundings of cornfields, sunflowers and yellow rooms.

### Yellow Ochre

Yellow Ochre is an important natural mineral yellow and has been used since prehistoric times. It is still made from natural iron oxide PY43 (see page 66). Many other ochre colors, such as Gold Ochre, may now be replicated by synthetic iron oxide ingredients (see Brown and Red Earth, pages 72–75).

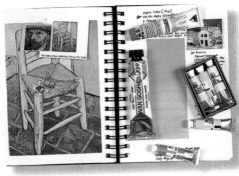

Unfortunately, many of Vincent's vivid yellows have not aged well. In the nineteenth century, many artists adopted chrome yellows to replace earlier yellow pigments that were unreliable or susceptible to fading, such as Gamboge and original Indian Yellow. But, Chrome Yellow, too, brought problems. In many paintings the color has turned green and, in some cases, nearly black. Even van Gogh's famous sunflowers have darkened, and the somewhat sickly yellows that appear in many of his pictures are signs that the Chrome Yellow is deteriorating.

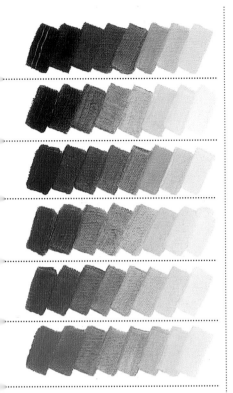

Yellow Ochre is a dull yellow earth pigment. It is one of the oldest natural minerals and has been in use since prehistoric times. Like all earth pigments, it is mined from surface deposits and is, therefore, easily accessible and fairly cheap to obtain. The natural yellow iron-oxide pigment is PY43. Yellow Ochre is usually listed among the yellows in art materials manufacturers' literature, and its hue can vary from a reddish brown to an earthy, golden yellow. It is said that the higher the iron content the darker the hue becomes.

Since the 1920s manufacturers have also used synthetic yellow iron oxide PY42, which replicates the permanent and lightfast qualities of mined Yellow Ochre. However, it can also be more transparent, because of the absence of clay. Natural Yellow Ochre PY43 is found in many places, including India, South Africa, Italy and the USA. France also has good deposits of high grade ochre. Past names, such as Oxford Ochre from the Shotover Hills, Oxford, England, relate to other sources of the color.

Other ochres to be found are:
**Attish Light Ochre**
**Bronze Yellow**
**Burnt Yellow Ochre**
**Deep Ochre**
**Flesh Ochre**
**Gold/Golden Ochre**
**Mars Yellow**
**Nickel Azo Yellow**
**Orange Ochre**
**Roman Ochre**
**Yellow Oxide**

## Ochres
A selection of colors whose ingredient is PY42, synthetic yellow iron oxide. Ochre hues can vary from light brownish yellows to darker reddish yellows.

**Modern pigment production at the Maimeri plant in Italy**

## Palaeolithic cave paintings, c. 15,000BC
As far as we can tell, the Palaeolithic artists used a limited palette of three colorfast pigments: yellow, red and black. All the colors are based on iron-oxide deposits from the earth, and carbon, thought to be from fire ashes.

**Green Earth straight from the tube and in tint with Titanium White**

*(From left to right, top to bottom)*

Green Earth (Old Holland)

Terre Verte (Talens)

Terre Verte (Sennelier)

Verona Green Earth (Lukas)

**Natural and synthetic sources**

Green Earth sources are not as widespread as iron oxides and the natural deposits of the pigment, mainly from Cyprus and central Europe, are almost exhausted. A famous source of the mineral was near Verona in Italy; hence, its name Terra Verde di Verona, dating to the Middle Ages. Current manufacturers may replace the natural earth with Phthalo (PG7) or Viridian (PG18) plus yellow or brown oxide.

**Creta viridis**

Records of Green Earth date back to Roman times, when it was used as a base for frescoes and called *Creta viridis*. It has also been discovered in wall paintings in Pompeii, Asia Minor and India. In medieval and Renaissance painting, Green Earth was incorporated as an underpainting for flesh tones (see pages 112–113). Natural Green Earth is translucent and has a high oil absorption and is well suited to water-based media. In the past the pigment was mixed with various plants, such as parsley, rue and columbine, to enhance its greenness. When heated, Green Earth turns brown and is sometimes known as Green Umber.

☞**See also**

**Green Earth colors**

A variety of Green Earths and hues are similar to traditional Terre Verte. Green Earth colors are available from most manufacturers in nearly all the popular media.

*(From left to right, top to bottom)*

Green Earth (Talens)

Green Earth (Sennelier)

Green Umber (Lukas Studio)

Olive Green (Talens)

Green Earth (Lukas Sorte 1)

Rowney Olive (Rowney)

Bohemian Green Earth (Lukas)

Green Earth (Old Holland)

Olive Green (Winsor & Newton)

Greenish Umber (Talens)

**Other trade names you may see are:**

| | |
|---|---|
| Belgian Green | Holly Green |
| Celadon Green | Rhenish Earth |
| Cyprus Green | Saxon Earth |
| Green Bice | Tyrol Green |
| Green Stone | Venice Green |
| Hessian | Verona Green |

Green Earth is a natural pigment (PG23), ranging in color from yellow-olive green to a gray-blue green. It is one of the earliest known pigments and is commonly known as Terre Verte or Terra Verde. Its origins, unlike other earth pigments, which are iron oxides, are commonly from marine clays containing iron silicate. The mineral contents are mainly celadonite (bluish gray) or glauconite (dark brownish olive).

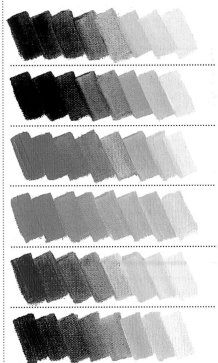

> *"Grass green and aspen-
> green, Laurel-green and
> sea-green, Fine-emerald
> green, And many
> another hue;
> As green commands the
> variables of green
> So love my loves of you."*
>
> ROBERT GRAVES (1895–1985)
> *VARIABLES OF GREEN*

Chlorophyll is the source of green in the earth's vegetation. It traps the sunlight and retains the red and blue-violet parts of the visible spectrum, allowing the green portion to be reflected. Green lies between yellow and blue in the color spectrum and is readily mixable on the palette from blue and yellow.

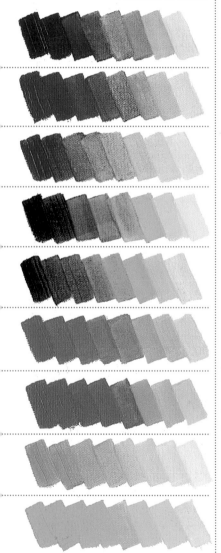

### Green in history

Most descriptions of early green pigments refer to copper and arsenic ingredients, which were common until the invention of synthetic pigments in the nineteenth century.

### Copper green and malachite

The history of malachite runs closely parallel to that of azurite (see Blue, page 50). Malachite is a naturally occurring copper green derived from a basic carbonate of copper. It is found in many parts of the world, usually in association with azurite. Among the obsolete names for this bright green pigment are Mineral Green, Mountain Green and Hungarian Green.

Cennini writes of the virtues of malachite in the fifteenth century:

*"A half natural color is green; and this is produced artificially, for it is formed out of azurite; and it is called malachite…. This color is good in secco, with a tempera of yolk of egg, for making trees and foliage, and for laying in."*

### Chrysocolla

In classical and medieval writing there are references to a blue-green mineral known as chrysocolla, found in combination with malachite. The name is derived from the Greek words for "gold" and "glue," because it was used by the ancients for soldering gold. Chrysocolla has been identified in wall paintings in China and Central Asia and in Egyptian tombs dating to 2000BC.

**Carl Wilhelm Scheele (1742–86)**

### Scheele's Green

In 1775, while experimenting with arsenic, Swedish chemist Carl Wilhelm Scheele discovered an acid, copper arsenite. Scheele did not immediately publish details for the manufacture of this copper green pigment, because he felt that potential users should be first aware of its poisonous nature. The color was later named after him, but there is some doubt about the extent to which Scheele's Green was used by artists. It is not mentioned in literary sources of the period, except for the following account in George Field's *Chromatography* (1869):

*"…To make the green, some potash and pulverized 'white arsenic' (that is arsenious oxide) were dissolved in water and then heated, and the alkaline solution was added, a little at a time because of effervescence, to a warm solution of copper sulfate. The mixture was allowed to stand so that the green precipitate could settle, the liquid was poured off, and the pigment was then dried under a gentle heat…"*

### Pigment green (PG)

In art materials terms, green exists as a pigment in its own right, identified on products as PG (pigment green). For example, you will come across PG7 Phthalo Green, PG8 Naphthol Green and PG18 Viridian as single pigments. Conversely, several greens available are made of combinations of pigments and contain yellow, blue and white (see page 70).

### Naming greens

Green is the largest color family discernible to the human eye. Prior to the standardization of pigment nomenclature many names were used to describe hues of green. Some of the following names are still in current use, while many have now disappeared:

| | |
|---|---|
| Almond Green | Leaf Green |
| Apple Green | Leek Green |
| Arnaudon's Green | Lily Green |
| Avocado Green | Mineral Green |
| Bottle Green | Mittler's Green |
| Brunswick Green | Moss Green |
| Casali's Green | Mountain Green |
| Celadon Green | Munich Green |
| Chartreuse | Myrtle Green |
| Chlorophyll | Nitrate Green |
| Chrome Green | Pansy Green |
| Cinnabar | Paris Green |
| Cobalt Green | Plessy's Green |
| Copper Green | Prussian Green |
| Dingler's Green | Scheele's Green |
| Emerald Green | Schnitzer's Green |
| Evergreen | Schweinfurt Green |
| Hungarian Green | Verdigris |
| Jade Green | Vienna Green |
| Kelly Green | Woodland Green |

### Verdigris

Verdigris (from the French meaning "green of Greece") is a blue-green pigment made by scraping the patina from copper that has been exposed to vinegar or wine. It is the most well known of the early artificially prepared green copper pigments. Its production originated in wine-growing areas, and it was made by alternately stacking copper sheets and grape husks. A crust would form on the surface of the copper sheets and, when scraped off, the scrapings were pulverized to produce a light blue powder sold as verdigris. Verdigris is not seen nowadays as an artists' pigment, but *Vert antique* is a decorative finish used for bronzing plaster casts and other surfaces to simulate the natural green patina of old bronze or copper.

### Vegetable greens

Green pigments were extracted from flower petals in the seventeenth century and lake colors with names such as Pansy Green, Lily Green, Iris and Honeysuckle were created. Sap Green, a name still in use to describe a bright leafy color, was made from ripe buckthorn *(Rhamnus)* berries and is mentioned frequently from the twelfth century. In the eighteenth century, Sap Green became popular for use in watercolor. It was also termed Bladder Green, because it was often stored in bladders.

### Sap Green

Today, the vegetable ingredient of Sap Green is replaced by modern arylide, phthalocyanine or naphthol pigments.

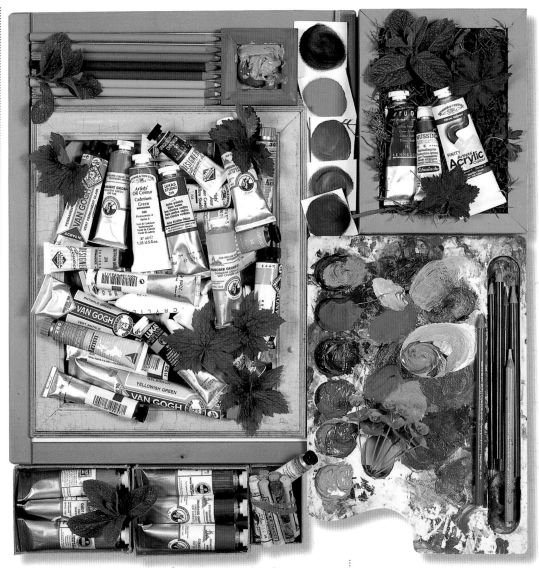

### Chromium Green

This is a dull grayish green derived from chromates or chromium, which was discovered by Nicolas Vauquelin, in 1797, in a mineral known as Siberian red lead, later known as chrocoite. Many colored compounds, including Chrome Red and Chrome Yellow, were derived from chromium (see Chrome Yellow, page 64). Of chromium oxide greens, Vauquelin wrote:

*"On account of the beautiful emerald color it communicates...will furnish painters...with the means of enriching their pictures, and of improving their art."*

### Chromium oxide green

Green pigments that owe their color to chromium have been used widely since the nineteenth century. Chromium oxide green was listed by Winsor & Newton in the 1840s, and the pigment is widely available today. Identified as PG17, the chromium oxide greens are well known for their opacity, or "hiding power," and their great tinting strength. In mixtures with white, yellow or blue, brilliance can be substantially increased.

### Cinnabar

Cinnabar is a shade of green or yellow, widely available in makers' catalogs. It is made of a combination of modern green and yellow pigments. In the nineteenth century, a variety of chrome green, also called Zinnober Green, or Royal Green, was made by mixing Prussian Blue and Chrome Yellow.

## Emerald Green

Emerald Green generally has a bright, bluish-green color and was one of the most brilliant of the inorganic colors. Popular among the French Impressionist and Post-Impressionist painters, it has been identified in many of their works. Original Emerald Green contains both copper and arsenic, and it is also known as Paris, Munich or Vienna Green, and Schweinfurt Green. The improved pigment was brighter, more durable and had a more intense color than other copper greens. Winsor & Newton introduced Emerald Green in their watercolors and oil colors in their first catalog in 1832. Paul Gauguin, writing in February, 1897, to George Daniel de Monfreid, requested 20 tubes of Emerald Green along with other colors.

The color was used in the decorative arts for coloring wallpapers, cloth lampshades and linoleum, for decorating domestic furniture and fabrics, and as a component of paint for toys. It was also used as an exterior and interior house paint. One of Emerald Green's main applications was as an insecticide and fungicide, and it was still being marketed in the 1950s, despite its toxicity, because of its bright tone and lightfastness.

Winsor & Newton discontinued the original copper-arsenic Emerald Green in the1960s, replacing it with Winsor Emerald, a mixture of azo yellow and phthalocyanine green. Most manufacturers have followed this initiative.

## Hooker's Green

William Hooker painted pottery and may be the source of this name. Hooker's Green is a mid-green with a blackish undertone. Originally a mixture of Gamboge and Prussian Blue and considered an unreliable pigment, it is now based on more modern pigments, such as Phthalo Green and Cadmium Yellow.

## Olive Green

This is a dull brownish yellow-green, often derived from Raw Sienna, offered by several manufacturers. A similar color may be mixed by the artist by toning down a bright leaf green with a little orange.

## Modern greens

A vast number of green hues are available in manufacturers' catalogs, and one of the main ingredients used is Phthalo Green, although some original pigment names are still incorporated as a description on the tube. This modern organic pigment, introduced in 1938, was a product of artificial dyestuffs. The pigment is from brominated or chlorinated copper phthalocyanine. Its color is similar to the bright, traditional Emerald Greens, which contained copper and arsenic.

### Phthalo-based greens

Phthalo Green (PG7 and PG36) has excellent lightfast qualities and high permanence in all media and is produced by most manufacturers under the name Phthalo Green and several trade name variations.

Other very widely used greens, all of which rely on Phthalo but have a modern yellow pigment added, are the bright mid-greens named Permanent, Cadmium, Emerald, Yellowish, Chrome, Cinnabar, and the blackish blue-green, Hooker's.

Sap Green, a bright leafy color produced since the Middle Ages, originally from unripe buckthorn berries, is now synthesized from Phthalo or Naphthol Green.

Even the popular Viridian Green is today often made from Phthalo. Olive Green, originally made from fugitive lakes, uses Phthalo Green pigment as a base, mixed with a variety of red, yellow, orange, blue or violet.

### Exceptions

Exceptions to the extensive Phthalo usage is the grayish green Chromium Oxide, consistently made from its oxide of chromium pigment, compared to Chrome Green made from Prussian Blue and Chrome Yellow. Cobalt Green, a bluish version of Emerald, is made from a cobalt oxide and Green Earth (Terre Verte or Green Umber), a blue-gray green, which usually consists of the natural inorganic pigment (see Green Earth, page 67).

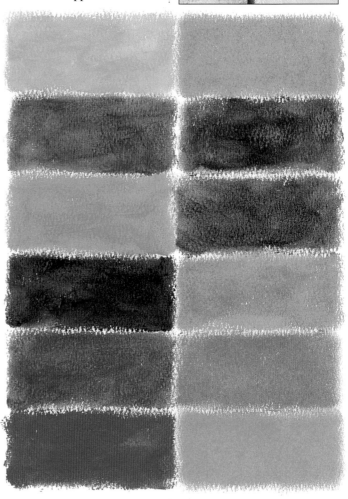

**Prepared greens**
You will see various names in color charts. Some of them are single pigments and others are combinations of pigments. The list (right) gives an average guide to formulations, which will vary from manufacturer to manufacturer.

*(From top to bottom, left to right)*

| | |
|---|---|
| Cadmium Green | (PG18 or PG7 + PY35/PY37) |
| Chromium Oxide Green | (PG17) |
| Cinnabar | (PG7 or PG36 or PG18 + PY1/3/35/42) |
| Cobalt Green | (PG19 sometimes PG26 or PG50) |
| Emerald Green | (PG7 or PG36 + PY1/3/97/154) |
| Hooker's Green | (PG7 or PG36 + PY3 or PY42) |
| Olive Green | (PG7 + PY42/PR101/PBr7) |
| Permanent Green | (PG7 +PY1/3/35/128) |
| Phthalo Green | (PG7 or PG36) |
| Sap Green | (PG7 or PG8 or PG36 + PY1/42/73/83) |
| Viridian Green | (PG18 or PG7) |
| Yellowish Green | (PG7 or PG36 + PY3/74/154) |

### Viridian

A transparent variety of chromium oxide, now known as Viridian, was created in Paris in 1838. Viridian is a stable, very dark, deep pure green. As a glaze or wash this pigment appears as a vivid emerald color with a slight blue undertone. When applied thickly it takes on a duller blackish-green appearance. The pigment is popular with artists because of its excellent tinting strength and stability in all mediums. It is invaluable not only for use as a green, but also for cooling reds, pinks and browns. Portrait and life painters find Viridian a useful color in flesh tints. When mixed with Mars or Cadmium Yellow, this color produces a rich scale of brilliant greens.

### Experiment with green

The little canvas example below shows how the range of ready-made greens is increased by simply adding white to create a tint.

*(From top to bottom, left to right)*

| |
|---|
| Cobalt Green Deep (Winsor & Newton) |
| Phthalo Green Yellow Shade (Golden) |
| Viridian (Lukas) |
| Emerald Green (Winsor & Newton) |
| Hooker's Green Hue (Liquitex) |
| Bohemian Green Earth (Lukas) |
| Permanent Green Light (Tri-Art) |
| Chrome Oxide Green (Golden) |
| Sap Green (Lukas) |
| Olive Green (Rowney) |
| Permanent Green (Winsor & Newton) |

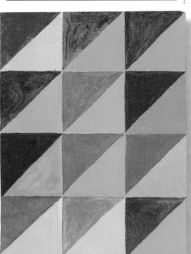

*"Why do two colors, put one next to the other, sing? Can one really explain this? No. Just as one can never learn how to paint."*
Pablo Picasso (1881–1973)

### Green sketch

Ready-made acrylics were used to create this green sketch – light leaf green for the hills, pale olive for the mid-ground, opaque oxide of chrome for the foreground, and finally a light green again. The details are Viridian.

### Complementary opposites

Green is a secondary color, and the opposite to red. This complementary color combination has contributed to the vibrant energy in the design of many paintings.

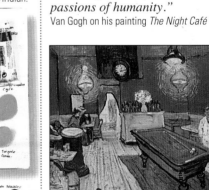

*"I tried to express through red and green the terrible passions of humanity."*
Van Gogh on his painting *The Night Café*

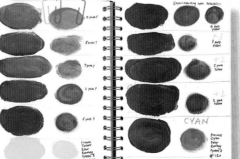

Vincent van Gogh (1853–90)
**The Night Café, 1888**
Oil on canvas (detail)
27½ x 35in (70 x 89cm)
Yale University Art Gallery

### Mixing greens

Many ready-made greens are very clean and bright and are difficult to replicate. However, at its simplest, green is a combination of blue and yellow, and many manufacturers recommend the best blues and yellows to buy for the purest mixtures. Experimentation with different types and proportions of blue and yellow can lead to interesting results.

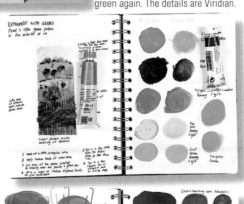

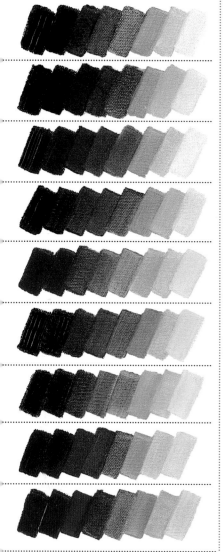

Raw and Burnt Sienna, Raw and Burnt Umber, the red-brown oxide colors, such as Venetian and Indian Red, and Yellow Ochre, Red Ochre and Terre Verte (Green Earth), are all earth colors. They are some of the oldest pigments known to man. Burnt Sienna is produced by roasting the raw pigment, named after the Italian city near which it was first found, and Burnt Umber is made in a similar way. Earth pigments come from clay and other substances in the ground. Cennino Cennini described the wonder of seeing these colors of the earth:

*"And upon reaching a little valley, a very wild steep place, scraping the steep with a spade, I beheld seams of many kinds of color: ochre, dark and light sinoper, blue, and white; and this I held the greatest wonder in the world – that white could exist in a seam of earth…. And these colors showed up in this earth just the way a wrinkle shows in the face of a man or woman."*

## Earth pigments

These very ancient rich mineral sources produce yellow, red, brown and green pigments, depending on the natural iron-oxide coloring agent in the deposits. They were used in prehistoric cave paintings and are probably the most permanent colors available, because they are little affected by atmospheric conditions. The minerals are dug from the earth, washed and then ground to produce the pigments.

**Ancient earth pigments**
It is thought that oxides of iron were dug right out of the ground in the form of lumps that were rich in clay, and that the blacks were derived from manganese ores, charcoal and ashes. The raw pigments were ground with various ingredients, such as blood, urine, animal fat, saliva and bone marrow, to make a paintlike paste.

## Red Ochre and iron oxides

These natural pigments range in color from dull yellow (see page 66) to red and brown. Ochres and oxides in art have a long history.

Red Ochre is a warm red-brown earth color and is based on deposits of hematite (see opposite). Traditionally, Spain and the Persian Gulf were excellent sources of this iron oxide and the large variety of names used for the color relate to its original source locations. Red Ochre can also be produced from calcined (roasted) Yellow Ochre. The color was used in medieval times for fresco and oil-painting grounds, because of its quick drying time and low oil-absorption qualities.

**Some other reddish ochre hues are:**

| | |
|---|---|
| English Red | Pozzuoli Red |
| Indian Red | Red Oxide |
| Light Red | Sinopia |
| Mars Orange | Spanish Red |
| Mars Red | Terra Rosa |
| Persian Red | Turkey Red |
| Pompeiian Red | Venetian Red |

## Brown Ochre

Brown Ochre is another reddish brown, but the name is not used as much as the other ochres. The natural iron-oxide pigment is PBr7, and it is widely used today in the manufacture of siennas and umbers. In seventeenth-century England, this color was sometimes described as Spanish Brown. It was prepared by heating Red Ochre, the name relating to its similarity to the natural Red Ochre from Spain. However, there are references to Spanish Brown as a synonym for Vandyke Brown. Mars Brown (PBr6) is the modern synthetic version.

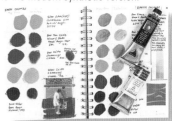

**Spanish Brown**
In the frequent mentions of Brown Ochre under this name is the charge that it was coarse and gritty. The best ochres traditionally come from France and range from light yellow to deep red.

## Iron ores and reddish browns

Iron oxide is a principal coloring agent derived from four main types of iron ore: hematite, limonite, magnetite and siderite.

### Hematite

Most iron oxides come from hematite and limonite ores. Hematite is a name derived from the Greek *hema* (meaning "blood"). Hematite means "bloodlike" and refers to natural red earth. A hard, compact and pure natural variety of anhydrous ferric oxide is used in the production of dark red pigments.

### Sinopia

This is the old Latin name for natural red earth pigment. More particularly, it is an obsolete name for the red iron-oxide pigment derived from Sinope, the Turkish town on the Black Sea where it is mined. This was an important classical source of red oxide (see also Renaissance skin tones, page 112). In the fifteenth century Cennini recorded "a natural color known as sinoper," which when mixed with lime white was "very perfect for doing flesh, or making flesh colors of figures on a wall." The color was often used for the underdrawing on plaster in mural painting and the drawing itself was called the "sinopia."

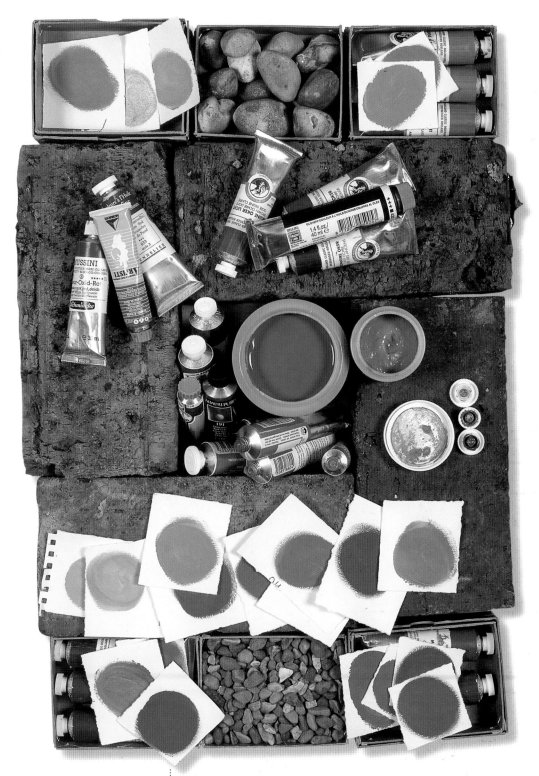

Browns are generally considered to be drab colors, but this is clearly untrue when viewing the variety of brownish hues and earth pigments available. Their documented usage from prehistoric times to the present day indicates the reliability and popularity of these easily obtainable and permanent colors.

*"I cannot pretend to feel impartial about colors. I rejoice with the brilliant ones, and am genuinely sorry for the poor browns."*

WINSTON S. CHURCHILL
THOUGHTS AND ADVENTURES (1932)

**Sir Anthony van Dyck (1599–1641)**

## Synthetic oxides

Natural iron-oxide pigments are still in use today and are considered among the most permanent colors available. Most are not affected by atmospheric conditions and most of the pigments are nonhazardous. Iron-oxide paints resist corrosion and the distinctive red-brown hue is commonly seen as a base coat protection on raw steel. From the eighteenth century, a synthetic product, Mars Red (PR101), has been used as a substitute for the natural red earth pigments, because it has similar properties of durability and permanence. Most red oxides today are made from the synthetic pigment.

☛**See also**
*Color index 172–175*
Yellow Ochres–Raw Siennas 172
Brown Ochres–Red Oxides 173
English Reds–Burnt Siennas 174
Brown Madder–Neutral 175

## Vandyke Brown

This brown ranges from pale to black in color. Its original composition was of humus or vegetable earth ingredients in the form of peat or lignite, plus iron. The color was popular with Flemish painters such as Rubens, Rembrandt and van Dyck, after whom it is named. It is also known as Kassel Earth, from the place in Germany where the natural ingredients were found. In its original formulation, the pigment is not permanent and it fades. Owing to its transparency, artists found it useful for shading and wood staining. Vandyke Brown is often substituted by Umber. The natural pigment bituminous earth (NBr8) is still available and used. However, most modern ingredients for this color consist of synthetic red oxide (PR101) or natural iron oxide (PBr7) plus black. Other names are Cassel Earth, Cologne Earth, and sometimes Ruben's Brown, although this name is seen in association with Brown Madder, too.

## Mars colors

Mars colors are artificial iron oxides. Used as substitutes for natural earth pigments, they are often more brilliant and opaque with higher tinting strengths. Like the natural oxides, they are highly permanent. Mars Brown is a mid-chocolate shade, generally made from pigments PR101 and black. Mars Violet contains synthetic red oxide (PR101) and is a chocolate purple-brown, also known as Caput Mortuum and Violet Oxide (see page 55). Mars Black is a dense neutral black (see pages 77–78).

The descriptive "Mars" may have originated from the name given by alchemists for iron or to the yellow ochre-colored pigment formed through oxidization of iron in air, *crocus martis*, of which the literal translation is simply Mars Yellow.

Other frequently seen colors bearing the prefix are: Mars Yellow, similar to Yellow Ochre; Mars Orange, a cross between Red and Yellow Ochre; and Mars Red, similar to the red ochres, which can range from scarlet to maroon.

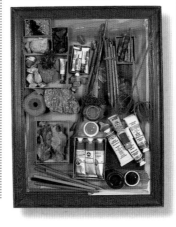

## Sepia

This organic pigment originates from the ink-sacs of cuttlefish (*Sepia officinalis*), found in the Adriatic Sea. It is reputed to have been used by the Romans as an ink, but its popularity was marked after 1780 by its introduction by Prof. Jacob C. Seydelmann in Dresden. It was used mainly as a watercolor or ink. Today's colors named Sepia are synthesized, using black, brown or red-oxide pigments.

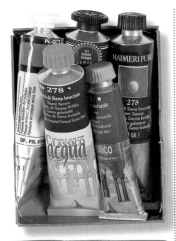

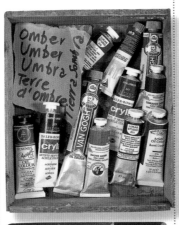

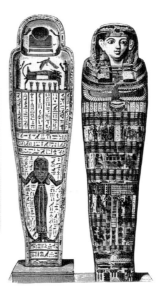

### Brown Madder
A brownish-orange color, originally derived from madder (see page 58), this was also known as Ruben's Madder. Now based on Alizarin Crimson (PR83), it is a transparent permanent lake, and current formulations may contain red, brown, yellow and green pigments.

### Mummy Brown
A brown pigment made from asphaltum used for embalming, this was originally obtained from Egyptian tombs. Its recorded usage as an art color was from the 1800s until the 1920s.

### Asphaltum
Also called Bitumen (see page 83), this ancient blackish-brown color, composed of modified organic matter, is not a true pigment. It is made from asphalt, a natural resin often sourced from Trinidad or the Dead Sea, which is dissolved in oil or turpentine. It was popular with van Dyck, and, because of its instability, it was used thinly. It dries badly, cracks and wrinkles. Since the nineteenth century, it has been replaced with synthetic coaltar dyestuffs, and today's asphaltum uses combinations of modern yellow, red, green, violet and black. However, a natural black exists, NBk6 (trade name Gilsonite), and is still available as an oil paint.

### Raw Sienna
An orange-brown color, produced from a natural yellow-brown earth oxide. The natural clays contain iron and manganese, the finest variety of earth, and were originally mined near Siena in Tuscany, Italy. The deposits are now depleted and the source of the pigment has been superseded by other regions in Italy, particularly Sardinia and Sicily. Raw Sienna is one of the most permanent pigments. Current manufacturers of the color often use synthetic yellow (PY42) or red oxides (PR101). Some producers still employ natural oxides, also known as Italian Earth and Terra di Siena.

### Burnt Sienna
A warm red-brown, produced by calcining (roasting) Raw Sienna, this is an extremely permanent pigment, clean and transparent. Because of its lack of chalkiness, it is perfect for mixtures of dark colors. Like Raw Sienna, modern production uses either synthetic red oxide (PR101) or the natural iron oxide (PBr7).

### Raw Umber
A greenish-brown earth color, Raw Umber is obtained from oxides containing iron and manganese. The name is thought to originate from the Latin *umbra* (meaning "shadow"), because the pigment was often used for shadows and shading other colors. It is a highly permanent, transparent and lightfast pigment. Records indicate its use since the 1600s. Most modern umbers consist of natural oxide (PBr7), but some use a mixture of synthetic oxides (PY42 and PR101). It is also known as Cyprus Umber, Turkey Brown and Sicilian Brown.

### Burnt Umber
Produced by calcining Raw Umber, this is a darker reddish brown with similar properties to Raw Umber, but more transparent. Current pigments mainly use natural iron oxide (PBr7), although combinations of synthetic oxides (PY42 and PR101) and black are also manufactured. Old names for Burnt Umber include Chestnut Brown, Euchrome and Jacaranta Brown.

### Bistre
This is a yellowish-brown pigment made from boiling the soot produced through burning beechwood. It was used from the fourteenth to the nineteenth centuries in watercolor or in tonal wash drawings. It is now replaced with Burnt or Raw Umber.

### Pozzuoli Earth
A native red earth pigment from Pozzuoli near Naples, this is the traditional brown-red used in the frescoes of the Italian Renaissance. The color produces a clean, bright reddish hue, and it is renowned for its unique property of setting as hard as cement. Some makers still offer a synthetic red oxide pigment that bears the name Pozzuoli Earth or Pozzuoli Red, and there are many similar hues available, too, such as Terra Rosa and Venetian Red.

*"White may be said to represent light, Without which no color can be seen; yellow the earth; green, water; blue, air; red, fire; and black, – black is for total darkness."*

LEONARDO DA VINCI (1452–1519)

It is often said that black is unnecessary in an artist's palette, because it rarely appears at its purest in nature – perhaps black velvet seen on a dull day is the nearest there is. So, is black a color that could easily be disposed of and omitted from the artist's palette? It is common knowledge that you can readily mix successful deep, solid blacks from the primary colors, and from many of the secondaries, too. You can also use these mixtures to darken other colors and tint whites as required.

Technically speaking, neither black nor white has any color. However, for the purposes of this book, we will describe black and white as colors.

### Defining black

"Of the color of jet or carbon, having no hue due to the absorption of nearly all the incident light. Without light, completely dark."

COLLINS ENGLISH DICTIONARY

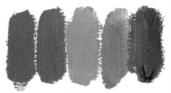
**Black as a tinting color**
Creates a multitude of gray tints.

**Making black**
It is easy to mix black in all media, particularly from the primaries.

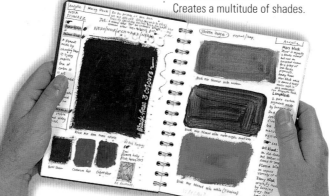

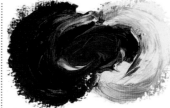
**Dominator**
Black can easily overpower and deaden colors.

### Respect black

Black in its own right, however, is a useful and convenient color, ideal for fluid, spontaneous brush drawing and for attaining a tremendous range of gray tints

when mixed with white. It is a color worth getting to know and has a rightful place in every studio, but its strength and power should never be underestimated. Respect black and handle it with caution.

**Black as a darkener**
Creates a multitude of shades.

### Naming blacks

You will come across many descriptive names for types of black in books on art and in manufacturers' catalogs and color charts. Several of the names are old-fashioned and may refer to obsolete brands or original, naturally occurring pigment sources that are now manufactured synthetically. Other names are manufacturers' descriptive brand names, often giving different names to what is essentially the same product. Some of the names you may see are:

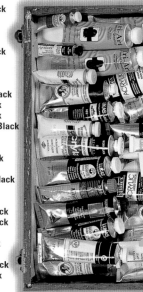

**Animal Black**
**Black Lake**
**Blue Black**
**Bone Black**
**Carbon Black**
**Coke Black**
**Deep Black**
**Drop Black**
**Elephant Black**
**Flame Black**
**Grape Black**
**Iron-Oxide Black**
**Ivory Black**
**Jet Black**
**Kernel Black**
**Lamp Black**
**Magnetic Black**
**Marc Black**
**Mars Black**
**Mineral Black**
**Mummy Black**
**Oil Black**
**Oxide Black**
**Paris Black**
**Process Black**
**Velvet Black**
**Vine Black**

### Black pigment disclosure

These are the references for black pigments, the coloring ingredient of black paint. You will see these in small print on tubes and packaging. Note that the product name, more often than not, is different from the name of the pigment that constitutes the product.

Aniline Black, **PBk1** (50440)
Bone Black, **PBk9** (77267)
Carbon Black, **PBk6/PBk7** (77266)
Synthetic Iron Oxide, **PBk11** (77499)

*Note: some listings show Carbon Black as either PBk6 or PBk7

Taken at face value, black is black, and all blacks look the same. Once you are familiar with the different blacks, however, their subtle and individual characters become evident.

A variety of blacks is available across the media ranges in oil, watercolor, gouache, acrylic, pastel, etc. When you look in manufacturers' catalogs and at their color charts you will

see many of the descriptive names seen opposite, particularly in less-expensive student and craft color ranges.

Among the quality blacks are Ivory, Lamp, Vine and Mars Black, and Payne's Gray, or very close relatives to them. These five are generally the most popular. They are supplied by most of the major art materials' manufacturers and are widely available in most painting media.

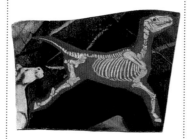

### Ivory Black
This is Bone Black sold under the name Ivory Black. As its name suggests, Ivory Black was originally obtained by roasting elephant tusks, a process that produced a pure and intense pigment. Happily, this practice no longer exists, but that is why Ivory Black is also sometimes known as Elephant Black. At its simplest, Ivory Black is a pigment derived from charred bones. Its predecessors were known as Bone Black and Animal Black and were often impure and unreliable in paint. A finer grade of Bone Black was later developed and manufactured under the name of Ivory Black. It is an intense black pigment, being permanent and stable. Ivory Black has a brown undertone compared to the bluish Lamp Black. In tints with white it tends to produce warmish grays.

### Mars Black
Mars is originally a trade name that has been adopted to prefix earth-color pigments derived from the mineral iron oxide; Mars was the alchemical name for iron. Among these colors is Mars Black, which is dense and heavy, a pigment that behaves well in oils; however, it is often recommended as being most desirable for use in watercolor and other water-based media.

### Vine Black
Originally made by roasting vine stalks and other vegetable matter at high temperatures (calcining), Vine Black was considered a lower-quality pigment to Lamp Black due to its inferior intensity. It was also found to be unreliable for fresco painting, where the vegetable content of the pigment would react badly with the minerals of the plaster. Vine Blacks have a bluish undertone and, when mixed with whites, produce cool-gray tints. Vine Blacks offered today are composites of black and blue pigments. Grape Black and Kernel Black are among the old-fashioned names for this type of black pigment.

### Payne's Gray
Among the blacks in artists' color charts, you will nearly always see this color listed. Payne's Gray is not a pure black but a composite pigment containing more than one basic ingredient, commonly Ultramarine Blue (sodium polysulfide aluminosilicate) and Mars Black (synthetic iron oxide), and sometimes crimson pigments are included, too. It is considered useful by watercolorists, because it thins well and is good for glazes. In the opaque media – oil and acrylic – it mixes well with white to produce a range of cool, blue-shade grays. Many purists find such a composite unnecessary. However, it is popular in most media and is available in nearly all of the manufacturers' catalogs. Payne's Gray is named after William Payne (1760–1830), a British watercolorist, active in Devon and the Lake District in England.

### How to make lamp black

"...there is a perfect black which is made in this manner: take a lamp full of linseed oil...and light the lamp. Then put it, so lighted, under a clean baking dish...and the smoke which comes out of the flame will strike the bottom of the dish and condense. Sweep this color that is the soot into some dish for it is a very fine color, and make as much of it in this way as you need."

"Grind this black for half an hour or an hour, or as much as you please; but know that if you were to grind it for a year it would be blacker and better..."

CENNINO CENNINI
THE CRAFTSMAN'S HANDBOOK
(FIFTEENTH CENTURY)

### Lamp Black
This carbon pigment is made from burning oils and collecting the residual soot. Lamp Black is one of the oldest manufactured pigments. It is not a pure black, because it has a slightly bluish color that is more evident when seen in tints. Lamp Black produces good neutral grays, veering slightly to the cool, blue side. Oil Black and Flame Black are old-fashioned names for earlier and often impure varieties of Lamp Black.

There are subtle differences between the various blacks when spread thinly as undertone. You can begin to discern greater differences when the colors are diluted with medium. The differences become even more apparent when mixed with white in tints. The blacks begin to behave differently again when mixed with other colors to produce tints and shades.

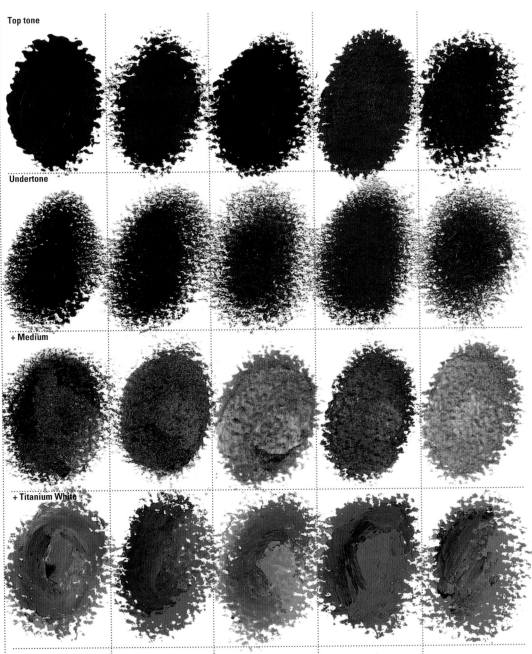

**Top tone**

**Undertone**

**+ Medium**

**+ Titanium White**

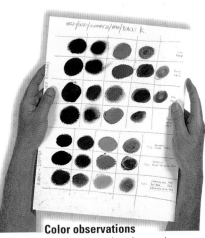

### Color observations

Tests were made using random blacks taken from the paint-storage box. The medium used for these illustrations was oil paint. You will find that the properties of the various blacks will vary from maker to maker and behave differently, depending on whether the vehicle is oil, water or acrylic.

☛**See also**

**Ivory Black**
A dense black, slightly brown in undertone, produces warm glazes and tints. Widely available in oil paint, composed of PBk9. *(Sample: Winsor & Newton, Artists' Oil, PBk9).*

**Vine Black**
Traditionaly considered inferior in intensity to Lamp Blacks. Vine Blacks have a bluish undertone and, when mixed with whites, produce cool, bluish gray tints. Vine Black is often a composite of Ivory Black PBk9, Carbon Black PBk7 and Ultramarine PB29 and is commonly available in oil paint. *(Sample: Lukas, Series 1, Artists' Oil, PBk9).*

**Lamp Black**
A very dense opaque black that produces neutral grays in tint. *(Sample: Daler-Rowney, Artists' Oil, PBk7).*

**Mars Black**
Dense, neutral, veering towards cool gray in tints. Widely available in acrylic and composed of PBk11. *(Sample: Old Holland, Classic Artists' Oil, PBk9).*

**Payne's Gray**
A composite color commonly made of Lamp Black PBk6, Ultramarine PB29 and powdered slate PBk19. A cool-shade black, producing cool, blue-grays. Ingredients of Payne's Gray vary from manufacturer to manufacturer. (See also Blue Black in some ranges.) *(Sample: Schmincke, Mussini, Resin Oil, PBk7, PB29, PR101).*

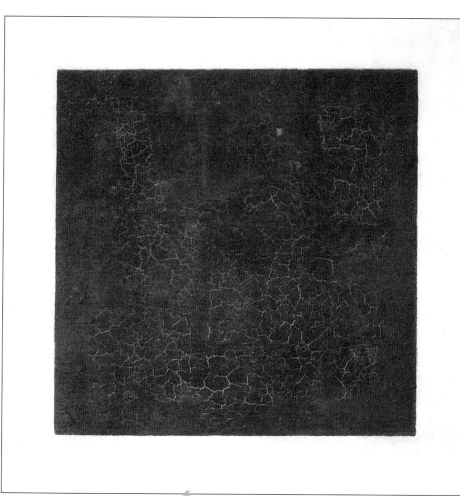

### Pure black

The most famous black in the history of modern art is *Black Suprematist Square* (1914–15) by the Russian artist Kasimir Malevich (1878–1935). This is among the first absolutely abstract paintings, and it seems to refer to nothing but itself. Histories of twentieth-century art attach much importance to this work. *Black Suprematist Square* is a painting that works on the imagination of the viewer, prompting reflection, and is wide open to interpretation. It is a simple black square painted on a white ground. The irony is that over the years this all-black canvas has become cracked and crazed and this seemingly blank image continues to change before our eyes.

Kasimir Malevich (1878–1935)
**Black Suprematist Square, 1914–15**
Oil on canvas 31 x 31 in (79 x 79cm)
*Tretyakov, Moscow*

### Chiaroscuro

There are many examples of paintings dominated by the blacks, and in these paintings the colorless aspects contribute to the visual theme.

This style of painting is known as chiaroscuro – the contrast of dark against light. Rembrandt (1606–69) and Caravaggio (1573–1610) were masters of chiaroscuro, and they used it in their paintings effectively to heighten the tension and drama of both the subject and composition.

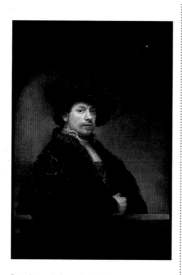

Rembrandt (1606–69)
**Self-portrait aged 34**
Oil on canvas 40 x 31½ in (102 x 80cm)
*National Gallery, London*

### Absence of light and color

American artist Ad Reinhardt (1913–67) produced a series of black paintings during the 1950s and 1960s. At first sight his canvases look completely black, demonstrating a total absence of light and color.

On closer inspection, however, you can see a geometric composition of the most minimal variations of blackness, which are almost invisible to the spectator and certainly unreproducible here in a printed form. Reinhardt's black paintings can be seen in many collections around the world.

After Ad Reinhardt
**Abstract Painting No. 5, 1962**
Oil on canvas
60 x 60in (152.4 x 152.4cm)
*Tate Modern, London*

## Comparing makes

Within the same price and quality range, colors of the same name can vary in hue, pigment composition and behavior from maker to maker. For example, some pigments may be more finely ground and may be less likely to granulate than others, some may be more intense and have stronger staining power, while others may be more transparent. There are general guidelines and standards relating to the behavior of and expectation from the various kinds of blacks. The watercolor chart (right) shows that similarly named colors vary depending on the manufacturer. We have included Payne's Gray, Blue Black and Neutral Tint among the blacks here.

*(From left to right, top to bottom)*

**Payne's Gray**
Schmincke, PB29/PBk7

**Payne's Gray Bluish**
Schmincke, PB6/PB15/PBk6

**Payne's Gray**
Winsor & Newton, PB6/PB15/PBk6

**Payne's Gray**
Lukas, PB15/PBk7/PR17

**Payne's Gray**
Daler-Rowney, PB29/PBk7

**Blue Black**
Winsor & Newton, PBk6

**Blue Black**
Schmincke, PBk6

**Ivory Black**
Daler-Rowney, PBk9

**Ivory Black**
Lukas, PBk7

**Ivory Black Extra**
Old Holland, PBk7

**Ivory Black**
Schmincke, PBk9

**Mars Black**
Old Holland, PBk11

**Ivory Black**
Maimeri, PBk9

**Ivory Black**
Winsor & Newton, PBk9

**Lamp Black**
Winsor & Newton, PBk6/7

**Lamp Black**
Daler-Rowney, PBk7

**Carbon Black**
Maimeri, PBk7

**Scheveningen Intense Black**
Old Holland, PBk7/PBk11

**Vine Black**
Old Holland, PBk8

**Neutral Tint**
Lukas, PY83/PR122/PB15:1/PG7

**Neutral Tint**
Maimeri, PB29/PBk7

**Neutral Tint**
Winsor & Newton, PBk6/PB15/PV19

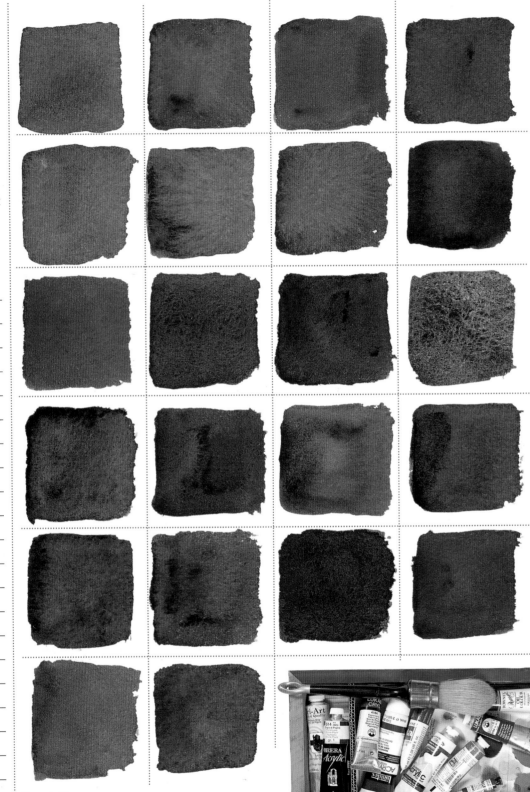

## Payne's Gray
Nearly always listed with the blacks, it is a composite pigment available in most media. The color varies from maker to maker.

Experiment with the tremendous range of tints and shades to be obtained by mixing blacks with whites and other colors.

### Tinting

Variation in the gray tints you achieve will be dictated by the choice of the type of black and white, and, of course, the medium (watercolor, acrylic, gouache, oil). You will notice how some blacks make warm brownish grays and others cool bluish grays, and how some are neutral.

### Gray scale

A simple gray scale (above right) may be made using Ivory Black and opaque white gouache colors. A gray scale is a traditional basic teaching device. Its aim is threefold: to familiarize the student with handling materials, color mixing and tonal values.

### Shading

Experiment by mixing blacks with other colors, but be careful! Black used as a darkening ingredient in color mixtures can easily overpower and readily obliterate other colors.

### Tone scale

A tone scale (right) also helps to familiarize students with color mixing and handling. Here Lemon Yellow and Carbon Black acrylic paints have been used.

### Coal tar

No article on the color black would be well balanced without mentioning the importance of coal tar. Coal tar is a heavy, sticky, black liquid, a byproduct of many industrial processes, particularly the manufacture of gas. It was considered to be fairly useless until a major discovery in the middle of the nineteenth century.

In 1856 industrial chemist William Perkin (1838–1907) announced the discovery of "mauve," the first artificial color to be derived from coal tar. This color took the world by storm and became the height of Victorian fashion. Fifty years later there were 2,000 artificial colors, known as aniline pigments, all stemming from Perkin's original experiments with coal tar.

*"Coal-Tar Wizard Transmuted Dross To Gold"* HEADLINE, *NEW YORK HERALD*, AUTUMN 1906

The headline above, published on Perkin's arrival in New York to receive a professional medal of honor, testifies to the significance of his discovery and the lasting impact it made on the production of synthetic organic pigments.

**Synthetic organic pigments were originally derived from coal tar.**

Black is regarded by artists as a fairly straightforward color to mix, so this leads to the question, "Do I really need to spend good money on black paint?"

When used in combination with other colors on your palette, the answer is probably no, and many artists make do without it. One criticism leveled at the ready-made pure blacks is that they tend to dominate the palette and deaden other colors when used in mixtures.

**Process Magenta**

**Cyan Blue**

**Cadmium Red Medium**

**Ultramarine Blue**

**Cadmium Red**

**Phthalocyanine Blue**

**Alizarin Crimson**

**Viridian**

### Black-mix combinations
You can make successful darks and replacement colors for black by mixing combinations of any of the above colors. The darker hues, such as Alizarin Crimson and Viridian, give the blackest results. When spread thinly as undertone, as seen in the righthand column of the chart, the character of the mixing colors is revealed. If you add a dark earth color, such as Burnt Sienna or Burnt Umber, the mixes can become even darker.

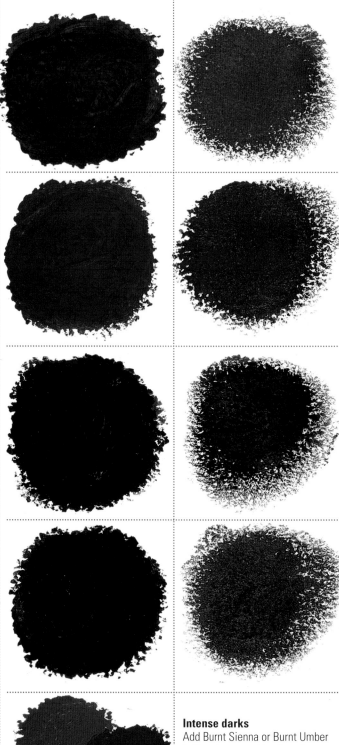

### Intense darks
Add Burnt Sienna or Burnt Umber to the above combinations for even more intense dark mixtures.

### London colors
Much London painting of the post–World War II years was tonal and subtle in color, maybe even somber. Many paintings from this period (1945–60) convey the austerity of the times and an atmosphere of discoloration caused by the widespread burning of coal.

British artist Lucian Freud (b. 1922), famous for his nude figure paintings, called his colors "London colors." To his whites and light colors he added a ground charcoal to create the slightly grubby colors of urban London. Ground charcoal, of course, is a pigment in its own right, identified as PBk8, and is used as an ingredient in paint.

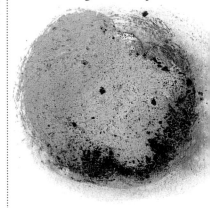

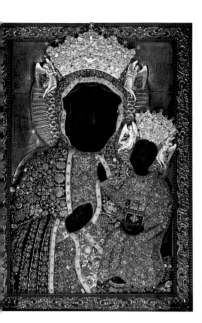

**Our Lady of Czestochowa**
Painted wood panel
48 x 32⅓in (122.2 x 82.2cm)
*Monastery of Jasna Góra,
Czestochowa, Poland*

There is much debate about the
origins of this picture. Legend
attributes it to the hand of St. Luke
the Evangelist, who painted it, from
life, on a tabletop used by the Virgin.
Evidence suggests that it may date
from the fifth or sixth century, with
extensive repainting in the fifteenth.

**Dark hues**
Many makers provide colors
similar to those shown below.
They are mostly combination
pigments made of blacks, blues,
browns, greens and violets. The
samples here are applied thickly as
top tone, and the inset color shows
how the color behaves when a little
Titanium White is added.

**Nearly black**
Along with Payne's Gray,
manufacturers provide many
serious, dark colors that at
first glance could be mistaken
for black. Among these are
deep viridians and phthalos,
violets, grays, neutral tints
and burnt earth colors. When
applied thickly, these dark
colors appear nearly black.
Add the appropriate diluent
(thinner) or medium,
however, and the real
character of these deep, dark
colors becomes apparent.

**Unreliable blacks**
There are several examples of
black-skinned depictions of
the Virgin Mary, and experts
dispute why the Virgin
Mary's original Caucasian
features in these paintings
have blackened. Some
believe that the accumulation
of centuries of candle smoke
or the effects of fire damage
is the cause. Others think that
the picture's underpainting,
executed in a dark, blackish
brown bitumen pigment
known as asphaltum, has
migrated to the surface over
the years.

**Bitumen or Asphaltum**
This deep-shade brown, which is
almost black in top tone, produces
warm, earthy neutral tints when
mixed with white.
It is still available
in oil paint from
a number of
makers.

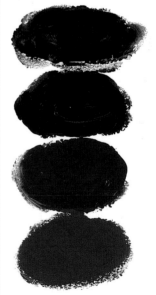

**Traditional darks**
Samples above taken from
Old Holland's Classic Oil Color range.

*(From left to right, top to bottom)*

| |
|---|
| Paris (Prussian) Blue Extra |
| Blue Deep |
| Olive Green Dark |
| Neutral Tint |
| Van Dijk Brown |
| Sepia Extra |

*(From top to bottom)*

| |
|---|
| Phthalo Turquoise |
| Dioxazine Violet |
| Virdian |
| Raw Umber |

*"Forcing yourself to use restricted means is the sort of restraint that liberates invention."*

PABLO PICASSO (1881–1973)

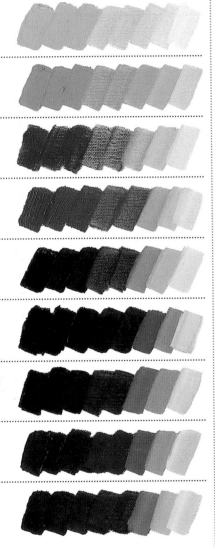

Grays may be produced by mixing black and white in varying proportions, or by mixing complementary colors. Adding red and yellow, or green and blue, produces warm, or cool, grays respectively. In oil painting gray was traditionally obtained by glazing with varnish mixed with a little paint. Grays are also obtained optically by placing small quantities of complementary colors side by side.

## Grays in history
There are many descriptions of the specific use of gray in the history of painting.

### Veneda
An old fresco, grayish-black color, Veneda was made from lime and a suitable black pigment. The term was also used to describe a mixture of white lead and black for tempera on gesso panels or parchment. Veneda was used in medieval illumination.

### Grisaille
This French word is used to describe the technique of painting in several shades of a single color, usually gray, to build up sculptured relief. The technique is specially suited to architectural subjects. The term also describes underpainting in one color, specifically gray, to produce a detailed monochromatic painting before coloring over with many layers of glaze. The technique was particularly favored by the Northern Renaissance artists of Flanders and Germany. Grisaille is also a gray pigment used in stained-glass work.

### Guazzo
This gray-in-gray tempera painting was employed by the Old Masters as preliminary exercises for oil painting. It is from the Italian *guazzo* that the French word "gouache" is derived.

Grays are easy to mix and, using reliable pigments, may be more lightfast than some premixed grays. A primary color mixed with a secondary will provide a wide range of grays and the classic "palette mud," the remnants of a day's work, provides a good neutral gray that is often reused.

### Charcoal Gray
In oils this is ground charcoal. Watercolor is strengthened with carbon black and natural iron oxide. Lightfast, but often gritty. (See London colors, page 82.)

### Cool and Warm Grays
Used to describe the particular hue bias. Cool Grays are typically of a green or blue hue, while Warm Grays are of a red or yellow hue.

### Graphite Gray
This blue-gray is dense and opaque. A soft, blackish form of crystalline carbon, it was first used in the eighteenth century to make lead pencils. It is named from the Greek *grapho* (meaning "to write").

### Payne's Gray
A blue-gray made from crimson, blue and black or ultramarine, ochre and black, the color is lightfast and inert, but somewhat coarse. It is thought to have been named for William Payne (1760–1830), a British watercolorist.

### Davy's Gray
Originally based on a special variety of powdered slate that tended to be gritty, this is a dull, yellowish gray. The color is now strengthened and is based on a variety of ingredients – greens, browns, blacks, yellows and whites – but its lightfastness is still not always reliable. Davy's Gray is excellent for toning down mixes. The name was first suggested by Mr. Henry Davy in the 1890s.

## Naming gray
Grays may bear a descriptive name that gives an indication of their distinguishable hue or bias. There are also several Neutral Grays that are described as achromatic, having no distinguishable hue. These Neutral Grays are often identified by a numbering system – for example, Neutral Gray 1, Neutral Gray 2 etc. – which indicates the shade.

| | |
|---|---|
| Bluish Gray | Mouse Gray |
| Brownish Gray | Neutral Gray |
| Charcoal Gray | Olive Gray |
| Cold Gray | Payne's Gray |
| Cool Gray | Pebble Gray |
| Davy's Gray | Purplish Blue Gray |
| Deep Gray | Reddish Brown Gray |
| Dove Gray | Shade Gray |
| Graphite Gray | Shell Gray |
| Greenish Gray | Warm Gray |
| Light Gray | Yellow-Green Gray |
| Medium Gray | |

## Prepared grays

Manufacturers offer several prepared grays. Many are simply composed of two pigments – black (PB) and white (PW), for example. Others are very complex blends of many pigments.

*(From top to bottom, left to right)*

Davy's Gray (Winsor & Newton)

Graphite Gray (Tri-Art)

Warm Gray (Talens)

Neutral Gray N3 (Golden)

Warm Gray Light (Old Holland)

Cold Gray (Old Holland)

Warm Gray (Lukas)

Middle Gray (Daler-Rowney)

Neutral Gray N5 (Golden)

Neutral Gray N2 (Golden)

Davy's Gray (Old Holland)

Neutral Gray N7 (Golden)

## Blended pigments

Makers offer many grays composed of many pigments. A warm gray could typically comprise white (PW4), green (PG36), yellow ochre (PY42), and brown (PBr33). A cooler gray, such as Payne's Gray, often contains three pigments.

**Warm Gray**          **Cool Gray**

*"One of the most difficult problems I have been involved with…is that of warm and cold grays."*
BRIDGET RILEY (b. 1931)

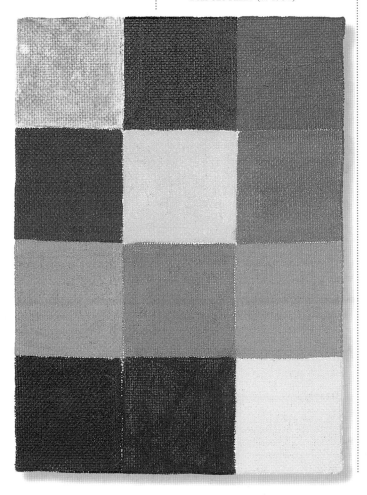

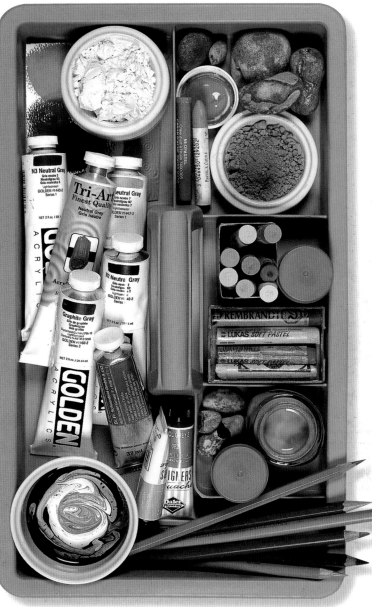

## Homage to Gray

"I don't know what I want," stated Gerhard Richter, a German painter born in 1932. Richter grew up in Germany under the ideology of the Nazis, then in East Germany under the Communists and has subsequently expressed his resistance to any ideology. He was attracted to the inconspicuous neutrality of the color gray, and, in the 1970s he made a series of flat, gray paintings to express his feelings.

> *"And finds, with keen discriminating sight Black's not so black; nor white so very white."*
> GEORGE CANNING (1770–1827)

If black is thought to be unnecessary in an artist's palette, then white is the opposite. It is indispensable to such media as oils, acrylics and gouache. A unique and unmixable color, it provides the strongest expression of light on the palette. In watercolor the white of the paper performs the function of white pigment, but the versatility of white as a functional color is well known, too. Used as a primer, ground or base coat, it is the essential foundation color on which many a painting is built.

**White lead stacking**
The Dutch developed the modern stack process for making white, hence the name Dutch White (PW1). Lead white has been made by the stacking process since Egyptian times. White pigment was made by placing strips of lead in clay pots with a separate compartment that contained vinegar. The pots were packed tightly together on shelves and interspersed with animal dung to accelerate the chemical process, then sealed in a small outbuilding. A fermentation process took place over about three months, producing carbonate of lead, or lead white pigment. This method of manufacture only ceased in the 1960s.

☞**See also**
Choosing mediums 36–37
Tinting 81
Metallic & special-effect colors 88
Color index/White 179

### The earliest white

White lead is one of the earliest manufactured pigments on record. It was known in ancient China and is common in the earliest periods of European art. It was the only white oil color available to artists until the mid-nineteenth century and, although new white pigments have come along, it is still a popular choice among oil painters. It has many fine and, some say, unique qualities, producing a buttery paint with great opacity and covering power. It is an excellent mixer that provides fine tones and tints. It is very durable and permanent when applied properly following good oil-painting practice. However, it is poisonous if accidentally ingested, and in many cases has been superseded by less hazardous whites.

### Flake White

This is the name you will find in manufacturers' catalogs for white lead (basic lead carbonate PW4). It is available only as an oil medium, because it does not work in other media, such as acrylics. It is the traditional choice for the oil painter. Flake White is sometimes offered in two consistencies, one being stiffer. It is a comparatively quick-drying, flexible and durable white. It has two major drawbacks – its toxicity (see above) and its tendency to darken if in contact with sulfur, which may be found in a polluted atmosphere.

### Cremnitz White

This is an old-fashioned, high-quality white lead paint made with pure lead carbonate. It is more stringy than Flake White and yellower.

### Titanium White

Titanium White is the modern, less hazardous replacement for white lead pigments, particularly for Flake White. It is a fairly slow dryer as an oil paint and popular as a mixing white. The most powerful of the whites, it is dense and opaque, and should be used with caution, because it can overpower more transparent colors. In some catalogs it is suffixed Permanent White. It may be considered a neutral to warm mixer, compared to the cooler Zinc White.

### Zinc White

In addition to oils, you will find this color listed with the water-soluble media too, particularly gouaches and acrylics. It is a very versatile white, but is less opaque than the other whites. It is an excellent mixer, particularly for glazing and making tints. In oil paint it is a slow dryer and is said to produce a colder, bluer effect when compared to Flake White. It is manufactured as a watercolor under the name Chinese White.

### Chinese White

This is a specially prepared Zinc White and is the traditional watercolor white. It was introduced in 1834 by Winsor & Newton and is now available from many manufacturers. Purist watercolor painters shun the use of Chinese White, claiming the integrity of a watercolor painting relies on the transparency of the medium and the technique of reserving white paper for its unique effect.

### Mixing White

Some manufacturers offer this color in their acrylic ranges. It is a good general-purpose white that is excellent for lightening when used in glazes and for the general toning down of colors. It is very translucent and mixes well to produce good transparent tints.

### Iridescent White

This is composed of a Titanium White type pigment that is coated with mica. It has a pearlized appearance when seen undiluted. Iridescent White produces effective shimmer colors when used in admixture. Used in thin glazes over color, it produces unique effects of light interference. It is available in oil and acrylic media.

### Underpainting White

A general-purpose oil-painting white, this white may be used for preparing grounds and for mixing with other colors. It is quick drying and, when used alone, produces a matte finish. It should be applied to previously sized or primed canvas.

## Naming whites

As with blacks (see page 76), you will come across many descriptive names for types of white in books on art and in makers' catalogs and color charts. Several of the names are old-fashioned and may refer to outmoded brands and recipes. Other names are manufacturers' descriptive brand names. These days the naming of whites is fairly consistent across the different brands. However, a white bearing the same name may vary in behavior and handling from one manufacturer to another. You will almost certainly find that students'-quality whites have less pigment and covering power than artists'-quality whites.

### Baryta White

You may come across this name in old-fashioned or technical publications. The word is derived from barytes, an obsolete term for barium sulfate, which is a heavy, white inert pigment that is the main component of Baryta White.

### Bismuth White

Used in the early nineteenth century as a less toxic substitute for white lead, this color is now superseded by Zinc White.

### Blanc Fixe

This is a later development of Baryta White, but made from artificial barium sulfate. Blanc fixe is sometimes used as a base during the manufacture of pigments. The term "blanc fixe" has largely gone out of general use.

### Permanent White

Originally used as an alternative name for blanc fixe, Permanent White is now used to describe the more modern Titanium White. It is also a name that is sometimes seen in school, student, designer and craft paint listings. It is commonly used to indicate opacity and nonyellowing characteristics.

### Chinese White

An old-established name used to describe Zinc White. It has been manufactured as a prepared watercolor white since 1834. The name is still used today (see opposite).

### Resists

Resists works on the principle that oil and water do not mix, and white areas can be created by this process. For example, a line drawing can be made with a candle or any greasy medium on a white ground. Subsequent areas of water-based color may be washed over the initial greasy drawing, which remains as a white line.

### Reserved white

This is the effect of white in watercolor painting, created by leaving passages such as clouds, reflections and highlights as unpainted white paper. Masking fluid may be applied to achieve this.

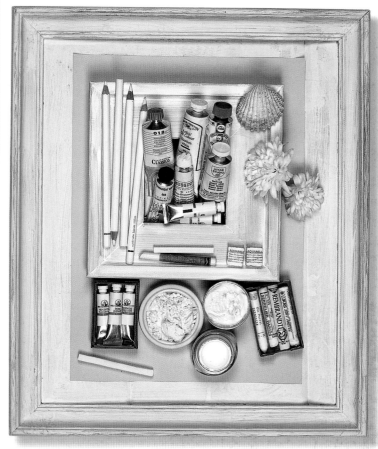

### White magic

White can have a magical influence on the darkest and most somber of hues. By adding white, many colors are transformed.

*(From top to bottom, left to right)*

| |
|---|
| Indigo (Lukas) |
| Violet Dioxazine (Tri-Art) |
| Payne's Gray (Rowney) |
| Prussian Blue Extra (Old Holland) |
| Madder Lake Deepest (Lukas) |
| Van Dyke Brown (Winsor & Newton) |
| Burnt Umber (Winsor & Newton) |
| Sepia (Lukas) |
| Van Dyke Brown (Lukas) |
| Viridian Hue (Liquitex) |
| Phthalo Green Blue Shade (Golden) |
| Green Earth (Sennelier) |

Traditionally, artists have achieved the illusion of metal or highly reflective and light-scattering surfaces in their paintings by skillful techniques using a base color with white highlights and colored ambient reflections.

Yellow is traditionally used to represent gold and copper. Various grays and blues can be seen for silver, while steel and pewter are treated similarly. Browns and ochres with subtle green glazes are often used for bronze.

The ancient and highly skilled craft of gilding is an important element in painting heraldry and historical decoration. This involves the application of very thin leaves of real gold to the surface of the artwork, then burnishing to a high sheen.

Nowadays, most of the major art materials' manufacturers offer metallic colors to imitate gold, silver, bronze or steel. Most of these products use mica as one of the ingredients. Color is coated onto the mica, then the pigment-coated mica is suspended in the appropriate vehicle, such as oil or acrylic.

Similarly, many light-scattering and iridescent colors are available that produce pearlized effects. These are often known as "interference" colors and are so named because of the way that they disperse the light and create changing visual effects as the viewer moves.

**NB:** Due to limitations of the printing process, it is not possible to show the full effect of metallic and iridescent paint samples. For greater accuracy, refer to manufacturers' hand-painted color charts.

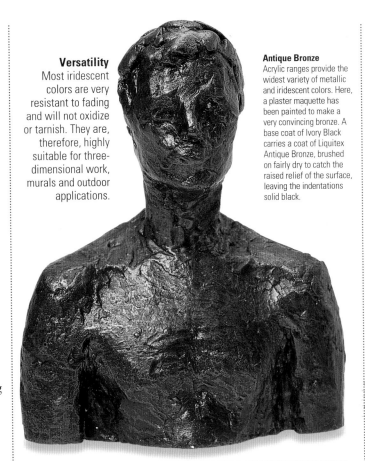

**Versatility**
Most iridescent colors are very resistant to fading and will not oxidize or tarnish. They are, therefore, highly suitable for three-dimensional work, murals and outdoor applications.

**Antique Bronze**
Acrylic ranges provide the widest variety of metallic and iridescent colors. Here, a plaster maquette has been painted to make a very convincing bronze. A base coat of Ivory Black carries a coat of Liquitex Antique Bronze, brushed on fairly dry to catch the raised relief of the surface, leaving the indentations solid black.

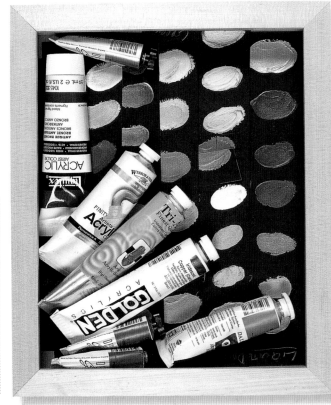

## Metallic and iridescent colors

Metallic colors fall into a group known as iridescent pigments. Some are derived from metal and metal oxides, such as the colors named Iridescent Stainless Steel and Micaceous Iron Oxide that are manufactured by Golden in the USA.

### Increasing brilliance

Iridescent pigments depend on light for brilliance. Adding glossy gels or mediums will allow more light to surround the pigments and increase their iridescent quality. A final top coat of gloss varnish can also increase the metallic look of an artwork, while matte varnishes tend to reduce brilliance and reflectivity.

**Add ordinary yellows or browns to iridescent gold for antique gold.**

### Mixing

You can mix iridescent acrylics with ordinary acrylics to create a vast array of pearlescent colors – yellows or browns added to gold produce antique golds, blue plus iridescent pearl or iridescent white gives a blue pearl color, and so on.

### Base coats

Some iridescent colors appear to be transparent and low in pigment. This is because the physical paint formulation has to carry a high volume of the ingredient that creates the iridescent effect (such as mica flakes) in addition to the pigment color. You can compensate for any weakness by applying a base coat of similar hue to the iridescent color you want to use. For example, Yellow Ochre acts as a good base coat for most gold colors and will save several layers of paint.

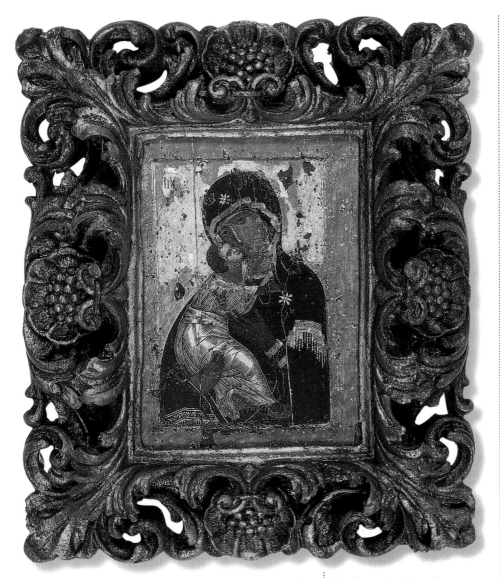

Anon
**Vladimir Madonna,** *c.* **1125**
Pigment on panel
21 x 30in (53 x 75cm) (original size)

The illustration above shows a postcard reproduction (4 x 6in, 10 x 15cm) of the *Vladimir Madonna*, which dates from the twelfth century. Gold and red pigment combinations dominate the background. The later decorative frame has been given a faux poliment and gilding treatment to enhance the reproduction (see right).

☞**See also**
Pigments in history 12–15
Brown and Red Earth 72–75
Color index 178–179

**Red poliment**
Poliment is a natural red iron-oxide pigment (PR102) and was the traditional base coat for gilding. There are many similar colors available. In acrylic ranges, for example, you may come across colors named Rich Transparent Red Oxide, Venetian Red or Red Iron Oxide. Used as a base coat for metallic gold colors, you can imitate the rich effect of traditional gold leaf by leaving a little of the red undercoat showing through.

**Gold on Rich Transparent Red Oxide**

**Gold on Venetian Red**

**Gold on Red Iron Oxide**

**Pearlizing colors**
Many ranges offer pearl whites or iridescent whites that can be used very effectively to create pearlized colors. Use them directly in mixtures with regular paint or apply as transparent glazes over previously painted layers to create the effect.

**Iridescent white used as a mixture and as a glaze**

Flesh is never seen as a solid, even color – it consists of a multitude of hues, tints, tones, textures and reflections. Art materials' manufacturers offer many ready-made skin colors that they identify as flesh or portrait colors. These colors usually depict light skin tones and, historically, were produced for a European market.

### Ready-made colors

Flesh hues are usually made up of a combination of pigments and are good, convenient starting colors for painting bodies and portraits, and they are ideal for color sketching. These ready-made colors provide useful basic flesh tones and hues that can be used for other purposes than painting flesh. However, when it comes to capturing the quality of human skin, either in figure painting or portraiture, you may discover that mixing and blending colors from a variety of pure colors is the only effective way to convey the real nature of flesh.

**Naples Yellow Reddish**

**Jaune Brillant**

**Unbleached Titanium**

**Flesh experiments**
The colors here came straight from the tube and are from a variety of makers. Some of these colors are sold specifically for painting flesh. Others are single-pigment earth and ochre colors that, even when used alone, can be particularly useful for rendering flesh tones.

**Straight from the tube**
Colors sold specifically for painting flesh provide warm neutrals and useful pinks. Many other colors available, although suitable for flesh tones, are not labeled as such. Naples Yellow Reddish, Jaune Brillant and Unbleached Titanium are good examples of such useful colors.

**Raw Umber**          **Titanium White**

### Warm neutrals

You can make warm neutral grays by mixing Raw Umber and Titanium White. This mixture produces tints that are suitable for flesh tones.

**A multitude of hues**

These are Vincent van Gogh's own words on his technique for painting flesh, in a letter to his brother Theo:

*"When I compare my painted study with those of others, it is curious to see that theirs have almost nothing in common with mine. Theirs have the same color as the flesh, so that seen from nearby they are correct, but if you stand back a little they appear painfully flat – all that pink and delicate yellow, soft in itself produces a harsh effect. As I do it from nearby it is greenish red, yellowish gray – but when one stands back a little it stands out from the paint; there is atmosphere around it, and there falls on it a certain vibrating light."*

VINCENT VAN GOGH, LETTER

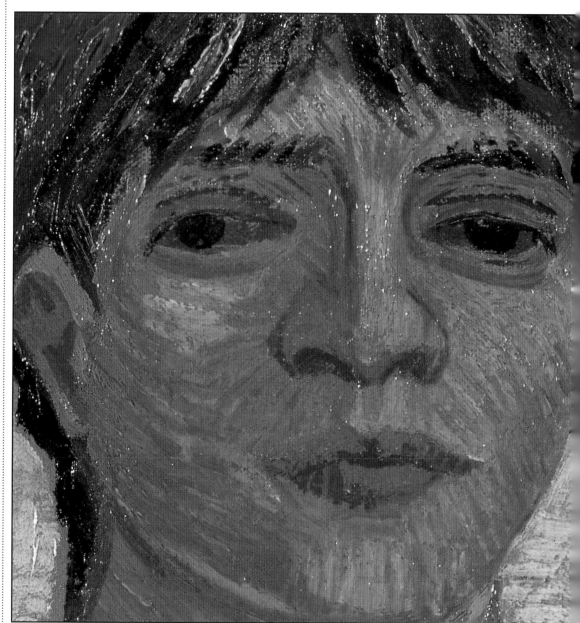

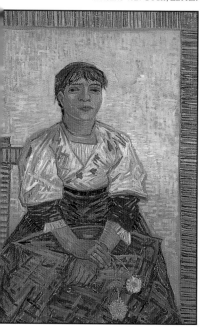

Vincent van Gogh (1853–90)
**Italian Girl, 1887**
Oil on canvas
32 x 23½in (81 x 60cm)
*Musée d'Orsay, Paris*

**Selecting colors for mixing**
For the color-mixing experiments shown here, acrylic paints were used and the following colors were chosen.

**Basic five-color mixing**

| |
|---|
| Process Magenta |
| Process Yellow |
| Raw Sienna |
| Raw Umber |
| Titanium White |

☛ **See also**

## Light flesh tones
For the purpose of the color-mixing experiments, Process Magenta and Process Yellow have been chosen, but you can experiment by substituting any reds or yellows you prefer.

**Mixing combinations**
● Process Magenta & Titanium White
● Process Yellow & Titanium White
● Process Yellow & Process Magenta & Titanium White

## Toning down
Try adding different yellows and ochres, and earth colors, such as umbers and siennas, to create less florid colors and richer, darker shades.

**Mixing combinations**
● Raw Sienna & Titanium White
● Process Magenta & Titanium White & Raw Sienna
● Process Yellow & Titanium White & Raw Sienna
● Process Yellow & Process Magenta & Titanium White & Raw Sienna

## For darker colors
Experiment with the previous combinations, then replace Raw Sienna with Raw Umber for darker colors.

**Mixing combinations**
● Raw Umber & Titanium White
● Raw Umber & Titanium White & Raw Sienna
● Raw Umber & Titanium White & Raw Sienna & Process Yellow
● Process Yellow & Process Magenta & Titanium White & Raw Umber

The mixing process and combinations can go on practically ad infinitum. You can continue the experiments with Burnt Umber and Burnt Sienna and all kinds of ochres and other earth colors.

### Combination pigments

The manufactured flesh colors shown here contain, in various degrees, red, yellow and blue ingredients. Some of the darker hues dispense with the white component altogether and others have added violet and orange pigments to enrich the depth of color.

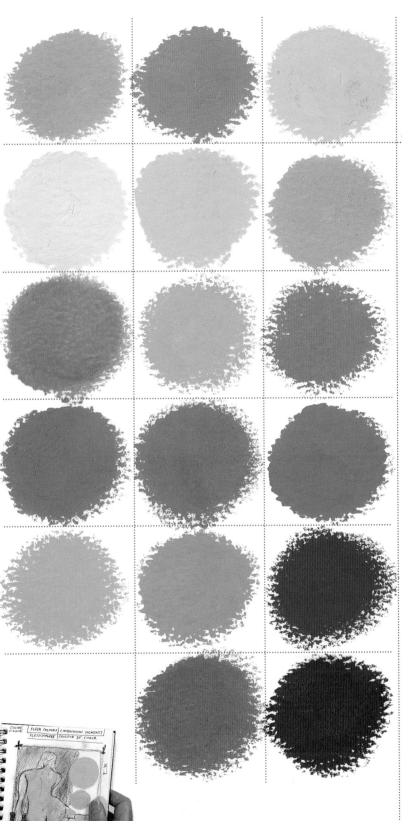

### Prepared flesh colors

These colors are not exclusively for portraiture and life painting and may be used generally to extend the warm color range on the artist's palette. Most of the prepared flesh colors shown in the sketchbooks and the color charts (left) represent light skin shades. Some are combinations of red, yellow and white pigments that can easily be mixed, while others are more complex combination pigments.

*(From top to bottom, left to right)*

**Flesh Tint,** Schmincke Mussini **(rO)**
**Flesh Tint,** Schmincke Norma **(O)**
**Flesh Color,** Lukas Studio **(O)**
**Flesh Color 2,** Lukas Series 1 **(O)**
**Flesh Color 4,** Lukas Series 1 **(O)**
**Flesh Color,** Lukas Designers' **(G)**
**Flesh Tint,** Rowney Artists' **(O)**
**Flesh Tint,** Daler-Rowney Designers' **(G)**
**Flesh Tint,** Daler-Rowney Cryla **(A)**
**Flesh Tint,** Old Holland Classic **(O)**
**Flesh Tint,** Winsor & Newton Artists' **(O)**
**Flesh Tint,** Winsor & Newton Griffin Alkyd **(aO)**
**Light Portrait Pink,** Liquitex **(A)**
**Portrait Tone,** Tri-Art **(A)**
**Flesh Ochre,** Lukas Studio **(O)**
**Flesh Ochre,** Sennelier Extra Fine **(O)**
**Flesh Ochre,** Old Holland Classic **(O)**

**(O)** = oil
**(rO)** = resin oil
**(aO)** = alkyd oil
**(G)** = gouache
**(A)** = acrylic

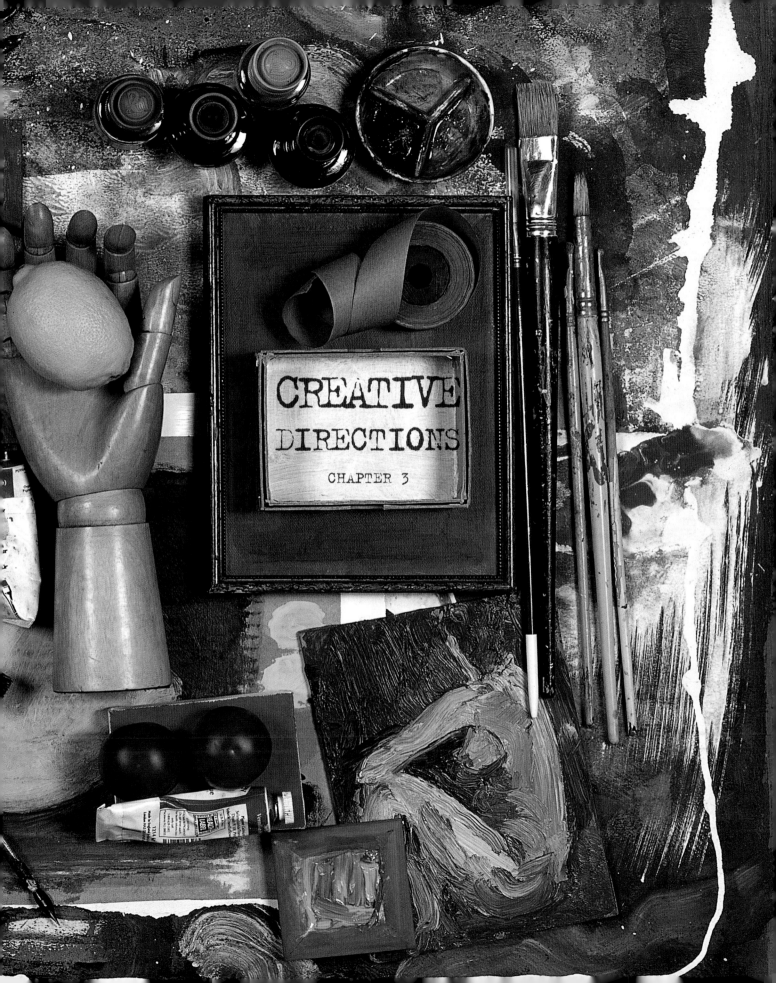

CREATIVE
DIRECTIONS
CHAPTER 3

Color produces a very personal reaction and there are as many creative directions and methods for using color as there are individual artists.

In this section we have had the privilege of speaking with a number of artists who use a variety of techniques and a range of media. They have opened their homes and studios and given their time generously to bring us an insight into their approach and ideas about color.

In discussion these artists have mostly said that there are no rules, and the ones who do acknowledge rules say that they are there to be broken. The notion of rules, although low on their list of priorities, clearly relates to style and aesthetic convention in art. In relation to color, however, method and good practice were rated highly.

The artists all emphasized the importance of respecting their materials and of maintaining a disciplined approach to color selection and palette layout, often with designated areas for mixing and blending. This was not always apparent when looking at their mixing surfaces and painting tables, which frequently seemed chaotic and uncontrolled. However, these do not give the true picture – the artists agreed unanimously that without a sense of discipline toward color, the results will be mud and confusion.

**Palettes and painting tables**
A selection (left, from top to bottom):
Tim Riddihough, Desmond Haughton,
George Rowlett, Daphne Jo Lowrie,
John Reay.

## Watercolor: straight and mixed 98
Ray Balkwill

Putting more color into watercolor

## Subdued colors 102
Joan Elliott Bates

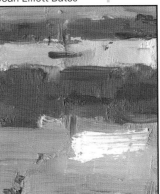

Subtle color and tone

## Working without black 104
Nick Bowering

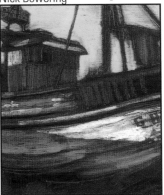

Rich darks without using black

## Fast color for flesh 106
Tim Riddihough

Expressive color in a variety of media

## A seven-color palette 110
Desmond Haughton

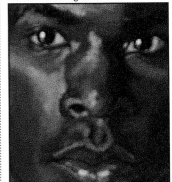

Many colors from a simple palette

## Renaissance skin tones 112
George Underwood

Tried techniques for glowing portraits

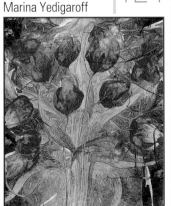
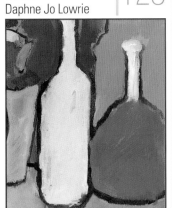

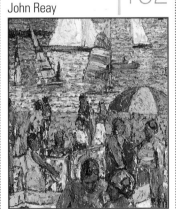

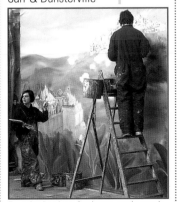
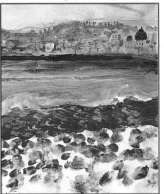

*"My watercolor paintings have definitely become more colorful in recent years – probably due to introducing opaque media into them."*

Ray Balkwill is an artist who has explored new ways of painting his maritime subjects, but he returns time and again to what he describes as "the most wonderful medium of expression yet devised" – watercolor paints.

### Watercolor explorations

Living in Exmouth, England, it is little wonder that the sea and its wealth of maritime subjects are the artist's main inspiration. The elemental forces in nature and the wide open spaces of sea, estuary and sky have long been an interest.

Mood and atmosphere play a big part in his paintings, and he finds that watercolor is the perfect medium to convey this. However, it is not an easy medium, and, for the first 10 years of painting, the artist worked solely in watercolor, trying to master its elusive and unpredictable qualities. These, he believes, are the secret of the medium's success and why it is so popular with artists.

When he is painting in pure watercolor, he favors a limited and restrained palette. His usual colors include Ultramarine Blue, Cerulean Blue, Naples Yellow, Raw Sienna, Aureolin, Cadmium Orange, Permanent Rose, Light Red, Burnt Sienna and Burnt Umber. He chooses artists' colors for their transparency, lightfastness and purity, but finds the students' ranges of colors perfectly acceptable for the earth colors, such as the umbers and siennas.

### Contrast and tone

As a professional painter, the artist is continally looking for new ideas, and, more recently, he has been making paintings that combine opaque media with watercolor.

Ray's palette usually varies according to the medium he is working in. In addition to his preferred watercolor palette, he also uses colors such as Winsor Blue, Viridian, Sepia and Indigo – particularly in mixed-media paintings in which he combines pastel and wants fiercer colors and stronger contrast.

Tone plays an important part in painting – especially in watercolor: "When painting I concentrate on tone first, with color in a supporting role. I find my black and white charcoal sketches an invaluable source for reference, when I am working in the studio."

**Winsor Blue and Cadmium Orange**

**Cerulean Blue and Light Red**

**Ultramarine Blue and Light Red**

### For grays and browns

The artist mixes pairs of intense colors that oppose each other on the color wheel. A favorite mixture includes Winsor Blue, or Ultramarine Blue, and Cadmium Orange. For lighter grays, middle-value colors, such as Cerulean Blue and Light Red, or watery mixtures of more intense colors, such as Cerulean and Rose Madder, create clean, colorful grays.

### Instead of black

Ray never uses black in his watercolors, preferring to mix darks, using Ultramarine Blue and Burnt Umber, or Burnt Sienna. He sometimes uses Viridian mixed with Sepia when he wants a near black.

**Ultramarine Blue and Burnt Sienna**

**Ultramarine Blue and Burnt Umber**

**Viridian and Sepia**

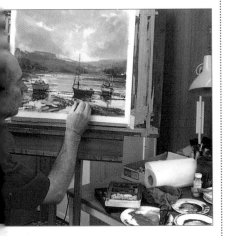

### Spontaneity in the studio

Watercolor's characteristics of translucency, expressiveness and unpredictability demand much forward planning by artists who use the medium. Energy is also vital in watercolor painting, and, although this can come naturally when working outdoors, it can also be achieved in the studio by working quickly to ensure spontaneity. Ray Balkwill believes that the artist should take risks and allow watercolor to "do its own thing."

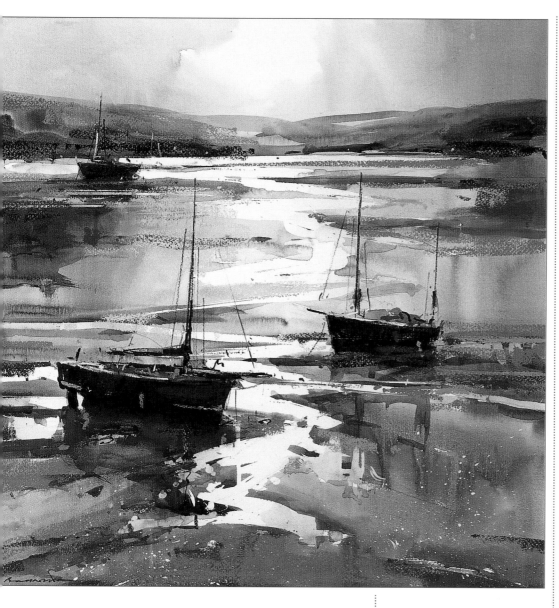

Ray Balkwill
**Sheltered Moorings** (detail)
Watercolor and mixed media

### Mixing media
The artist often adds ink and gouache to the watercolor and pastel in his mixed-media paintings: "I believe that there are only a few basic rules in painting. It's all about making your picture and expressing your own vision."

The painting *Sunset on the Exe* is a typical example of how he has used the contrast of watercolor with other media effectively. Here, by using color counter-change, or complementaries, the warm areas of color against cool ones create the intensity of tones that balance light against dark to their limit. The contrast of the two media working together makes for a much more vibrant picture than the "softer" look of a pure watercolor. In this painting the watercolors used are Winsor Blue, Cadmium Orange and Raw Sienna.

### Combining watercolor and other media
The artist feels it is important that every painter searches for interesting new ways to extend his or her experience and knowledge of technique, so he has also been experimenting in acylics, oils and pastels. More recently, he has used mixed media – mainly watercolors and pastels combined. This seemed the natural progression from pure watercolor. The transparency and fluidity of watercolor and the opacity and vibrancy of pastel work extremely well together, and their interplay produces paintings that are rich in a variety of marks, color and technique.

With this method, he still uses watercolor paper as the support, but he aims to apply the watercolor more directly and loosely. He does this by using stronger colors – with plenty of paint – so that the color is stated without the need for further washes, as in the more traditional method.

Ray Balkwill
**Sunset on the Exe**
Watercolor and mixed media
17 x 18in (43 x 45.5cm)

## Working with pure watercolor

Watercolor works best when it is expressed as simply and spontaneously as possible. When using pure watercolor, the artist likes to paint in the traditional way by building up the picture gradually, applying washes and working from light to dark. One of the most important elements in a watercolor painting is the role of the paper itself, and the artist makes good use of its qualities to retain translucency and "sparkle."

The painting *Quayside* (opposite) was built up using three or four washes, allowing each to dry before applying the next. By using masking fluid at the start, the artist could retain the whiteness of the paper as the lightest area. The use of some highly transparent colors – the essence of watercolor – also permits the white reflective surface to shine through.

Transparent watercolors have an attractive airy quality that is perfect for capturing the illusion of atmosphere, space and light. Of course, the opaque colors are also transparent when thinly diluted, but they impart a degree of opacity to other colors they are mixed with. White gouache is only added if necessary, to put in finishing touches, such as rigging and seagulls, as here.

After masking fluid was applied with a brush on the boat and water, the artist applied a light wash of Cadmium Orange and Naples Yellow over the whole of the paper to set a warm mood, knowing that there would be cooler washes to follow. Naples Yellow is a semi-opaque color that softens other colors, as well as adds warmth and mistiness.

When this was dry, a mixture of Cerulean Blue and Permanent Rose was washed over the distant hills and harbor wall. Both of these colors have a cool bias. The artist repeated the wash, but dropped a mixture of Ultramarine Blue and Raw Sienna into the background hills, merging it in places with a little Burnt Sienna. This "wet-in-wet" technique is useful for suggesting distance, particularly if you want to keep a painting simple. By using coolish colors, the background tends to recede, while merging and moving these colors around helps keep the background lively to excite the eye without involving too much detail.

Burnt Sienna was dragged across the foreground with a "dry brush" to suggest mud. This technique is a useful way of adding texture to contrast with the areas of soft washes. A further wash of the darker mixes was used in the buildup of darks for the wall and boat, letting some of the initial colors show through.

Light Red was used for the hull of the boat and a mixture of Ultramarine and Permanent Rose for the shadows and distant water. Ultramarine and Light Red, and Ultramarine and Burnt Sienna, were added for further darks. Finally, the masking fluid was removed and any hard edges were softened with watercolor.

A painting is often ruined by adding too much detail in the final touches and destroying its freshness. "Letting go" of a painting is difficult, particularly if you are enjoying it. In fact, the two most difficult aspects of painting, Ray Balkwill believes, are starting a painting – being faced with a sheet of white paper – and finishing one off.

### Palettes
Ray uses artists'-quality watercolors. He prefers tubes instead of pans, because it is easier to prepare large quantities of strong wash from them. In the studio old plates and saucers are employed for mixing colors. When working outside, he uses a large plastic palette with plenty of deep wells.

### Brushes
He uses four brushes, including a 1in (25mm) hake, a filbert, a no. 12 round and a rigger. He advises against using a small brush too early in a painting, otherwise it will look too detailed.

### Finishing touches
The finishing touches in *Quayside* involved adding a few flicks with a rigger for the rigging, ropes and seagulls, using white gouache. Further darks were added in the walls, steps and boat.

### Core colors and materials used
Artists'- and students'-quality watercolors: Ultramarine Blue, Cerulean Blue, Cadmium Orange, Permanent Rose, Light Red, Raw Sienna, Naples Yellow, Burnt Sienna and white gouache. In addition the artist used masking fluid and worked on 140lb (300gsm) Whatman (Not) watercolor paper.

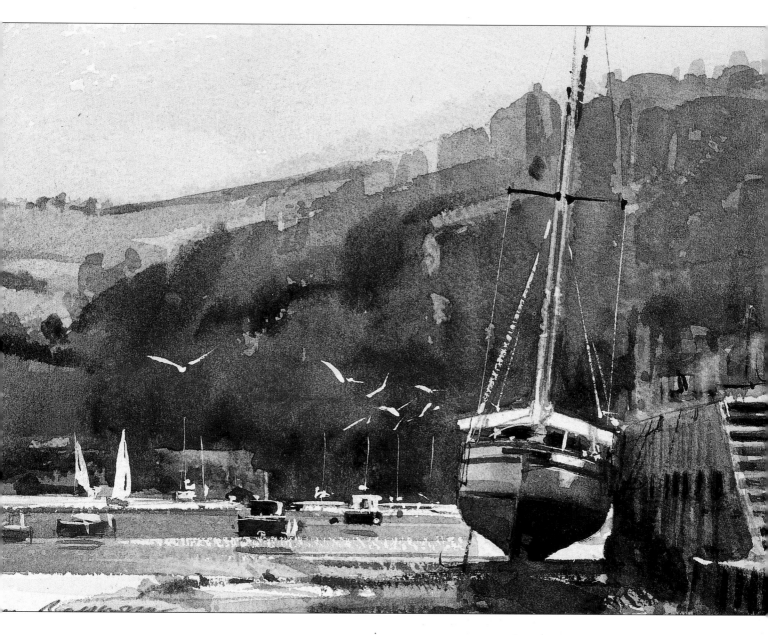

Ray Balkwill
**Quayside**
Watercolor
5 x 7in (12.5 x 17.5cm)

The artist is a strong advocate of working "en plein air." He does much of his painting in the UK, where the atmosphere tends to soften the colors. This is why many of his paintings contain mellow mixtures of blue-gray produced by the weather and climate. The view is taken from a pontoon at Dartmouth, Devon, and it was a difficult position to paint from. The inspiration for the painting was the late afternoon light and the strong contrast it created. *Quayside* is a good example of how color can be used to suggest and accentuate the mood and atmosphere of a place.

*"Whereas some think of color as primaries, I tend towards the secondaries or tertiaries for my chords and harmonies."*

Tonalism is a style of painting in which the artist strives to capture the effect of light and form through color areas known as tonal masses, as distinguished from a linear approach. Joan Elliott Bates studied at the Slade School of Fine Art in London under Professor William Coldstream, and her acutely observed landscapes display an instinctive awareness of color and tonal values.

**Sir William Coldstream (1908–87)**
Coldstream was a member of the famous Euston Road School of painters, founded in the late 1930s, whose figurative work was subdued in color.

**White**
The soft tonality of the artist's work relies on the use of a great deal of white. Joan Elliott Bates's choice is Flake White. This is a white that is traditionally used by oil painters and is probably one of the oldest known paint formulations. Being made from lead, Flake White is toxic and should be handled with caution.

The artist recalls that "William Coldstream was a fine Slade Professor, not least because he encouraged all kinds of different talents to emerge and prosper. Despite the fact that he had been a member of the Euston Road School, there was no pressure on the students to work in that way." However, students at the Slade were familiar with his work and that of other members of staff who followed that tradition.

Any painting is made up of composition, color and tone. Joan Elliott Bates's drawings are often tonal, too, and she also produces linear etchings with tonal aquatints. She sees a landscape, still life or figure in terms of color and tone and regards these two elements as inextricably linked: "I think this is instinctive. I once heard a notable teacher saying that color mixing, composition and other elements can be taught, but not a sense of tonal values." She much admires the work of Piero della Francesca, Rembrandt, late Turner, van Gogh, Bonnard, Vuillard, and Gwen John.

**Personal palette**
The artist believes that a limited palette results in a cohesive, unified painting – "perhaps analogous to setting a key in music."

Her favorite colors are White, Naples Yellow, Yellow Ochre, Cadmium

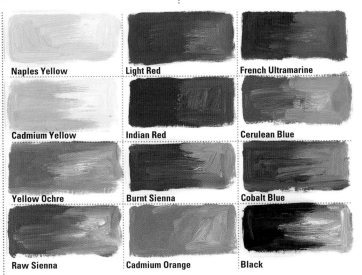

**Naples Yellow** **Light Red** **French Ultramarine**

**Cadmium Yellow** **Indian Red** **Cerulean Blue**

**Yellow Ochre** **Burnt Sienna** **Cobalt Blue**

**Raw Sienna** **Cadmium Orange** **Black**

Yellow, Raw Sienna, Light Red, Indian Red, Burnt Sienna, French Ultramarine, Cerulean Blue, Cobalt Blue and Cadmium Orange. She follows a set procedure in laying out her palette.

Only very occasionally does she pick perhaps three colors, probably black, white and one other, for more abstract painting – or she may try a completely different palette to force herself to rethink, in case her habitual palette is becoming too much of a cliché. She learns by doing this, but reverts with pleasure to her own familiar "voice."

The artist has no particular preferred brand of oil paint, and the only additive she uses is genuine turpentine, never linseed oil. Colors are mixed instead of taken straight from the tube.

**Color and tone**
Joan Elliott Bates describes her painting as close in tone and high in key. The terms "tone" and "tonalism," when used to describe the visible quality of color in painting, are used broadly. The hue may be described as yellow or reddish tone, for example; the value as pale or deep tone; and the degree of vividness, known as saturation, as bright or dull tone.

**Palette choice and layout**
Joan Elliott Bates will typically use only five or six colors. She lays her palette out in a set order, counter-clockwise from the thumbhole. She always uses White. For her yellows she will choose from Naples Yellow, Cadmium Yellow or Yellow Ochre, and she always uses Raw Sienna. From the warm pigments, she chooses Light Red, Indian Red or Burnt Sienna, and, for coolness from the blues, she selects from French Ultramarine, Cerulean and Cobalt. Occasionally, she adds Black and Cadmium Orange to her palette.

**See also** ☞
| Choosing media/Oils 30–31 |
| Mediums 36–37 |
| Choosing palettes 40–41 |
| White 86–87 |

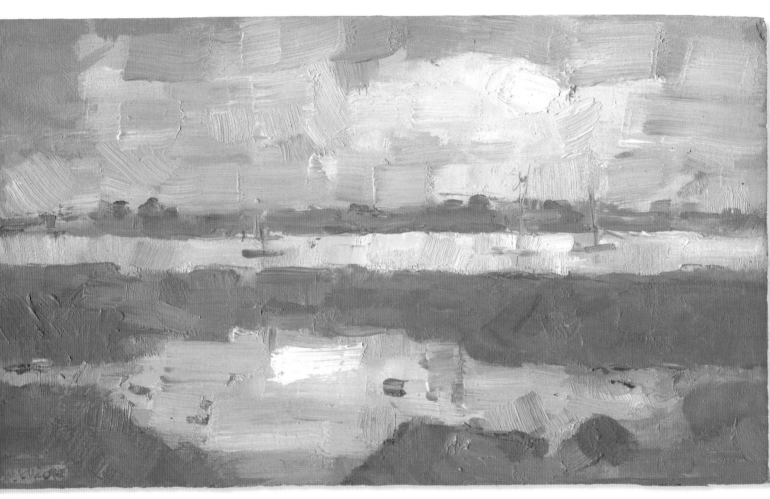

Joan Elliott Bates
**East Anglian Estuary**
Oil on board
6 x 10in (15 x 25.3cm)
*The painting
above is shown nearly
actual size.
(detail enlargement, right)*

"My paintings are often small but not always so. I often work directly from nature on a small scale and then continue with them or develop them in the studio. Most of my colors are in a high key and concerned with light. My brushwork is very much concerned with mark-making, which shows the individual hand of the artist – his or her calligraphy."

*"I find if you have thousands of colors to choose from, it discourages the act of mixing."*

Nick Bowering is an artist who has exploited the potential of black. He has mixed darks effectively from a limited palette, creating a series of boat paintings that convey subtlety of color and specific mood. His work shows what can be achieved from the darker end of the spectrum with a limited selection of colors.

**A controlled palette**
Naples Yellow
Cadmium Yellow
Cadmium Red
Alizarin Crimson
Ultramarine
Prussian Blue

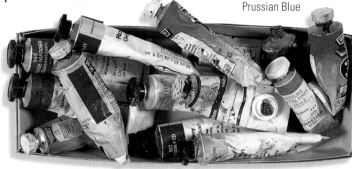

### Monochrome experiments

Instinctively, this artist views things monochromatically: "I have spent a lot of time exploring the potential of black-and-white photography, and I have been involved in single-color printmaking. In both lithography and etching, I have experimented with black ink."

Recently, he has become interested in glass painting, and he has found black a particularly important graphic and tonal element in bringing an image together when painting on colored glass.

### Depth, body and subtlety

Blacks and darks can have so much depth, body and subtlety of color. If you think of black and white as complete opposites with all those grays in between, it is this tonal range that interests him, and, to a certain extent, this has influenced his series of boat paintings.

He likes light and dark contrasts and "all those halftones." He has painted purely monochromatic studies and experimented with dark single-color paintings that are virtually black, he but has gradually introduced more color into the boat pictures. He feels that it is the use of black that is the significant unifying element in these pictures.

### Limited palette

Nick Bowering tends to use a palette limited to about five or six colors, and he typically works with a palette of primary colors but varies his selection. He may use Naples Yellow, Cadmium Yellow, Cadmium Red, Alizarin Crimson, Ultramarine and Prussian Blue, and white, but he often lets the white of the primed background show through to brighten the mid-tones.

### Mixing colors

He never uses black straight from the tube, because it can be "quite deadening and overpowering." You can create a wide range of hues, including dense, dark colors that appear to read as black, but on closer inspection carry plenty of color.

The beauty of working with a limited palette is that you can steer the painting in any direction you want it to go: "I will mix reds and blues to create a sort of base black. If I want a warm black, I add more yellow. If I want a cool, deep black I add more blue."

### Different layers

He works in oils on either white-primed board or canvas, but his surface technique and brushwork vary. He seldom makes a drawing or outline sketch but draws directly with the paint. Some areas are very opaque. In other parts he may do a local-color underpainting, then work with thinned paint. By adding layer on layer, he builds up rich dark glazes and washes to create an overall mood and surface harmony.

**Linear detail**
Sometimes the artist scratches back into the paint, using the end of the brush handle to reveal either linear underpainted areas of color or the white of the canvas.

**Basic dark**
A basic black from red and blue.

**Warm**
Adding more red and yellow creates a warmer mixture and moves the color toward a Burnt Umber color.

**Cool**
Adding more blue increases darkness and takes the color toward a deep slate gray.

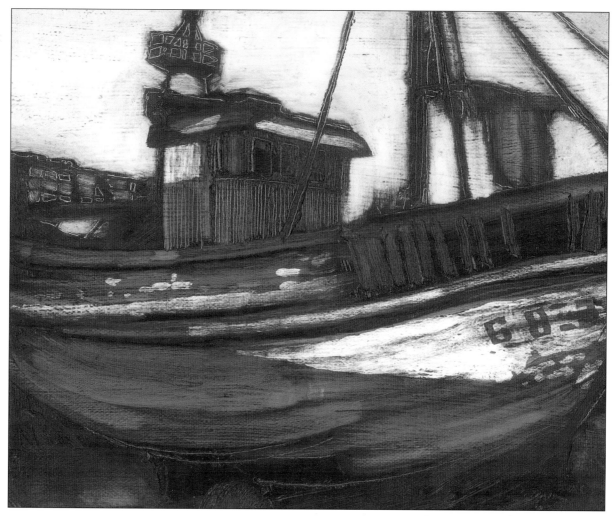

Nick Bowering
**Orange Boat
Essaouira**
Oil on canvas
10 x 12in
(25.5 x 30cm)

Nick Bowering
**Beached Boats**
Oil on board
(*below left*)
7 x 14in
(18 x 35.5cm)
(*below right*)
9 x 14in
(23 x 35.5cm)

**Manipulating blacks**
In these two small mono-chrome studies, the dark color has been steered toward cool or warm by adjusting the proportions of the colors in the mixture.

☛ **See also**

| |
|---|
| Choosing media/Oils 30–31 |
| Mediums 36–37 |
| Choosing palettes 40–41 |
| Blacks/Darks 76–83 |
| Color index/Black 176 |

Tim Riddihough is an artist who has been through many phases in his approach to life painting and his attempts to capture the variety of hues and subtlety of tones to be seen in human flesh.

*"Avoid getting into a rut with a particular technique or style. Try using new materials and new methods. Sometimes start with colored outlines, sometimes start with colored shapes."*

### Seeing flesh

While at art school Tim first used a naturalistic approach to figure painting, trying to reproduce as accurately as possible the colors of the model in front of him.

His tutors encouraged him to be individual and less natural in style, and he went through a stage of painting colors that were totally different from the ones that he was seeing. He tried painting bodies red to contrast with the green of a sofa, or green, because they were in a blue room, but he found that this approach did not work for him.

*"If I am painting a dark body or a pinkish one, these are the colors that appear in my painting, but I will add all sorts of other colors, too."*

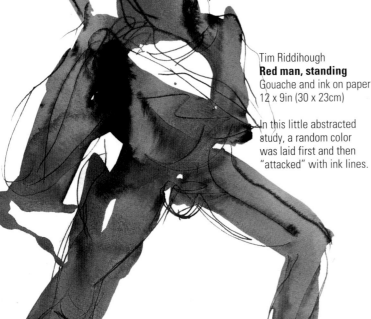

Tim Riddihough
**Red man, standing**
Gouache and ink on paper
12 x 9in (30 x 23cm)

In this little abstracted study, a random color was laid first and then "attacked" with ink lines.

He moved on to a more representational approach, and started to take note, probably subconsciously he thinks, of what the color of flesh is, trying to convey these colors as they appear to him. He does not stick rigidly to attempting to reproduce the actual colors, but tries to create an impression of the image.

### Supports and grounds

He sometimes works directly on plain white grounds and sometimes lays a tint first. Both approaches produce a specific kind of feel: "I may try a big splash of Yellow Ochre with a bit of something else to make a warmish ground and then work into it with other materials. I am very messy when I paint and I splash it on."

He uses thick, rough watercolor paper of no specific make as long as it is heavy enough to remain reasonably flat when a lot of moisture is put on it.

### Mixing media

His mixed-media paintings usually consist of gouache, oil pastel, conté and water-soluble ink. He might decide to use ink for outline and structure, then oil pastel to highlight the background and certain areas of the form.

*"If it has paint on it, then it is a painting to me."*

Gouache is his main painting medium and the basic colors he would choose for a light-skinned person would be Yellow Ochre and White, and Alizarin Crimson or Cadmium Red. These are his basics for flesh mixtures, but then he might add a color that is more purplish, such as Rose Madder, but this depends on the particular figure and the background.

## Working with color and a reed pen

The artist often works with black or brown ink for his colored figure studies. He uses a reed pen cut from *Phragmites* collected locally and cuts the nib with a penknife. He likes working with this tool, because it gives an uncertain result. The ink sometimes runs out in mid-line or gets scratchy and then blobs, and he is never sure what is going to happen. It is this element of uncertainty that he finds creative. The unpredictable line brings more vitality to the end result.

Tim Riddihough
**Check headband**
Reed pen and ink, and mixed media on tinted paper
19¾ x 13½in (50 x 35cm)

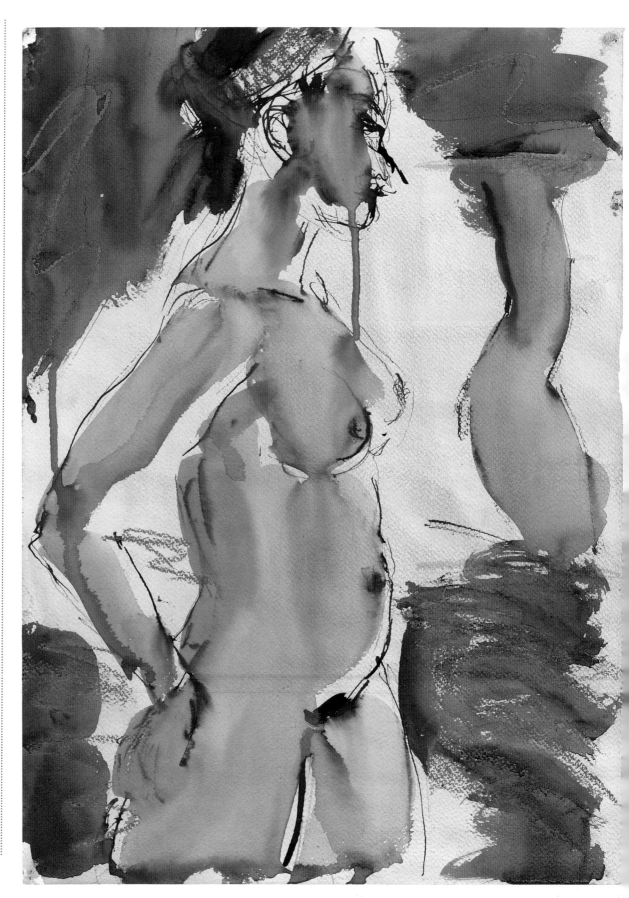

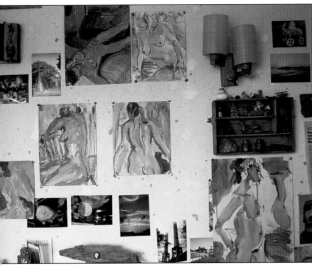

*"I find I can work all day on a painting, spending hours and even days on it, and sometimes the results are not very encouraging. The paintings that work best for me are the ones I have worked on as quickly as possible with as little conscious thought as possible. I am like a bull at a gate and just jump in. I would not recommend this approach for everyone. Some artists spend days, even years, on one painting."*

## Working at speed

Tim Riddihough tries to vary his approach and not have a set routine, because he finds this restricts the end result. Sometimes he starts with an ink outline and, because he uses water-soluble ink, the subsequent paint dissolves it and the ink starts to run.

Sometimes he reverses this approach and starts with a flat painted shape, then works on it with ink or pastel, or sometimes he will start with pastel. He does not just draw outlines and fill them in, because this can become very stilted and flat, like painting by numbers, but he always tries to paint the figure and the background together so that there is unity and harmony across the painting.

Exactly how his paintings work is a mystery to him: "I am useless at talking about painting, because I have not got a clue how it works. My most successful paintings seem to occur despite my best efforts, but in the past there has been a lot of work and practice put in."

Painting and color are now instinctive to the artist, but his method does not always work. He admits that he has a sort of shotgun approach and makes as many paintings as he can, as quickly as he can: "I will often put a painting up on the wall for a week or two and contemplate it, but my rate of production is so great the display keeps changing. Then the paintings go in a cupboard, and come out after a month or two. Some of them I will like, some of them I will not. It's a big problem. I sometimes go back to paintings, but very rarely. If they do not succeed the first time, I abandon them."

☞**Opposite page**

Tim Riddihough
**Fast studies**
Oil, acrylic and mixed media
Size range:
12 x 9in (30 x 23cm) –
19¾ x 13½in (50 x 35cm)

Just about all the paintings on the opposite page were done at top speed with the minimum of conscious thought. The bigger pictures take about half an hour, the smaller ones 10 to 15 minutes at the most.

### Green-outlined figure
*(top left)*
The artist used hard conté pastel on a damp gouache-painted surface. Conté color flows smoothly on a damp ground and dissolves and blends. White oil pastel applied first, with a dark color over the top, creates a resist that indicates light coming through a screen behind the model.

### Red man, crossed legs, leaning back
*(bottom left)*
Here is an example of using a random color for flesh, one of those experiments intended to break with convention and loosen up the artist's thinking.

### Straight paint
*(top and bottom right)*
These are pure paintings only using acrylic color to define the shapes and forms of the figure.

*"My palette is limited, but not my color range. The more colors you try to use, the more confusing a painting can become, unless you are a very experienced colorist."*

**Core seven-color palette**
From top to bottom: French Ultramarine, Cadmium Red, Alizarin Crimson, Viridian Green, Lemon Yellow, Burnt Sienna. Tints are made with the seventh color, which is Titanium White.

Desmond Haughton's painting is about exploiting a few colors within a simple design. He always uses a seven-color palette consisting of Titanium White, Lemon Yellow, Cadmium Red, Viridian Green, French Ultramarine, Alizarin Crimson and Burnt Sienna to bring a full-color range to his work.

The artist moves between student and artists' colors with no particular brand preference, choosing his palette from what he refers to as the complementary primaries – colors that are directly opposite one another and those that he considers to be purest in hue.

For example, he chooses Viridian Green for being the purest of greens, without drifting toward yellow on the one hand or blue on the other. Similarly, he chooses French Ultramarine as the purest blue, one that does not veer toward green or red. He never uses black, but creates all his deep, dark and shadow areas from mixtures of his core palette of seven colors.

Desmond makes very clear decisions about his colors and design before committing a painting to canvas, and his colors are always mixed before laying them down.

In the self-portrait shown opposite, the yellow vest makes a striking element. The artist was drawn to the high contrast between the colors yellow and black, and the dramatic effect created by visual opposites. He used Lemon Yellow with Titanium White and Burnt Sienna to produce the yellow of the vest, which is central to the composition. In turn, the yellow sits on a white shirt, which lifts and brightens the yellow color even more. The brightly clothed torso is sandwiched between the dark of the trousers and the face.

While making the painting, the artist was thinking about complementaries and opposites and basic ways of bringing out the cools and purples of the skin tones to create an interesting atmosphere to the portrait.

Clarity of design and composition is also important to the artist. One of the reasons he was drawn to the vest was its shape, as well as its color. Desmond describes his approach to composing the portrait as being one of simple design and simple colors, as if looking at a poster or a print – just well-balanced blocks of color. He has tried to achieve a monumental composition by carefully placing his figure to fill the frame of the canvas with the arms just fitting in, pushing himself close to the picture frame.

The artist does not draw the composition first or employ underpainting techniques. He works immediately, drawing with the paint and creating blocks of color that are at first abstract patterns and shapes. His technique is immediate and direct, applying undiluted paint to the picture surface, using only turpentine to thin it. He does not build up the color with washes and glazes, trying to get the painting right the first time. He favors round brushes, using a big brush to block areas in and a small one to draw details out.

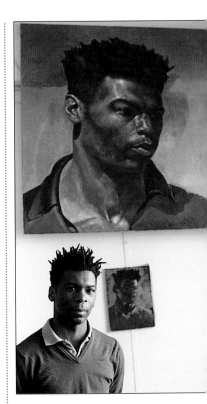

*"For a warm gray, I mix white, Burnt Sienna and French Ultramarine. Buying gray paint is a waste of money, as any two complementaries and white make gray. I never use black in my palette, but I always work on a black or brown primed canvas. One of the biggest mistakes is to use black as a mixing color on the palette."*

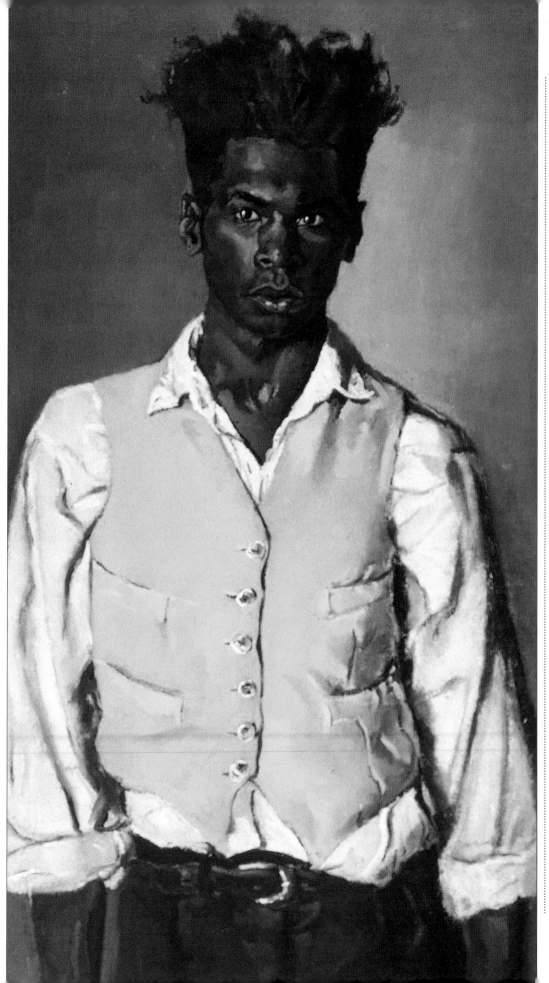

*"In my paintings there are no lines as such. Lines are defined where one area of color stops and another starts."*

Desmond Haughton
**Self-portrait
with Yellow Vest, 1994**
Oil on canvas
34 x 20in (86.5 x 51cm)

The choice of color and style of costume influences the design and mood of a portrait painting and conveys a tremendous amount about the sitter. Desmond Haughton is an artist who has painted several self-portraits from a simple seven-color palette. Lemon Yellow, used with Titanium White and Burnt Sienna for tints and shades, creates the yellow vest around which the composition revolves.

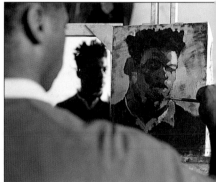

*"If you are not honest to the colors you see and the shapes you see, a painting can start to go wrong. It is all about logic, a logical sense of seeing. Ask yourself, what color is this, what shape is that?"*

The Italian Renaissance that flourished from the fourteenth to the sixteenth centuries is still recognized for its supreme artistic achievement and technique. These are some of the colors for painting flesh that you may come across when looking at paintings by masters of the Renaissance.

**Verdaccio**
A composite color used in Florence, made of Burnt Sienna, ochre, Lamp Black, chalk, green-brown and Raw Umber, and used for outlining and shading. In Siena a similar mixture was known as "Bazzeo."

**Terre Verte**
A common and inexpensive pigment used in admixture with white lead for underpainting flesh. Known in English as "Green Earth."

**Sinopia**
A name for a red iron-oxide pigment originating from the city of Sinope in Asia Minor. Similar colors are known today by such names as Red Iron Oxide, Venetian Red and Red Ochre.

**Cinabrese**
An ancient red pigment derived from mercuric-sulfide ore, also known as Cinnabar. Used in admixtures with white lead to create warm flesh tones. Later superseded in popularity by the invention of the far superior Vermilion.

Michelangelo Buonarroti (1475–1564)
**Madonna, Child and St. John with Angels,** *c.* **1506**
Oil on wood panel (detail)
41½ x 30¼in (105.4 x 76.8cm)
*National Gallery, London*

**Cennino Cennini's advice on painting flesh on panel**
"Take a little terre verte and a little white lead…and lay two coats all over the face, over the hands, over the feet, and over the nudes…. On a wall make your pinks with cinabrese, bear in mind on a panel they should be made with vermilion. And when you are putting on the first pinks, do not have straight vermilion – have a little white lead in it. And also put a little white lead into the verdaccio with which you shade at first – make three values of flesh color, each lighter than the other, laying each flesh color in its place on the areas of the face… do not work up so close to the verdaccio shadows as to cover them entirely; but work them out with the darkest flesh color, fusing and softening them like a puff of smoke…. Bear in mind that a panel needs to be laid in more times than a wall; but not so much as not to need to have the green, which lies under the flesh colors, always show through a little. When you have got your flesh colors down so that the face is just about right, make a flesh color a little bit lighter and pick out the forms…until you finally come to touch in with pure white lead any little relief more pronounced than the rest, such as there would be on the eyebrow or the tip of the nose, etc."

THE CRAFTSMAN'S HANDBOOK (FIFTEENTH CENTURY)

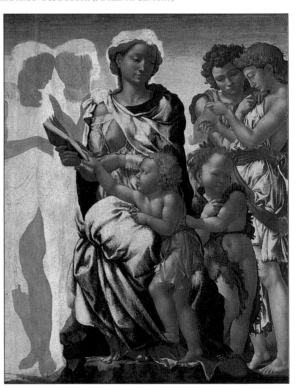

**Lay two coats of terre verte**
In this partly finished work, the technique of using the mixture of Terre Verte (literally, "green earth") and white lead for underpainting flesh, as discussed by Cennini, above, can be clearly seen. The effect of using a complementary or contrasting ground color in cool green enhances the warmth of the subsequent red-shade skin tones.

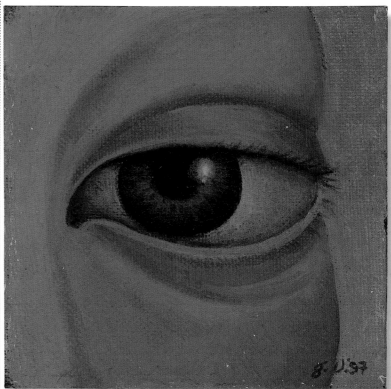

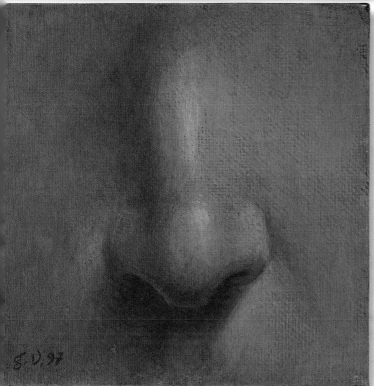

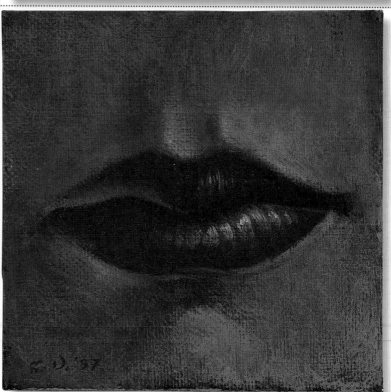

George Underwood
**Portrait Fragments, 1997**
Oil on canvas
4 x 4in (10.2 x 10.2cm) (actual size)
*Collection of Simon Jennings*

**A traditional approach**
In these small detail studies, the artist has been influenced by Renaissance coloring techniques. Green is an unusual choice for underpainting skin colors, but here, as in fifteenth-century paintings, it is used effectively to enhance the warmth and solidity of the skin tones.

*"This is painting, not sculpture. If I could do it with thin paint, then I would – but I can't."*

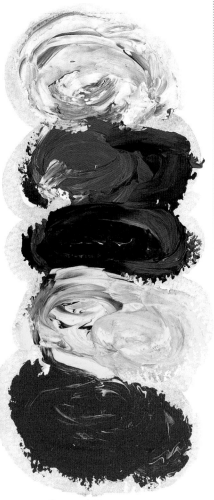

**Core palette**
George Rowlett's palette consists of only four colors – Ultramarine Blue, Brunswick Green, Chrome Yellow (bulk-branded Lead-Free Lemon) and Cadmium Red Medium (bulk-branded Bright Red) – plus Titanium White.

☛**See also**
Choosing media/Oils 30–31

Entering George Rowlett's intimate London studio (he has a studio on the east Kent coast, too) is like getting right inside one of his paintings. The whole atmosphere is permeated by oil paint. The physical presence of it is everywhere – on the walls, the floor, the working surfaces and the equipment, but, most importantly, on the paintings themselves.

It is a privileged experience for anyone with an interest in painting to find themselves projected into this surprisingly well-organized world, dripping with colors.

The artist is well known for his thickly painted views of London's river and for his seascapes and landscapes of the east Kent coast. A question people frequently ask him is: "How long does it take for the colors to dry?" The artist's answer is that a painting will skin over in one to two weeks, and the reds are the slowest colors to dry: "I usually sell my paintings when they are touch-dry; they will bruise if you knock them at first. Then they take about four to six years to dry through, and become as hard as concrete."

Another recurring question is: "Do the paintings crack?" George has seen a painting that he made 35 years ago and it is absolutely sound. One of the reasons for the longevity of his pictures is that they are painted on well-primed framed hardboard instead of canvas. Also, he uses a simple palette of colors, and this means that there are fewer chemical reactions taking place between the pigments: "I try to be absolutely honest and straight about color."

The artist has always applied his paint thickly, and his first inspiration was van Gogh. His sense of color, he says, is drawn from the work of the Impressionists. He describes his own technique as drawing with color, manipulating mass and bulk, and he has deliberately stopped using brushes.

The artist feels compelled to work by believing, literally and physically, in what he calls "the deed'" and acting instinctively as if "running with the painting, following the dramatic weather and light changes." By taking the "losses" and the "gains" in high concentration that such an approach produces, he says that he becomes different, and totally absorbed, as he tries to connect with nature.

An act of self-censorship then takes place in which he scrapes back, removes, and rebuilds the paint, although he also accepts that every mistake is a small part of the whole painting. Most of his landscapes are started and finished in situ. Others are completed in the studio.

**Method of working**
George works on primed board, usually white, but sometimes gray or a neutral pink color. He starts painting in the middle of the picture, toward the top, and then works outward.

His main colors are mixed on a piece of board used as a palette. Again, he likens his way of working to running as hard as you can – mixing first, picking up pure colors, and working wet-in-wet. It is not an accidental process, but chance and error play a part when you are trying to push things to the extreme.

The paint is applied with spatulas, the kind used for scraping wallpaper, about 4in (10cm) wide for the broadest marks. He works in as broad areas as possible, laying in lights first, moving toward darks in the painting. Different sizes of spatulas – 1in (2.5cm), 2in (5cm), 4in (10cm) – are used to pick up the individual colors.

The thickness of the paint produces a powerful drawing, and the artist uses the edges of the spatula blades for marks and details.

George finds that he is applying increasingly larger amounts of paint and has discovered that he can do more with fewer marks and bigger drags of the spatula. He has also tried using pieces of hardboard as spatulas, and plasterer's trowels, but he isn't comfortable with them.

### A "long" paint

The artist uses a vast amount of paint at a ratio of about four cans of white to any other color, so he buys the most economical, high-quality oil paint that is available.

His favorite is manufactured by Stokes in Sheffield in the north of England. He buys it in bulk and it is shipped directly to him in 1gal (5l) cans. Many professional artists use this paint, and George likes its quality and feel.

He has tried other brands, but the colors are different and the textures do not feel the same. It is important for his technique to have the elasticity provided by this paint. He is familiar with the pull and stretch of it. It is what is termed a "long" paint, with the feel of an old-fashioned formula. Modern paints are "short" paints, and the artist finds them over-ground and too fine.

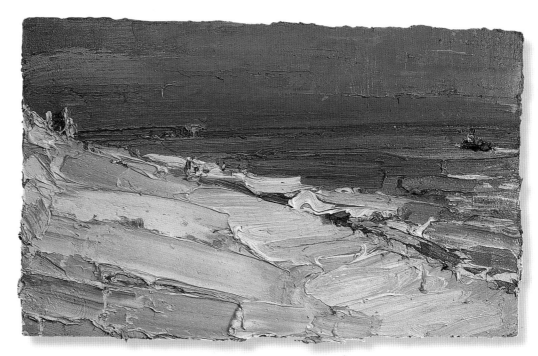

George Rowlett
**Sunlit Walmer Beach, Deal Pier, Bathers and Crab Boat, 1997–98**
Oil on board
30 x 48in (76 x 122cm)
*Collection of University of St Andrews*

### Dripping with colors

An easel, paint-mixing table, spatulas, still-life objects and a painting in progress in the artist's studio are all encrusted with color.

George Rowlett
**Sudden Storm over Thames, Rotherhithe Pier, 1996**
*(above and detail overleaf)*
Oil on board
24 x 40in (61 x 101.5cm)
*Private collection*

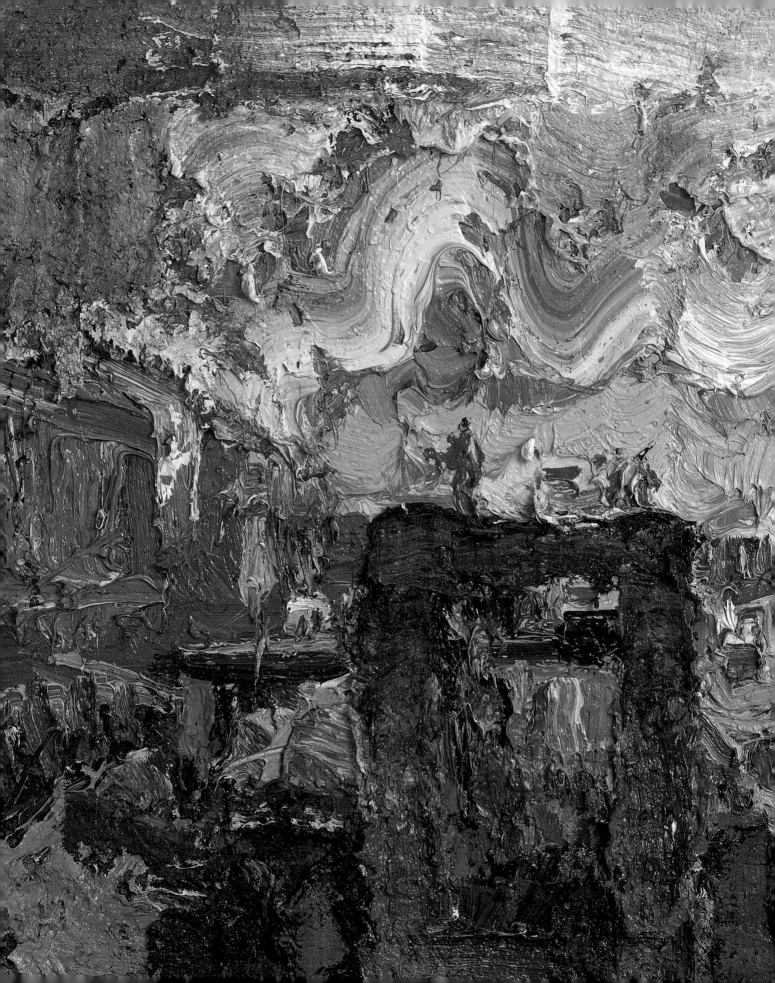

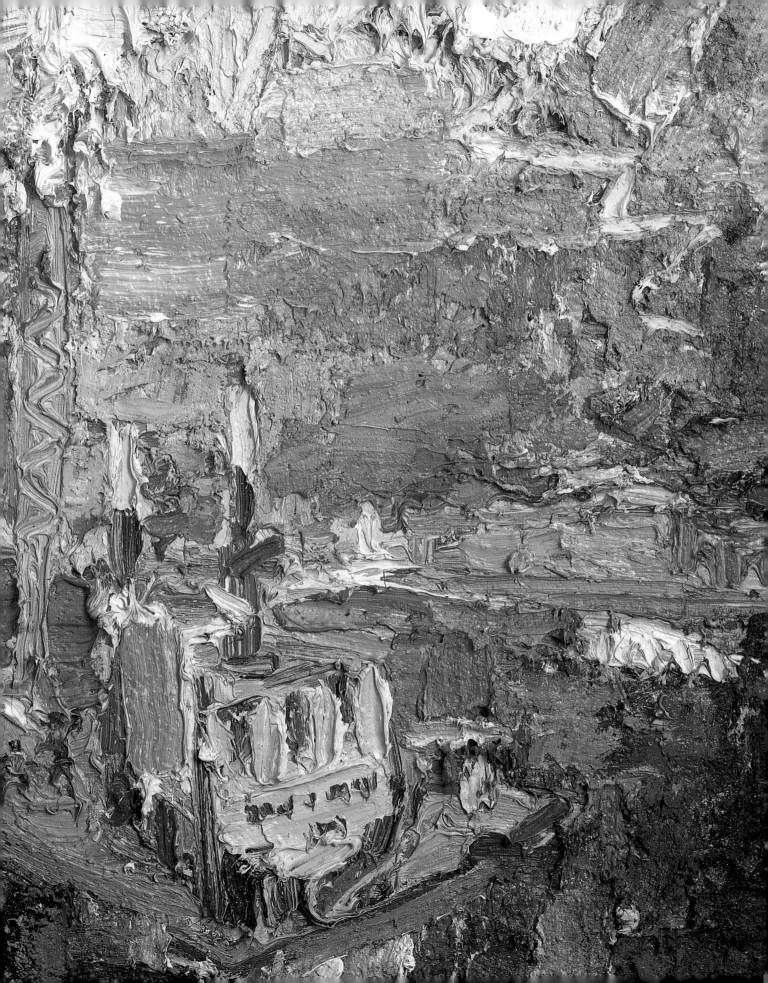

Sue Fitzgerald's vibrant, multilayered acrylic paintings reflect her passion for southern France and the Far East. She explores the richness of local culture and is inspired by an enveloping wealth of color and texture, from exotic fruits to rich carpets and fabrics to music.

### Color inspiration

Sue collects interesting china and textiles on her travels. She is particularly attracted by the sheen found on silks. Eastern fabrics are often threaded through with gold, and many cloths have mirrors and further patterns sewn into them. Sometimes she finds fabrics that are sewn from sections of old Indian bridal gowns, with a variety of patterns and textures, gold and silver thread all combined in one piece of material.

These treasures provide inspiration for her paintings: "I never really know what I'm going to paint next, except I may see an interesting object or a piece of textile." A find, such as a yellow Moroccan teapot, can suggest a picture that will feature yellow on a bright blue background: "I've got a mind-store of subjects I'm going to paint."

### Acrylic paints

Like many artists, she has noticed the considerable improvement in the quality and range of artists' acrylic colors since their general introduction in the 1960s. Good artists'-quality acrylics now compare favorably with oil paints.

She chooses colors, such as Alizarin Crimson, that are similar to the traditional oil-paint alizarins. Some of the cheaper "hue" colors have white or other additives in them and seem to lack the intensity and clarity of oils. Sue is not averse to student colors, but thinks that "when you spend time creating something a bit special, it's worth making the effort to use good-quality paints."

She uses many different colors and brands, not particularly favoring one make over another, but, in general, she likes artists'-quality paints that "have a nice buttery consistency." She also uses a more liquid acrylic that comes in jars.

### Mediums and methods

Mediums are sometimes useful if building up thick layers, but, with the more buttery tube colors, you can actually place a thick wedge of paint on the canvas, one that holds its shape, without using mediums. If you use gel mediums or texture pastes, you have to make sure you use the correct acrylic-compatible ones to avoid any cracking. A little medium in the paint will build it up more and can give the surface dramatic ridges and textures. When the paint is dry, Sue might rub a cloth over it and actually polish some parts to give a shine, accentuating the texture and reflection of color off the surface.

Equally, if the painting is not working, she rubs the picture over with a cloth, not to obliterate it but just to give it some "knocking around": "I throw paint at it, sometimes in blots, just shaking a loaded brush at it to disturb it. You can get too precious with a painting." Sometimes she may work for three days and then destroy what she has done, because she doesn't want to continue working at an unsatisfactory painting.

*"The reason why I describe my paintings as mixed media is because they are not just acrylic. In addition to a spot of watercolor, they have some gold or silver leaf."*

### Mixing media

Sue could never achieve the richness and depth she was after, so started using acrylic with watercolor. Now she mostly uses straight acrylic, which she applies very thickly. Sometimes it is mixed with a gel medium and texture or modeling paste. She works on canvas, with a palette knife, laying paint on quickly and building up the textures. When the light catches the painting, it reflects off different planes of texture, adding an extra color dimension to the work. Brushes are used for broad areas and detail.

Occasionally, she uses watercolor with acrylic to create a fluid-wash effect and then, finally, when everything is dry, she works in a gold or silver metallic color; this is a powder suspended in oil.

Sue Fitzgerald
**Cardinal Grapes and Silken Shawl**
Acrylic and mixed media on canvas
15 x 18in (38 x 46cm)
*(detail, left)*

*"Do not be afraid of using color in an unconventional way. Just because you think of leaves as green, break the preconceptions. If you think the leaves would look good blue, then paint them blue. Quite often when people look at foliage they don't realize that leaves are really blue or red or purple anyway."*

**Mixing colors**

Sue Fitzgerald uses mostly pure colors, but they become blended and overlaid to a certain extent on the canvas as she paints. Sometimes a dinner-plate palette is used but, by and large, the color effects and mixing, and the color differences, are all made and blended wet-in-wet on the painting instead of on the palette. For instance, she might decide to add a little green over the top of another color, although the one underneath is still wet. Then she works them together. She has always used color in this way, even when working in oils or watercolors.

Sue Fitzgerald
**Two Dragons**
Acrylic and mixed media on canvas
36 x 48in (91 x 122cm)

*"Whenever I go into an art shop I think, 'Oh! This is an interesting color,' and I buy it. Often it's just because of the color, or I may be thinking of a piece of cloth or china I want to include in a picture. For example, I've got some saffron silks, and I was thinking to myself that I needed a really 'saffronlike' color; then I came across a slightly transparent yellow, one that would work well. I don't set out to buy a standard set of colors, but just pick them up as I go. It's a haphazard method, but this is the way I build up my repertoire of colors."*

### Core colors
There are certain core colors that Sue always keeps in her studio, ones that she likes to return to in her paintings time and again.

### Colors and contrasts
Sue Fitzgerald likes contrast in painting, contrast between thin and thick line, large and small shapes, rough and smooth texture, dark and light, and bright and dull. She delights in the juxtaposition of precise pattern against big blocks of color.

Her advice is not to be frightened of color, but to experiment. Sometimes she might place a bright pink near a dark brown, for instance. Many artists like dealing with muted colors, but muted colors need not look dull. You can use Burnt Sienna or Indian Red and still get them to glow. Getting colors to glow depends on their context, what you put them against and how they contrast. For example, placing Burnt Sienna next to purple works well. You might think that these are strong dark colors without much contrast, but you do not have to use bright reds or bright yellows to create a glow. "People think of me as using really bright colors all the time, but I don't necessarily. I use an awful lot of dark purple and Burnt Umber and Raw Umber, too."

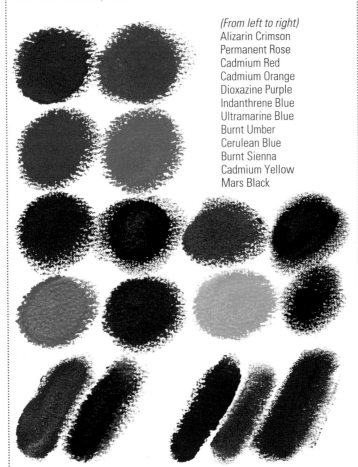

*(From left to right)*
Alizarin Crimson
Permanent Rose
Cadmium Red
Cadmium Orange
Dioxazine Purple
Indanthrene Blue
Ultramarine Blue
Burnt Umber
Cerulean Blue
Burnt Sienna
Cadmium Yellow
Mars Black

### Essential colors
Alizarin Crimson is a particularly important color for Sue. She also relies on Olive Green as a soft color for glazing and layering, although this color does not tend to be immediately evident in her paintings.

### Siennas and purples
A color, such as Burnt Sienna, can be used with purples to create vivid effects. Never think of such colors as umbers and siennas as dull colors, because they can be as bright and brilliant as, say, Cadmium Reds.

### Improvised palettes
The artist uses old dinner plates as palettes to put her colors on. She has employed a proper palette now and again and tried to use it in an orderly fashion, but finds china plates more acceptable. Colors are not laid out in any particular order, but squeezed out, with two or three on one plate and some on another.

### Organizing colors
Sue appreciates that a tidy studio would make her painting life easier: "I know if I was more organized, things would move along at a quicker pace and everything would be very precise, but that's not part of my nature. I have tried putting colors in order, the blues here, the earth colors there and so on, and it stays like that for about half an hour."

## Planning the composition

She never makes measured or preparatory drawings, or even initial color sketches before starting a painting: "I set up a still life, but only vaguely; it's not ruled or measured. If I want to do that blue cloth with that plant on it and those pots, I'll set it up but not in a very precise way, because I might decide to change it around or begin to move away from it. I never draw, I just go straight in with brush or knife."

## Working on canvas

She works on prestretched and primed canvas. "The type of surface weave doesn't really matter, because the surface gets obliterated by paint and texture anyway."

When she starts a new canvas, she puts some color on to break it up and get rid of the white. She may cover it all in Yellow Ochre, or just use up whatever is left on the palette. Sometimes more than one color is brushed on.

## Starting points

It does not really matter which colors are put on first. If two of the initial colors work well, they might be left as part of the painting.

Next, texture is introduced onto the surface. To start, Sue perhaps chooses one section to do some thick painting with a palette knife. This gives her an idea of how she might continue the painting, but she leaves it to dry before doing so.

**Unifying texture**
The overall textured surface brings a unifying element to the variety of colors and shapes in the painting.

## Developing the painting

She might leave spaces for the objects, or just roughly paint in basic shapes on the canvas, then works over them, or she might put some white shapes in. Acrylic is a versatile medium that allows for many approaches. The underneath texture tends to unify the painting. She works over the top, going into details, such as flowers and surface decorations, studying them and working them into the rough surface textures. Sometimes she works into wet paint with the tip of the handle of the brush, scratching into the paint.

**Gold and silver**
Sue uses gold or silver leaf most of the time in the final stages of a painting, not with every picture, but particularly for still lifes. "I use it in powdered form mixed with oil. I suppose it is becoming my hallmark. I put it on with an old brush, or I might flick it on, or I might rub it on, or whatever – all very accidental, a happy accident, but sometimes you get an unhappy one."

## Brush care

Sue always washes her brushes scrupulously and makes sure after a day's painting that all the brushes are dry. Acrylic can ruin a brush even in a couple of hours.

## Keeping brushes and colors clean

Sue is very conscientious about making sure that her brushes are always cleaned, dried off properly and standing up after use.

She is also fussy about changing the water frequently when painting: "I have a big pot of water, no little jam jars. I always try and keep the water as clean as possible. I change the water a lot, because, if you've used one color and then you start to use another color, you are sure to get elements of the previous one spoiling the subsequent colors."

*"I am trying to achieve a luminosity and transparency of light and color. I call it see-throughness."*

Marina Yedigaroff is a painter who is fascinated by surface and beyond. She paints on paper, canvas, board, fabric, walls, doors, furniture, boxes and even wooden bowls. Moving from surface to surface, her techniques and her attitudes toward color are constantly evolving. Her gallery paintings are executed in a variety of sizes and media.

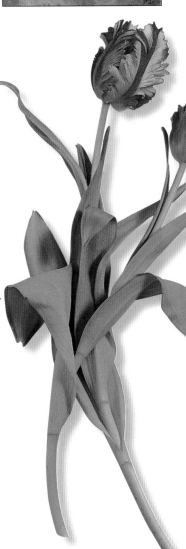

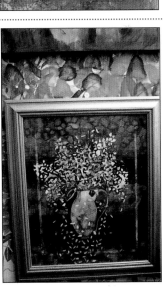

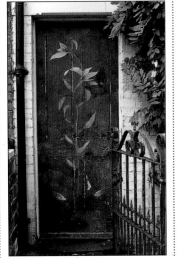

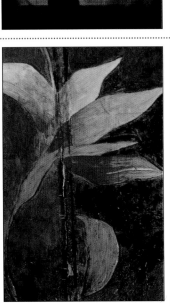

**Decorated house**
One of Marina Yedigaroff's concerns as an artist is with what lies beyond the surface. Behind the painted doors and curtains of her house lies a wealth of color and imagery.

**Inspiration and media**
The artist paints figures, birds, animals and flowers, creating intense decorative compositions that she describes as being in a "mood-affective colorist style." She is inspired by stained glass and the idea of light shining through objects from the back to the front – something that nature does all the time. The paint is applied extremely wet, so that the work has fluidity and transparency. "See-throughness" is an obsession, and she is constantly seeking to achieve a luminosity in her painting.

**Visual themes**
Flowers, figures, birds and animals appear in the artist's work. Among her favorite subjects are tulips with their variety of petal shapes and inspirational colors.

## Working in gouache and ink

The artist uses a technique that is her own. She paints a picture in the normal way, using gouache, and, when it is all done, she draws all over it with a technical pen. The process is not as simple as it sounds, because the idea is to create another dimension of see-throughness. This involves drawing a transparent veil over the painting. She starts from the bottom of the picture and progresses upward, working in parallel, horizontal lines in colored inks.

Gouache, ink and technical pens

Marina Yedigaroff
**Chrysanthemums**
Gouache and ink on paper
20 x 30in (51 x 91.5cm)

The degree of transparency and color of the ink changes as she proceeds: "I work over the whole surface of the painting row after row, changing the ink color and transparency as I go; it is all terribly time consuming. It is as if I am putting a fine gauze curtain between the viewer and the image." She leaves parts untouched, too, so the pure color of the gouache can still be seen underneath. In the painting *Chrysanthemums*, for example, areas of pure color are left and a frame within a frame is created by leaving the border untouched.

*"I mix and mix my colors, adding Alizarin Crimson, Bengal Rose, anything. I use small brushes and strong paper, but I am very organized. I have to be to maintain clean, pure colors."*

The artist never knows what is going to happen as her technique creates further dimensions of diffusion: "It just does something to the painting; you look through it and at it at the same time. It kicks the colors in and out."

*"Everything I do has this wish to get behind and beyond the surface and look through to something else, yet not see it absolutely."*

The point is not in the lines on the painting, but about the effect they have on the colors underneath. The color of the ink changes from blue to black to brown. Although the lines are evident in the finished work, the artist sometimes wishes they were not, as it is the altering effect that interests her instead of the physical appearance of the lines. She acknowledges that there may be some influence from textiles, describing her work as "a kind of embroidery with a pen," but these are not textile designs, they are paintings.

These pictures come into the category of mixed-media paintings and a strong surface is needed to support the wet layers. The artist always uses a heavy 140–200lb (300–425gsm) watercolor paper with a smooth or Not surface and works in a variety of sizes. She is not particular about the make of gouache or ink she uses, simply judging by personal preference.

The artist usually works flat on a table. Colors are not set out in any particular order, and instead of a conventional palette, she uses an old china dinner plate. Favorite colors to which she likes to return time and again are Olive Green, Burnt Sienna, Payne's Gray and white. She makes numerous mixtures of her colors, adding any colors that attract her and are at hand. However, she is careful to work methodically in order to preserve clean mixtures.

Ink and gouache works are framed behind glass to protect them, but she is passionately averse to nonreflective glass, because it seems to drain all the color away from a painting.

## Oils

### Working in oils

In some cases Marina Yedigaroff works from life and in others from her imagination. The tulips in *Red Tulips*, for example, worked in oils, are painted from life. She often chooses to paint tulips, but many of the flowers she depicts are from her head. Birds are another favorite subject.

Some people are surprised to find that these paintings are oils and believe them to be watercolors because of the transparency of the effect, but oil paint is the artist's main medium when working on board. Again, she paints extremely wet to maintain luminosity and transparency, mostly on MDF, first preparing the board with white acrylic primer.

She starts with the image, sometimes drawing it out first, but not always. With *Red Tulips*, the flowers were painted on the board and looked "rather ordinary" on a white background, so she started working into the background, using a brush in one hand and a hair dryer in the other. Her painting evolves subconsciously without a plan in mind, using very thin, diluted paint.

A painting such as this is worked flat, sitting at a table, but for larger paintings an easel is used. Oil painting is much faster than painting in gouache and ink. The artist's oil technique is very precise, because she is still aiming for transparency and movement. Color is not flooded on, but she needs to work very fast and the hair dryer helps to move the paint, blowing it around the surface. Although working in oils, the paint tends to dry fairly quickly because it is so thin.

Mineral spirits is used to dilute the colors: "I have to keep my brushes clean to maintain clear, pure colors and have to frequently change the mineral spirits."

The artist believes that oils settle. A finished painting is put straight up on a wall, and, after a few days, it looks as if the surface has changed. If she thinks it looks awful, she just paints over it.

*"I am very driven and always planning what I am going to paint next."*

Marina Yedigaroff
**Red Tulips**
Oil on board
20 x 30in (51 x 91.5cm)

### Choice of media
Oil paint, gouache and ink are the main mediums used. Occasionally, the artist paints with acrylics, particularly for exterior mural work, but she dislikes this medium for conventional painting, finding it artificial and plastic-looking. The transparent effect that she achieves with oils, using diluted mixtures of colors, is more usually associated with watercolor paintings.

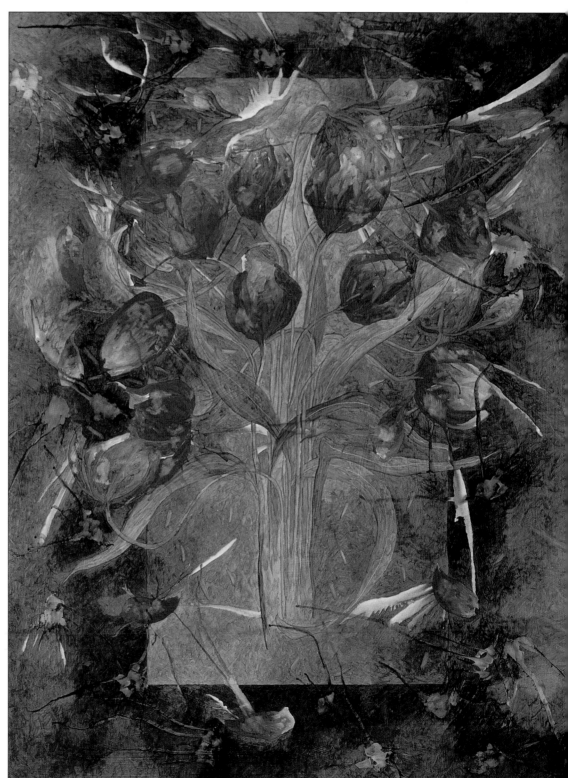

Daphne Jo Lowrie is an artist who moves freely between oils and watercolors. In her recent works, she has used oils for painting still-life and landscape subjects and has concentrated on simplicity of color, form and composition to convey the basic essence of her subjects.

*"My work is about simplification. I am trying to get to the essence of the subject by eliminating unnecessary detail, which may confuse the eye and detract from the colors and shapes of the painting."*

**Titanium White and Yellow Ochre**

**Cadmium, Alizarin and Venetian Red**

**Cerulean and Cobalt Blue**

**Medium and Light Cadmium Yellow**

**Lemon Yellow and Aureolin**

### Choosing color

Although the artist does not necessarily choose expensive pigments, she insists on having good-quality colors in her primary color selection. She always has an artists'-quality red, yellow and blue available, and there are two core colors that are essential to her palette and color mixing range. These colors are white – usually a Titanium White is selected – and Yellow Ochre.

Colors are chosen from the primary colors, depending on the subject or mood, but the artist often chooses her primary hues at random. Those she tends to use are Cadmium, Alizarin and Venetian Red, Cobalt, Ultramarine and Cerulean Blue, and a medium and a light Cadmium Yellow, a Lemon Yellow and a rich yellow, such as an Aureolin. For a blue-mauve effect, for example, she works with Alizarin Red and Ultramarine Blue.

Specific color themes are often developed. A coastal series of paintings, for instance, uses Cadmium and Venetian Red, Cerulean and Cobalt Blue, and a Cadmium Yellow for warmth. Her foundation colors of white and Yellow Ochre are always included.

### Working with oils

Daphne Jo loves working in oils. Oil paint is malleable and dries slowly, and she particularly likes the way it can be moved around, allowing the artist to stroke it on smoothly or leave brush marks and textures: "It is sheer joy every time I dip my brush into this lovely buttery material. I enjoy its versatility and its sensuality."

From an emotional, rather than practical, point of view, the artist finds that oils have a quality that takes her mood. It is a positive medium, so she can take a gentle approach, yet within seconds become dramatic and forceful.

Getting it on clothing and having to clean brushes afterward is a problem, but oils offer something that other painting media cannot.

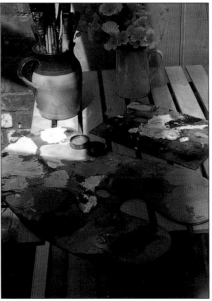

### Mixing color

The artist works with two palettes, keeping her main colors on one palette and using another palette for mixing. It is all very organized, although it sometimes does not look so. She may take half an hour to mix a color, and it is an important process for her: "I sit quietly and think about my graduation of mixes that will create the harmony in the painting." She mixes a lot of color first in order not to stop work in midflow.

Picking up individual colors to create a mixture is equated to a marriage, with the colors regarded as a family. A little of all those colors are taken from her basic palette through to her mixtures. These are modified all the time, but because they are all from a common source and related, this creates harmony in the painting.

*"At the end of the day, with the paints that are left over, I can create a lovely gray. And I know that this gray is made up from all the relatives."*

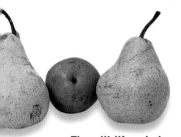

**The still-life paintings**
The artist has been exploring a pictorial theme that is strong and graphic with blocks of color contained within defined shapes. In these paintings the negative or background and in-between shapes are as important to her as the positive shapes of the objects. Her starting points are simple still-life arrangements set up on a table in front of a window. These become a basic color, shape and compositional reference, and from this the artist can quickly start interpreting and improvising.

Daphne Jo Lowrie
**Siblings, 2001**
Oil on canvas
21½ x 17¾in (55 x 45cm)

☛ **See also**
Choosing media/Oils 30–31
Choosing palettes 40–41
Black 76–79

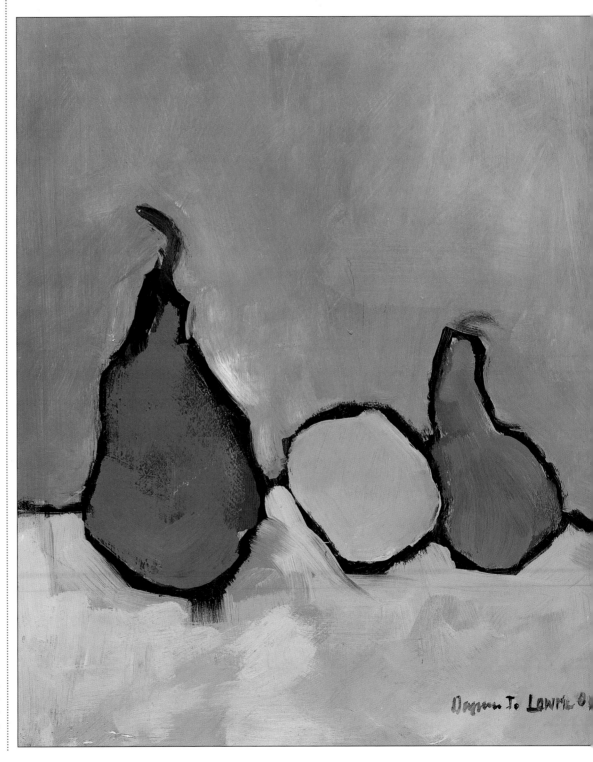

Daphne Jo Lowrie
**Still Life with Orange Flower**
Oil on canvas
21½ x 17¾in (55 x 45cm)

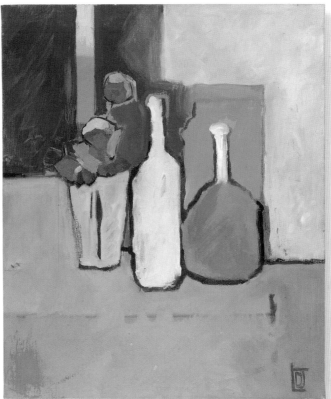

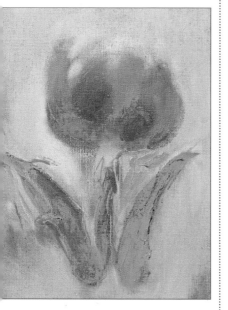

## **Varying intensity**

The intensity of the color and texture within a painting is changed by applying color either thickly or very thinly in the way one would use watercolors. The artist works with paint straight from the tube, without mediums except for turpentine or mineral spirits. Working over or around "dribbly," thinly painted passages with thick, "juicy"' paint, she makes almost three-dimensional marks: "I do not tend to build up surfaces and layers and transparent glazes.
I like working directly and immediately. Processes and stages worry me."

Daphne Jo Lowrie
**Still Life with Bottles**
Oil on canvas
21½ x 17¾in (55 x 45cm)

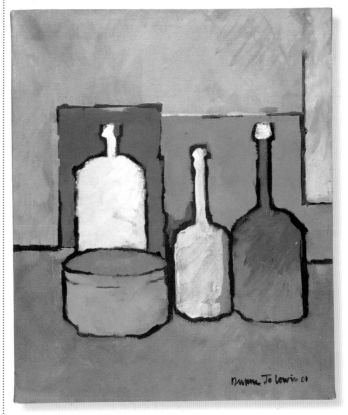

## **Exploring a theme**

In these paintings the artist started by tinting the canvas with a thin mix of Burnt Sienna, then very aggressively painted in the outlines of the objects. She made a dark-line brush drawing of the entire setup. Black is not normally used as a mixing color, but here she used pure black with a little Alizarin Crimson to take off the intensity.

When you look closely, however, you can see that the outline is not all black. Traces of other colors have been picked up, so the line wanes and softens. Sometimes there is a little red, making the outline brownish. Sometimes a little Raw Umber is added and this, too, makes the outline a little gentler. This brush drawing is used as a basis to give the picture its structure.

The artist originally thought of these still lifes as being very conventional paintings of objects standing in space. Her plan was to fill the shapes in and overpaint them, but she started painting up to the line, biting into it and occasionally obliterating it altogether, although always leaving it as part of the composition. On standing back and looking at the outlines in relation to the colors, she decided that she liked the line and that it worked in the painting. The outlines are very successful in defining both color and shape, particularly in the way the color bounces off the dark lines. The pictures evolved accidentally from here, and she went on to paint a series of images.

**Interpreting color**

The colors from the still-life setup are interpreted to the painting in an emotional rather than an objective, observational way. For example, in *Still Life with Orange Flower,* there is a clear white bottle and a blue pot with an orange flower. It is the orange flower that attracted the artist in the first place, and she wanted this to take her into the painting. So she played with colors until she found a combination that worked with the orange flower, mixing a blue for the vase that complements the orange of the flower. This approach makes a starting point and sets the code for the rest of the painting.

*"As soon as I get my first colors down, I am already sensing how to move the painting forward in color and tone. I sometimes go wrong with a painting and have to scrape it back to zero, but I realize quite quickly whether a painting is going to work or not."*

Daphne Jo Lowrie likes painting on paper and started the studies for the outlined still lifes on paper before moving on to canvas. The artist wanted the pictures to be simple and unframed, so the color is carried around the edge of the canvas, too, and she started thinking about the whole painting as an object in itself. When you look into these paintings, there is a lot of pattern and abstraction in the forms. Working in oils allows you to create lovely movements in the color, which adds to the design. Getting excited about the paint and the color overtakes concerns with the observation of the image. The forms and shapes become the vehicles that allow the artist to play around with color and the texture of the surface.

*"I sometimes pick up colors unintentionally. There are often happy accidents that take place, mishaps that can transform a painting from the mundane to the sublime."*

## Vivid solid-ground colors

Sometimes the artist paints a whole canvas in a really strong, assertive ground color, and then everything that goes on top of that color involves a hard fight. You have to work hard to get your colors to register and in that process you can come up with some extraordinary and interesting hues. You are setting yourself a challenge by starting with dominant and powerful ground colors.

**Solid-color grounds drying, waiting for the first marks.**

The artist may decide to paint some boats on one of these strong grounds, not boats with all their rigging and equipment, but the organic shapes and geometry of boats. These strong ground colors are painted as a challenge for when she does the final paintings, and they enable her to create color mixes and combinations that "sock you in the eye." Strong and powerful effects often cannot be achieved on a purely white ground.

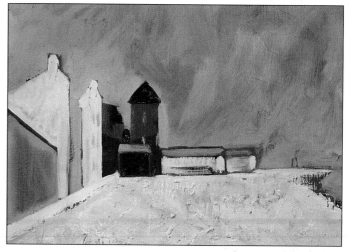

**Venetian Red ground**
This painting in progress is painted on a solid Venetian Red ground, and there is also some local underpainting in solid Burnt Sienna. The dark red and sienna peep through the subsequent colors; these little areas that are left attract the eye and create an excitement on the surface of the picture.

*"I work mostly with oil paint straight from the tube, applying it with a knife. I like the simplicity of it. I do little preliminary work other than a basic simple line and brush drawing."*

## Working with oilbar

Oilbar, also known as oil-painting stick, is used like a drawing tool. The basic drawing work can then be thinned and blended to make transparent lines and washes.

*"I find this preliminary oilbar work can bring a glow to the color. The underlying transparency brings a luminousness to the subsequent layers of pure opaque color that I lay on with a knife."*

John Reay is an artist who works on large oil paintings. Many of his works are populated with hundreds of figures. Using a palette-knife technique, often worked over an oilbar underpainting, he creates what he calls "a broken prismatic effect" to produce luminous and vibrant surfaces of color and light.

## Working methods

The artist works on primed board, either hardboard, plywood or MDF. He likes working on board, because its tough surface allows him "to attack it when using a knife."

Experience has shown him how to prime the board with the exact painting surface he wants: "I use a coarse lambswool roller to give the surface a bit of tooth and, depending on the speed and density of primer application, I can lay down whatever surface texture I need."

He then tints the prepared board with a thin wash of neutral-colored acrylic or oils. He tends to keep to a consistent lilac-gray tint color when painting directly. This neutral ground color does not influence the outcome of the final picture greatly, and there is little chance of it darkening and influencing the subsequent colors in later years. If he is underpainting with oilbars, he often works onto a white-primed surface.

He uses good-quality oil paint, with no thinners or mediums, except for paintings where he has employed oilbar (oil-painting sticks) to make the basic underpainting.

**A lilac-gray tint color provides a useful neutral ground.**

## Composing the painting

With these very crowded subjects, the artist has an idea of the dynamics of the whole painting, but he does not draw each individual figure. If he started drawing all the figures one by one, he could become confused, so it is essential to have an overall pattern and scheme in place.

Sometimes he makes a few rough preparatory sketches with a ballpoint pen to work out the dynamics of the composition, but he puts in the figures as he goes, reinventing them as he paints. He has an overall picture in his mind, but he does not draw it all out in detail: "I put in a very basic brush-line drawing, but I do not stick to it when I get going. The idea of the drawing is just to indicate the basic size and position of the figures."

If you look closely, you will see that the application of color, the knifework and brush marks create the figures. The color is not filled in between drawn outlines.

The artist knows roughly what type of space the figures and groups need to occupy. With so many figures appearing in a painting, correct perspective is important and the diminishing sizes must look right. He does not want some figures too small or others too big, so he keeps an eye on where these people all are in space. The painting is improvised within a fairly tight mental plan as he works.

## Oilbar for underpainting

The artist often uses oilbar as a basic drawing tool to make an underpainting and to draft in the forms and the composition. He makes a large drawing with oilbar that looks very crude at this stage, then he uses a round brush to blend the drawing with turpentine, so that it looks more like a painting. The oilbar work becomes very thin and transparent, and then he works over it with the painting knife.

He considers the oilbar technique as another way of drawing, as an intermediary stage to lay out the composition and lay in color. Sometimes he reverses the color; for example, he may have an underpainting of green and then work over it with red. Oilbar enables him to build up layers quickly and to create color contrasts of one color over another, so he can create the broken prismatic effect of the surface of his paintings.

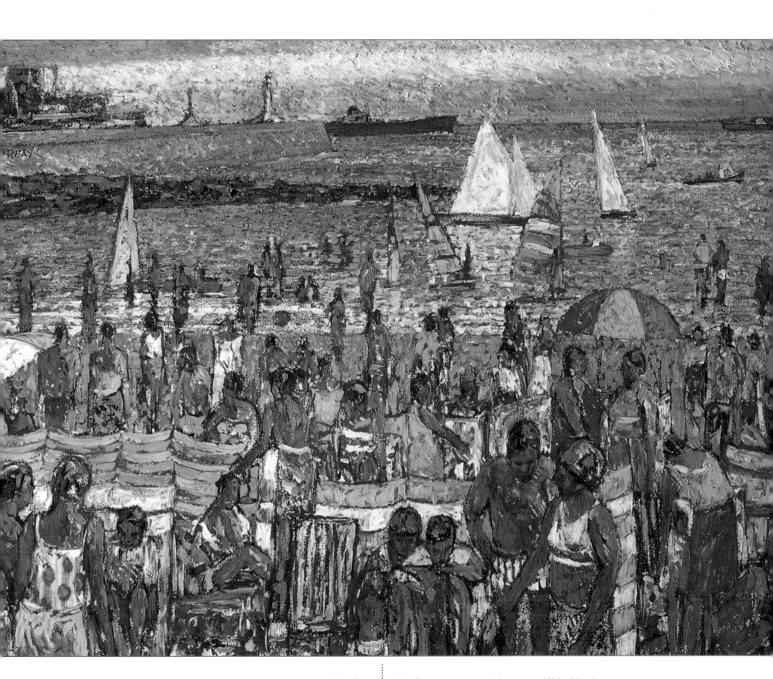

John Reay
**Lowestoft Beach**
Oil on board
36 x 48in (91.5 x 122cm)

John Reay pursues techniques established by the Fauvists and Impressionists, who expressed light not through tonal means but through color contrasts and juxtaposition.

## Light

For about five years, John Reay worked exclusively outside, painting from nature. As a result his approach to light in a studio painting is now automatic and intuitive. In a complicated figure scene, he finds that light is a unifying factor in a picture. It pulls everything together and brings a logic to the color: "It is not entirely this, of course. There are other factors to take into account, but light is so important for me. In all my paintings, whether single or massed-figure compositions, light and the way it strikes the forms is an important part of the painting."

*"I seldom mix color on the palette. If I want a midtone, for example, I pick up the component colors and mix them while spreading them on the canvas."*

*"I often pick up two or three colors on the knife in one go and blend them wet-into-wet on the surface."*

## Colors and paints

The artist usually works with more or less the same color range. The reds are Alizarin Crimson, Cadmium Red and Vermilion. The yellows he chooses are Cadmium Yellow, Cadmium Yellow Light, Lemon Yellow, Yellow Ochre and, sometimes, Raw Sienna.

For blues he selects Cerulean Blue, Ultramarine Blue and sometimes a Cobalt Blue. He also likes Viridian, a premixed green. He does not use black, preferring to mix Alizarin Crimson and Viridian to create a lovely dark that is full of color.

**A mix of Alizarin Crimson and Viridian creates a soft, rich dark.**

He nearly always chooses Titanium White as it is a strong opaque white. He finds Flake White can often be a little too heavy and textured when used straight from the tube. Titanium White has a much smoother consistency for knifework.

The color that he tends to use probably more than any other is Yellow Ochre. He describes it as "a lovely, earthy color and a medium range one, too, a warm glowing color." He finds it brings a bronze quality to flesh and an underlying earthy, yet human, warmth to figure painting.

**Yellow Ochre is a warm, resonant color.**

### Core colors

| |
|---|
| Alizarin Crimson |
| Cadmium Red |
| Vermilion |
| Cadmium Yellow |
| Cadmium Yellow Light |
| Lemon Yellow |
| Yellow Ochre Dark |
| Yellow Ochre |
| Raw Sienna |
| Cerulean Blue |
| Ultramarine Blue |
| Cobalt Blue |
| Viridian |

## A prismatic palette layout

He lays out his colors in a rough sequence. Because he does not stick too carefully to a set order, some of the colors can become mixed up. Basically, he follows a visual layout, from reds, grading through purples to warm blues, then through to cooler blues and on to yellows and greens.

Following this prismatic approach is useful, particularly because he works at a fast rate when he starts painting. It makes sense for the colors on the palette to have some kind of order and relationship, with the reds next to the oranges and the crimson closer to the ultramarine, for instance.

His palettes are disposable pieces of board. He uses the same boards time and again, but they eventually reach the point where they are unusable, and he simply throws them away. Because the color mixing takes place on the surface of the painting, there is a good chance of colors contaminating one another on the palette. With the colors arranged prismatically, there is less chance of contamination.

*"Sometimes you find accidental color mixes on the palette are more interesting than those that are happening in the work."*

## Knife and brushwork

Most of the color mixing takes place on the surface of the painting. The artist frequently blends his knifework with a brush, particularly in parts of the painting where the forms are small, and also where using pure knifework would overshadow the form and make it look clumsy.

The outline of a form is reestablished with a brush and the inside attacked with a knife, creating a kind of visual dialogue of brushed and knifed marks: "You cannot paint with a knife in a tight, limited way; it has got to be used in blocks and patches of color."

He finds that, with a knife, it is a process of defining, losing and redefining the form throughout the whole composition, going over it again and again with the knife.

*"I find with a painting knife, I can get amazing mixes, because the individual colors never quite blend, particularly if you pick up two colors on different parts of the knife blade. They become blended in the mark that results."*

*"In this technique of painting, accident and chance can play a large part."*

John Reay
**Lowestoft Beach**
(same-size detail)

In this technique of painting, interesting effects can occur by chance. It is very much part of painting with a knife that the artist can accidentally pick up a fleck of color, but the color does not blend in the same way as it does with brushwork. The colors showing through from underneath are important, making an interaction between the different layers of color. Sometimes, if an area of the painting has gone "dead," the artist will deliberately change the color. If someone is wearing a blue shirt, for instance, he may find that changing it to a red or green one brings some sparkle back into the painting.

## How long does it take?

John never times how long a painting takes. It can be weeks or months, sometimes years: "The initial laying in is usually done quite quickly, but, when the picture has a lot going on, I am redrawing it all the time, building up the colors and working to get a greater richness and balance."

He tries to complete the knife-worked passages in one session, but it is not always possible. It is not so satisfactory to go over a painting again when it is dry. There is a different feeling and a different blend of paints when working over a dry, encrusted surface.

Sometimes he needs to go over a painting or parts of it again to make it work, but the best ones are often those done with minimum overworking. There is always a greater obvious freshness in the application of the color.

*"We tend to get through a lot of white; it's probably the greatest volume of any of the colors we use. When working on this scale we use a lot of tints – we don't need our colors to be too bright."*

Jessie Carr and Lucy Dunsterville are two artists who paint huge backdrops or "cloths." Their work is seen mainly in film, television and stage productions and is often used to decorate and provide atmosphere for special events. They are, in a sense, commercial artists working to order or commission, but they also create their own works, for sale or hire, which they post on their website. They choose household colors as a matter of course, and use them successfully.

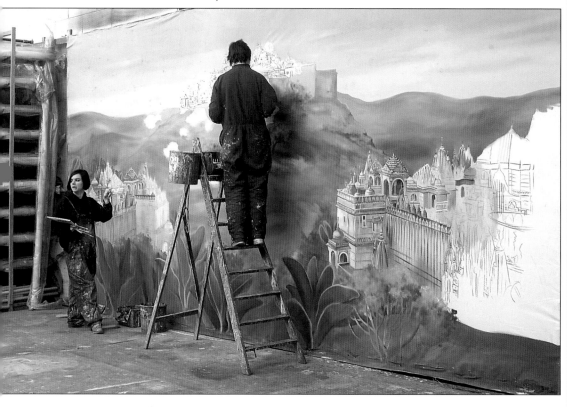

## Bulk-volume colors

There are many kinds of colors – mainly with an acrylic base – that are available specifically for large-scale, scenic and mural painting. However, through experience, these artists have found that ordinary household flat latex paint suits their working methods best.

## House and industrial paints

While household paints are inexpensive in comparison with artists' paint, the artist needs to bear in mind that these paints are designed for a specific purpose. They are made for decorating rooms and houses where the colors will be changed, on average, every two to five years. Thus, these products are aimed at a market where extreme longevity is not the prime concern, so they are generally composed of ingredients that can eventually fail.

From an artist's point of view, the binders and fillers they contain, particularly in latex paints, can often make colors look flat and chalky and, therefore, lacking in intensity when used for painting a picture.

## Sound technique

Paint specialists generally recommend that artists do not use industrial, household and decorating paints in their paintings, and there are good reasons for this advice. The main one is that the pigments and binders used in these paints, compared to artists' colors, are less stable over time. Decorating paints, however, are perfectly good products in themselves. They offer a huge variety of colors and finishes, and they are available in hundreds, perhaps thousands, of different hues, tints and shades.

For painters who use nonart colors, the longevity of their work is an important consideration that requires them to follow sound technique. By staying with one medium – that is, not mixing alkyd, or oil-based, and latex, or water-based, paints – and working on appropriate supports, artists can avoid future problems. Works that are 20 years old can look as good as new after being vacuumed, then sprayed with water to tighten them.

## Core colors

Decorating paints are given names that aim to create a mood and emotional response in the buyer. The same hue may be given one name one year and a different name the next. Sometimes a color is discontinued altogether, which can lead to difficulties with consistency. The core colors used by Jessie Carr and Lucy Dunsterville all have commercial names, but they have fairly well-matched equivalents in artists' paint-color ranges, too. If you have a good eye and know your colors, you can easily find hues that resemble artists' colors.

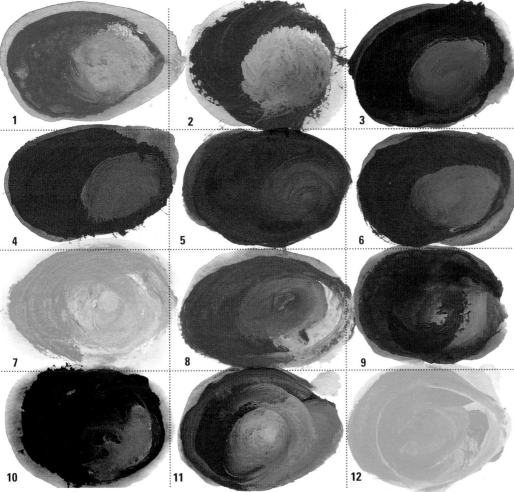

## Choosing a palette

Their palette consists of ready-mixed paint bought directly from the supplier, and, with a chosen set list of colors, they can achieve a multitude of effects without having to resort to complex color mixing in the studio. Obviously, they mix and blend individual colors to achieve specific detail and the subtlety of effect they are after in certain passages of a painting, but, on the whole, they find their set palette of around 12 colors covers most of their requirements. The standard colors they use are: black, white, three blues, three browns, two reds, a pink, two greens and a yellow (see left).

## Preferred finish

Just as artists working on conventional "easel" paintings discover their preferred brand of color, so these two artists have discovered theirs and always use the paint brand Dulux. They only use the flat-matte finish, except for black, where they prefer the satin-gloss variety for its stronger pigmentation.

*"We find this brand best for consistency and flow; the colors mix well and dry evenly. Some other brands can dry with a bit of a plasticky film."*

| Trade Name | Generic Name |
|---|---|
| 1. Regatta | Cerulean Blue |
| 2. Aria | Cobalt Blue |
| 3. Apothecary | Ultramarine Blue |
| 4. Poppy | Cadmium Red Light |
| 5. Fancy Dress | Naphthol Red Light |
| 6. Monarch | Quinacridone Red |
| 7. Gold Cup | Cadmium Yellow |
| 8. Bracken | Yellow Ochre |
| 9. Saddle | Burnt Sienna |
| 10. VanDyke | Burnt Umber |
| 11. Hollybush | Chrome Oxide Green |
| 12. Goblin | Perm. Green Light |

## Mixing and painting

The medium the artists use for thinning their colors is water, and a lot of it. At times their painting method almost becomes a staining technique, because they brush and scrub the color into the unprimed and absorbent support, flooding pure color into large areas with big housepainter's brushes, alternately picking up the shadow and detail with smaller brushes. They blend colors directly on the raw-calico cloth and create special colors by mixing their paints on the floor.

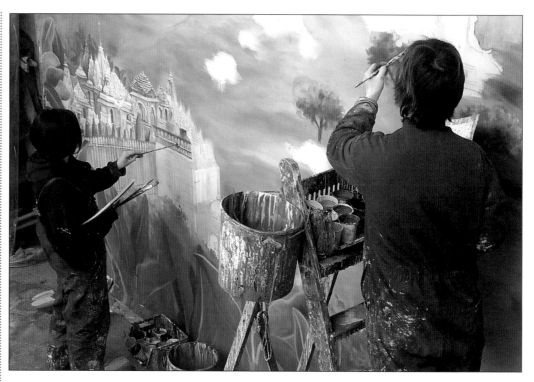

**Studio techniques**
Housepainter's brushes are used for painting large areas and the floor is used as an improvised mixing palette.

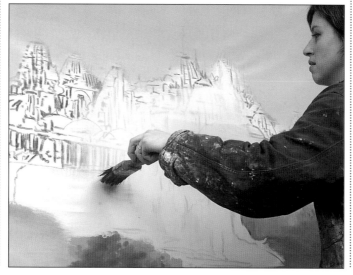

## Color on a large scale

The scale of the work is amazing when compared to a conventional painting. An average work would be 20ft (6m) long and 13ft (4m) high. The maximum scale the artists prefer to work to is dictated by the height of their studio – their current painting frame is limited to a 13ft (4m) height – but they have worked on huge pieces up to 120ft (37m) long, and these have to be tackled in sections. If the height exceeds 13ft (4m), they have to allow the calico to extend down the wall onto the floor, and they often paint sections working upside down. It tends to work out that Lucy, being the taller, works on the top sections, while Jessie tackles the lower ones.

**Painting surface**
The support used to paint on is artists'-quality calico. This is a fairly lightweight cotton material, and they work on it unprimed.

## Planning a painting

On approval, after discussing details with the client, the artists transfer a preparatory sketch onto the calico support, using a measuring system, then draw the whole composition in with charcoal, modifying it as they go.

When painting the final canvas, they keep color references at hand, working from their own reference photographs or magazine and book references, depending on the commission.

In this case an Indian city was central to the commission, and they had to work from photographic references for the scorched city and the dry, sandy earth colors of the landscape. The succulent green foreground foliage was taken from references made at the Royal Botanic Gardens, Kew, in England, and the final success of the painting is left to their skill and imagination.

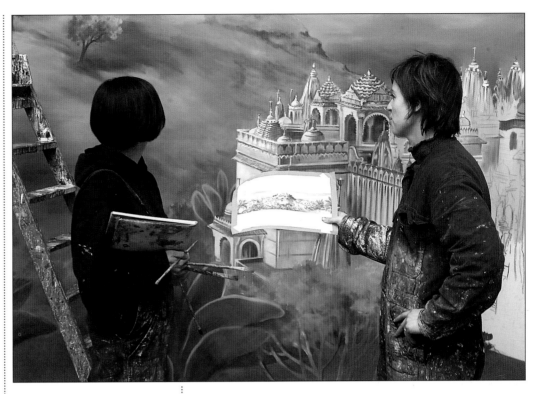

### Color swatches

When painting the final canvas the artists make color swatches, planning the hues, tints and shades they will require. They keep the selection of colors as simple as possible, having found through experience that if too many colors are mixed together the overall effect is deadened and the life taken out of the painting.

### Teamwork

The artists work as a team – two people as one. They tend to paint their own sections, with different spurts of energy. A painting measuring 13 x 20ft (4 x 6m) takes two or three days to complete.

### Preparatory sketch

If it is a commission the artists are working on, it will start off as a fairly detailed small sketch painting that will be done to the exact proportions of the final required size. They may show some alternative color variation sketches, too, and the presentation sketches are accompanied by a color swatch.

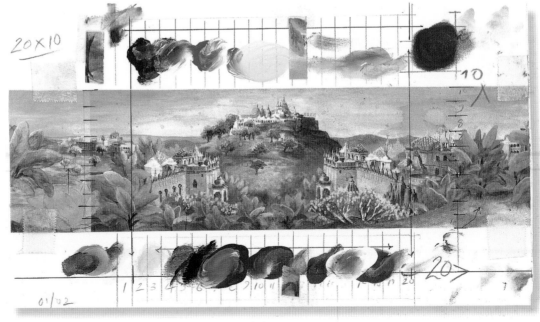

*"I admire the recycling ethic and work with that in mind."*

Judith Chestnutt describes herself as a papermaker, and the raw material of her work is junk mail that she makes into paper pulp. Judith utilizes the mountain of printed advertising material that accumulates in her home – the unsolicited coupons, leaflets and flyers that are commonplace in every household. She rarely needs to buy any manufacturers' colors for her creative pursuits, because her medium is delivered for free through her letter box every day.

### Selecting the raw materials

Judith Chestnutt has developed a sharp eye for the type of junk mail she is looking for. Some printed papers perform better than others in the recycling process and produce a more successful finished work. When thinking of a new paper-pulp picture, she sorts her papers for reuse, using tried and tested criteria.

The artist avoids paper that has previously been recycled, and she can usually tell through experience which papers these are. This usually precludes the use of newsprint, which is often, but not always, on recycled paper. The problems with such papers are that the fibers are too short: "If you think about it, the paper has been shredded once before in the original recycling process; I get hold of it and shred it again and the fibers have become even shorter. The paper pulp does not blend easily and join together in the finished work."

The papers should not be too shiny. Gloss art and machine-glazed papers and those with heavily varnished inks do not recycle into pulp easily. These papers do not absorb water readily and this makes the process of conversion to paper pulp more difficult than it needs to be.

This does not entirely exclude the reuse of shiny paper for recycling; it can be used, but it has to be soaked for an extremely long time. Or it can be boiled, because this helps accelerate the water-absorption process that is essential in making a good pulp, but boiling results in color loss and, in turn, leads to a pulp that is of more subdued color.

Selection of the raw materials for the paper-pulp medium is a continuous process, and the artist sorts the junk paper systematically by color into her storage system – reds in one drawer, blues in another, yellows in another, and so forth.

### Shredding and pulping

The selected paper is torn and shredded color by color, and, from this selection of raw material, the artist manufactures her paper pulp.

It is a simple enough process, but achieving a workable pulp that will blend and stick together in the final artwork requires experience and a good eye for the right raw materials.

### Shredding

Having selected the papers for recycling, the next process is shredding. Hand shredding is best, and the artist simply tears up the paper into small pieces. Sometimes she uses a shredder, the type you can buy in an office-supply store for destroying documents. Using a shredder is less labor intensive and saves time when working on a large piece, but on the whole the artist has found hand shredding to be a more satisfactory method. Torn-edged paper breaks down more easily than paper with cut edges, and the fibers tend to remain intact for the pulp-making process.

### Recycling envelopes

Bank and junk-mail envelope interiors provide a wealth of blues for recycling to paper pulp.

Judith Chestnutt
**Color sample**
Paper pulp
6 x 4in (15.2 x 10.2cm)

*"I use whatever paper I can get. Bank envelopes with blue patterns printed inside make nice skies."*

Judith Chestnutt
**Shoreline, 2001**
Paper pulp
12 x 12in (30 x 30cm)

The artist is committed to conservation, and the materials seen in her paper-pulp images of shorelines celebrate this passion. In recycling seemingly useless paper into individual artworks, she combines her practical and creative skills to create pictures that she describes as paperworks. Her fresh, unpolluted shoreline studies make a positive stand against wastefulness and overt consumption.

*"It is very important to use lots of water. My ingredients are very pure and simple. I do not use any glues, binders or chemicals, and my final colored pulp is stored in recycled plastic containers."*

### Soaking and pulping

The shredded paper is then soaked in buckets with lots of water. After about three or four days, the wet paper is ready for pulping and is transferred in small amounts to an ordinary kitchen blender. Again, this is where the artist's experience comes into play, and she has learned through trial and error the exact amount of shredded paper and the exact amount of pulping time – about five seconds – that is needed to make the perfect paper pulp.

It is important that the pulp is the right consistency for working with on the final picture. If the shredded paper is pulped (that is, blended) for more than five seconds, the short fibers will disintegrate and the work will not hold together. If it does not pulp after five seconds, the paper has not been soaked for long enough.

*"The pulped fibers have to stick together and lock into each other. If you overprocess, nothing holds together."*

## Working with colored-paper pulp

Currently, Judith is working on shoreline sea and sky compositions, and, from her collection of papers, she selects various blues, and both cool and warm yellows, for shredding and pulping. Fortunately, she says, blue and yellow are predominant junk-mail colors, so she has a lot of color choice for her subject matter.

Before she starts a pulp picture, the artist thinks a lot about it and what she wants to do. She makes preparatory paintings and drawings and has a design for the composition in mind. All her themes – sea, sky and horizon – are inspired by nature.

She often works on a back piece, a prepared piece of paper, to act as a support for the paper-pulp composition. This is particularly helpful if it is a larger work, but the pictures in the shoreline series are fairly small, about 12 x 12in (30 x 30cm), so for these the artist works directly with the paper pulp.

The artist works flat on a table, first laying down an absorbent surface, in this case tough, absorbent disposable paper towels. The work with the colored pulp is started by using a fork to pick it up, the way one would use a paintbrush: "I work with the colored pulps, picking them up, laying them down on the absorbent cloth, laying and blending the pulp just as if I was using paint, until I feel the work is finished."

Then she puts another absorbent paper towel over the whole work, squeezes out the surplus moisture and lays it on one side to dry: "I press really hard to take the water and compact the pulp, and then leave it to dry overnight." The finished work is, by its very nature, highly textured, a handmade piece created with no grain or direction.

Once the completed picture is dry, another process is employed to modify the surface and accentuate various parts of the composition. The artist often irons parts of the work to bring in another textural dimension. She uses a hot, ordinary domestic iron to flatten certain areas of the surface and uses the hot tip to indent small local areas to add to the texture and relief.

### Using the blender

If the shredded paper is blended for more than five seconds, the paper fibers will break up and the work will not bind together properly.

### Remnants of the original

"I like seeing some of the original material and being able to see what it is made of – a bit of type here, the lining pattern of an envelope there."

### Junk-mail colors

"In the sky and sea, there are all sorts of colors. I can mix the pulps just like paint – I use them just like paint."

Judith Chestnutt
**Color samples**
Paper pulp
8 x 6in (20.3 x 15.2cm)

*"It is a very simple process, using very simple equipment. Anyone can do it anywhere."*

☛**See also**
Colors for free 144–145

## Waste-paper collages

In addition to pulping junk mail, old newspapers and magazines are an endless free source of colors and materials for collage work. You will be surprised at the large areas of pure color to be found that are uninterrupted by text or images. To avoid what is known as "show through" – this is when print or type matter shows through from the back – paste the collages onto gray or black backgrounds.

### Print editions

If you have a home computer setup, you can make convincing lithograph-like prints by scanning junk-paper collages and printing them onto heavy-quality papers or special printer-compatible canvas. Make short, signed and numbered editions, using archive-quality inks in the printer for longevity.

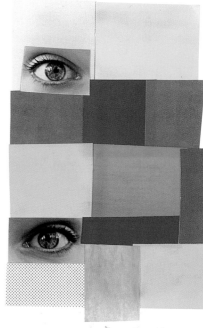

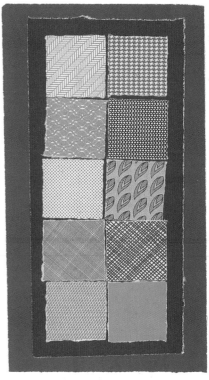

**Collage samples**
Magazine cuttings
and envelope interiors
5 x 6in (12.7 x 15.2cm) *(above)*
5 x 7in (12.7 x 17.7cm) *(above right)*
5 x 7in (10.2 x 17.7cm) *(right)*

Many artists experiment with found materials and primitive societies still use naturally occurring colors in their work. In developed societies, too, it is easy and fun to find colors from animal, vegetable and mineral sources around the house and yard.

**Red wine (Cabernet Sauvignon)**

**Custom tinting**
You can create warm tints, using wine, tea, coffee and cola.

**Natural complementaries**
Autumn leaves of *Rhus trichocarpa*

☞ **See also**

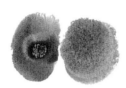

### Blood
Myths exist of deranged artists who painted with blood. It is said that El Greco (Domenikos Theotocopoulos) (1541–1614) used his own blood, because he was often seen with bandaged hands, thought to be a result of drawing his own blood. It is more probable the bandaging was to protect skin damage caused by turpentine. It is known that blood is useless for painting, because it becomes dark brown within a few days and eventually turns black.

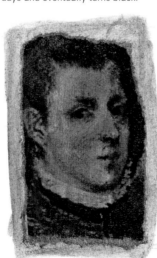

**El Greco (1541–1614)**

**Cochineal and vanilla essence**

### Fat, saliva, ash and charcoal
Early known examples of pigment used for images date back at least 35,000 years. Analysis of the famous cave paintings of southwest Europe, some 15,000 years old, reveals the use of animal fat, saliva, ash and charcoal. Pigments derived from the earth — colors that are now categorized as oxides, ochres and siennas — are also commonly found.

### Cochineal mask
This graphite drawing is tinted with cochineal food color. Foodstuffs and food colorings provide good sources of tinting materials.

**Mustard powder in matte acrylic medium**

**Mustard powder in red wine**

### Mustard powder
English mustard in powder form makes a good transparent ochre.

**Chili powder in acrylic medium**

## Vegetable colors

Color can be obtained from vegetable matter. Grass, petals and berries can be rubbed into the surface of the paper to impart some of their original pigment. Many colors tend to go brown or quickly fade. However, the samples here are at least one year old.

**Brick dust**

**Brick dust plus Titanium White**

**Sandstone in matte acrylic medium**

**Grass**

**Rose hip**

**Coal ash**

**Coal ash plus Titanium White**

**Blackberry**

**Blackberry and Titanium White**

**Soot**

Simon Jennings
**Dust to Dust**
Teak wood dust
and acrylic medium on canvas
11½ x 8in (29.3 x 20.5cm)

**Terra-cotta in matte acrylic medium**

## Mineral colors

Colors can easily be obtained by drilling into bricks and stones with a masonry drill bit. The resulting spoil, or dust, can then be bound in an acrylic medium and used like paint.

**Red-hot poker *(Kniphofia)***

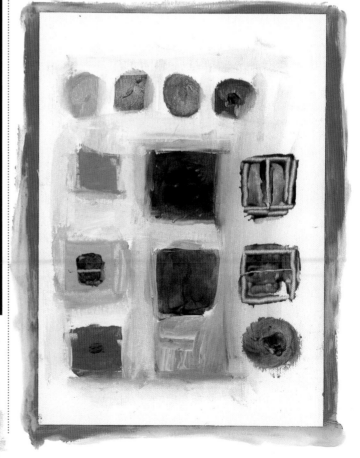

**Beach color**
The beach in this location was composed of gray volcanic pebbles, creating a mottled carpet of shadows and textures.

There is a great tradition of painting outdoors and observing light and color directly from nature. When traveling it may be impractical to carry full-scale painting equipment, but successful results can be achieved with a limited selection of colors and materials.

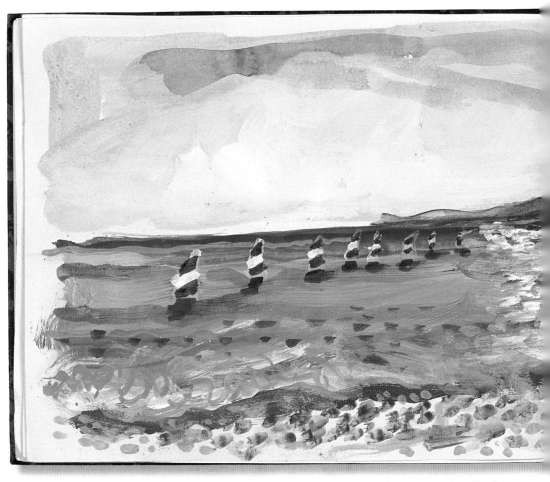

**Thinking ahead**
If you will be painting in a sunny climate by the ocean, for example, obvious color choices come to mind and you can preselect your palette accordingly. Choose fast-drying media and good-quality paper.

**Primary Blue**
An inexpensive and versatile middle blue. It is the most dominant color in the picture above, but any mid-blue would suffice. Primary Blue is fairly close in hue to Cerulean Blue.

**Neutral Gray, value 5**
An excellent neutral gray, used here for the beach and distant hills. It was mainly applied thinned with water, sometimes with a little white added.

**Parchment**
A very neutral lightish green, almost white; very useful when traveling light. It proved versatile here – applied thickly for the sea, in washes for the sky, and in admixture to lighten the other colors.

**Naples Yellow (Hue)**
An opaque lightish yellow; excellent for mixing. Subtle and not too dominant; here, it suggests the transparency and reflective qualities of the sea. It was also used in its pure state for the distant shore.

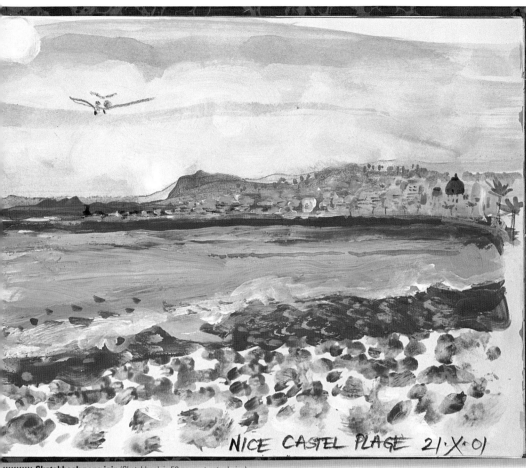

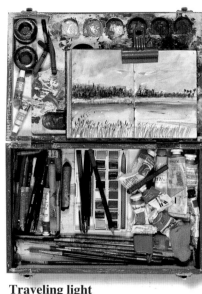

NICE CASTEL PLAGE 21·X·01

**Sketchbook page join** (Sketchbook is 50 percent actual size)

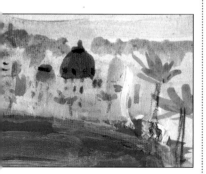

### Traveling light
A color sketching trip to the Mediterranean coast of the south of France necessitated traveling light. The artist, anticipating the opportunity to paint the sea and sky, took a small wooden box containing five tubes of acrylic paint – the four colors shown opposite, and white. In addition to a few brushes, the travel-painting kit included a small watercolor box to provide a wider range of colors. A red came in handy for the sails of the dinghies and the roofs of distant buildings, and a touch of green depicted the foliage in the hills and the shoreline palms.

### From Castel Plage
Acrylic and watercolor in sketchbook
8¼ x 21in (21 x 53cm)

The beach scene above takes up a double-page spread of a sketchbook, and it is shown here at about half size. Acrylics were the predominant materials used, but watercolor, applied fairly thickly, provided the small red and green color accents that are shown in the actual-size details on the left.

### Color inspiration
Abandoned rope fragments from nets and boats are among the colors and textures to be found on most beaches.

☛**See also**
Choosing media/Acrylics 33
Dry color and line 152–153

*"I am a painter not a dyer."*

REMBRANDT'S RESPONSE TO THE CRITICISM
THAT HE APPLIED HIS COLORS TOO THICKLY

A strong relationship exists in the making of artwork between the use of color in painting and in textiles. Cotton and linen canvas has always provided a traditional base for the artist's creations. Fabric dyes, too, share many color sources and similarities with paints used in fine art painting.

In addition to straightforward painting, the techniques of dyeing, embroidery and appliqué can be used effectively in making colorful art. In most manufacturers' catalogs today, you will find textile and fabric paints, and general art materials suppliers even provide plain white cotton T-shirts for painting on. You will also find a wide range of silk and encaustic paints suitable for fabric applications.

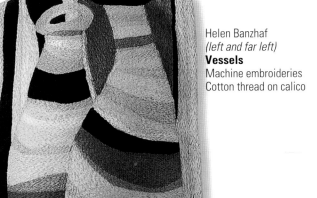

Helen Banzhaf
*(left and far left)*
**Vessels**
Machine embroideries
Cotton thread on calico

Helen Dougall
*(below)*
**Set Aside**
Wall hanging,
Wax-resisted dyes on silk
18½ x 25¼in (47 x 64cm)

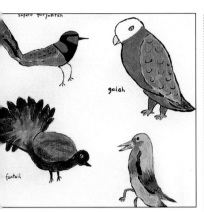

**Australian bird species**

Chris Perry is an artist whose background is in film animation, where he learned about colors and color mixing. These skills have infuenced his work as an illustrator, painter, paper sculptor and textile artist. For inspiration for his work, he develops drawings and paintings from his sketchbook. Many of his images include people and animals, which he uses to communicate an environmental message.

Chris Perry
**Homage to Vincent** (*above and left*)
Acrylic fabric paints on cotton

*"The advantage of painting on T-shirts is that one can wear and communicate one's art and message to the rest of the world. It feels like a mix of watercolor and canvas painting; it is cheap and fun. I have a love of nature and I work for a range of environment charities; on occasions I produce limited editions of approximately 100 hand-painted shirts."*

Chris Perry
**Homage to Paul** (*left*)
**Australian birds** (*far left*)
Acrylic fabric paints on cotton

### T-shirt designs

The artist washes the T-shirt to remove the starch used in the manufacturing process. He then inserts plastic-covered cardboard the same size as the shirt to act as a stiffener and barrier for the paint. A black marker sketch on white paper may be inserted under the shirt for a drawing guide. Otherwise, paint is applied directly onto the shirt.

Acrylic-based screen and fabric printing colors are used. The artist mainly treats the paint like watercolor, mixing it with water using sable brushes, but, if he wants the color to be flat and opaque, he uses bristle brushes.

Sometimes black defining lines are required, so he leaves the areas of color to dry overnight and paints the black the next day. When dry, after two days, he irons the reverse of the fabric to fix the design.

Acrylic fabric paints are extremely bright and washfast. Chris limits his colors to Lemon Yellow, Brilliant Yellow, Vermilion, Crimson, Cobalt, Ultramarine, black and white, and he finds these are enough to produce a wide range of mixes. The artist is an ardent fan of primary colors, and he particularly likes to use a watered-down Cobalt, which is excellent for sea and sky.

There are many textile paints on the market, as well as a special textile medium that, when added to ordinary acrylic paint, renders it more flexible and increases washfastness.

Painting techniques are often associated with qualities of surface texture, involving impasto, mark making, glazes, washes and conscious brushwork. There are, however, many artists who practice a flatter, more controlled approach to color. These methods of applying paint smoothly are sometimes born of necessity, and this is particularly so when color images have to be considered for reproduction by photography or direct digital scanning.

In traditional, animated-film cel-painting techniques, before the use of computers, a special type of liquid acrylic paint with strong pigments and good covering power, known as Cel Vinyl or Cartoon Paint, was the preferred medium. Thinner, more viscous colors of this type are still often favored by artists who are pursuing a flatter, graphic or more fluid technique, and they are also used by painters of large-scale murals, as well as designers and illustrators whose work has to be photographed or scanned for reproduction.

**Flatness and density**
Although a little battered after nearly 35 years in storage, this original cel from the film *Yellow Submarine* (1968) shows the flatness and density of color achieved by painting in opaque colors on the reverse of transparent materials, such as glass and clear plastic. The detail above shows the not-so-smooth and more painterly effect on the reverse, or working side, of the cel.

Heinz Edelman
*(Original character design)*
**Paul and Ringo**
Hand-painted animation cel
12½ x 16in (32 x 41cm)
*Collection of Rose Jennings*
*© King Features 1967*

**Cel painting**
Prior to the advent of computers, nearly all animated cartoon films were produced by the "paint and trace" method. This is where the design is traced in black outline onto transparent celuloid, hence the abbreviation "cel." Each cel was then passed to the painting department, and the colors were filled in by hand. This process required a high degree of painting skill, because the artists had to keep the paint extremely flat and flood it into the image, making sure the liquid paint did not overrun the traced outline. Painters had to work quickly, because cartoon films were composed of hundreds of thousands of individual cels, which were then photographed onto movie film.

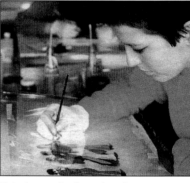

To make certain of complete flatness and evenness of color for photography, the outline designs were traced on the front of the cel and the color was painted onto the back. Painting opaque colors on the reverse of transparent materials is an invaluable technique that ensures an absolutely smooth surface effect.

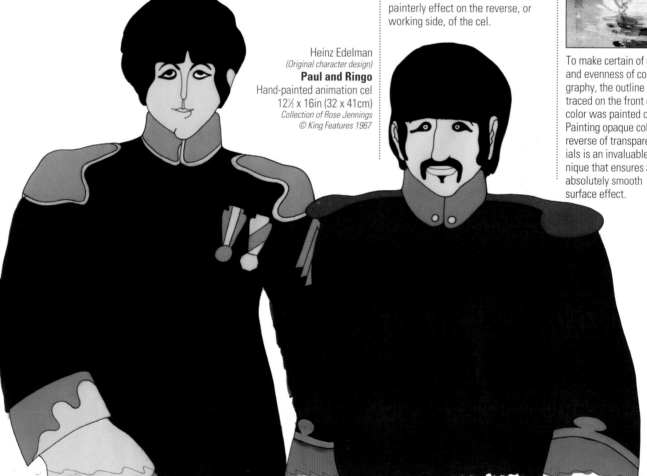

### Enamel paint

In the paintings of the building fascias, the flatness of the surface has been achieved by using hobby enamel paints. The fluid consistency and easy brush application make enamel an ideal medium for painting details and flat areas alike. Often associated with decorative applications, enamel paints can also be mixed and blended for painterly effects and take about 24 hours to dry.

Simon Jennings
**Building Fascias**
Enamel on board
24 x 24in (61 x 61cm)

### Liquid opaque colors

Opaque colors similar in consistency to those favored by traditional animation artists are available today and can be found in many manufacturers' catalogs in jar and bottle form. These paints are suitable for application to a wide range of surfaces and are made in acrylic, water-based or solvent-based enamel paint varieties. Most have strong pigments, good covering power and adhesion, are readily intermixable and are waterproof. Colors of this type are usually listed in the craft sections of catalogs, where similar, but more specialized, colors for painting onto glass, ceramics and textiles are often shown, too.

☞**See also**

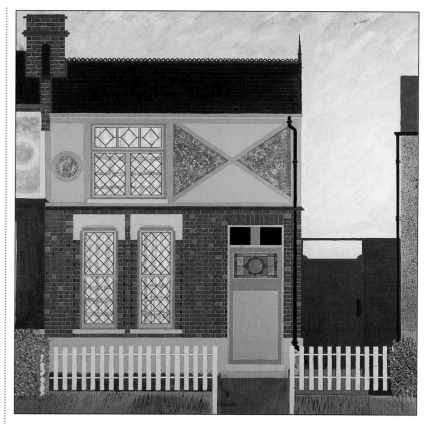

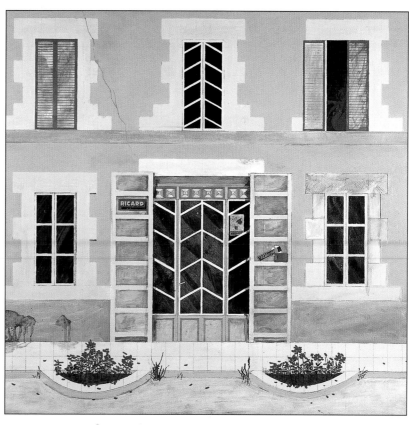

There is a huge variety of dry media available that is easy to use and transportable, suitable for use alone or in mixed-media applications. These materials cross the divide between drawing and painting.

These two pages show some of the dry media that can be used for both color and line: colored pencils (regular and water-soluble), pastels, oil pastels, oilbars (sometimes known as oil-painting sticks), graphite and charcoal.

There are many other pencil and sticklike, dry-color products available, such as wax crayons and conté sticks, that are highly suitable for creative color expression. Much of this media is soluble in water or solvent and can be used to create fluid painterly effects. Many media that use liquids, such as pen and inks and fiber-tips for color-linear techniques, are available, too.

Color availability varies from one maker to the next, but many of the pigments closely follow paint colors. Most major manufacturers offer high-quality products in these media.

**Colored pencil and soft pastel selection**

**Blending and mixing with colored pencils**

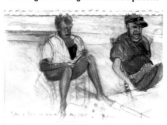

### Colored pencils
These come in various thicknesses. Some brands are soft and free flowing. Others are thinner and of a harder consistency. There are many water-soluble types available, suitable for mixing and blending and for creating watercolorlike effects.

**Charcoal sticks and pencil**

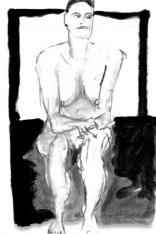

**Charcoal using linear and wash effects**

### Charcoal
The classic and time-honored artist's drawing medium, charcoal comes in traditional sticks and pencil form in a variety of thicknesses and grades. A wide range of tones may be produced by blending and rubbing to create shades and soft grays. Charcoal is also soluble for use as washes.

**Graphite pencil drawing**

### Graphite and charcoal
A selection of graphite and charcoal in pencil form. Graphite, like charcoal, is available in sticks, too. Use a white paper stump or torchon for blending and gradating tones.

### Mixing media
Oil pastel and graphite pencil are used here. Turpentine is used to blend the pastel, and pencil worked over the top.

Water-soluble colored pencil selection

Line and tone effects using soft pastels

## Oil pastels

These, too, can be used for linear and fluid techniques, enabling you to produce oil-like surface effects.

Oil pastels are versatile and transportable, highly suitable for outdoor color work.

## Water-soluble colored pencil

You can move freely between linear and fluid techniques, creating wet and dry effects in the same piece.

## Oilbar

Also known as oil-painting sticks, oilbars behave like oil paint. You can mix and blend them with solvent and use them to create surface texture and impasto effects.

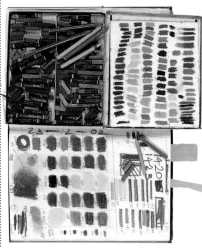

## Pastels

Soft pastels, or chalk pastels, are the artist's traditional choice when selecting a dry medium. Pastels come in hundreds of colors, whose pigments match those of paints, and most of the major manufacturers offer quality pastels in a wide color range. They can be used to produce large areas of color or finer lines. The technique of working in pastels is known as pastel "painting."

☛ See also
Choosing media/
Pastels & colored pencils 35

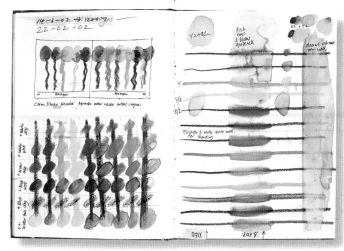

## Sketchbook experiments

Experiment with mixing and blending water-soluble colored pencils.

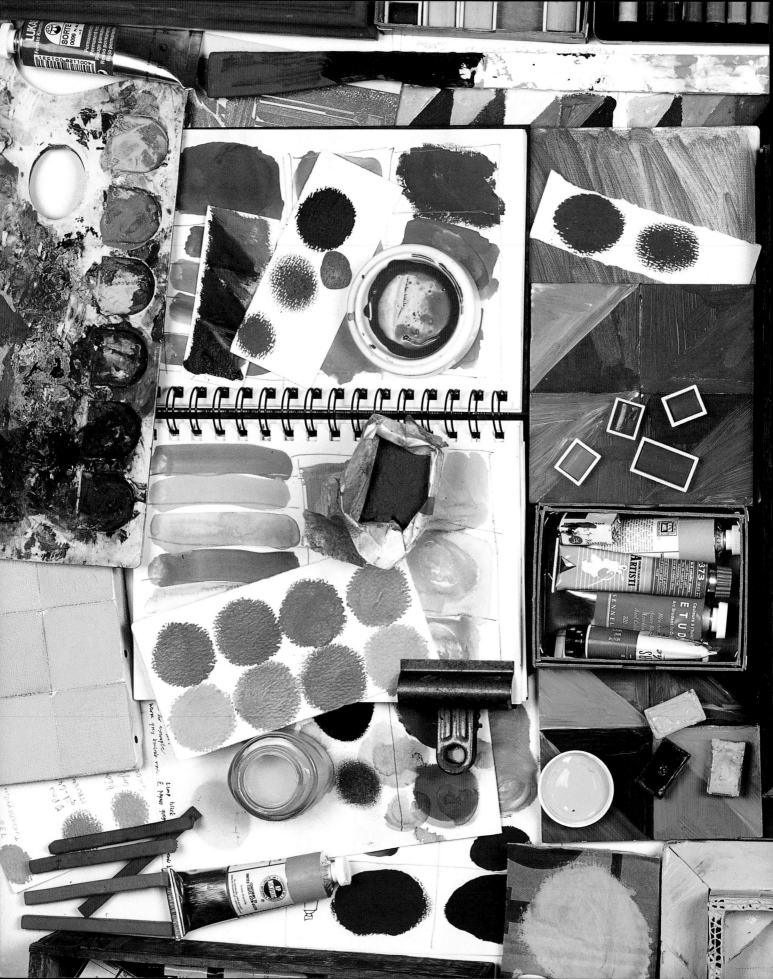

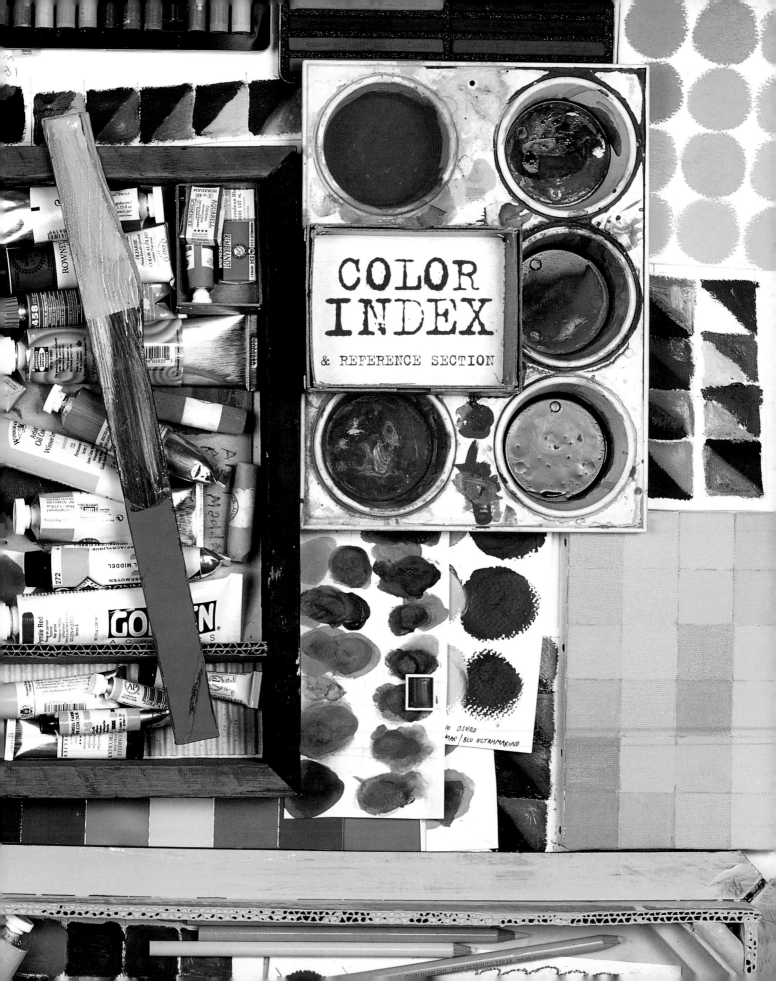

COLOR
INDEX

& REFERENCE SECTION

**The purpose of the Color index** is to provide a visual reference source of the popular artists' colors, the ones you are most likely to see in the most common painting media – oils, watercolor, acrylics and gouache – in the various manufacturers' color charts. This index is to help you get to know your colors and to demonstrate that, although artists' colors may be given the same name and contain the same basic ingredients, they can vary dramatically in appearance.

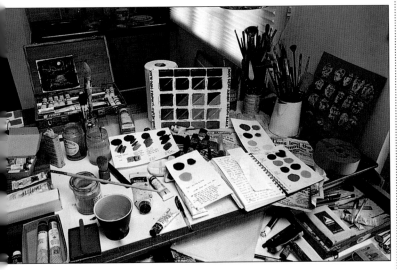

In the making and selecting of colors for the Color index, the art editors have reviewed and sampled more than 1,500 colors from 11 of the world's leading manufacturers. Of the 1,500 colors reviewed, over 400 have been selected for the index and the following criteria have been applied in the selection.

**Colors have been reviewed by name.** In certain circumstances you will see the same name repeated in the index – for example, Cadmium Red Deep. The purpose of this is to show how the same-named color from two, or sometimes more, different manufacturers may vary in hue.

**Colors have been reviewed by medium.** The Color index also provides the opportunity for the reader to see variations in colors of the same name but in different media – for example, how Cadmium Red Deep will look in oil color, gouache or acrylic.

**Colors have been reviewed by pigment.** All major manufacturers disclose the pigment content of their colors. It is now common to see this information printed on the tube or packaging. Failing this, the pigment declaration can usually be found in the maker's color chart or catalog. In the Color index you will find colors of the same name that are composed of different pigments or, more importantly for an artist when considering color, you will see colors with the same pigment content that vary considerably in color.

**Colors have been reviewed by hue.** By "hue," we mean color or variation of color (see Glossary of terms). As far as possible within the Color index, colors have been grouped – for example, into Neutrals, Reds, Yellows, Blues, Greens, Browns, Earths and Ochres, etc. This provides a direct visual comparison and enables you to see the differences between, say, a Cobalt Blue, a Phthalo Blue and an Ultramarine.

**Colors have been reviewed for variety.** In Chapter Two, "Color by color," we looked at the main color groups and learned something of the history, background, character and handling of various hues, and, in many cases, how professional artists have mixed and used color in their work. However, it was not possible to show as many colors as we would have liked. The Color index acts as an invaluable backup reference.

**Color behavior.** The Color index has used flat colors for sampling and most of the colors have been shown in what is known as top or mass tone. In short this means they have been applied thickly as if seen straight from the tube or sitting as solid blocks in the watercolor pan. The true character of many pigments, particularly at the darker end of the scale, only becomes apparent when diluted or mixed with a medium. In some cases color samples have been shown applied thickly as top tone and with a touch of white to create a tint to reveal something of the true character of the color.

**Color accuracy.** The only accurate color charts are hand colored, and most manufacturers supply these on request. Unfortunately, this book is restricted to the four-color printing process. While this is a sophisticated and accurate technological process, bear in mind that the colors you see here are not actual pigments but are made up from printing inks (see pages 20–21), so there will be variations between the colors shown and the actual manufacturers' pigment colors.

☞**Note**
The following manufacturers have kindly supplied colors for use in the Color index and throughout this book: Winsor & Newton, Daler-Rowney, Golden, Tri-Art, Royal Talens, Sennelier, Schmincke, Liquitex, Maimeri, Lukas, Old Holland.
*See pages 180–181 for details.*

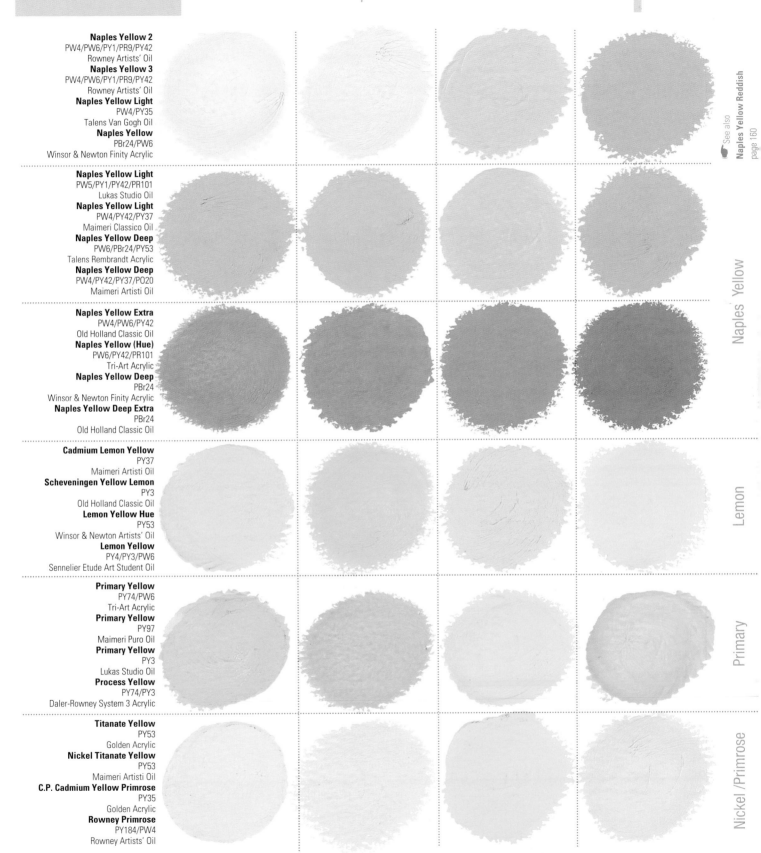

**Naples Yellow 2**
PW4/PW6/PY1/PR9/PY42
Rowney Artists' Oil
**Naples Yellow 3**
PW4/PW6/PY1/PR9/PY42
Rowney Artists' Oil
**Naples Yellow Light**
PW4/PY35
Talens Van Gogh Oil
**Naples Yellow**
PBr24/PW6
Winsor & Newton Finity Acrylic

**Naples Yellow Light**
PW5/PY1/PY42/PR101
Lukas Studio Oil
**Naples Yellow Light**
PW4/PY42/PY37
Maimeri Classico Oil
**Naples Yellow Deep**
PW6/PBr24/PY53
Talens Rembrandt Acrylic
**Naples Yellow Deep**
PW4/PY42/PY37/PO20
Maimeri Artisti Oil

**Naples Yellow Extra**
PW4/PW6/PY42
Old Holland Classic Oil
**Naples Yellow (Hue)**
PW6/PY42/PR101
Tri-Art Acrylic
**Naples Yellow Deep**
PBr24
Winsor & Newton Finity Acrylic
**Naples Yellow Deep Extra**
PBr24
Old Holland Classic Oil

**Cadmium Lemon Yellow**
PY37
Maimeri Artisti Oil
**Scheveningen Yellow Lemon**
PY3
Old Holland Classic Oil
**Lemon Yellow Hue**
PY53
Winsor & Newton Artists' Oil
**Lemon Yellow**
PY4/PY3/PW6
Sennelier Etude Art Student Oil

**Primary Yellow**
PY74/PW6
Tri-Art Acrylic
**Primary Yellow**
PY97
Maimeri Puro Oil
**Primary Yellow**
PY3
Lukas Studio Oil
**Process Yellow**
PY74/PY3
Daler-Rowney System 3 Acrylic

**Titanate Yellow**
PY53
Golden Acrylic
**Nickel Titanate Yellow**
PY53
Maimeri Artisti Oil
**C.P. Cadmium Yellow Primrose**
PY35
Golden Acrylic
**Rowney Primrose**
PY184/PW4
Rowney Artists' Oil

See also **Naples Yellow Reddish** page 160

Naples Yellow

Lemon

Primary

Nickel /Primrose

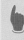

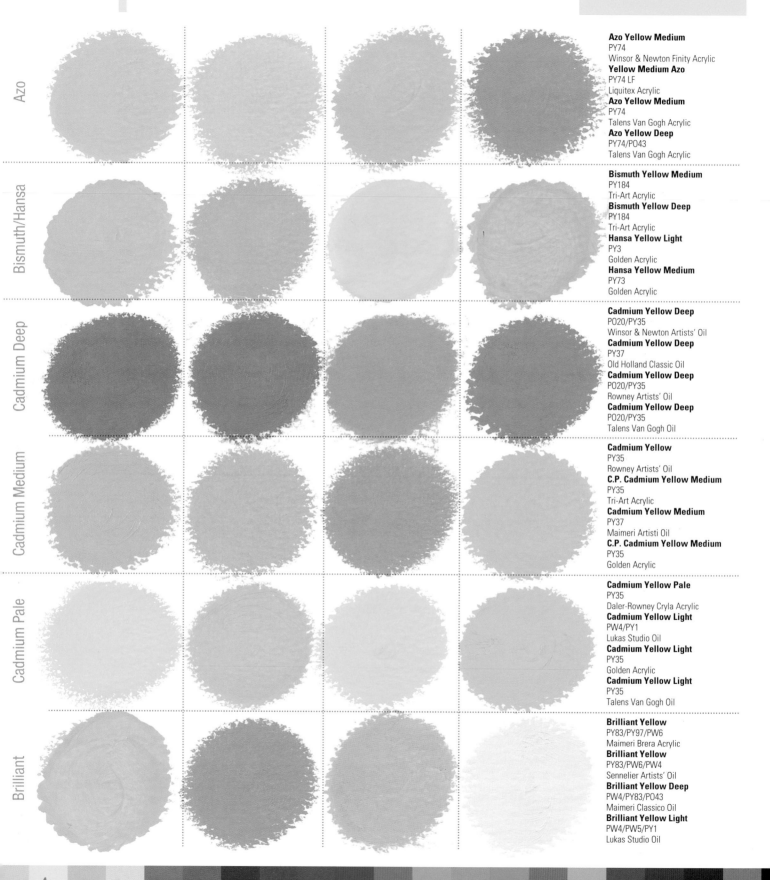

**Azo**

**Azo Yellow Medium**
PY74
Winsor & Newton Finity Acrylic
**Yellow Medium Azo**
PY74 LF
Liquitex Acrylic
**Azo Yellow Medium**
PY74
Talens Van Gogh Acrylic
**Azo Yellow Deep**
PY74/PO43
Talens Van Gogh Acrylic

**Bismuth/Hansa**

**Bismuth Yellow Medium**
PY184
Tri-Art Acrylic
**Bismuth Yellow Deep**
PY184
Tri-Art Acrylic
**Hansa Yellow Light**
PY3
Golden Acrylic
**Hansa Yellow Medium**
PY73
Golden Acrylic

**Cadmium Deep**

**Cadmium Yellow Deep**
PO20/PY35
Winsor & Newton Artists' Oil
**Cadmium Yellow Deep**
PY37
Old Holland Classic Oil
**Cadmium Yellow Deep**
PO20/PY35
Rowney Artists' Oil
**Cadmium Yellow Deep**
PO20/PY35
Talens Van Gogh Oil

**Cadmium Medium**

**Cadmium Yellow**
PY35
Rowney Artists' Oil
**C.P. Cadmium Yellow Medium**
PY35
Tri-Art Acrylic
**Cadmium Yellow Medium**
PY37
Maimeri Artisti Oil
**C.P. Cadmium Yellow Medium**
PY35
Golden Acrylic

**Cadmium Pale**

**Cadmium Yellow Pale**
PY35
Daler-Rowney Cryla Acrylic
**Cadmium Yellow Light**
PW4/PY1
Lukas Studio Oil
**Cadmium Yellow Light**
PY35
Golden Acrylic
**Cadmium Yellow Light**
PY35
Talens Van Gogh Oil

**Brilliant**

**Brilliant Yellow**
PY83/PY97/PW6
Maimeri Brera Acrylic
**Brilliant Yellow**
PY83/PW6/PW4
Sennelier Artists' Oil
**Brilliant Yellow Deep**
PW4/PY83/PO43
Maimeri Classico Oil
**Brilliant Yellow Light**
PW4/PW5/PY1
Lukas Studio Oil

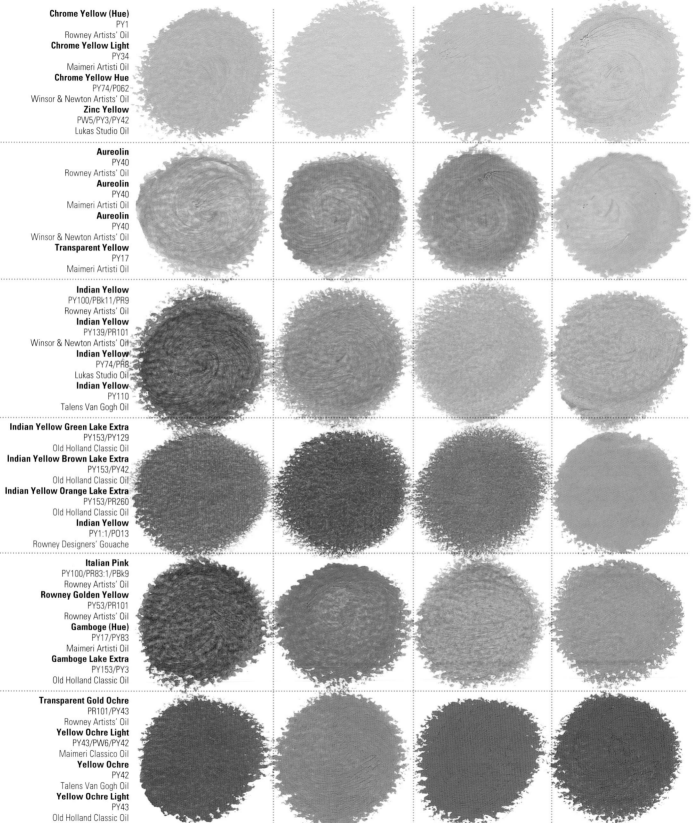

**Chrome Yellow (Hue)**
PY1
Rowney Artists' Oil
**Chrome Yellow Light**
PY34
Maimeri Artisti Oil
**Chrome Yellow Hue**
PY74/PO62
Winsor & Newton Artists' Oil
**Zinc Yellow**
PW5/PY3/PY42
Lukas Studio Oil

**Aureolin**
PY40
Rowney Artists' Oil
**Aureolin**
PY40
Maimeri Artisti Oil
**Aureolin**
PY40
Winsor & Newton Artists' Oil
**Transparent Yellow**
PY17
Maimeri Artisti Oil

**Indian Yellow**
PY100/PBk11/PR9
Rowney Artists' Oil
**Indian Yellow**
PY139/PR101
Winsor & Newton Artists' Oil
**Indian Yellow**
PY74/PR8
Lukas Studio Oil
**Indian Yellow**
PY110
Talens Van Gogh Oil

**Indian Yellow Green Lake Extra**
PY153/PY129
Old Holland Classic Oil
**Indian Yellow Brown Lake Extra**
PY153/PY42
Old Holland Classic Oil
**Indian Yellow Orange Lake Extra**
PY153/PR260
Old Holland Classic Oil
**Indian Yellow**
PY1:1/PO13
Rowney Designers' Gouache

**Italian Pink**
PY100/PR83:1/PBk9
Rowney Artists' Oil
**Rowney Golden Yellow**
PY53/PR101
Rowney Artists' Oil
**Gamboge (Hue)**
PY17/PY83
Maimeri Artisti Oil
**Gamboge Lake Extra**
PY153/PY3
Old Holland Classic Oil

**Transparent Gold Ochre**
PR101/PY43
Rowney Artists' Oil
**Yellow Ochre Light**
PY43/PW6/PY42
Maimeri Classico Oil
**Yellow Ochre**
PY42
Talens Van Gogh Oil
**Yellow Ochre Light**
PY43
Old Holland Classic Oil

Chrome/Zinc

Aureolin

Indian Yellow

Golden/Gamboge

Ochres

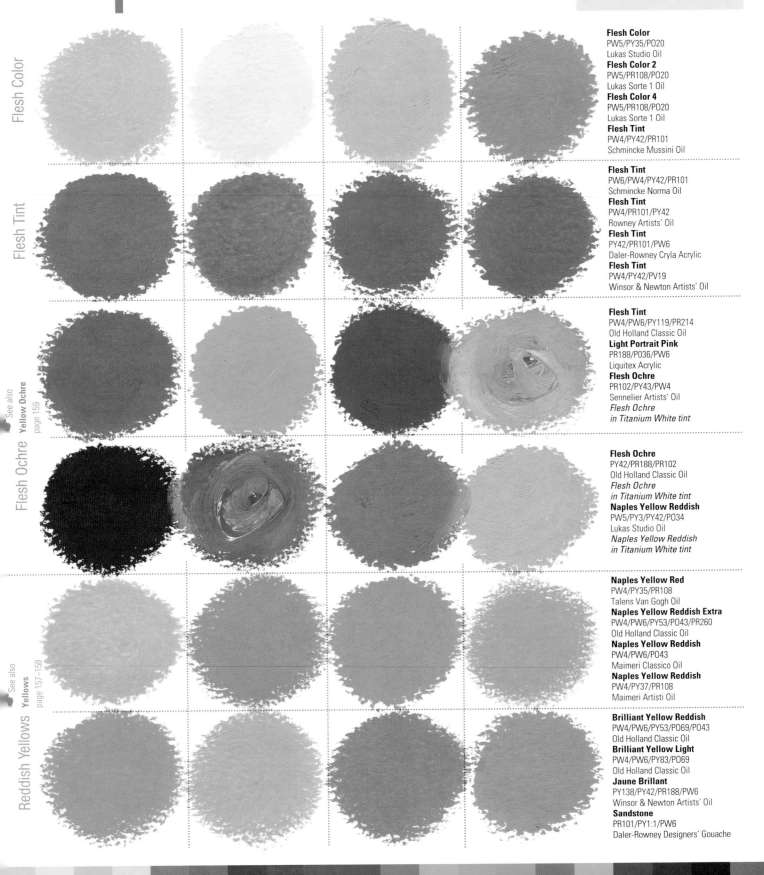

**Flesh Color** 

**Flesh Color**
PW5/PY35/PO20
Lukas Studio Oil
**Flesh Color 2**
PW5/PR108/PO20
Lukas Sorte 1 Oil
**Flesh Color 4**
PW5/PR108/PO20
Lukas Sorte 1 Oil
**Flesh Tint**
PW4/PY42/PR101
Schmincke Mussini Oil

**Flesh Tint**
PW6/PW4/PY42/PR101
Schmincke Norma Oil
**Flesh Tint**
PW4/PR101/PY42
Rowney Artists' Oil
**Flesh Tint**
PY42/PR101/PW6
Daler-Rowney Cryla Acrylic
**Flesh Tint**
PW4/PY42/PV19
Winsor & Newton Artists' Oil

**Flesh Tint**
PW4/PW6/PY119/PR214
Old Holland Classic Oil
**Light Portrait Pink**
PR188/PO36/PW6
Liquitex Acrylic
**Flesh Ochre**
PR102/PY43/PW4
Sennelier Artists' Oil
*Flesh Ochre*
*in Titanium White tint*

**Flesh Ochre**
PY42/PR188/PR102
Old Holland Classic Oil
*Flesh Ochre*
*in Titanium White tint*
**Naples Yellow Reddish**
PW5/PY3/PY42/PO34
Lukas Studio Oil
*Naples Yellow Reddish*
*in Titanium White tint*

**Naples Yellow Red**
PW4/PY35/PR108
Talens Van Gogh Oil
**Naples Yellow Reddish Extra**
PW4/PW6/PY53/PO43/PR260
Old Holland Classic Oil
**Naples Yellow Reddish**
PW4/PW6/PO43
Maimeri Classico Oil
**Naples Yellow Reddish**
PW4/PY37/PR108
Maimeri Artisti Oil

**Brilliant Yellow Reddish**
PW4/PW6/PY53/PO69/PO43
Old Holland Classic Oil
**Brilliant Yellow Light**
PW4/PW6/PY83/PO69
Old Holland Classic Oil
**Jaune Brillant**
PY138/PY42/PR188/PW6
Winsor & Newton Artists' Oil
**Sandstone**
PR101/PY1:1/PW6
Daler-Rowney Designers' Gouache

Flesh Color

Flesh Tint

See also **Yellow Ochre** page 159

Flesh Ochre

See also **Yellows** page 157–158

Reddish Yellows

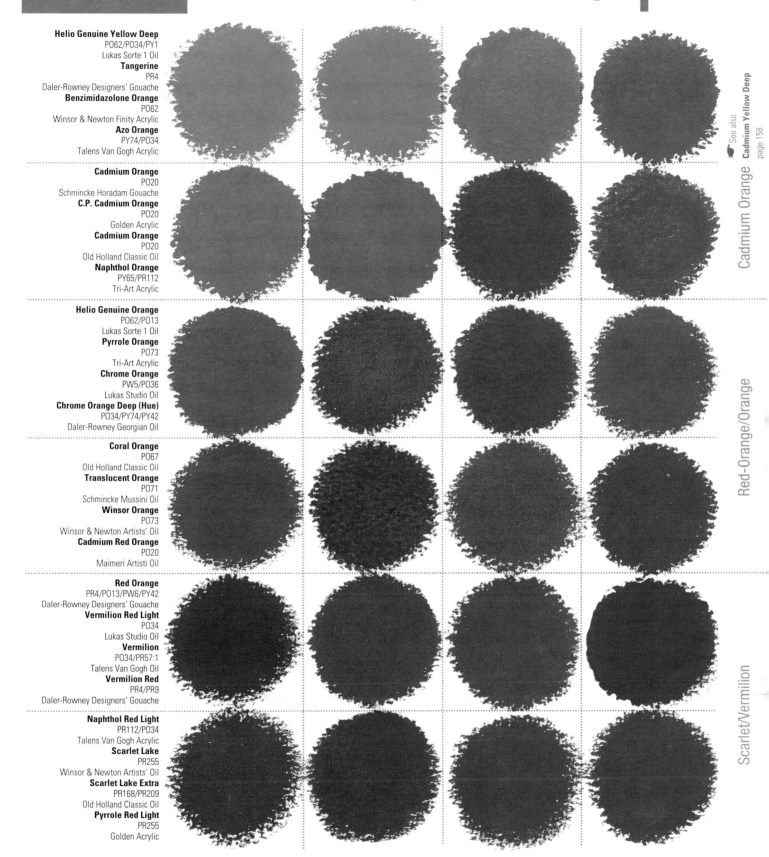

**Helio Genuine Yellow Deep**
PO62/PO34/PY1
Lukas Sorte 1 Oil
**Tangerine**
PR4
Daler-Rowney Designers' Gouache
**Benzimidazolone Orange**
PO62
Winsor & Newton Finity Acrylic
**Azo Orange**
PY74/PO34
Talens Van Gogh Acrylic

**Cadmium Orange**
PO20
Schmincke Horadam Gouache
**C.P. Cadmium Orange**
PO20
Golden Acrylic
**Cadmium Orange**
PO20
Old Holland Classic Oil
**Naphthol Orange**
PY65/PR112
Tri-Art Acrylic

**Helio Genuine Orange**
PO62/PO13
Lukas Sorte 1 Oil
**Pyrrole Orange**
PO73
Tri-Art Acrylic
**Chrome Orange**
PW5/PO36
Lukas Studio Oil
**Chrome Orange Deep (Hue)**
PO34/PY74/PY42
Daler-Rowney Georgian Oil

**Coral Orange**
PO67
Old Holland Classic Oil
**Translucent Orange**
PO71
Schmincke Mussini Oil
**Winsor Orange**
PO73
Winsor & Newton Artists' Oil
**Cadmium Red Orange**
PO20
Maimeri Artisti Oil

**Red Orange**
PR4/PO13/PW6/PY42
Daler-Rowney Designers' Gouache
**Vermilion Red Light**
PO34
Lukas Studio Oil
**Vermilion**
PO34/PR57:1
Talens Van Gogh Oil
**Vermilion Red**
PR4/PR9
Daler-Rowney Designers' Gouache

**Naphthol Red Light**
PR112/PO34
Talens Van Gogh Acrylic
**Scarlet Lake**
PR255
Winsor & Newton Artists' Oil
**Scarlet Lake Extra**
PR168/PR209
Old Holland Classic Oil
**Pyrrole Red Light**
PR255
Golden Acrylic

See also **Cadmium Yellow Deep** page 158

Cadmium Orange

Red-Orange/Orange

Scarlet/Vermilion

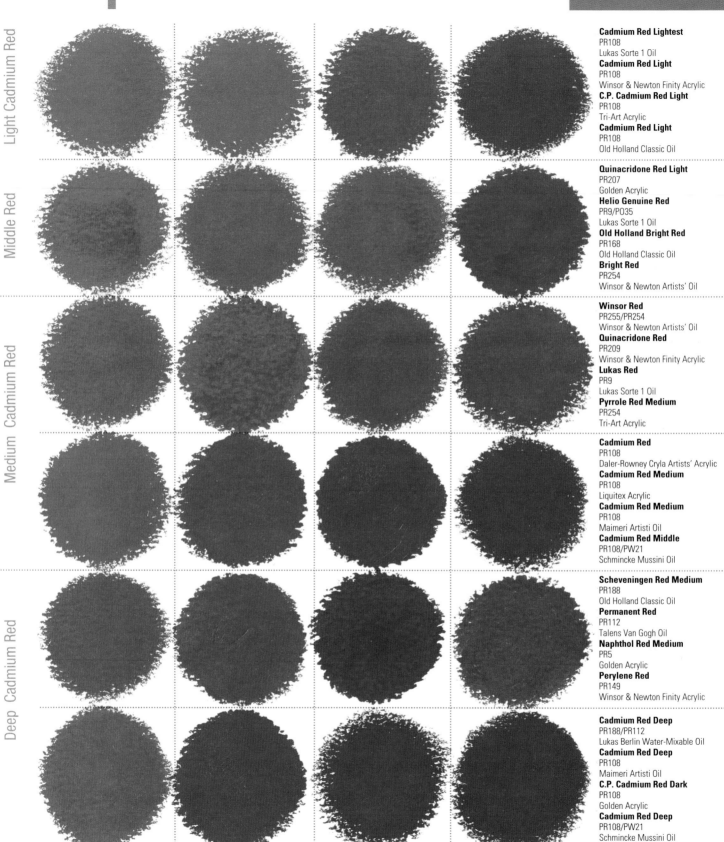

Light Cadmium Red

Middle Red

Medium Cadmium Red

Deep Cadmium Red

**Cadmium Red Lightest**
PR108
Lukas Sorte 1 Oil
**Cadmium Red Light**
PR108
Winsor & Newton Finity Acrylic
**C.P. Cadmium Red Light**
PR108
Tri-Art Acrylic
**Cadmium Red Light**
PR108
Old Holland Classic Oil

**Quinacridone Red Light**
PR207
Golden Acrylic
**Helio Genuine Red**
PR9/PO35
Lukas Sorte 1 Oil
**Old Holland Bright Red**
PR168
Old Holland Classic Oil
**Bright Red**
PR254
Winsor & Newton Artists' Oil

**Winsor Red**
PR255/PR254
Winsor & Newton Artists' Oil
**Quinacridone Red**
PR209
Winsor & Newton Finity Acrylic
**Lukas Red**
PR9
Lukas Sorte 1 Oil
**Pyrrole Red Medium**
PR254
Tri-Art Acrylic

**Cadmium Red**
PR108
Daler-Rowney Cryla Artists' Acrylic
**Cadmium Red Medium**
PR108
Liquitex Acrylic
**Cadmium Red Medium**
PR108
Maimeri Artisti Oil
**Cadmium Red Middle**
PR108/PW21
Schmincke Mussini Oil

**Scheveningen Red Medium**
PR188
Old Holland Classic Oil
**Permanent Red**
PR112
Talens Van Gogh Oil
**Naphthol Red Medium**
PR5
Golden Acrylic
**Perylene Red**
PR149
Winsor & Newton Finity Acrylic

**Cadmium Red Deep**
PR188/PR112
Lukas Berlin Water-Mixable Oil
**Cadmium Red Deep**
PR108
Maimeri Artisti Oil
**C.P. Cadmium Red Dark**
PR108
Golden Acrylic
**Cadmium Red Deep**
PR108/PW21
Schmincke Mussini Oil

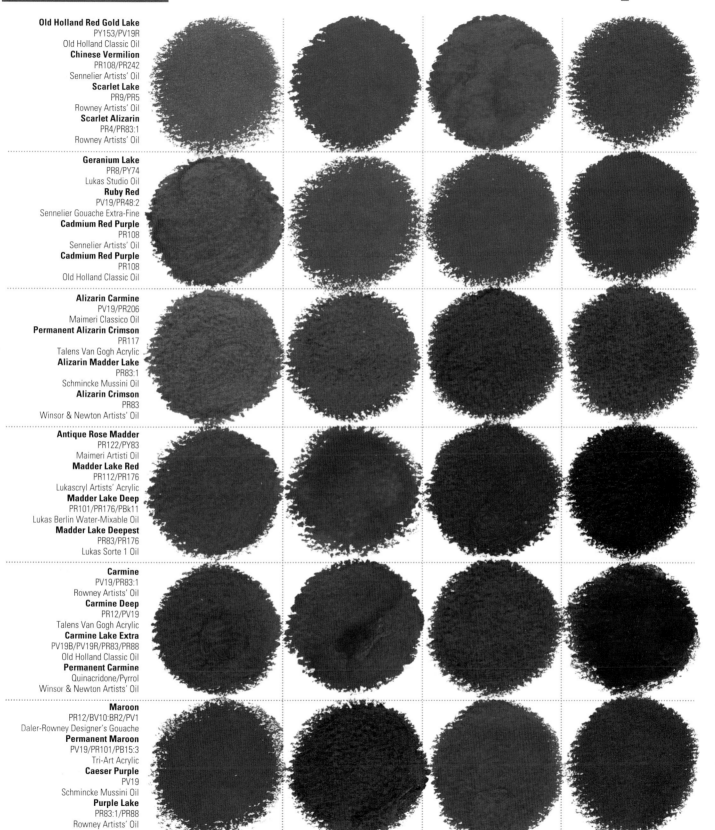

**Old Holland Red Gold Lake**
PY153/PV19R
Old Holland Classic Oil
**Chinese Vermilion**
PR108/PR242
Sennelier Artists' Oil
**Scarlet Lake**
PR9/PR5
Rowney Artists' Oil
**Scarlet Alizarin**
PR4/PR83:1
Rowney Artists' Oil

**Geranium Lake**
PR8/PY74
Lukas Studio Oil
**Ruby Red**
PV19/PR48:2
Sennelier Gouache Extra-Fine
**Cadmium Red Purple**
PR108
Sennelier Artists' Oil
**Cadmium Red Purple**
PR108
Old Holland Classic Oil

**Alizarin Carmine**
PV19/PR206
Maimeri Classico Oil
**Permanent Alizarin Crimson**
PR117
Talens Van Gogh Acrylic
**Alizarin Madder Lake**
PR83:1
Schmincke Mussini Oil
**Alizarin Crimson**
PR83
Winsor & Newton Artists' Oil

**Antique Rose Madder**
PR122/PY83
Maimeri Artisti Oil
**Madder Lake Red**
PR112/PR176
Lukascryl Artists' Acrylic
**Madder Lake Deep**
PR101/PR176/PBk11
Lukas Berlin Water-Mixable Oil
**Madder Lake Deepest**
PR83/PR176
Lukas Sorte 1 Oil

**Carmine**
PV19/PR83:1
Rowney Artists' Oil
**Carmine Deep**
PR12/PV19
Talens Van Gogh Acrylic
**Carmine Lake Extra**
PV19B/PV19R/PR83/PR88
Old Holland Classic Oil
**Permanent Carmine**
Quinacridone/Pyrrol
Winsor & Newton Artists' Oil

**Maroon**
PR12/BV10:BR2/PV1
Daler-Rowney Designer's Gouache
**Permanent Maroon**
PV19/PR101/PB15:3
Tri-Art Acrylic
**Caeser Purple**
PV19
Schmincke Mussini Oil
**Purple Lake**
PR83:1/PR88
Rowney Artists' Oil

Darks/Deeps

Alizarin

Madder

Carmine

Maroon/Purple

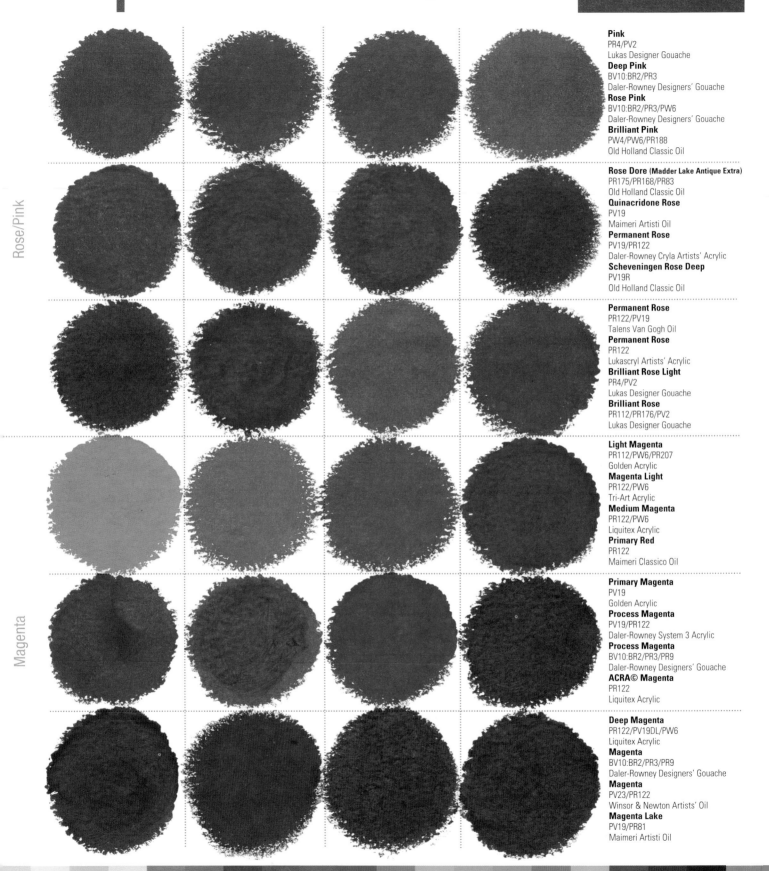

Rose/Pink

Magenta

**Pink**
PR4/PV2
Lukas Designer Gouache
**Deep Pink**
BV10:BR2/PR3
Daler-Rowney Designers' Gouache
**Rose Pink**
BV10:BR2/PR3/PW6
Daler-Rowney Designers' Gouache
**Brilliant Pink**
PW4/PW6/PR188
Old Holland Classic Oil

**Rose Dore (Madder Lake Antique Extra)**
PR175/PR168/PR83
Old Holland Classic Oil
**Quinacridone Rose**
PV19
Maimeri Artisti Oil
**Permanent Rose**
PV19/PR122
Daler-Rowney Cryla Artists' Acrylic
**Scheveningen Rose Deep**
PV19R
Old Holland Classic Oil

**Permanent Rose**
PR122/PV19
Talens Van Gogh Oil
**Permanent Rose**
PR122
Lukascryl Artists' Acrylic
**Brilliant Rose Light**
PR4/PV2
Lukas Designer Gouache
**Brilliant Rose**
PR112/PR176/PV2
Lukas Designer Gouache

**Light Magenta**
PR112/PW6/PR207
Golden Acrylic
**Magenta Light**
PR122/PW6
Tri-Art Acrylic
**Medium Magenta**
PR122/PW6
Liquitex Acrylic
**Primary Red**
PR122
Maimeri Classico Oil

**Primary Magenta**
PV19
Golden Acrylic
**Process Magenta**
PV19/PR122
Daler-Rowney System 3 Acrylic
**Process Magenta**
BV10:BR2/PR3/PR9
Daler-Rowney Designers' Gouache
**ACRA© Magenta**
PR122
Liquitex Acrylic

**Deep Magenta**
PR122/PV19DL/PW6
Liquitex Acrylic
**Magenta**
BV10:BR2/PR3/PR9
Daler-Rowney Designers' Gouache
**Magenta**
PV23/PR122
Winsor & Newton Artists' Oil
**Magenta Lake**
PV19/PR81
Maimeri Artisti Oil

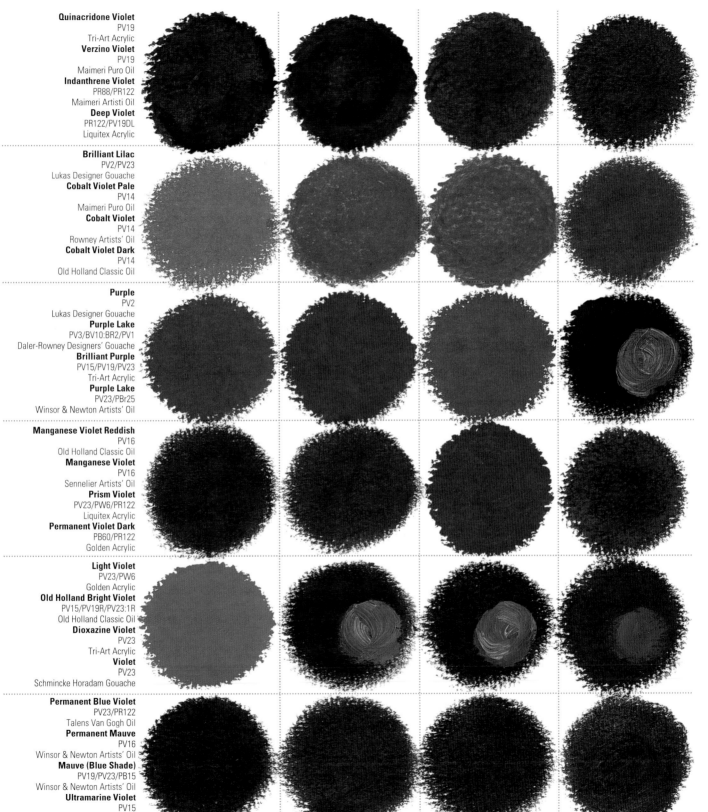

**Quinacridone Violet**
PV19
Tri-Art Acrylic
**Verzino Violet**
PV19
Maimeri Puro Oil
**Indanthrene Violet**
PR88/PR122
Maimeri Artisti Oil
**Deep Violet**
PR122/PV19DL
Liquitex Acrylic

**Brilliant Lilac**
PV2/PV23
Lukas Designer Gouache
**Cobalt Violet Pale**
PV14
Maimeri Puro Oil
**Cobalt Violet**
PV14
Rowney Artists' Oil
**Cobalt Violet Dark**
PV14
Old Holland Classic Oil

**Purple**
PV2
Lukas Designer Gouache
**Purple Lake**
PV3/BV10:BR2/PV1
Daler-Rowney Designers' Gouache
**Brilliant Purple**
PV15/PV19/PV23
Tri-Art Acrylic
**Purple Lake**
PV23/PBr25
Winsor & Newton Artists' Oil

**Manganese Violet Reddish**
PV16
Old Holland Classic Oil
**Manganese Violet**
PV16
Sennelier Artists' Oil
**Prism Violet**
PV23/PW6/PR122
Liquitex Acrylic
**Permanent Violet Dark**
PB60/PR122
Golden Acrylic

**Light Violet**
PV23/PW6
Golden Acrylic
**Old Holland Bright Violet**
PV15/PV19R/PV23:1R
Old Holland Classic Oil
**Dioxazine Violet**
PV23
Tri-Art Acrylic
**Violet**
PV23
Schmincke Horadam Gouache

**Permanent Blue Violet**
PV23/PR122
Talens Van Gogh Oil
**Permanent Mauve**
PV16
Winsor & Newton Artists' Oil
**Mauve (Blue Shade)**
PV19/PV23/PB15
Winsor & Newton Artists' Oil
**Ultramarine Violet**
PV15
Winsor & Newton Artists' Oil

Red Violet

Cobalt Violet

Violet/Purple

Violet

Blue Violet

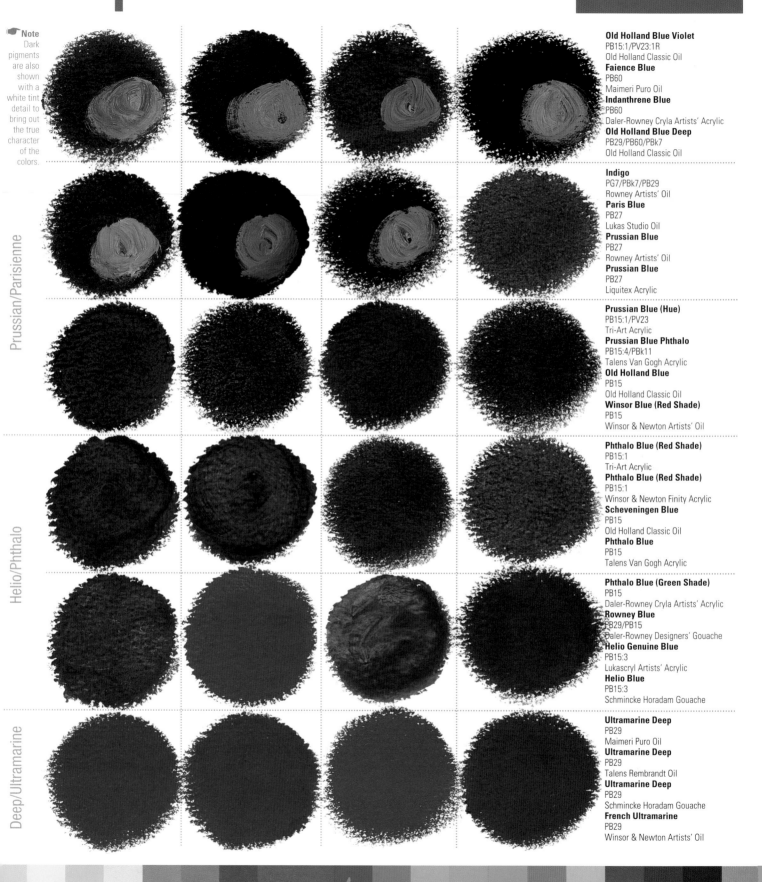

**Prussian/Parisienne**

**Helio/Phthalo**

**Deep/Ultramarine**

**Old Holland Blue Violet**
PB15:1/PV23:1R
Old Holland Classic Oil
**Faience Blue**
PB60
Maimeri Puro Oil
**Indanthrene Blue**
PB60
Daler-Rowney Cryla Artists' Acrylic
**Old Holland Blue Deep**
PB29/PB60/PBk7
Old Holland Classic Oil

**Indigo**
PG7/PBk7/PB29
Rowney Artists' Oil
**Paris Blue**
PB27
Lukas Studio Oil
**Prussian Blue**
PB27
Rowney Artists' Oil
**Prussian Blue**
PB27
Liquitex Acrylic

**Prussian Blue (Hue)**
PB15:1/PV23
Tri-Art Acrylic
**Prussian Blue Phthalo**
PB15:4/PBk11
Talens Van Gogh Acrylic
**Old Holland Blue**
PB15
Old Holland Classic Oil
**Winsor Blue (Red Shade)**
PB15
Winsor & Newton Artists' Oil

**Phthalo Blue (Red Shade)**
PB15:1
Tri-Art Acrylic
**Phthalo Blue (Red Shade)**
PB15:1
Winsor & Newton Finity Acrylic
**Scheveningen Blue**
PB15
Old Holland Classic Oil
**Phthalo Blue**
PB15
Talens Van Gogh Acrylic

**Phthalo Blue (Green Shade)**
PB15
Daler-Rowney Cryla Artists' Acrylic
**Rowney Blue**
PB29/PB15
Daler-Rowney Designers' Gouache
**Helio Genuine Blue**
PB15:3
Lukascryl Artists' Acrylic
**Helio Blue**
PB15:3
Schmincke Horadam Gouache

**Ultramarine Deep**
PB29
Maimeri Puro Oil
**Ultramarine Deep**
PB29
Talens Rembrandt Oil
**Ultramarine Deep**
PB29
Schmincke Horadam Gouache
**French Ultramarine**
PB29
Winsor & Newton Artists' Oil

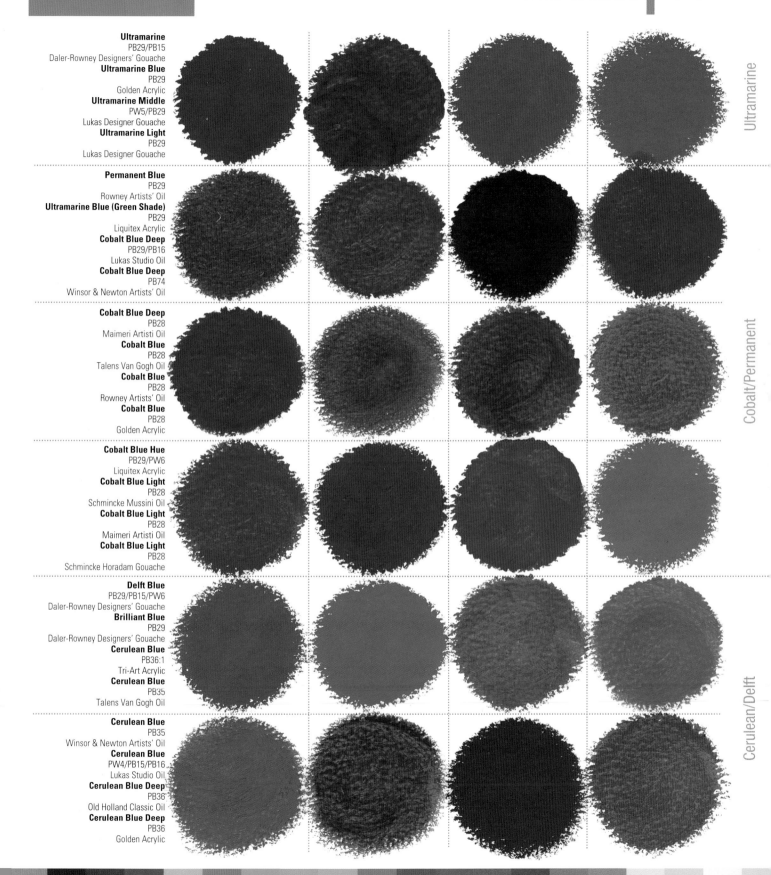

**Ultramarine**
PB29/PB15
Daler-Rowney Designers' Gouache
**Ultramarine Blue**
PB29
Golden Acrylic
**Ultramarine Middle**
PW5/PB29
Lukas Designer Gouache
**Ultramarine Light**
PB29
Lukas Designer Gouache

**Permanent Blue**
PB29
Rowney Artists' Oil
**Ultramarine Blue (Green Shade)**
PB29
Liquitex Acrylic
**Cobalt Blue Deep**
PB29/PB16
Lukas Studio Oil
**Cobalt Blue Deep**
PB74
Winsor & Newton Artists' Oil

**Cobalt Blue Deep**
PB28
Maimeri Artisti Oil
**Cobalt Blue**
PB28
Talens Van Gogh Oil
**Cobalt Blue**
PB28
Rowney Artists' Oil
**Cobalt Blue**
PB28
Golden Acrylic

**Cobalt Blue Hue**
PB29/PW6
Liquitex Acrylic
**Cobalt Blue Light**
PB28
Schmincke Mussini Oil
**Cobalt Blue Light**
PB28
Maimeri Artisti Oil
**Cobalt Blue Light**
PB28
Schmincke Horadam Gouache

**Delft Blue**
PB29/PB15/PW6
Daler-Rowney Designers' Gouache
**Brilliant Blue**
PB29
Daler-Rowney Designers' Gouache
**Cerulean Blue**
PB36:1
Tri-Art Acrylic
**Cerulean Blue**
PB35
Talens Van Gogh Oil

**Cerulean Blue**
PB35
Winsor & Newton Artists' Oil
**Cerulean Blue**
PW4/PB15/PB16
Lukas Studio Oil
**Cerulean Blue Deep**
PB36
Old Holland Classic Oil
**Cerulean Blue Deep**
PB36
Golden Acrylic

Ultramarine

Cobalt/Permanent

Cerulean/Delft

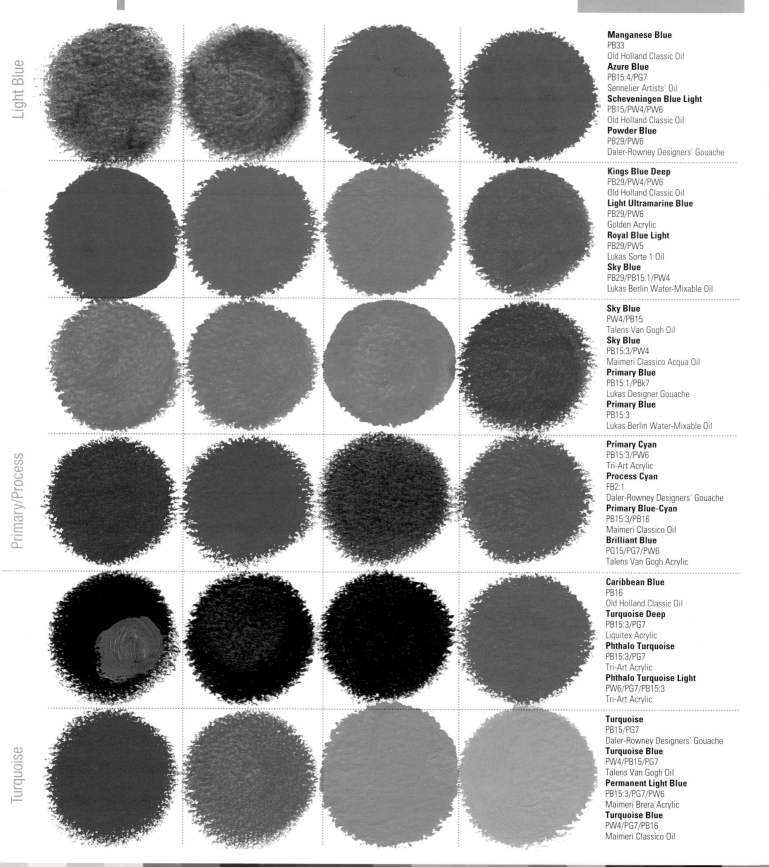

Light Blue

Primary/Process

Turquoise

**Manganese Blue**
PB33
Old Holland Classic Oil
**Azure Blue**
PB15:4/PG7
Sennelier Artists' Oil
**Scheveningen Blue Light**
PB15/PW4/PW6
Old Holland Classic Oil
**Powder Blue**
PB29/PW6
Daler-Rowney Designers' Gouache

**Kings Blue Deep**
PB29/PW4/PW6
Old Holland Classic Oil
**Light Ultramarine Blue**
PB29/PW6
Golden Acrylic
**Royal Blue Light**
PB29/PW5
Lukas Sorte 1 Oil
**Sky Blue**
PB29/PB15:1/PW4
Lukas Berlin Water-Mixable Oil

**Sky Blue**
PW4/PB15
Talens Van Gogh Oil
**Sky Blue**
PB15:3/PW4
Maimeri Classico Acqua Oil
**Primary Blue**
PB15:1/PBk7
Lukas Designer Gouache
**Primary Blue**
PB15:3
Lukas Berlin Water-Mixable Oil

**Primary Cyan**
PB15:3/PW6
Tri-Art Acrylic
**Process Cyan**
FB2:1
Daler-Rowney Designers' Gouache
**Primary Blue-Cyan**
PB15:3/PB16
Maimeri Classico Oil
**Brilliant Blue**
PG15/PG7/PW6
Talens Van Gogh Acrylic

**Caribbean Blue**
PB16
Old Holland Classic Oil
**Turquoise Deep**
PB15:3/PG7
Liquitex Acrylic
**Phthalo Turquoise**
PB15:3/PG7
Tri-Art Acrylic
**Phthalo Turquoise Light**
PW6/PG7/PB15:3
Tri-Art Acrylic

**Turquoise**
PB15/PG7
Daler-Rowney Designers' Gouache
**Turquoise Blue**
PW4/PB15/PG7
Talens Van Gogh Oil
**Permanent Light Blue**
PB15:3/PG7/PW6
Maimeri Brera Acrylic
**Turquoise Blue**
PW4/PG7/PB16
Maimeri Classico Oil

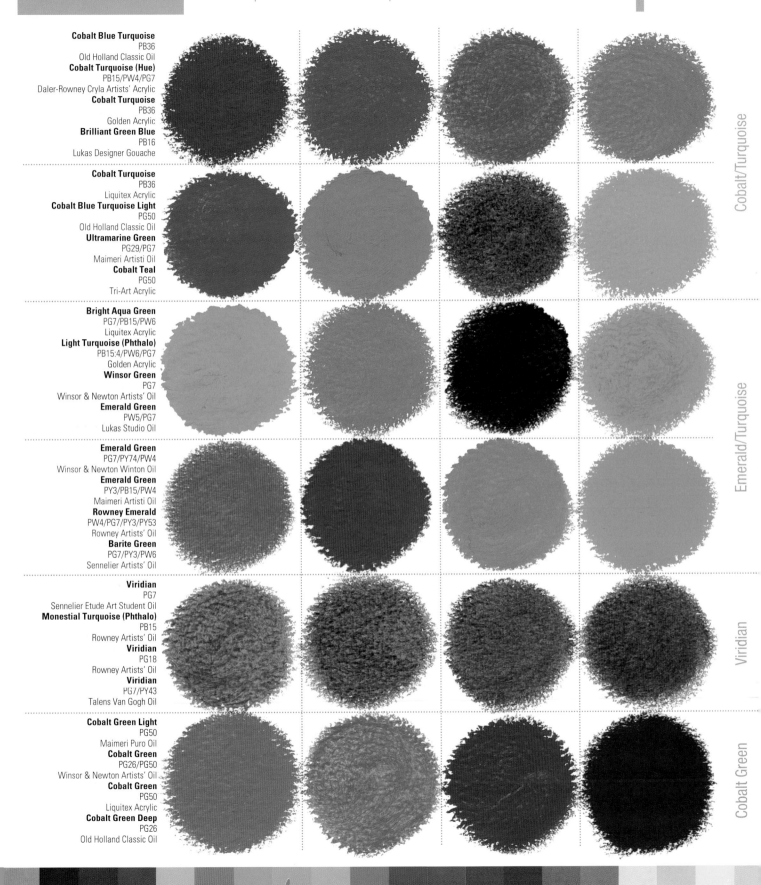

**Cobalt Blue Turquoise**
PB36
Old Holland Classic Oil
**Cobalt Turquoise (Hue)**
PB15/PW4/PG7
Daler-Rowney Cryla Artists' Acrylic
**Cobalt Turquoise**
PB36
Golden Acrylic
**Brilliant Green Blue**
PB16
Lukas Designer Gouache

**Cobalt Turquoise**
PB36
Liquitex Acrylic
**Cobalt Blue Turquoise Light**
PG50
Old Holland Classic Oil
**Ultramarine Green**
PG29/PG7
Maimeri Artisti Oil
**Cobalt Teal**
PG50
Tri-Art Acrylic

**Bright Aqua Green**
PG7/PB15/PW6
Liquitex Acrylic
**Light Turquoise (Phthalo)**
PB15:4/PW6/PG7
Golden Acrylic
**Winsor Green**
PG7
Winsor & Newton Artists' Oil
**Emerald Green**
PW5/PG7
Lukas Studio Oil

**Emerald Green**
PG7/PY74/PW4
Winsor & Newton Winton Oil
**Emerald Green**
PY3/PB15/PW4
Maimeri Artisti Oil
**Rowney Emerald**
PW4/PG7/PY3/PY53
Rowney Artists' Oil
**Barite Green**
PG7/PY3/PW6
Sennelier Artists' Oil

**Viridian**
PG7
Sennelier Etude Art Student Oil
**Monestial Turquoise (Phthalo)**
PB15
Rowney Artists' Oil
**Viridian**
PG18
Rowney Artists' Oil
**Viridian**
PG7/PY43
Talens Van Gogh Oil

**Cobalt Green Light**
PG50
Maimeri Puro Oil
**Cobalt Green**
PG26/PG50
Winsor & Newton Artists' Oil
**Cobalt Green**
PG50
Liquitex Acrylic
**Cobalt Green Deep**
PG26
Old Holland Classic Oil

Cobalt/Turquoise

Emerald/Turquoise

Viridian

Cobalt Green

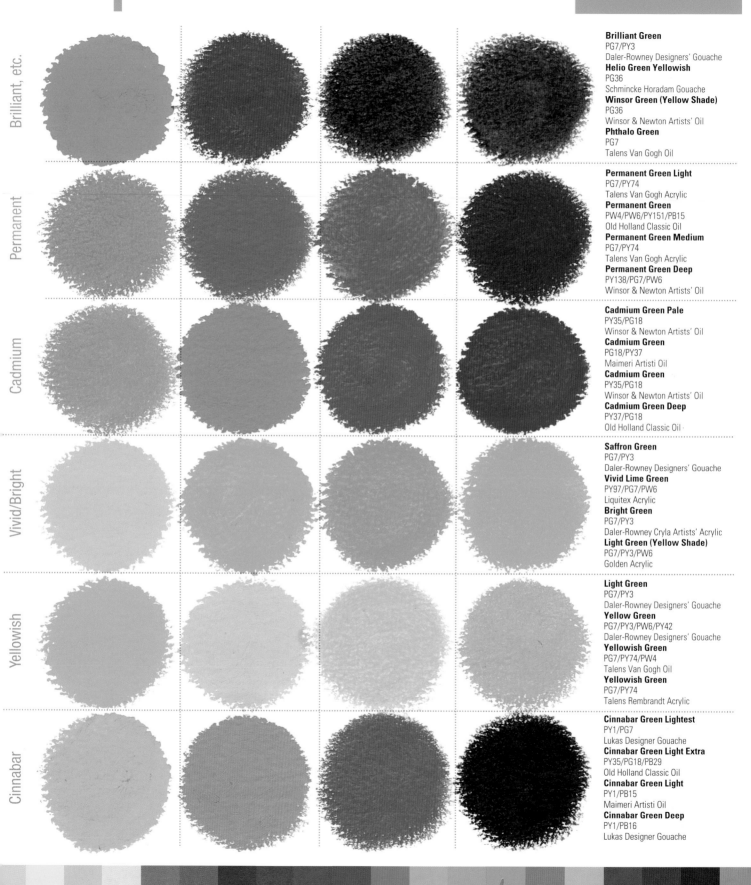

**Brilliant, etc.**

**Brilliant Green**
PG7/PY3
Daler-Rowney Designers' Gouache
**Helio Green Yellowish**
PG36
Schmincke Horadam Gouache
**Winsor Green (Yellow Shade)**
PG36
Winsor & Newton Artists' Oil
**Phthalo Green**
PG7
Talens Van Gogh Oil

**Permanent**

**Permanent Green Light**
PG7/PY74
Talens Van Gogh Acrylic
**Permanent Green**
PW4/PW6/PY151/PB15
Old Holland Classic Oil
**Permanent Green Medium**
PG7/PY74
Talens Van Gogh Acrylic
**Permanent Green Deep**
PY138/PG7/PW6
Winsor & Newton Artists' Oil

**Cadmium**

**Cadmium Green Pale**
PY35/PG18
Winsor & Newton Artists' Oil
**Cadmium Green**
PG18/PY37
Maimeri Artisti Oil
**Cadmium Green**
PY35/PG18
Winsor & Newton Artists' Oil
**Cadmium Green Deep**
PY37/PG18
Old Holland Classic Oil

**Vivid/Bright**

**Saffron Green**
PG7/PY3
Daler-Rowney Designers' Gouache
**Vivid Lime Green**
PY97/PG7/PW6
Liquitex Acrylic
**Bright Green**
PG7/PY3
Daler-Rowney Cryla Artists' Acrylic
**Light Green (Yellow Shade)**
PG7/PY3/PW6
Golden Acrylic

**Yellowish**

**Light Green**
PG7/PY3
Daler-Rowney Designers' Gouache
**Yellow Green**
PG7/PY3/PW6/PY42
Daler-Rowney Designers' Gouache
**Yellowish Green**
PG7/PY74/PW4
Talens Van Gogh Oil
**Yellowish Green**
PG7/PY74
Talens Rembrandt Acrylic

**Cinnabar**

**Cinnabar Green Lightest**
PY1/PG7
Lukas Designer Gouache
**Cinnabar Green Light Extra**
PY35/PG18/PB29
Old Holland Classic Oil
**Cinnabar Green Light**
PY1/PB15
Maimeri Artisti Oil
**Cinnabar Green Deep**
PY1/PB16
Lukas Designer Gouache

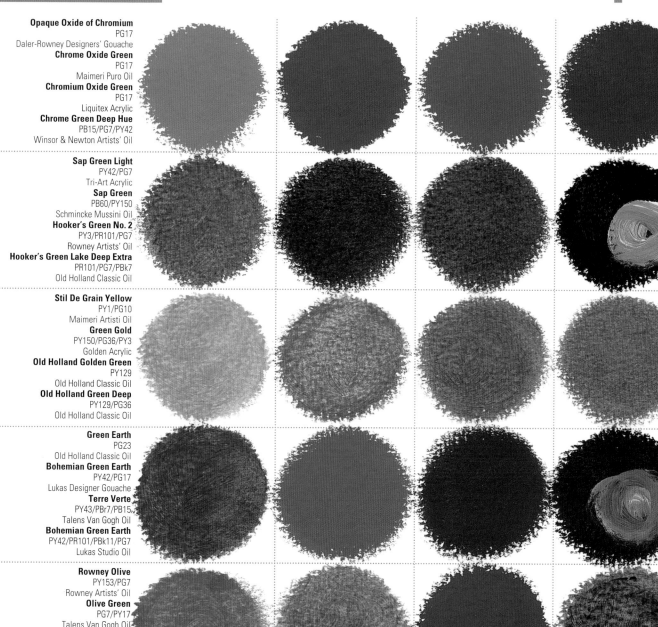

**Opaque Oxide of Chromium**
PG17
Daler-Rowney Designers' Gouache
**Chrome Oxide Green**
PG17
Maimeri Puro Oil
**Chromium Oxide Green**
PG17
Liquitex Acrylic
**Chrome Green Deep Hue**
PB15/PG7/PY42
Winsor & Newton Artists' Oil

**Sap Green Light**
PY42/PG7
Tri-Art Acrylic
**Sap Green**
PB60/PY150
Schmincke Mussini Oil
**Hooker's Green No. 2**
PY3/PR101/PG7
Rowney Artists' Oil
**Hooker's Green Lake Deep Extra**
PR101/PG7/PBk7
Old Holland Classic Oil

**Stil De Grain Yellow**
PY1/PG10
Maimeri Artisti Oil
**Green Gold**
PY150/PG36/PY3
Golden Acrylic
**Old Holland Golden Green**
PY129
Old Holland Classic Oil
**Old Holland Green Deep**
PY129/PG36
Old Holland Classic Oil

**Green Earth**
PG23
Old Holland Classic Oil
**Bohemian Green Earth**
PY42/PG17
Lukas Designer Gouache
**Terre Verte**
PY43/PBr7/PB15
Talens Van Gogh Oil
**Bohemian Green Earth**
PY42/PR101/PBk11/PG7
Lukas Studio Oil

**Rowney Olive**
PY153/PG7
Rowney Artists' Oil
**Olive Green**
PG7/PY17
Talens Van Gogh Oil
**Olive Green**
PG7/PY3/PO13
Daler-Rowney Designers' Gouache
**Olive Green**
PB60/PO49
Winsor & Newton Finity Acrylic

**Olive Green Dark**
PY129/PB60/PG7/PBr7
Old Holland Classic Oil
**Greenish Umber**
PY42/PBk11
Talens Rembrandt Oil
**Green Umber**
PY42/PBk11/PG17
Lukascryl Artists' Acrylic
**Green Umber**
PY42/PR101/PBk11/PG7
Lukas Studio Oil

Oxide

Sap/Hooker's

Golden

Earth Green

Green Umber/Olive

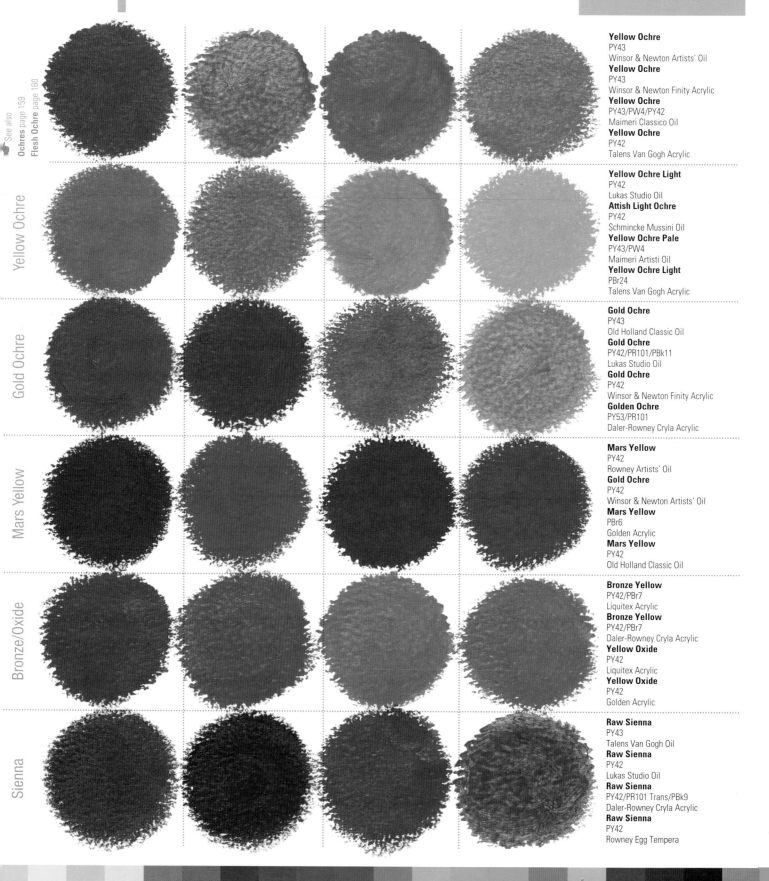

See also
Ochres page 159
Flesh Ochre page 160

**Yellow Ochre**
Yellow Ochre

Gold Ochre

Mars Yellow

Bronze/Oxide

Sienna

**Yellow Ochre**
PY43
Winsor & Newton Artists' Oil
**Yellow Ochre**
PY43
Winsor & Newton Finity Acrylic
**Yellow Ochre**
PY43/PW4/PY42
Maimeri Classico Oil
**Yellow Ochre**
PY42
Talens Van Gogh Acrylic

**Yellow Ochre Light**
PY42
Lukas Studio Oil
**Attish Light Ochre**
PY42
Schmincke Mussini Oil
**Yellow Ochre Pale**
PY43/PW4
Maimeri Artisti Oil
**Yellow Ochre Light**
PBr24
Talens Van Gogh Acrylic

**Gold Ochre**
PY43
Old Holland Classic Oil
**Gold Ochre**
PY42/PR101/PBk11
Lukas Studio Oil
**Gold Ochre**
PY42
Winsor & Newton Finity Acrylic
**Golden Ochre**
PY53/PR101
Daler-Rowney Cryla Acrylic

**Mars Yellow**
PY42
Rowney Artists' Oil
**Gold Ochre**
PY42
Winsor & Newton Artists' Oil
**Mars Yellow**
PBr6
Golden Acrylic
**Mars Yellow**
PY42
Old Holland Classic Oil

**Bronze Yellow**
PY42/PBr7
Liquitex Acrylic
**Bronze Yellow**
PY42/PBr7
Daler-Rowney Cryla Acrylic
**Yellow Oxide**
PY42
Liquitex Acrylic
**Yellow Oxide**
PY42
Golden Acrylic

**Raw Sienna**
PY43
Talens Van Gogh Oil
**Raw Sienna**
PY42
Lukas Studio Oil
**Raw Sienna**
PY42/PR101 Trans/PBk9
Daler-Rowney Cryla Acrylic
**Raw Sienna**
PY42
Rowney Egg Tempera

**Red Ochre**
PR102
Old Holland Classic Oil
**Red Ochre**
PR101
Maimeri Puro Oil
**Brown Ochre Light**
PBr7
Old Holland Classic Oil
**Brown Ochre**
PR101/PBk11
Talens Rembrandt Oil

Brown/Red Ochre

**Deep Ochre**
PR102
Old Holland Classic Oil
**Terra Rosa**
PR101
Winsor & Newton Artists' Oil
**Mars Orange**
PY42
Maimeri Artisti Oil
**Pouzzoles Red**
PR101/PY154
Sennelier Artists' Oil

Orange/Deep Ochre

**Quinacridone Gold**
PO49
Winsor & Newton Finity Acrylic
**Quinacridone Gold**
PO48/PO49
Golden Acrylic
**ACRA© Gold**
PO48/PY83
Liquitex Acrylic
**Chinese Orange**
PR83/PY13
Sennelier Artists' Oil

Burnt Orange/Gold

**Quinacridone Burnt Orange**
PO206
Winsor & Newton Finity Acrylic
**Transparent Oxide Orange**
PY42/PR101
Talens Rembrandt Acrylic
**Transparent Oxide Red**
PR101
Talens Rembrandt Acrylic
**Translucent Red Oxide**
PR101
Schmincke Mussini Oil

Orange/Red Oxide

**Transparent Brown**
PBr25
Tri-Art Acrylic
**Italian Brown Pink Lake**
PR101/PY83
Old Holland Classic Oil
**Transparent Mars Brown**
PR101
Maimeri Puro Oil
**Transparent Oxide Red Lake**
PR101
Old Holland Classic Oil

Brown Pinks

**Light Red Oxide**
PR101
Talens Van Gogh Oil
**Red Oxide**
PR101
Liquitex Acrylic
**Red Oxide**
PR101
Golden Acrylic
**Red Earth**
PR5/PR8/PR101
Daler-Rowney Designers' Gouache

Red Oxide/Earth

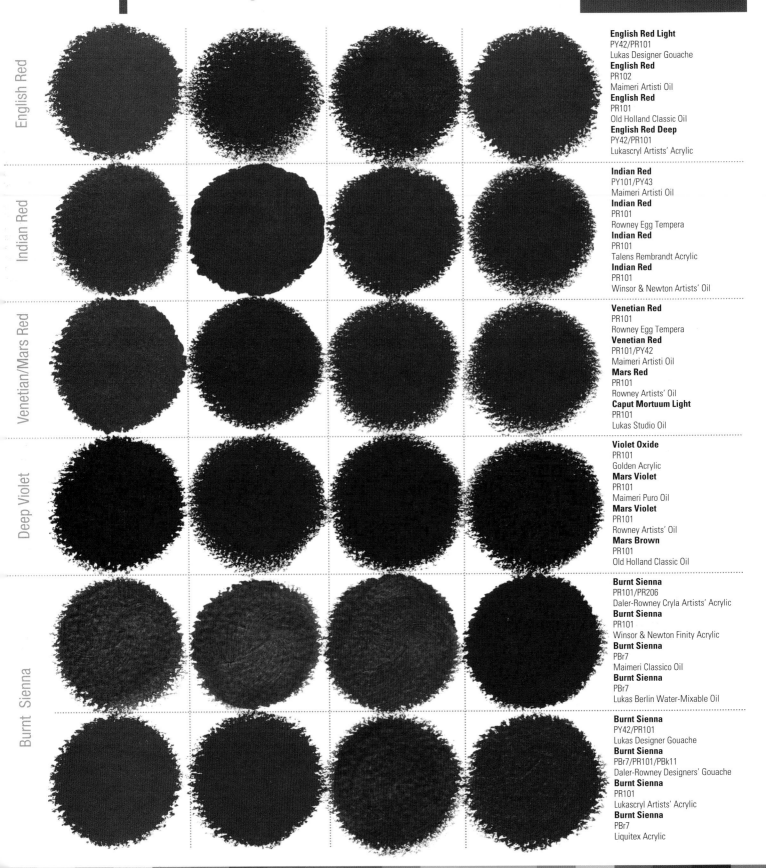

English Red

Indian Red

Venetian/Mars Red

Deep Violet

Burnt Sienna

**English Red Light**
PY42/PR101
Lukas Designer Gouache
**English Red**
PR102
Maimeri Artisti Oil
**English Red**
PR101
Old Holland Classic Oil
**English Red Deep**
PY42/PR101
Lukascryl Artists' Acrylic

**Indian Red**
PY101/PY43
Maimeri Artisti Oil
**Indian Red**
PR101
Rowney Egg Tempera
**Indian Red**
PR101
Talens Rembrandt Acrylic
**Indian Red**
PR101
Winsor & Newton Artists' Oil

**Venetian Red**
PR101
Rowney Egg Tempera
**Venetian Red**
PR101/PY42
Maimeri Artisti Oil
**Mars Red**
PR101
Rowney Artists' Oil
**Caput Mortuum Light**
PR101
Lukas Studio Oil

**Violet Oxide**
PR101
Golden Acrylic
**Mars Violet**
PR101
Maimeri Puro Oil
**Mars Violet**
PR101
Rowney Artists' Oil
**Mars Brown**
PR101
Old Holland Classic Oil

**Burnt Sienna**
PR101/PR206
Daler-Rowney Cryla Artists' Acrylic
**Burnt Sienna**
PR101
Winsor & Newton Finity Acrylic
**Burnt Sienna**
PBr7
Maimeri Classico Oil
**Burnt Sienna**
PBr7
Lukas Berlin Water-Mixable Oil

**Burnt Sienna**
PY42/PR101
Lukas Designer Gouache
**Burnt Sienna**
PBr7/PR101/PBk11
Daler-Rowney Designers' Gouache
**Burnt Sienna**
PR101
Lukascryl Artists' Acrylic
**Burnt Sienna**
PBr7
Liquitex Acrylic

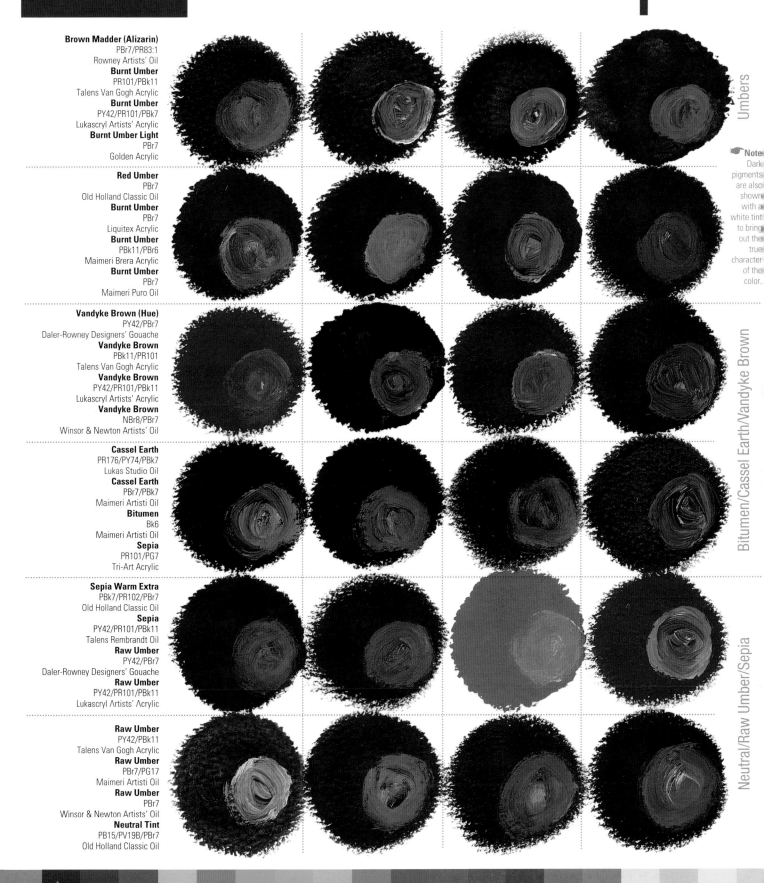

**Brown Madder (Alizarin)**
PBr7/PR83:1
Rowney Artists' Oil
**Burnt Umber**
PR101/PBk11
Talens Van Gogh Acrylic
**Burnt Umber**
PY42/PR101/PBk7
Lukascryl Artists' Acrylic
**Burnt Umber Light**
PBr7
Golden Acrylic

**Red Umber**
PBr7
Old Holland Classic Oil
**Burnt Umber**
PBr7
Liquitex Acrylic
**Burnt Umber**
PBk11/PBr6
Maimeri Brera Acrylic
**Burnt Umber**
PBr7
Maimeri Puro Oil

**Vandyke Brown (Hue)**
PY42/PBr7
Daler-Rowney Designers' Gouache
**Vandyke Brown**
PBk11/PR101
Talens Van Gogh Acrylic
**Vandyke Brown**
PY42/PR101/PBk11
Lukascryl Artists' Acrylic
**Vandyke Brown**
NBr8/PBr7
Winsor & Newton Artists' Oil

**Cassel Earth**
PR176/PY74/PBk7
Lukas Studio Oil
**Cassel Earth**
PBr7/PBk7
Maimeri Artisti Oil
**Bitumen**
Bk6
Maimeri Artisti Oil
**Sepia**
PR101/PG7
Tri-Art Acrylic

**Sepia Warm Extra**
PBk7/PR102/PBr7
Old Holland Classic Oil
**Sepia**
PY42/PR101/PBk11
Talens Rembrandt Oil
**Raw Umber**
PY42/PBr7
Daler-Rowney Designers' Gouache
**Raw Umber**
PY42/PR101/PBk11
Lukascryl Artists' Acrylic

**Raw Umber**
PY42/PBk11
Talens Van Gogh Acrylic
**Raw Umber**
PBr7/PG17
Maimeri Artisti Oil
**Raw Umber**
PBr7
Winsor & Newton Artists' Oil
**Neutral Tint**
PB15/PV19B/PBr7
Old Holland Classic Oil

Umbers

☞ **Note**
Dark
pigments
are also
shown
with a
white tint
to bring
out the
true
character
of the
color.

Bitumen/Cassel Earth/Vandyke Brown

Neutral/Raw Umber/Sepia

**Note**
Dark pigments are also shown with a white tint to bring out the true character of the color.

Black

Blue Black

Green Black

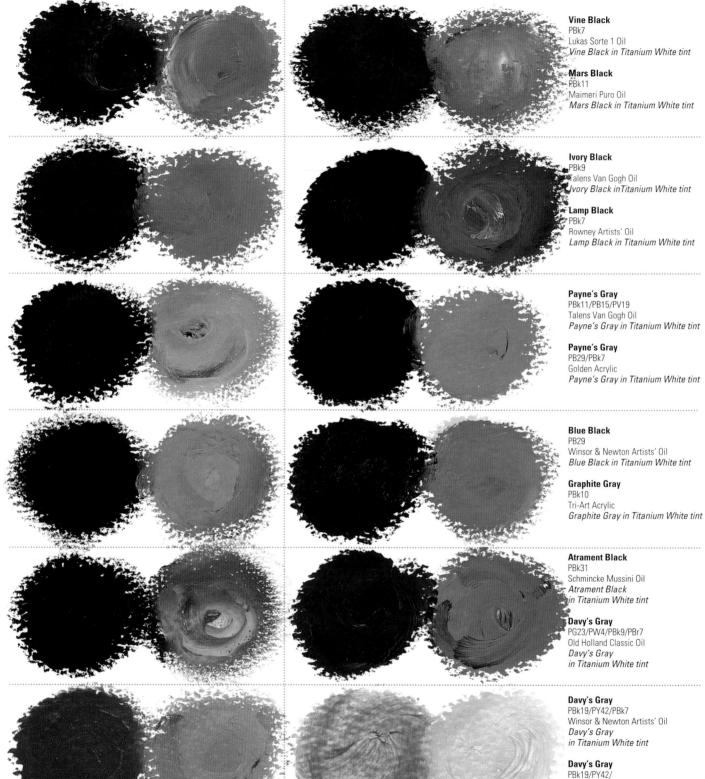

**Vine Black**
PBk7
Lukas Sorte 1 Oil
*Vine Black in Titanium White tint*

**Mars Black**
PBk11
Maimeri Puro Oil
*Mars Black in Titanium White tint*

**Ivory Black**
PBk9
Talens Van Gogh Oil
*Ivory Black inTitanium White tint*

**Lamp Black**
PBk7
Rowney Artists' Oil
*Lamp Black in Titanium White tint*

**Payne's Gray**
PBk11/PB15/PV19
Talens Van Gogh Oil
*Payne's Gray in Titanium White tint*

**Payne's Gray**
PB29/PBk7
Golden Acrylic
*Payne's Gray in Titanium White tint*

**Blue Black**
PB29
Winsor & Newton Artists' Oil
*Blue Black in Titanium White tint*

**Graphite Gray**
PBk10
Tri-Art Acrylic
*Graphite Gray in Titanium White tint*

**Atrament Black**
PBk31
Schmincke Mussini Oil
*Atrament Black in Titanium White tint*

**Davy's Gray**
PG23/PW4/PBk9/PBr7
Old Holland Classic Oil
*Davy's Gray in Titanium White tint*

**Davy's Gray**
PBk19/PY42/PBk7
Winsor & Newton Artists' Oil
*Davy's Gray in Titanium White tint*

**Davy's Gray**
PBk19/PY42/
Winsor & Newton Finity Acrylic
*Davy's Gray in Titanium White tint*

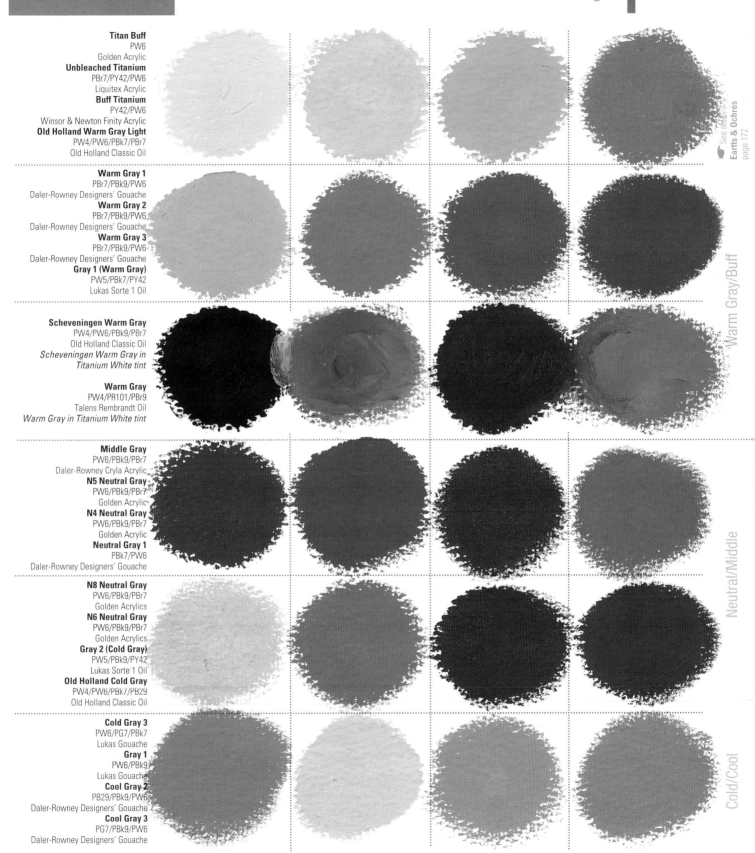

**Titan Buff**
PW6
Golden Acrylic
**Unbleached Titanium**
PBr7/PY42/PW6
Liquitex Acrylic
**Buff Titanium**
PY42/PW6
Winsor & Newton Finity Acrylic
**Old Holland Warm Gray Light**
PW4/PW6/PBk7/PBr7
Old Holland Classic Oil

**Warm Gray 1**
PBr7/PBk9/PW6
Daler-Rowney Designers' Gouache
**Warm Gray 2**
PBr7/PBk9/PW6
Daler-Rowney Designers' Gouache
**Warm Gray 3**
PBr7/PBk9/PW6
Daler-Rowney Designers' Gouache
**Gray 1 (Warm Gray)**
PW5/PBk7/PY42
Lukas Sorte 1 Oil

**Scheveningen Warm Gray**
PW4/PW6/PBk9/PBr7
Old Holland Classic Oil
*Scheveningen Warm Gray in
Titanium White tint*

**Warm Gray**
PW4/PR101/PBr9
Talens Rembrandt Oil
*Warm Gray in Titanium White tint*

**Middle Gray**
PW6/PBk9/PBr7
Daler-Rowney Cryla Acrylic
**N5 Neutral Gray**
PW6/PBk9/PBr7
Golden Acrylic
**N4 Neutral Gray**
PW6/PBk9/PBr7
Golden Acrylic
**Neutral Gray 1**
PBk7/PW6
Daler-Rowney Designers' Gouache

**N8 Neutral Gray**
PW6/PBk9/PBr7
Golden Acrylics
**N6 Neutral Gray**
PW6/PBk9/PBr7
Golden Acrylics
**Gray 2 (Cold Gray)**
PW5/PBk9/PY42
Lukas Sorte 1 Oil
**Old Holland Cold Gray**
PW4/PW6/PBk7/PB29
Old Holland Classic Oil

**Cold Gray 3**
PW6/PG7/PBk7
Lukas Gouache
**Gray 1**
PW6/PBk9
Lukas Gouache
**Cool Gray 2**
PB29/PBk9/PW6
Daler-Rowney Designers' Gouache
**Cool Gray 3**
PG7/PBk9/PW6
Daler-Rowney Designers' Gouache

See also
**Earts & Ochres**
*page 172*

Warm Gray/Buff

Neutral/Middle

Cold/Cool

Gold

**Rich Gold**
Mica-coated titanium dioxide/Iron oxide
Liquitex Acrylic
**Iridescent Gold Deep**
(Mixed pigment/vehicle content)
Tri-Art Acrylic
**Renaissance Gold**
Titanium dioxide–coated mica/Iron oxide
Winsor & Newton Finity Acrylic
**Pale Gold**
(Mixed pigment/vehicle content)
Daler-Rowney Designers' Gouache

Copper

**Iridescent Rich Bronze**
Mica-coated titanium dioxide/Iron oxide
Liquitex Acrylic
**Iridescent Bronze (Fine)**
Iron oxide–coated mica particles
Golden Acrylic
**Antique Bronze**
Mica-coated titanium dioxide /Iron oxide/PBk9
Liquitex Acrylic
**Bronze (Imitation)**
(Mixed pigment/vehicle content)
Daler-Rowney Cryla Acrylic

Bronze

**Copper**
(Mixed pigment/vehicle content)
Daler-Rowney Designer's Gouache
**Copper (Imitation)**
(Mixed pigment/vehicle content)
Daler-Rowney Cryla Acrylic
**Iridescent Copper (Coarse)**
(Mixed pigment/vehicle content)
Golden Acrylic
**Iridescent Copper**
(Mixed pigment/vehicle content)
Tri-Art Acrylic

Silver

**Iridescent Bright Silver**
Mica-coated titanium dioxide/Iron oxide/Stainless st
Liquitex Acrylic
**Silver**
(Mixed pigment/vehicle content)
Daler-Rowney Designer's Gouache
**Dark Silver**
Titanium dioxide–coated mica/Iron oxide
Winsor & Newton Finity Acrylic
**Iridescent Stainless Steel (Coarse)**
(Mixed pigment/vehicle content)
Golden Acrylic

Interference colors

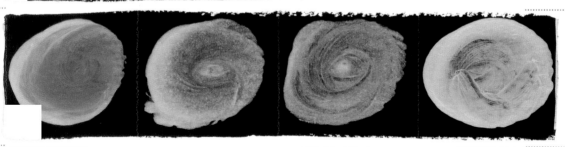

**Interference Violet (Fine)**
(Mixed pigment/vehicle content)
Golden Acrylic
**Interference Red (Coarse)**
(Mixed pigment/vehicle content)
Golden Acrylic
**Interference Blue (Coarse)**
(Mixed pigment/vehicle content)
Golden Acrylic
**Interference Green (Fine)**
(Mixed pigment/vehicle content)
Golden Acrylic

Spectral colors

**Spectral Fuchsia**
(Mixed pigment/vehicle content)
Tri-Art Acrylic
**Spectral Brilliant Red**
(Mixed pigment/vehicle content)
Tri-Art Acrylic
**Spectral Brilliant Blue**
(Mixed pigment/vehicle content)
Tri-Art Acrylic
**Spectral Brilliant Green**
(Mixed pigment/vehicle content)
Tri-Art Acrylic

**SAMPLE WHITES**
*(From left to right, top to bottom)*

**Cremnitz White**
PW1
Old Holland Classic Oil

**Flake White**
PW1/PW4
Old Holland Classic Oil

**Zinc White**
PW6
Winsor & Newton Artists' Oil

**Titanium White**
PW6/PW4
Rowney Artists' Oil

**Mixed White**
PW6/PW4
Talens Van Gogh Oil

**Underpainting White**
PW6/PW4
Winsor & Newton Artists' Oil

**Mixing White**
PW6
Rowney Artists' Oil

**Opaque White**
PW4
Lukas Studio Oil

**Warm White**
PW6
Tri-Art Acrylic

**Iridescent White**
Mica-coated titanium dioxide
Liquitex Acrylic

**Iridescent Pearl**
Mica-coated titanium dioxide
Tri-Art Acrylic

**Iridescent Pearl (Coarse)**
Mica-coated titanium dioxide
Golden Acrylic

**☛Note**

Whites given the same name can vary considerably in opacity, consistency, mixing and handling properties. There are commonly two types of white seen in manufacturers' color charts. These are Zinc White and Titanium White in oils and acrylics. In watercolors you will come across Chinese White, and, in many artists'-quality oil-color ranges, you will see the traditional Cremnitz White and Flake White. Many products are labeled as "mixing" whites and "underpainting" whites, and in acrylic ranges pearl and iridescent whites are available, too. See pages 86–87 for details.

**☛ NOTE: Metallic and special-effect colors**

All metallic and special-effect samples (opposite) are shown against black for tonal variation. It is impossible to show the true light-scattering effects of these samples. Refer to manufacturers' hand-painted color charts and see more details on pages 88–89.

There are hundreds of art materials manufacturers, ranging from small specialists who produce traditional pigments using time-honored methods to well-known brands that are household names recognized throughout the world. Many European and North American manufacturers have assisted with images, materials and information in the making of this book, and the following have been particularly generous in supplying samples.

### Daler-Rowney

Daler-Rowney's reputation as a manufacturer of art materials dates back more than 200 years. Turner and Constable are said to have used Daler-Rowney colors and, to this day, the company offers a comprehensive range of high-quality art materials throughout Britain, continental Europe and beyond.

Daler-Rowney
2 Corporate Drive
Cranbury, NJ 08512
Telephone: (609) 655–5252
www.daler-rowney.com

### Winsor & Newton

The William Winsor and Henry Newton partnership was founded in London in 1832 and, over the years, the names Winsor & Newton have become universally synonymous with many ranges of reliable and quality fine art materials.

Winsor & Newton
11 Constitution Avenue
P.O. Box 1396
Piscataway, NJ 08855
Telephone: (732) 562–0770
www.winsornewton.com

### Royal Talens

Talens, founded in 1899, is a prestigious producer of artists' materials and is a name that is known throughout the world. Royal Talens is based in The Netherlands and produces color materials under the brand names Rembrandt, Van Gogh and Amsterdam.

Royal Talens USA
Canson Inc.
21 Industrial Drive
South Hadley, MA 01075
Telephone: (413) 533–6554
www.talens.com

### Golden

Golden have gained a worldwide reputation for their heavy-body acrylic colors and mediums. In the 1980s Golden heavy-body acrylics were available only in jars and sold directly to professional Manhattan artists. As they gained in popularity, Golden started to manufacture heavy-body acrylic colors in tubes for a wider and ever-growing market. They now produce a range of 94 different colors, shades and tints.

Golden Artist Colors, Inc.
188 Bell Road
New Berlin, NY 13411
Telephone: (800) 959–6543
www.goldenpaints.com

### Maimeri

Painter Gianni Maimeri was an artist who ground his own colors. His methods were so satisfactory that in 1923 he and his brother, a chemist, founded the company Maimeri to produce fine art colors in a competitive domestic market. Eighty years later, Maimeri is still a family company and has developed into a major player in the world of artists' colors and materials.

Maimeri USA
4321 North United Parkway
Schiller Park
Chicago, IL 60176
Telephone: (847) 678–6845
www.maimeri.it/index_en.asp

### Lukas

Lukas was founded in 1862 by Dr. Franz Schoenfeld in Düsseldorf and the company has enjoyed prominence as a manufacturer and supplier of colors and materials since the nineteenth century. Van Gogh requested colors from Schoenfelds in his letters to his brother Theo. Saint Lukas is the patron protector of painters and the brand name Lukas came into being in 1900, becoming the trademark of all products from the manufacturer Dr. Fr. Schoenfeld. Lukas now enjoy an international reputation as suppliers of quality art materials.

Lukas USA
Jerry's Artarama
5325 Departure Drive
Raleigh, NC 27616
Telephone: (919) 790–6676
www.lukas-online.com

### Schmincke

In 1881 the chemists Herman Schmincke and Josef Horadam imported raw materials, particularly ultramarine, to produce high-quality artists' colors. A reputation was established, particularly for resin-oil formulations, which before the invention of the tube had been difficult to store and transport. The resin-oil formulations are based on old master recipes obtained from Prof. Cesare Mussini of Florence, and the Mussini name, along with Horadam, has become synonymous with quality art materials from Schmincke.

Schmincke USA
Artist Mercantile Inc.
192 Thomas Lane
Stowe, VT 05672
Telephone: (802) 253–6338
www.schmincke.de

### Old Holland

The Old Holland Oil Color Association was established in 1664 and is still continuing a tradition of nearly 300 years in the oldest artists' paint factory in the world. Old Holland paints are still manufactured according to seventeenth-century methods, using natural oils and pigments ground on stone rollers to create strong pure colors that are a little more expensive than other brands. Old Holland enjoys an international reputation and their classic oil and watercolors are exported to over 56 countries.

Old Holland USA
Armadillo Arts & Crafts
Building 2, Unit 1, Homestead Road
Belle Mead, NJ 08502
Telephone: (908) 874–3315
www.armadilloart.com
www.oldholland.com

### Liquitex

The first water-borne acrylic, the type of acrylic color we use today, was developed and launched in 1955. Combining the words liquid and texture, the product was named Liquitex. Liquitex as an artists' material was developed by Henry Levinson in the USA in a family-owned business named Permanent Pigments, a firm with a pedigree dating back to the early 1930s, and one with an impressive record in the development of permanence and lightfastness in pigments. Liquitex has become known worldwide as the original heavy-bodied, solvent-free artists' medium.

Liquitex
11 Constitution Avenue
P.O. Box 1396
Piscataway, NJ 08855
Telephone: (800) 445–4278
www.liquitex.com

### Sennelier

The company of Sennelier have been producing artists' materials in France since 1887. Gustave Sennelier was a chemist who developed a distinctive and meticulous process for manufacturing colors, and soon his palette became a benchmark of quality and reliability among artists. Sennelier products are now admired worldwide for combining nineteenth-century traditions with twenty-first-century innovations.

Sennelier USA
Savoir Faire
40 Leveroni Court
Novato, CA 94949
Telephone: (415) 884–8090
www.savoir-fair.com
www.max-sauer.com

### Tri-Art

Tri-Art is a modern Canadian-based company established in 1984. They have been manufacturing new-generation acrylic paints in Canada and North America since the mid-1990s and are now exporting to 10 countries. In addition to liquid acrylics and inks, Tri-Art produce 92 colors in artist-quality, high-viscosity acrylic colors. They use 100 percent acrylic paint to produce many colors with drastically improved properties that mimic the rich, transparent hues of older lake pigments.

Tri-Art
Woolfitt's Art Enterprises Inc.
1153 Queen Street West
Toronto, Ontario M6J 1J4
Canada
Telephone: (416) 536–7878
www.woolfitts.com

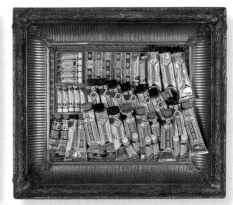
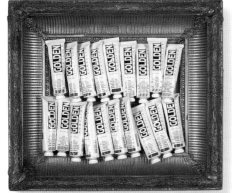
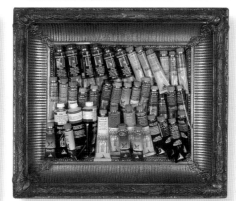
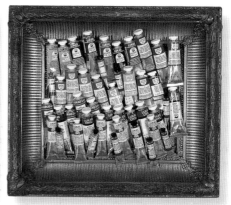
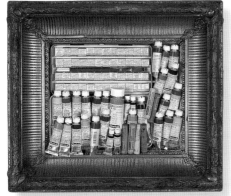
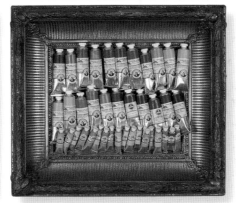
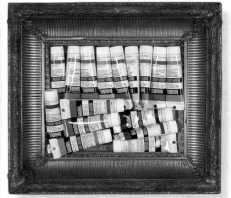
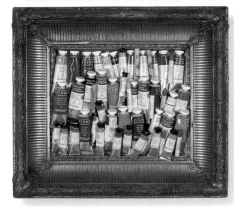

**Acrylic paint**
A paint that contains acrylic resin obtained by the polymerization of acrylic acid. Acrylic color can be mixed with water, but dries to a hard, plasticky film.

**Additive mixing**
The mixing of colored light. When the three primary additive colors of red, green and blue are mixed together, they produce white light.

**Advancing colors**
Colors that appear to move toward the front of the picture plane. These tend to be the "warm" colors, such as reds, yellows and oranges. (See also Receding colors.)

**Aerial perspective**
This is the technique of using cooler, lighter colors toward the back of the picture plane to give an impression of recession and depth. Sometimes also known as "atmospheric perspective."

**Alizarin**
One of the constituent dyes of the madder root, produced synthetically from the 1860s.

**Alkyd resin**
A synthetic resin, usually clear, used in paints and mediums. Alkyd resins are soluble in most solvents.

**Alla prima**
(Italian for "at the first")
Used to describe a painting made in one session, with no underpainting.

**Aniline pigment**
A dye synthesized from coal tar. Aniline dyes first produced in the 1850s were in the mauve, purple and red range.

**Archive-quality**
A term particularly applied to paper that is acid free with a neutral pH rating that ensures it will not yellow with age. The term may also be applied to paints and inks with respect to their permanence.

**Artists'-quality colors**
Paints made with the best-quality ingredients. They contain maximum purest pigments and binders.

**ASTM**
Acronym for the American Society for Testing and Materials. Provides an independent and international paint qualities standard recognized by major manufacturers.

**Azo**
Descriptive word pertaining to synthetic organic pigments, short for "diazotized amines."

**Backrun**
A term used mainly in watercolor to describe an irregular, unwanted blotch that may occur when wet paint is introduced into a previous layer that has not completely dried.

**Balance**
The overall arrangement and distribution of shapes, colors and tones in a painting.

**Base coat**
Layer of paint that acts as a ground for a painting.

**Bice**
Descriptive word pertaining to colors obtained from combining copper carbonates with silver. Used in the seventeenth century, these blue or green colors were also referred to as "ashes."

**Binder**
A liquid medium mixed with powdered pigment to form a painting or drawing material. In watercolor and gouache, the binder is gum arabic, in oil paints it is oil, and in acrylics it is acrylic resin.

**Bleeding**
A color moving past its required limit or leaking into another color, sometimes from a previous layer.

**Blending**
Merging the edges of two adjacent colors together to create a smooth gradation where they meet.

**Blocking in**
The initial process in painting a picture when the basic shapes of color and tone are broadly placed. This provides a foundation for refining the composition.

**Blue wool scale**
An international standard that measures the lightfastness of dye colors by dyeing samples of blue wool. The highest rating of 8 is regarded as permanent. Originally used in the textiles industry, the blue wool scale is now also used as a measure in commercial paint and print environments.

**Board**
Prepared artists' board covered with canvas or cotton, usually already primed for use with oils or acrylics.

**Body color**
Opaque water-based paint, particularly gouache, also known as designers' color. "Body" can also refer to the density of a color.

**Broken color**
Applying color so that previous layers of other colors show through for maximum optical effect.

**Brushwork**
The characteristic way that an artist applies paint with a brush.

**Canvas**
Traditional ground or support used for oil painting and acrylics. The term may refer to the actual fabric used, such as linen, cotton or jute canvas, or calico, or it may be used for the whole support of stretched canvas on a frame.

**Cartoon**
A full-size drawing from which a final fresco or tapestry is copied. The term particularly applies to Renaissance fresco works.

**Charcoal**
Carbonized, burned wood specially prepared for art use. Charcoal sticks produce a dark mark and are available in different grades and sizes. The best quality is soft and nongritty, often made from willow, but also from vine wood. Charcoal is also available in pencil form. This medium smudges easily and drawings made in charcoal need to be sprayed with a fixative.

**Chiaroscuro**
(Italian for "light/dark")
The use of light and shade in a painting where strong tonal contrasts are a feature, particularly applied to oil painting.

**Chroma**
A term used to designate the purity of a color. A color with high chroma contains little or no gray. (See also Saturation.)

**CMYK**
Acronym for cyan, magenta, yellow and black, the four colors used in the printing process. (See also Four-color process.)

**Cockling**
The unwanted wrinkling or puckering of a paper support when too heavy a wash is painted on. It particularly occurs with watercolor when the paper has not been stretched.

**Cold-pressed paper**
Watercolor paper that has a slightly textured surface. Also known as CP or Not paper (that is, paper that is not hot pressed).

**Collage**
Artwork composition in which pieces of paper, fabric or other items are pasted onto a support.

**Color**
The visual sensation and attributes of distinguishable wavelengths of refracted or reflected light.

**Color cast**
Mainly a printing term referring to a particular bias of color in an image.

**Color field painting**
Style of abstract painting developed by American Abstract Expressionist artists of the 1950s. Artists such as Mark Rothko painted large areas of pure color to give the sensation that the field of color seemed to go beyond the picture plane.

**Color swatch**
A small sample of a particular color that can be used for matching, experimenting or reference purposes.

**Color temperature**
Colors may be described as "warm" or "cool." Colors within a hue may also be described as warm or cool in relation to each other. (See also Warm colors and Cool colors.)

**Color wheel**
The arrangement of primary and secondary colors into a circle in the order of the spectrum. Intermediary colors may be added to enlarge the circle. Used as a basic device to explain color theory.

**Complementary colors**
Colors that are opposite each other on the color wheel. Red is the complementary of green, yellow of violet, and blue of orange. Similarly, on the enlarged color wheel, red-orange is the complementary of blue-green, yellow-orange of blue-violet, and yellow-green of red-violet.

**Composition**
The arrangement of subject matter within a picture. It involves the planning of color, use of light and shade and considered placing of the various elements.

**Conté crayons**
Similar to pastels, conté crayons are sticks made from pigment and graphite bound with gum and a little grease. They have a harder consistency than pastels.

**Contrast**
The degree of difference between the light and dark tones in a drawing or painting. Low contrast has fairly even tones throughout, while high contrast has bright highlights and dark shadows.

**Contre-jour**
(French for "against day")
A photographic term, meaning a painting or drawing in which the light is behind the subject.

**Cool colors**
Colors in the green/blue/violet sector of the color wheel are generally described as cool.

**Crosshatching**
A method of indicating tone and shading by crisscrossing close parallel lines. (See also Hatching.)

**Cyan**
A bright greenish blue that is used with magenta, yellow and black in the four-color printing process. (See also CMYK and Four-color process.)

**Dead color**
Sometimes used to refer to the underpainted colors in a painting.

**Diluent**
A liquid used to thin down paint. For oil paints, liquids such as turpentine and mineral spirits are used; for water-based media, water.

**Dot screens**
Screens from which regular patterns of dots are produced for each separate color in the four-color printing process. (See also CMYK and Optical mixing.)

**Dry brush**
A technique in which a minimum amount of paint is brushed lightly across the painting surface for a slightly textured effect. Can be used in any medium, but with watercolor the brush is literally kept dry.

**Dye**
A coloring agent that dissolves in water, used for coloring fabrics. Dyes are also used to color white powder to produce pigment "lakes" and "pinks." (See also Lake and Pink.)

**Earth colors**
Colors traditionally produced from naturally occurring pigments, such as oxides, ochres, umbers and siennas. Although regarded as the most stable pigments, many earth colors are now replicated by synthesized ingredients.

**Egg tempera**
Pure pigment bound with egg yolk and distilled water. As the paint dries it leaves a hard, silky surface, and, traditionally, this paint was applied to wooden panels over a gesso ground. The term "tempera" actually refers to binder, and it is also sometimes used for other bound paints, such as gouache, or "body" color.

**En plein air**
(French for "in open air")
Used to describe a painting made outdoors, usually directly from the subject in the landscape.

**Encaustic**
A technique in which the pigment is bound with wax. When melted the wax binds the pigment to the ground or support.

**Etching**
A print or impression produced from a drawing scratched into a metal plate. Areas of tone and texture may be added by dipping the plate into acid. The plate is then inked and passed through a printing or etching press.

**Fat**
Used to describe the oil content of oil paint, particularly when it has not been thinned. Fat, oil-rich paint takes a long time to dry and shrinks as it does so. To prevent the problem of the surface cracking, fat layers are traditionally applied on top of lean, thinned paint that is likely to dry first. (See also Lean.)

**Faux**
(French for "false")
A paint effect that gives the illusion of being real.

**Fixative**
A thin varnishlike solution that is sprayed by aerosol or mouth diffuser onto pictures worked in a medium likely to smudge, such as pastels, charcoal or graphite. It enables the particles of pigment to adhere fully to the support.

**Flocculation**
An effect particularly found in watercolor where particles of pigment settle in groups. The appearance of the dried paint is grainy rather than evenly dispersed.

**Form**
The three-dimensional appearance of a subject that produces its shape.

**Format**
The size and proportions of a painting or drawing. The two most popular are traditionally landscape and portrait, but square and round are frequently also chosen. (See also Landscape format and Portrait format.)

**Found colors**
Colors that may be obtained from nonpaint sources, such as natural materials, liquids and foodstuffs.

**Four-color process**
The printing process that uses three process colors – cyan, magenta and yellow – and black to produce a full-color effect. (See also CMYK and Dot screens.)

**Fresco**
(Italian for "fresh")
A method of painting using water-based colors applied to wet plaster.

**Fugitive**
Description given to pigments and dyes that are liable to fade with exposure to light. Modern methods of manufacture have reduced this problem considerably. (See also Lightfast and Permanence.)

**Genre**
(French for "kind")
The type of painting that a picture can be categorized as by its subject matter, such as still life, landscape or portrait. The term "genre" is particularly applied to paintings that have domestic subjects.

**Gesso**
A mixture of chalk whiting and glue size used traditionally as a ground and primer in tempera and oil painting. The term is also used to describe modern acrylic primers.

**Gilding**
The application of thin gold leaf, which may be burnished to give a high sheen.

**Glaze**
A transparent or semitransparent layer of color painted over another color to modify or enhance its effect.

**Gouache**
Opaque water-based body color, also known as designers' colors. In inexpensive student ranges, also known as poster paint.

**Granulation**
An effect particularly found in watercolor where coarse particles of pigment give a speckled appearance when dry.

**Graphite**
A form of carbon used in pencils, graded from soft to hard. Also available in solid stick or as powder.

**Gridding up**
A means of transferring a drawing or composition to another support. By drawing a grid over the original and a larger or smaller grid onto the new surface, the drawing can be copied section by section to an enlarged or reduced size. Also sometimes called squaring up.

**Ground**
A layer of priming or preparation that protects the support and provides a surface for painting. It may be colored to set a key for the subsequent painting.

**Ground color**
A color applied to a prepared support to give a more sympathetic background to a painting instead of brilliant white.

**Gum arabic**
A water-soluble gum made from certain acacia trees, added as a binder for watercolor pigment. It can also be used as a medium for watercolor to increase gloss and transparency.

**Harmonious colors**
Colors that are near each other on the color wheel, generally involving no more than two primary colors.

**Hatching**
A method of indicating tone and shading, using close parallel lines.

**Highlights**
The lightest areas of tone within a painting or drawing, generally describing reflected light.

**Hot-pressed paper**
Watercolor paper that has a smooth surface. Also known as HP paper. (See also Cold-pressed paper.)

**Hue**
The general name for a color, such as red or green. Hue may also be used to describe the comparative character of a color; for instance, Vermilion and Cadmium Red may be said to be similar in hue. Modern color manufacturers also use the term to denote that a synthetic pigment has been used to replicate the color of a traditional one.

**Icon**
A stylized image of Christ, the Virgin Mary or a saint, particularly as painted in Byzantine style. Now also used to describe a figure who has become symbolic or representational of a particular era or fashion.

**Impasto**
A technique of painting in oils or acrylics where the paint is applied thickly to create a textural surface. Mediums may be added to the paint to enhance the effect.

**Impressionism**
A movement in painting in France that developed in the 1870s. Among the principal artists were Monet, Renoir, Sisley and Pissarro, all of whom were interested in painting the changing impressions of light perceived when working outdoors.

**Imprimatura**
A coat of diluted color applied to a primed surface to tone down its brightness prior to painting.

**Intensity**
The brightness and strength of a color, also called saturation. Intensity also links to purity of color.

**Interference colors**
Paints that disperse the light in such a way that they give a varying effect as the viewer moves.

**Iridescent colors**
Paints that mimic the effect of iridescence typical of an insect's wing or bird's feather. Also known as interference colors, they produce a pearlized effect. (See also Interference colors.)

**Key**
The dominant tone of a painting, whether light or dark. Key may also refer to the process of abrading the surface to receive a heavier layer, such as for mural painting, when the wall must be prepared by adding a layer of plaster.

**Lake**
The pigment color produced by dyeing a white inorganic mineral powder such as gypsum or chalk with organic coloring matter through the use of a mordant. (See also Pink.)

**Landscape format**
A painting or drawing where the height is narrower than the width. This is the traditional shape for painting a landscape or vista. (See also Portrait format.)

**Lean**
Used to describe thinned oil paint, applied in the underlayers of an oil painting. (See also Fat.)

**Lifting out**
This technique relates particularly to watercolor and involves removing paint from the paper with a damp brush or a tissue. It can be used to create highlights or to soften edges, or to create effects, such as clouds.

**Lightfast**
Description of pigments that are not liable to fade after exposure to light.

**Limited palette**
Term applied to a particular choice of colors that an artist chooses to use, usually a small number of colors, so that there is control over the color balance in a picture. Also known as a "restricted" palette. (See also Palette.)

**Local color**
The actual color of an object with no added effects of light or shade or reflected color.

**Luminosity**
The quality of reflecting light, particularly in watercolor, where areas of white paper show through the layers of paint.

**Magenta**
Bright violet-red aniline color, named in 1859 after the battle in Italy. It is one of the three primary colors used in the four-color printing process. (See also CMYK and Four-color process.)

**Maquette**
Initial sketch or model for a painting or sculpture.

**Mars colors**
Applied to colors with iron oxide as their source. Mars was the alchemical name for iron.

**Masking**
The covering of an area in a painting to protect it or reserve it for further applications. In watercolor a rubbery solution called masking fluid is often applied to reserve the white paper as highlights. When the paint is dry, the protective coat is simply rubbed off or peeled away with the fingers.

**Medium**
The type of drawing or painting material used, such as oil, acrylic, watercolor or pastel (plural "media"). Medium is also used to refer to the various substances that may be added to paint to change its character in use (plural "mediums").

**Mica**
Silicates used in particle or flake form in metallic and iridescent paints. The paint is coated onto the mica to give a varying effect when viewed.

**Mixed media**
The use of two or more different media in a painting, such as watercolor with pastel or ink.

**Monochrome**
An image made using different tones of either black and white or a single color.

**Munsell scale**
A three-dimensional scale used in specifying color, developed by Albert Munsell (1858–1918), where color is shown in both degrees of saturation of hue and brightness.

**Mural**
A painting made directly on a wall, as with fresco.

**Negative shapes**
The shapes around or between the main objects in a drawing or painting. (See also Positive shapes.)

**Not paper**
Slightly textured watercolor paper. (See also Cold-pressed paper)

**Oilbars**
Oil colors in solid stick form, made by combining pigment and oil with waxes. Also called oil-painting sticks. They may be applied as drawing instruments, but the oil worked into with knife or brush.

**Opacity**
The degree to which a medium or color can obliterate what is underneath. Different media and colors within them vary in their covering power.

**Optical mixing**
The technique of painting small areas or dots of color close to each other so that they appear to mix when viewed from a distance. This is the method used in four-color printing where colors are screened to be reproduced in dot form. (See also Dot screens and Four-color process.)

**Palette**
The tray or surface on which colors are arranged and mixed. Palette also refers to the particular selection of colors that an artist chooses.

**Pantone®**
A proprietary system of color standards and quality that describes each color in terms of its composition in percentages. The system, therefore, provides a method that enables the printer to match an exact specified color.

**Pastels**
Sticks of color made from a hardened paste of pigment bound together with chalk or clay and gum. They are available as soft (chalk) or hard sticks, or in pencil form. Oil pastels are made from pigments, fat and wax, so they have a different character in use.

**Permanence**
The degree to which a pigment is lightfast or liable to fade on exposure to light. Art materials' manufacturers supply details about the permanence of individual colors in their ranges. (See also Lightfast.)

**Perspective**
A method of establishing space and depth in a painting or drawing by describing objects in the distance as smaller than those in the foreground. Parallel lines converge to a vanishing point as they meet the horizon (eye level). Also called linear perspective. (See also Aerial perspective.)

**Phthalocyanine**
A pigment synthesized from copper in the 1930s. It provides the base for a number of modern blue colors, mainly greenish, but sometimes with a reddish bias.

**Picture plane**
The vertical surface or area of a drawing or painting in which the composition is placed.

**Pigment**
The coloring agent in drawing and painting media. Originally from natural plant and mineral sources, most pigments are now synthetic. Pigment also refers to pure color in powder form.

**Pink**
A color produced by dyeing a white inorganic powder, such as chalk, with natural materials, such as berries and plants. Many yellows were produced by the this method, and the term "pink" was used to describe them. (See also Lake.)

**Pointillism**
A style of painting in which dots of color are juxtaposed so that they mix optically when viewed from a distance. The nineteenth-century French artist Georges Seurat used the technique successfully (see page 23).

**Poliment**
A red iron-oxide pigment that is applied as a base for gilding.

**Portrait format**
A painting or drawing where the height is taller than the width. As its name suggests, this is the traditional shape for painting a portrait. (See also Landscape format.)

**Positive shapes**
The actual shapes of the objects in a drawing or painting. (See also Negative shapes.)

**Primary colors**
The three primary colors – red, yellow and blue – are so-called because they cannot be mixed from other colors. In theory, however, all other colors can be mixed from primaries. All three primaries mixed together produce "black." (See also Subtractive mixing.)

**Primer**
A base coat, usually required for oil and acrylic painting, to protect the support and to provide a suitable foundation for paint. Gesso is traditionally used to prime surfaces for oils, but synthetic preparations are now available for both oil and acrylic paints.

**Process colors**
The colors used in the four-color printing process. (See also CMYK.)

**Receding colors**
Colors that appear to move into the distance within the picture plane. These tend to be the "cool" colors, particularly blues. (See also Advancing colors.)

**Recession**
The impression of depth in a picture. This can be achieved both through linear perspective and aerial perspective, involving the use of lighter, cooler colors.

**Reduction**
Mixing a color with white paint.

**Reflected color**
The light reflected from a colored surface onto another object, so modifying the object's own local color. (See also Local color.)

**Relief**
Usually a sculpture or carving in which the image stands proud of its background, described as high or low relief, depending on the extent to which this is apparent. The term may also be used to describe the effect of paint applied thickly, as with impasto. (See also Impasto.)

**Renaissance**
A period of history in Europe that lasted from the fourteenth to the sixteenth centuries. The Renaissance was a rebirth and flowering of the arts, science and culture, much of which was associated with the great master Italian painters.

**Resist**
A material, such as wax, placed on a support to repel water. The technique is used effectively in watercolors for texture and highlights.

**Rough paper**
Unpressed watercolor paper, perhaps handmade, which has a rough, indented surface texture.

**Saturation**
The degree of vividness and purity of a color. A light color or tint may be regarded as of low saturation, while pure color is termed fully saturated or of high saturation. (See also Chroma and Intensity.)

**Scumbling**
A technique originally applied to oil painting, but now used with all opaque media. It consists of dragging dryish paint over the surface of a painting so that the layers underneath show through.

**Secco**
(Italian for "dry")
A wall painting made on dry plaster or plaster that is slightly dampened. (See also Fresco.)

**Secondary colors**
Colors obtained by mixing two primary colors. Orange is produced from red and yellow, green from yellow and blue, and violet from blue and red.

**Series no.**
A number that denotes the quality and price range of the pigment.

**Sfumato**
(Italian for "smoked" or "misty")
A gradual transition from light to dark with no noticeable change from one to the other.

**Sgraffito**
(Italian for "scratched")
A technique where the top layer of color is scratched or incised to reveal the layer or ground beneath.

**Shade**
A color that has been darkened by the addition of black.

**Shaped canvas**
A canvas that is not rectangular.

**Sinopia**
A red iron-oxide color used by Renaissance artists to make a preliminary drawing prior to painting, itself referred to as the sinopia.

**Size**
A gluelike liquid that is applied to a canvas support to make it impermeable before applying a layer of gesso or primer.

**Sketch**
A rough drawing, sometimes made as a preliminary to a composition.

**Solvent**
Agent or medium that thins or dissolves undiluted paint or pigment.

**Spectrum**
The arrangement of colors produced when white light passes through a prism. Seven separate colors are distinguished – red, orange, yellow, green, blue, indigo and violet.

**Split complementaries**
These are colors that are adjacent to the true complementary of a color. For instance, the split complementaries of blue are red-orange and yellow-orange.

**Staining colors**
A term that refers particularly to watercolors. Some colors are made from very finely ground particles of pigment and may not be completely "lifted out" from the paper.

**Stretcher**
The wooden frame on which canvas is stretched and fixed to provide a support for painting in oils or acrylics.

**Study**
A detailed drawing or painting of a part or parts of a composition.

**Subtractive mixing**
The mixing of pigments. When the three primary pigment colors of red, blue and yellow are mixed together, they produce black.

**Support**
The surface on which a drawing or painting is made, such as paper, canvas, board or wood panel.

**Tertiary colors**
Colors produced by mixing equal proportions of a primary color with its adjacent secondary color. For instance, yellow mixed with green creates yellow-green.

**Thinner**
A liquid added to paint to dilute it and make it easier to apply to the support. Many are available, depending on the medium used and the consistency required. The traditional thinner for oil paint is turpentine.

**Three-dimensional**
The impression given in a drawing or painting of objects having depth or volume, as well as height and width.

**Tint**
A color that has been lightened by the addition of white.

**Tinting strength**
The degree to which a pigment can dominate in color mixtures.

**Tondo**
A circular easel painting or relief carving.

**Tone**
The lightness or darkness of an element in a drawing or painting, irrespective of its local color. Also called value. The term tonal value is also used to describe the relation of one tone to another.

**Tonking**
A means of removing surplus paint by pressing a sheet of paper over the surface of the painting, used particularly in oil painting.

**Tooth**
Term used for the surface texture or interweave of fibers of the paper. A paper with pronounced tooth is required when painting with pastels so that the dry pigment may be held.

**Top tone**
The obvious hue of a color, such as red or blue. (See also Undertone.)

**Torchon**
A tightly rolled paper stump used for blending pastels and charcoal. The pointed end can be used for detail.

**Transparency**
The degree to which light can pass through a color. Watercolor is a transparent medium, but thinned glazes of oils and acrylics may also allow transparency.

**Trompe l'œil**
(French for "deception of the eye") A painting that is so realistic that the viewer is fooled into thinking the objects or a scene are real.

**Underdrawing**
A drawing made on a surface or support to indicate the basic positions or guidelines for the composition.

**Underpainting**
The early stages of a painting when the color balance, tone and composition are laid down.

**Undertone**
The underlying tone of a color, which may veer toward another hue. For instance, a blue may be reddish or yellowish. (See also Top tone.)

**Vanishing point**
In perspective the point at which parallel lines converge as they meet the horizon. There may be several vanishing points in a picture.

**Varnish**
A transparent liquid applied to the surface of a painting, which dries to form a transparent protective film. Varnishes are available in matte or glossy finishes, and specific formulations are available for the medium used in the painting.

**Vehicle**
A liquid, including the binder and additives, which holds pigment in suspension so that it can be applied to a surface in the form of paint.

**Vignette**
A painting or drawing of which the edges are shaded off or fade away, often in the shape of an oval.

**Volume**
The space filled by an element or object in a drawing or painting.

**Warm colors**
Colors in the red/orange/yellow sector of the color wheel are generally described as warm.

**Wash**
A layer of transparent or thinly diluted paint or ink, usually applied in broad sweeps. Color may be built up by layering one wash over another.

**Watercolor**
The term mainly applies to pigment bound with a water-soluble substance, such as gum arabic, which produces a transparent color when dry. However, opaque watercolors, known as gouache or "body" color, which contain fillers, such as chalk, are also applied by diluting with water. (See also Gouache.)

**Water-soluble pencils**
Colored pencils and crayons that may be used with water to produce watercolor effects.

**Wet-in-wet**
A technique in watercolor in which a wash is applied on top of another while the first is still wet.

**Wet-on-dry**
A technique in watercolor in which a wash is applied on top of another after the first is completely dry.

**Wetting agent**
A liquid, such as ox gall, added to watercolor that enables it to flow more easily on the paper.

**White light**
This effect is produced when red, blue and green light are combined in equal proportions. (See also Additive mixing and Subtractive mixing.)

**Whiting**
Ground and washed white chalk used to make whitewash and gesso.

**Yellowing of paint**
An effect of yellow discoloration on oil paintings that may occur if too much linseed oil is added to the paint. Some varnishes may cause a painting to take on a yellow tinge or the surface of the varnish may become grimy. Oil paintings kept in the dark also tend to take on a yellowish look.

**Yellowing of paper**
Gradual darkening of paper toward a yellowish or brownish shade. This is especially noticeable in acidic papers, such as those made from wood pulp.

Much of the material contained in this manual was formed by firsthand experience, curiosity and experimentation, and through talking to practicing artists and manufacturers of artists' colors. Many hundreds of books have been browsed through, too, and the following were of particular interest. Some are standard works of reference on color, and some just tell a fascinating story. Many of the older works contain practical information on coloring techniques from bygone ages and may encourage more curious readers to experiment for their own amusement.

**Advice to Artists**
Leonardo da Vinci
Edited/Annotated by Emery Kelen
Running Press, Philadelphia, 1990

**The Art of Color**
Johannes Ittens
Van Nostrand/Reinhold, New York, 1961
(Original German Edition, Kunst der Farbe,
Studienausgabe, 1961)

**The Artist's Handbook of Materials & Techniques**
Ralph Meyer
Fifth Edition, Faber & Faber, London, 1991
Revised and expanded by Steven Sheehan

**Artists' Materials**
*Which, Why and How*
Emma Pearce
A&C Black (Publishers) Limited, London, 1992

**Artists' Pigments**
F. W. Webber
Van Nostrand, New York, 1923

**Bright Earth**
*The Invention of Color*
Philip Ball
Viking, London, 2001

**The Craftsman's Handbook**
*Il Libro dell 'Arte, Cennino d'Andrea Cennini*
Translation: Daniel V. Thompson Jr.
Yale University Press, 1933
Dover Publications Inc. (paperback), New York, 1960

**Color**
*How to Use Color in Art and Design*
Edith Anderson Feisner
Laurence King, London, 2001

**Color**
*Making and Using Dyes and Pigments*
François Delamare & Bernard Guineau
Translated by Sophie Hawkes
Thames & Hudson, London, 2000
(Original edition, Gallimard, Paris 1999)

**Color**
*Travels Through the Paintbox*
Victoria Finlay
Sceptre/Hodder and Stoughton, London, 2002

**Color for the Artist**
*A Pocket How to Do It*
Hans Schwarz
Studio Vista, London, 1980

**Color and Culture**
*Practice & Meaning from Antiquity to Abstraction*
John Gage
Thames and Hudson, London, 1993

**Color and Meaning**
*Art, Science and Symbolism*
John Gage
Thames and Hudson, London, 1999

**Concerning the Spiritual in Art**
Wassily Kandinsky
Dover, New York, 1977
(Original edition, trans. from German, 1914)

**The Elements of Color**
*A Treatise Based on the Art of Color*
Johannes Ittens
Edited by Faber Birren
John Wiley & Sons Inc., 2001

**Interaction of Color**
Josef Albers
Yale University Press, 1963

**Lights and Pigments**
*Color Principles for Artists*
Roy Osbourne
John Murray, London, 1980

**Living Colors**
*The Definitive Guide to Color Palettes Through the Ages*
Margaret Walch and Augustine Hope
Chronicle Books, San Francisco, 1995

**The Materials of the Artist and Their Use in Painting**
*With Notes on the Techniques of the Old Masters*
Max Doerner
Harcourt Brace & Company, 1949
Harvest Paperback edition, 1984
(Original German edition, Maltmaterial und seine
Verwendung im Bilde, 1934)

**The Materials and Techniques of Painting**
Jonathan Stephenson
Thames and Hudson, London, 1989

**Mauve**
*How One Man Invented a Color That Changed the World*
Simon Garfield
Faber & Faber, London, 2000

**Methods and Materials of Painting**
*of the Great Schools and Masters*
Sir Charles Lock Eastlake
(Two volumes bound as one, paperback)
Dover Publications, New York, 2001
(Original edition, Materials for a History of Oil Painting,
Longmans, London, 1847)

**Notes on the Composition and Permanence of Artists' Colors**
Winsor & Newton
ColArt Fine Art & Graphics Ltd, 1997

**The Oxford Companion to Art**
Edited by Harold Osborne
Oxford University Press
First published 1970, nineteenth impression 1999

**The Painter's Handbook**
*A Complete Reference*
Mark David Gottsegen
Watson Guptill, 1993

**Painting Materials**
*A Short Encyclopedia*
Rutherford J. Gettens & George L. Stout
Dover Publications, New York, 1966
(Original edition, D. Van Nostrand Co. Inc. New York, 1942)

**The Primary Colors**
*Three Essays*
Alexander Theroux
Picador, London 1995
(Original edition, Henry Holt & Co Inc., New York, 1994)

**What Every Artist Needs to Know about Paint & Colors**
David Pyle
Krause Publications, Wisconsin, 2000